Art and Solidarity Reader.
Radical Actions, Politics and Friendships
Edited by Katya García-Antón

Art and Solidarity Reader.
Radical Actions, Politics and Friendships

Office for Contemporary Art Norway (OCA) / Valiz, 2022

Katya García-Antón
*Introduction. On the Possibilities of Art
and Solidarity to Restructure Relations
and Make Worlds* [1]

1 Subtitle inspired
by Rauna Kuokkanen
*Restructuring Rela-
tions. Indigenous
Self-Determination,
Governance and Gender*
(Oxford: Oxford Uni-
versity Press, 2019).

'To live one's own life well, such that we might say that we are living a good life within a world in which the good life is structurally or systematically foreclosed to so many' [2]

Judith Butler

'Solidarity … ties people together – it binds' [3]

Shirin M. Rai

'Asymmetrical acts of solidarity establish the master-slave relationship and therefore bondage' [4]

Michael Hoelzl

'Our relationship to the land itself generates the processes, practices and knowledges that inform our political systems, and through which *we practice solidarity*' [5]

Glen Coulthard and Leanne Betasamosake Simpson

2 Judith Butler, 1997, 'Merely cultural', *Social Text* 52 (53): 265-77. Judith Butler, 'Can One Lead a Good Life in a Bad Life?' Transcript of the Adorno Prize Lecture, Frankfurt 11 September 2012 in *Radical Philosophy* 176: www.radicalphilosophy.com/article/can-one-lead-a-good-life-in-a-bad-life accessed 30 September 2021.
3 Shirin M. Rai, 'The Good Life and the Bad: Dialectics of Solidarity', in *Social Politics*, Vol. 25, no. 1, 2018: 15.
4 Michael Hoelzl, 'Recognizing the Sacrificial Victim: The Problem of Solidarity for Critical Social Theory', University of Manchester, JCRT6.1, December 2004.
5 Glen Coulthard and Leanne Betasamosake Simpson, 'Grounded Normativity / Place-Based Solidarity' in *American Quarterly*, Johns Hopkins University Press, Vol. 68, no. 2, (June 2016): 254.

What comes to mind when one hears the word 'solidarity'? Whatever is conjured is inevitably a projection of social and political values as much as it is an incarnation of the structural realities of the day.[6] In other words, solidarity is defined by the epistemologies, ontologies and methodologies one inhabits. From a western perspective, the ideology of solidarity grew as a reaction to the doctrinaire individualism that character-ised so much of Enlightenment political thought and the law it called forth. In this context, the word appears in the late 1700s, in the wake of the French Revolution. Its use spread with the ensuing political, economic and social changes that transformed the patterns of life across the western world and set the ideological ground for modernity in the centuries that followed.

The expressions of solidarity during this timeline have been bountiful, and have unfolded as many meanings in social and artistic fields as they have had users. To cite but a few areas in which the two fields have acted in tandem, throughout the nineteenth century the notion was central to the universal-ist discourse of the Catholic Church, and crucial to women's mobilisations demanding the vote across Europe. In the twen-tieth century, during the post-war period the term headed the wave of anti-colonial movements of independence across the global south (post-revolutionary Cuba played a crucial role in this in the 1960s and 1970s, fuelling artistic and polit-ical solidarity across Africa, Asia and Latin America; such efforts of anti-colonial and solidarity world-making were especially prevalent in relation to the Palestinian Revolution). In the 1970s the notion was key to the emergence of the World Council of Indigenous Peoples that led to the crystal-lisation in the United Nations of a political formulation for global Indigenous solidarity two decades later.[7] The term was also strongly associated with labour movements world-wide that generated remarkable political shifts (such as the Polish social movement of the 1980s that spear-headed the fall of the Soviet Bloc). Since the 1970s, it has been a pivotal element of the now faded rhetoric of European social policy.[8] In the new millennium, solidarity movements are powering the global zeitgeist with particular vigour in relation to (and intercon-

6 Kristine Khouri & Rasha Salti, 'Intro-ducing Past Disquiet' in *Past Disquiet. Artists, Internati-onal Solidarity and Museums in Exile*, ed. Kristine Khouri and Rasha Salti (Warsaw: Museum of Modern Art, 2018), 21.
7 Sorcha Thomson, 'A Cosmovision of Solidarity: Anti-Co-lonial Worldmaking in Havanna, Palestine and the Politics of Possibility', *Border-lines*, 6 June 2021.
8 'Solidarity not only constitutes one of the "indivisible, universal values" on which the European Union is founded, but also represents a body of substan-tive rights that the constitution will guarantee', as is discussed by Thomas C. Kohler in 'The Notion of Solida-rity and the Secret History of American Labor Law', *Buffalo Law Review* 53 (2006): 103.

necting) Climate Urgency, MeToo and 2SLGBTQIA+, Black-, Trans- and Indigenous Lives Matter campaigns.

The mobilisations around these issues characterise some of the most poignant socio-political and artistic struggles of the last centuries. Protean in character, the notion of solidarity has been prevalent in the dissemination of world perspectives defined by the western nations, their empires and surviving neocolonial regimes; and yet they have simultaneously been deeply embedded in epistemologies antithetical to modernism, such as those that structure Indigenous worlds.[9] Far from resolved, these disputes over relationality between beings and with their variegated surroundings have continued unabated into the present. If anything, they have become more pressing, and the debates around them have involved thinkers as far-ranging as Karl Marx (who predicated solidarity amongst workers), Rabindranath Tagore (who advocated solidarity amongst Hindu Muslim communities in the Indian subcontinent), Audre Lorde (who called for solidarity with Black people and their allies), Grand Chief George Manuel (who led the creation of a global Indigenous solidarity movement) and Greta Thunberg (who has galvanised the world's attention around climate solidarity), to name but a few.[10]

Simultaneously a potent ideal and a slippery category, solidarity is still today one of the most evoked but least analysed concepts within the arts. Why? Because the notion of solidarity traces the fault lines delineated by the values that modernity predicates and that run through the foundations of societies and the so-called international art field. Solidarity inhabits this mined ground, and so any consideration of it requires the deployment of an array of critical tools, akin to the multiple vantage points from which the aesthetic expression of modernity (from low modernism to high modernism to postmodernism), and the narration of its art history/ies, are being examined and rethought today.

With these complexities in mind, this *Reader* sets out to shed light upon the transformative power that solidarity processes and works created by artists, art collectives and art institutions have generated over the last 50 years of world-making and of restructuring relations between humans and their complex surroundings. It does so from an intersectional

9 Rolando Vazquez, 'The museum, decoloniality and the end of the contemporary', in the conference *Collections in Transition. Decolonizing, demodernising, decentralising*, Van Abbemuseum, Eindhoven, 22 September 2017.

10 The newspaper article by Arnab Mitra, 'How Rabindranath Tagore used Raksha Bandhan as means to prevent 1905 Bengal partition', *The Indian Express*, 7 May 2019, points out that philosopher, poet, pedagogue and artist Rabindranath Tagore used the term 'Raksha Bandhan' to advocate harmony between Hindus and Muslims in the face of the British Raj's efforts to break up the growing solidarity between the two communities. While it started off as a religious observance dating back to mythical eras of gods and goddesses, in the wake of the partition of Bengal in 1905 Tagore was instrumental in ensuring that Rakshabandhan transcended from being a religious ceremony to a socialist movement to mark a symbolic protest. The Rakshabandhan was perhaps the only festival in India's struggle for freedom that was used to send a signal to the British Raj.

and critical standpoint that challenges the hegemonic frames through which solidarity in the arts have so often been implemented and narrated. The time span, necessarily specific given that a broader consideration would be beyond the scope of this publication, traces an arc of inter-related eras between the Cold War and today. This is a relevant time-frame given that during it, modernity and modernism expanded their reach world-wide exponentially; a global reach that today is experiencing a vigorous process of critique, deconstruction and de-centring.

Dehegemonising Solidarity in the Arts

Part of the problem has been that the mobilisations of solidarity awarded most visibility in the last centuries have taken on a legendary association with the 'good fights'. In the arts and social field, this has come at a price. It is vital to recall what and whom such an approach may have left out, and how it is premised on those leavings out, as well as to consider how solidarity works across differences in kinds and degrees of oppression. Scholar Mpho Matsipa has called out the tendency for the relationship between art and solidarity in art histories to be viewed/narrated through a 'hydraulic' lens.[11] Instead, she advocates for a restructuring that favours micro-narratives. By doing so, one can prise open space for a quotidian and situated perspective on solidarity movements, move away from a western-centric art history of grand narratives, and towards histories based on multiple co-existing centres.

Zooming in on the micro-stories of those figures considered inconsequential until recently by the scholarship narrating the relationship between artistic and social movements, is an important process of acknowledgment of the significant agency these figures have wielded in the construction and maintenance of solidarity. It also allows us to unveil the hegemonic narration of solidarity that has favoured white, male, gender-binary, euro-centric, north-led relations with the south, and modernist-centric approaches that do not acknowledge Indigenous ontologies of solidarity. In this process, modernism's universalist and nation-state-centric underpinnings are revealed as generators of asymmetrical

11 Mpho Matsipa, lecturer at Wits School of Architecture and Planning in Johannesburg, understands the term 'hydraulic solidarity' as a power-based process. As examples of hydraulic forms of solidarity one could point to those characterised by asymmetrical relations where one party has the upper hand over the other; or by the military aesthetics prevalent in many artworks generated during anti-colonial movements. An example of the latter would be the solidarity posters designed by Felix René Mederos Pazos in Havana, during the 1960s, for the anti-colonial guerillas in Angola and the Black Panther. Mpho Matsipa, at 'The Radical Solidarity Summit', Day 4 Panel Discussion 'Urban Imaginaries, Mobilities and Why So Many Borders' Zeitz MOCAA, Cape Town, 17 September 2020.

Katya García-Antón

Introduction

relations of power and privilege.[12] Sociologist Akwugo Emejulu[13] highlights the destructive effects of asymmetrical and universalist forms of solidarity actions. She has noted that whilst impressive in scale, the 2017 Women's Marches in the UK and US that shook the globe with their worldwide support (and galvanised five million people in the US alone) were driven by a white middle-class, normative majority. In reproducing racial, religious, gender and class domination they replicated the flawed history of feminist movements in both America and Britain; they co-opted iconic elements from the American Civil Rights Movement and ignored the Million Man and Million Woman Marches of the 1990s that the Nation of Islam had already successfully organised. To this critique she adds historical context, observing that from the earliest days of women's suffrage in the nineteenth century to the Women's March in the twenty-first century, a 'call to sisterhood' has usually been made by and for white, middle-class women for whom the concept of 'woman' is an exclusive and excluding category of hierarchical and normative domination that fails to acknowledge the privileged ability of white middle-class normatively defined women to transit with ease between the realms of the private and the public. The sociologist Arjun Appadurai has picked up on this question further and alerts us to the ways in which the capacity to aspire (to a solidarity march for example) is itself located in everyday exclusions[14] and that the good life implied by solidarity actions needs to bridge public and private spaces, as well as individual and collective lives. A life of solidarity thus needs to be a shared one.

This crucial observation is at the heart of what has driven '¡Estamos Hartas!' ('We've Had Enough!') – Mexican feminist, artistic and civil coalitions that galvanised across class and race; operating during the 1970s in Mexico City they are still a reference point today. These groupings employed aesthetic strategies including street theatre, demonstrations, community organising and other forms of spontaneous mobilisation. At stake for them was the challenge of bringing issues from the private sphere into the public sphere in order to articulate political demands that would ultimately redefine their status as citizens. Their practices tackled embodied encounters

12 Scholarship on art and solidarity has tended to focus on the Cold War history of international solidarity between nation-states. Whilst important, this lens risks eschewing situated forms of solidarity whose processes defy the colonial foundations that lead to the nation-state, and whose temporalities operate beyond the event-logic.

13 Akwugo Emejulu, 'On the problems and possibilities of feminist solidarity: The Women's March one year on', *IPPR Progressive Review*, 24(4): 267–73, 2018.

14 Arjun Appadurai, *The capacity to aspire: Culture and the terms of recognition*, in 'Culture and public action', ed. Vijayendra Rao and Michael Walton (Stanford: Stanford University Press, 2004).

and the terms through which their bodies were discursively constructed by laws, social mores and images. Notable amongst them was a mobilisation conducted on 10 May 1979 that included around 200 women dressed in black, who walked across hegemonic landmarks of Mexico City, from El Angel de la Independencia and along Reforma Avenue towards the Motherhood Monument, to mourn the deaths of thousands of women as a result of illegally performed abortions. The procession carried a large funeral 'wreath' made not of flowers but of objects utilised to provoke the abortions: knitting needles, clothes hangers, turkey feathers and natural herbs. It was laid at the Motherhood Monument, and the march itself became a feminist ritual in the decades that followed. '¡Estamos Hartas!' ensured that multiple histories had a place in the official pantheon of heroes that adorn the streets of Mexico City. The group created an enduring space from which the diverse cultures of violence against bodies could be expounded, and upon which political solidarity could be forged.[15] Moreover, they overlaid a new cartography of feminist and sexual empowerment on the patriarchal markers that define the city, creating a site of ongoing contestation against the official foundation story of Mexico as a nation-state.

North of the border, the US's foundation story as a nation-state is similarly problematic – intimately bound to the American Civil War anti-slavery movements, it is riddled by forms of solidarity that stand upon the clay feet of colonialism. In Kansas City, to cite one example, there is a monument exemplifying how memorialising a historical impulse towards solidarity against one form of oppression can be built upon a refusal to acknowledge another. 23 tonnes of pink rock face the city hall, with a plaque that honours the heroism of those who founded the town as an antislavery outpost. It reads: 'To the pioneers of Kansas who in devotion to human freedom came into a wilderness, suffered hardships and faced danger and death to found this state in righteousness.' The fact that Kansas City is on Indigenous land is nowhere mentioned, an erasure which is an integral part of the story of the monument itself. The stone anchoring its plaque was a Shunganunga boulder, rare in the region's more habitual yellow-white rock formations, carried from the Dakota glaciers

15 As Yásnaya Elena Aguilar Gil has noted in her contribution to this *Reader*, 'Making a Territory of Collaboration Possible. Art, Solidarity and Indigenous Peoples', page 197, governmental political campaigns of the last decades have manipulated the term 'solidarity' to maintain hegemonic power, and so over the years have emptied any agency from the word. This is likely the reason why ¡Estamos Hartas! are mindful to avoid its use, despite the fact the notion itself underpins their endeavours. In her essay, Aguilar Gil points to the need to reclaim the term 'solidarity' back from central government abuse.

during the last Ice Age. Its distinctiveness was valued by the Kanza people living near its location at the intersection of the Shunganunga Creek and the Kaw River. Having incorporated the boulder into water-worship rites, and named it in 'zhúje 'waxóbe (Big Red Rock), the Kanza considered it as a source of their collective identity long after their nation was forcibly removed to Oklahoma in the wake of the Civil War. In 1929 as part of Lawrence's 75th anniversary celebration, the Santa Fe Railroad removed the stone from its centuries-old resting place. It went from marking a sacred place to being a Founders Monument in Lawrence. In 1989, the Kanza asked that the Shunganunga boulder be restored to its former place in the river. A Lawrence Sesquicentennial Commission member justified the rejection of this request with the argument that a monument to abolition could also be deeply embedded in long, unacknowledged histories of colonialism, twisting the narrative thus: 'To the Kanza, these things had a life and a spirit. In some ways, the spirituality of the rock has been shifted to a different area. The boulder was very important to the residents of Lawrence who brought it here – it was kind of like their Plymouth Rock.'[16] As a result of the continued lobbying by the Kanza Nation, in March 2021 the Lawrence City Commission voted unanimously to adopt a joint resolution with Douglas County agreeing to return the sacred rock to the Kanza Nation, and offering an official apology for appropriating and defacing it.[17]

Centring and Collectivising Self-Care. A Pandemic View on Artistic Solidarity

The coronavirus pandemic that spread since 2020 has been a shock not just to health systems globally, it has given a jumpstart to generative and discursive consciences in the world. Structural unfairness has become harder to ignore. Ethical exceptionalism – the idea that some people can operate by a different moral code – gets short shrift at a time of intimate interdependence and mutual care.[18] As the relations between bodies and space have been radically reconstituted by the virus, prioritising care – for others as well as ourselves – has changed the way one cares for oneself. Care and self-care have become interdependent. The pandemic has restruc-

16 Karl Gridley in 'Boulder, Plaque Pay Homage to Pioneers', *LJWorld.com Lawrence-Journal World* 19 September 2004 https://www2.ljworld.com/news/2004/sep/19/boulder_plaque_pay/ accessed 2 March 2022.

17 Rochelle Valverde, 'City Seeks Photos and Documents Related to Sacred Prayer Rock', *Lawrence-Journal World* (9 April 2021), https://www2.ljworld.com/news/2021/apr/09/city-seeks-photos-documents-related-to-kaw-nations-sacred-prayer-rock-which-was-stolen-and-made-into-monument-in-1929/ accessed 27 August 2021.

18 At the time of writing, Matt Hancock was forced to resign as Minister of Health in the UK for transgressing COVID-19 regulations that he himself legislated. www.theguardian.com/politics/2021/jun/26/matt-hancock-resigns-after-questions-over-relationship-with-aide

tured so many phenomena: grief, love, death, birth, family, friendship, work, health, learning, privacy, mobility, sound, our relationship with nature and our carbon footprint, amongst other underpinnings of society. Such changes have made it necessary to place care at the forefront of social and artistic conversations and practices, locally and internationally. In this regard, care is being rethought through the collective, rather than as an individualistic notion of self-care. It is this kind of care that emerges as the paradigm of our times and stands as a pivotal lens through which to consider solidarity in the arts.

As curator and theorist iLiana Fokianaki has recently observed, the social history of care has been informed by the intertwined relationships between capitalism, colonialism and modernity. 'With the industrial revolution, curing and caring for oneself took an individualist turn: it became a private affair for the privileged. Self-care was turned into a sign of cultural sophistication for the western imperialist class and looking after your own well-being was framed as the individual's obligation towards society.'[19] The settler colonialism that created nation-states across the Americas was one chapter in Europe's colonisation of much of the globe. The individualistic ideology at the root of this colonialism positioned self-care above and in opposition to care for the community and for others. As Fokianaki adeptly observes, modernism suppressed the collective notions of care centred by many non-western societies (specially Indigenous ones) across the Americas, Asia, Oceania and Africa. The western notion of individualist self-care, with its implied cultural superiority, drove colonial grabbing of land, resources and bodies at a planetary scale.

Taking this planetary asymmetrical relationality implanted by modernism as a starting point, the question is whether the pandemic has generated a reconsideration of solidarity as collective self-care that will endure as a catalyst for change. That seems unlikely unless we change the social imaginary of the collective body. Without this, the pandemic only magnifies long-standing problems in our neoliberal capitalist society. Amidst the drama of COVID-19, the terms 'a whole', 'a unity', 'a totality' are recurrent, suggesting that the crisis has brought people together. Yet such words may be devoid of any agency, since the COVID-19 crisis has served to weave

19 iLiana Fokianaki, 'A Bureau for Self-Care: Interdependence versus Individualism', *E-flux Journal* #119 (June 2021): 'This warped notion of self-care is exemplified by Victorian Britain, where it was widely propagated through the work of Samuel Smiles. Smiles was a Scottish political reformer and author of the 1859 book *Self-Help; with Illustrations of Character and Conduct*. A lifestyle guru before lifestyle gurus existed, Smiles was hailed in his time as the epitome of Victorian liberalism. His book proposed that any man can become anything he wants as long as he does not depend on others.'

more tightly together systems of governance, digital technology, and imbalanced working relations with our physical bodies. Within this networked framework, a solidarity based on collective self-care can be nurtured through intersectional, unstable, even ambiguous links, from loved ones to allies to comrades to fellow travellers. By reconsidering collectivity in this light, one comes closer to empowering the sustainable solidarities of the future.

What role can processes of solidarity in art and culture play in healing our collective body and re-inscribing care at its heart? Art, as an actualisation and embodiment of imagination, has an ambivalent position in society; it is enjoyed, disputed, feared and banned, sometimes all at the same time. Art can thus subversively reverse the hierarchies found within binary concepts (man-woman, white-nonwhite, individual-collective, freedom-captivity) and challenge the hegemonic (racist, patriarchal) order. By subverting these binaries and hierarchies, and centring the notion of collective self-care, art exposes their foundation in dominant economic and political systems. Can processes of artistic solidarity generate, in this sense, what scholar and dramaturge Ana Vujanović termed an 'aesthetic education' that 'trains the imagination for *different* epistemological (also ontological) performances'? And as she asks, 'Can art help create new social imaginaries that aren't bound by binaries and hierarchy?'[20] Art can encourage us to rethink the epistemologies and ontologies of old, from a dehegemonised stand-point, by foregrounding *collective* processes of care and identity formation. To make these experiments sustainable will require deep changes in the entangled economic, political and biological dimensions of life and require that we train our imaginations and our bodies for the epistemological and ontological performances of care (a collective embodiment of it) when living as individuals in a life always populated with others.

These are just a few ways in which the phenomenon of solidarity in the arts can participate in a meaningful and enduring manner in the current crisis, as contemplative, critical and affirmative social practices that examine society through the lens of collective care. As we shall see in the essays presented in this *Reader* (which includes new commissions as well as

20 Ana Vujanović continues: '… One of the binaries I have touched upon is the individual vs. the collective, where the individual is a normative concept, in relation to which we add the collective as the less worthy element of the pair. It is a standard conceptual hierarchy whose rationale lies in Western liberalism and capitalism, starting at least from eighteenth-century British political philosophy (John Locke and "possessive individualism")'. Ana Vujanović, 'The Collective Body of the Pandemic: From the Whole to (Not) All', *E-Flux Journal* #119 (June 2021).

historical material) the experimental and speculative character of these case studies creates an opportunity to disrupt the regular course of life, to advocate for a future of radical living through the experience of other possible lives. The *Reader* proposes that solidarity imaginaries expressed by artworks, and embodied by specific artistic actions, are always the outcome of the extensive processes of art-led care-building that precede and succeed them. Indeed, it is those very networks of personal connectivity and empathy that artists and art professionals (in alliance and in friendship with everyday citizens and activists) create over time around a particular issue, that inspire society at large to imagine life differently and step forward in ways that generate profound transformation. With this in mind, the *Reader* considers artistic solidarity as a process forged within crucibles of care, generating a politics of collective empathy, and doing so through a political imaginary, through collective agency, and through what could be termed the epistemological performance of solidarity or, better said, the radical living of collective self-care.

* * *

Nota Bene for a Place-Based and Indigenised Solidarity Reader[21]

Before proceeding to outline the various contributions that constitute this *Reader,* it is necessary to provide one further commentary that has particular bearing for the positionality of this publication. This *Reader* has been conceived and developed in and from Norway, one of four nation-states traversing Sápmi, the homeland of the Sámi people.[22] It is 2021, and the country is halfway through a process of Truth and Reconciliation, which by all standards looks likely to fail given that reconciliation is impossible without engagement from both sides of the equation. In this case, the process has been conceived as a forum of testimonials from the victims of past colonialism upon the Sámi nation. It fails to acknowledge the need for engagement from the culprits (whether considered individually or systemically) or to recognise that colonialism is still prevalent across all sectors of Norwegian society today. How different would this process be if its starting point were one of solidarity based on collective self-care?

21 This header is inspired by Coulthard and Betasamosake Simpson, 'Grounded Normativity / Place-Based Solidarity'.
22 Together with Inuit people in Kalaallit Nunaat (whose colonial name is Greenland) they are the Indigenous peoples of Europe.

Despite the long history of colonial pressures, Sápmi (and the millions of Indigenous peoples around the world) is still rich in the theory and practice of Indigenous political and community-based alliances of solidarity. Sámi and Indigenous nations negotiated and continue to practice diplomatic relationships between each other to co-inhabit land while respecting each others' governance, jurisdiction and sovereignty. As Yellowknives Dene scholar Glen Coulthard, and Michi Saagiig Nishnaabeg writer Leanne Betasamosake Simpson have commented, 'each nation also exists in deep reciprocal relationship with the land and waters, plants and animals within these territories, the thunders and rains, all the physical and spiritual forces that connect them to this place, their place of creation, in meaningful and intimate ways'.[23]

Coulthard and Betasamosake Simpson have elaborated further on this point, commenting that to many Indigenous peers, the past discussions within the art world regarding art and solidarity, and the fairly recent focus placed on the subject on the back of world calls for intersectional approaches to social and ecological justice, have almost always excluded the hosts of the lands upon which such dialogues and events have taken place. Sadly, it comes as no surprise to them that neither their lands nor sovereignties figure much in the conferences, publications and exhibitions on the subject. They write: 'This form of erasure – that is the erasure of Indigenous land and jurisdiction – is one of the "miseries" that constitute Indigenous peoples' experience of our settler-colonial present ... It is a negation of their intellectual and political practices of governance-in-solidarity that we ignore at our peril.'[24] So from this perspective, any Truth and Reconciliation process and any discussion of solidarity in the arts would need a different point of departure: the contestation of settler colonisation in all its dimensions of aggression and extraction.

With this in mind, and considering solidarity in the arts as a tool for collective self-care to overcome the many miseries of the world, there are no better words to end with than Coulthard and Betasamosake Simpson's when they warn that discourses and artistic projects of solidarity should not stand 'on the backs of Indigenous peoples, but engage as

23 Coulthard and Betasamosake Simpson, 'Grounded Normativity / Place-Based Solidarity', 249, 2016 (I express my gratitude to my colleague and assistant editor of the Reader Liv Brissach for bringing this article to my attention).
24 Coulthard and Betasamosake Simpson, 'Grounded Normativity / Place-Based Solidarity', 249.

related comrades, allied in critical co-resistance against the convergence of forces that divide and conquer us and the Earth on which we depend. It seems appropriate then to (re) centre these issues – Indigenous land and jurisdiction – in this discussion, and reflect upon why they occupy such an ambivalent if not contentious place in the politics of solidarity in settler colonial contexts.'[25]

* * *

The first section of the *Reader*, 'Political Imaginaries. The Past and Future of Museological and Organisational Solidarities' looks back in time and forward into the future to reflect upon the complexities of, and the possibilities for, generating non-hegemonic processes of solidarity within the institutional and governmental cultural field. This section begins with 'The Solidarity Community of the Museo Internacional de la Resistencia Salvador Allende in the Swedish and Finnish Collections', a text by Chilean scholar Soledad García Saavedra. She draws attention to the radical museology proposed by the Museo de la Solidaridad founded by Salvador Allende in 1971. A museum born out of struggle, and built upon the premise of artistic donations operating outside the market, it flourished through trans-national solidarity networks that endure to this day. García Saavedra points to the profound affinity that existed between artists, curators and different political organisations who united to make sure the Museo de la Solidaridad continued its existence in exile after the military coup of 1973 in Chile. Renamed Museo Internacional de la Resistencia Salvador Allende (MIRSA), the museum, headquartered in Paris, was embraced by 10 hospitable countries who mobilised artistic donations, hosted touring exhibitions in support of the Chilean cause and helped keep the collection safe. García Saavedra particularly outlines the solidarity networks between Chilean and Swedish artists and cultural workers, resulting in a Swedish MIRSA Committee and the large-scale exhibition 'ALLENDEMUSEET' at the Moderna Museet in Stockholm. The exhibition toured 15 Swedish cities, as well as Helsinki and Paris. The author also outlines how Chilean artists exiled in Finland organised

Katya García-Antón

Introduction

25 Coulthard and Betasamosake Simpson, 'Grounded Normativity / Place-Based Solidarity', 250.

an iteration of the museum within the Artists' Association of Finland (STS), resulting in the donation of 70 artworks to MIRSA's collection.

Further context to García Saavedra's essay is provided by the inclusion of President Salvador Allende's 1972 letter to the artists of the world, 'A los Artistas del Mundo', which officially launched the museum's global project of solidarity. Key speeches given by the President and the legendary Brazilian curator Mário Pedrosa during the opening of the museum in Santiago in 1972, are also included in this section.

Naeem Mohaiemen's visual essay 'Todos escriben al coronel' inverts the title of García Marquez's famous book of 1961 to allude to the militarisation of Chile a decade later. It features the headlines in Chilean newspapers such as *El Mercurio* and *La Estrella* around the 1973 coup d'état, which were suspected of containing coded messages between military leaders planning the coup. The juxtaposition of these headlines with images from the Non-Aligned Movement's (NAM) conference further afield in Algeria, which took place at the same time, is presented by Mohaiemen as a manifestation of both the breadth of NAM's mission for global south solidarity, and its disintegration at the very moment of President Allende's vision for an art field in solidarity with a just society.

Hungarian curator, editor and researcher Eszter Szakács' contribution titled '"Ali" in Jordan. Palestine Solidarity on Film' focuses on the 1971 Hungarian film, *Guerilla Fighters in Jordan.* Szakács takes this film as an example of Hungary's state-propagated solidarity with Palestine, and as a point of departure from which to look closely at the various forms that state-propagated solidarity took in relation to Hungary's shifting ideology and alignments during the Cold War. She also positions this case study within a larger international terrain, looking at intersections between global solidarity movements and what were often considered leftist film projects, as well as the larger trajectory of films by or about the Palestinian struggle. Situating the film within Hungary's last five decades, Szákacs finds that, paradoxically, it fits both the discourse of the internationalist Third World solidarity movements and the Hungarian right-wing nationalist aspirations that rose up in the 1990s, aptly revealing the vulnerability of solidarity discourses.

Following on from the above two contributions, the *Reader* moves to a visual intervention by collaborators <u>Naeem Mohaiemen</u> and <u>Eszter Szakács</u> featuring archival material presenting instances of artistic solidarity initiated in the global south within the context of the NAM platform, and drawn from an archive put together for their new book *Solidarity Must be Defended*.[26] This is the first of two collaborations in the *Reader* aimed at sharing resources and connecting labour. This intervention provides a scale of broad and interconnected geographies within which NAM was operative, and expands upon some of the context within which many of the texts that follow can be more deeply understood.

In 'Reproducing Festac '77: A Secret Among a Family of Millions', DJ and founding editor of the collective Chimurenga <u>Ntone Edjabe</u>, and Johannesburg-based journalist <u>Kwanele Sosibo</u> converse about the necessity to refresh the cultural imagination driving the organisation of large-scale events with a pan-African perspective – especially after the failure of South Africa's World Cup in 2010. In this dialogue, Edjabe shares Chimurenga's motivations for embarking on the Festac '77 book project, completed in 2019. Festac '77, also known as the Second World Black and African Festival of Arts and Culture (the first was in Dakar, 1966), was a major international festival held in Lagos, Nigeria, in 1977. The month-long event celebrated African culture and showcased African music, fine art, literature, drama, dance and religion. With about 16,000 participants, representing 56 African nations and countries of the African diaspora, the event was nothing short of epic in its ambitions and organisational prowess. Reflecting upon Festac '77, Edjabe and Sosibo reintroduce the notion that culture can change the way in which Africans see themselves and how the world sees Africa, positioning Black solidarity as inclusive and expansive. The dialogue also touches on the immediate impact that Festac '77 had upon liberation struggles and in fostering Black diasporic solidarity networks. As an example, Edjabe highlights the important delegation from the South African liberation movement, whose multi-disciplinary organ, the Medu Art Ensemble, mobilised support for the struggle in the following decade, and also ultimately led to the foundation of the African National Congress' (ANC) department for arts and culture.

26 Naeem Mohaiemen and Eszter Szakács, *Solidarity Must Be Defended*, (New Dehli: Tricontinental; Istanbul: SALT; Eindhoven:Van Abbemuseum; Budapest: Tranzit; Gwangju: Asia Cultural Center, 2022).

Following this discussion is a selection of four texts originally published in 1986 in 'Art Against Apartheid' – a special double issue of the US cultural journal *IKON* – that explore further the Black solidarity proposed by Festac '77. Operating within an American context in which scarce information regarding the apartheid regime was broadcast before the mid-80s, this issue of *IKON* played a role in disseminating personal narratives of Black liberation fighters in South Africa, of allies at home and abroad, and highlight the strong sentiments of solidarity the US felt with the people of South Africa. Introducing the journal, Alice Walker's 'The People Do Not Despair. An Introduction to Art Against Apartheid' focused on anti-apartheid work and solidarity between South Africa and the US. Walker shares her first (admittedly rather late) awareness of the state of things in South Africa, and as an African-American author, she points to the enslavement of Black native people as genocide. Audre Lorde's essay 'APARTHEID U.S.A.' and poem *Sisters in Arms* are calls for solidarity and general global alertness. In the former, the African-American poet, civil rights activist and feminist clearly connects apartheid in South Africa with past, and possible future, exploitation of (and violence against) Black people in the US, setting the foundations to embark on a global struggle against aggressive institutionalised racism, the wage gap and unequal rights that are, as she notes, 'guided primarily by the needs of a white marketplace'. *Sisters in Arms,* evokes a sense of sisterhood with a South African mother, of mutual despair and will for change, while also recognising the geographical and political differences between the two subjects. Lesbian Mohawk writer and poet Beth Brant's *Mohawk Trail* draws parallels (whilst acknowledging significant differences) between the arguments used by the Pretoria regime and the US government ('the native problem' as they both called it) to suppress Black South Africans and First Nations in the US respectively. The essay recounts the enforced assimilation of her family and ancestors into mainstream North American culture, whilst pointing to her cultural bilinguality, as well as the resilient preservation of native identity and oral traditions across generations, despite increasing pressure from the outside. The last of these four texts features an interview

between <u>Barbara Masekela</u> (poet, African literature professor and member of ANC) and Anti-Apartheid American Committee On Africa members <u>James Cason</u> and <u>Michael Fleshman</u>. Masekela reflects upon culture, education, sovereignty and liberation, focusing on the educational activities that the ANC set in motion in Tanzania, the role of cultural practitioners in the ANC and the future of culture in liberated South Africa. She also describes how the ANC's Department for Art and Culture, founded in 1982, grew out of an ad-hoc project that started in Lagos in 1977 with the presence of the Amandla theatre and music group at the Festac '77 festival of Black and African Arts and Culture.

In 'Solidarity and the Non-Exhibitable', Jerusalem-based artist <u>Noor Abuarafeh</u>, Alexandria-based curator, editor and critic <u>Ali Hussein Al-Adawy</u> and Palestinian curator and critic <u>Lara Khaldi</u> (co-curator of documenta fifteen) embark on a series of museological email exchanges. In their conversation, the authors discuss the pitfalls and possibilities of solidarity within the museum in relation (though not exclusively so) to Palestine. Bearing in mind the recent inauguration and subsequent challenges of the Palestine Museum in Birzeit, is an emancipatory museum possible, they ask, and if so, what forms would it take? The dialogue builds upon earlier discussions of solidarity and museum histories broadcast on Radio Alhara, in the programme 'Farewell to Museums'. Radio Alhara (which means 'the neighbourhood radio' in Arabic) was born out of the COVID-19 crisis and went on air for the first time on 20 March 2020, broadcasting from Bethlehem and Ramallah, as a way to stay connected during quarantine. Abuarafeh, Al-Adawy and Khaldi question what solidarity means when its focus is on the event itself, as something to be spectated. They ponder how to ensure solidarity within the museum is an inclusive process, mindful of the pitfalls inherent to the power asymmetries, representation hurdles and hegemonies embedded in museum structures. Can the coronavirus act as a catalyst to imagine and effect pivotal change?

In 'Based on True Stories: Harvests from Jatiwangi art Factory and INLAND', the Indonesian artist, writer and

researcher <u>farid rakun (ruangrupa)</u> reflects upon networks of empathy within the cultural field as drivers of knowledge production. As one of the members of ruangrupa, the Jakarta-based art collective who curated documenta fifteen in 2022, rakun discusses the models of sharing and connecting that ruangrupa regularly employs in collaborations that focus on building affinities and trust. This methodology informed ruangrupa's decision to activate the concept of *Lumbung* in the lead-up to documenta fifteen. In *Lumbung* (which translates as 'rice-barn') knowledge, time, network and finance are considered resources to be shared between the collaborators so that any surplus can benefit the whole. Central to *Lumbung* is the practice of harvesting, which occurs when collaborators come together to share resources collectively. In this sense, ruangrupa consider documenta fifteen as a celebration in which multiple harvests convene. In this text rakun shares the first harvests of two art collectives, Jatiwangi art Factory (JaF) and INLAND based in Indonesia and Spain respectively.

This section closes with a look towards the future of museums from the optics of the cultural commons, by US-based writer, curator and former interim Director of the Leslie Lohman Museum, New York, <u>Laura Raicovich</u>. Raicovich is interested in 'collectively re-imagining what culture creates and destroys', emphasising that 'there is no way around confronting neutrality as a persistent ideology within the museum'. Speaking from the US context she observes the urgent calls for diversity, inclusion and equality within the museum's interface, and reveals that the hidden structures underpinning the ways in which museums instruct their publics contradict those very calls. She argues in favour of dismantling the false neutrality of museums that those hegemonies uphold, centring the public at their heart, as a critique of the current tendency in the institutional world to concentrate the power in the hands of privileged individuals who serve on museum boards. Raicovich calls for the urgent healing of museums by collectively imagining our way towards the spaces we want to experience. She notes that since art and museums already shape society, it is by shifting the ways in which culture works that society too can shift.

Finally, she concludes that in order to reach a cultural commons that supports a complex, vibrant populace, we must engage that populace in culture and the structures that enable it.

The second section of this *Reader*, titled 'World-Building Solidarities. Friendships and Reciprocities' commences with a text by Oslo-based Palestinian historian Toufoul Abou-Hodeib called 'The Travelling Scarf and Other Stories. Art Networks, Politics and Friendships Between Palestine and Norway'. Through three vignettes – a letterhead, a children's book and a scarf – Abou-Hodeib traces the personal relationships framing the artistic and political endeavours that led to the opening of the Palestinian Art Exhibition in Oslo's Kunstnernes Hus (The Artist House) in 1981. Despite their geographic separation, the characters featuring in these three vignettes step on common ground in their belief that the personal is political. This sense of the personal also characterises the material aspect of their existence, where an artwork, a book, a scarf and other materials act as agents of interpersonal relationships, friendships and heart-to-heart commitments. Investigating how these objects came together across disparate geographies including Palestine, Norway, Japan and the US, amongst others, Abou-Hodeib highlights two timelines: firstly, the solidarity driven by the New Global Left in the 1970s that contributed to shifting Palestine's image as a permanent refugee crisis zone towards one of anti-colonial sovereignty; and secondly, the development of cultural anti-imperialist work, especially emerging from the 1969 Pan-African Festival in Algiers (at the time dubbed 'the Mecca of Revolution') and culminating in the ground-breaking cultural international activities generated by the Plastic Arts Section of the PLO.

In 'The Power to Make the Local Global', South African-born artist and curator Gavin Jantjes reflects upon his experience as the only non-white South African artist to be a part of the legendary 'Art Contre Apartheid' exhibition first presented at the UN building in New York in 1980. Jantjes comments on the relevance of this initiative of cultural and political solidarity through the lens of today's discussion about inclusion and the Black Lives Matter movement. The text emphasises the central role that extra-institutional artistic networks and personal friendships played in the making and fundarising for

'Art Contre Apartheid' and its 12-year-long world tour in solidarity with the people of South Africa. In addition, the author interrelates the peak of the anti-apartheid struggle with today's BLM movement, noting the 'need to distinguish an artistic response from the greater public outcry', as the latter challenges the politically concerned artist's *raison d'etre* as well as the value conferred by the contemporary art field.

In 'Making a Territory of Collaboration Possible: Art, Solidarity and Indigenous Peoples', Mixe woman and scholar Yásnaya Elena Aguilar Gil takes the Mayan book *Conjuros y ebriedades. Cantos de mujeres mayas* as her starting point for writing about the possibilities art opens up for radical accountability and solidarity between Indigenous and non-Indigenous people.[27] The book combines poetry, incantations and other writing, including that of Mayan women from Chiapas. Its sculptural cover was crafted by Norwegian artist Gitte Dæhlin, who spent several decades living and working in Chiapas, Mexico, as a committed ally to the local Indigenous people during the Zapatista uprising and beyond. In addition to speculating upon the reciprocal relationships and forms of collaboration that this book afforded, Aguilar Gil contextualises it within the troubled history of the word 'solidarity' in Mexico. The meaning of solidarity was emptied of its agency through the official propaganda attached to 'National Programme of Solidarity', a governmental policy that vigorously broadcast (theoretical) support of Indigenous people in the 1980s and 1990s but initiated land reforms facilitating the selling of Indigenous lands. Upholding the urgency of bringing agency back to the word, to replace the vacuity of governmental slogans, Aguilar Gil proposes a territorial model that empowers the ways of being and doing of Indigenous people in order to construct symmetrical relations from which solidarity, empathy and world-building can occur.

This section of the Reader concludes with various preexisting documents and new arrangements related to the 19-year long Greenham Common Peace Camp in the UK. It starts with a special selection of images compiled by British photographer Wendy Carrig from her black and white photo series, that tenderly capture simple details and give insights into the daily lives of the women in the Greenham Common

27 This text was originally written in Spanish. Aguilar Gil chose to write the word Indigenous with as small i (indigena) to demarcate the term from the government led movements in Mexico which over decades have emptied the word of its meaning. The author of this introduction acknowledges the complexities that the term Indigenous may generate in different parts of the world. However she also points to the planetary political agency that the UN's declaration of Indigenous Rights has given the term in its capitalised form. Métis artist and scholar David Garner, in his text 'Can I get a witness? Indigenous Art Criticism', in *Sovereign Words. Indigenous Art, Curation and Criticism* (Oslo: OCA/Valiz, 2018) gives a detailed breakdown of the nuances of the term which sheds further light on this question.

Women's Peace Camp. Taken for a college project with a Nikon Fe 35mm camera, the images document how women carved out a space to live on their own terms by inventing innovative and resilient forms of collective being. In this series, Carrig reveals a kind of daily living whose intimacy is familiar yet non-conformative. United in resistance and through the practice of care – for each other, for disenfranchised groups and for the planet – the women, across all ages, classes and backgrounds, embarked on a long-term dedication to one cause. The peace camp enabled a 19-year-long suspension of patriarchy, heteronormativity and the hegemony of the traditional family nucleus, a liberating context that led to the emergence of new forms of artistic and social solidarity, and to the eventual closure of the nuclear base.

The Fire Dragon Feast for the Future (1983) is a hand-drawn invitation including a story about the Earth Dragon, that was sent out to wide-reaching networks of women, with accompanying information about how you could contribute to the Greenham Common Peace Camp if you were not based in the UK. The invitation reads: 'bring food, music, stories, songs, poems … your recipes for peace and a better world … believe in yourselves and know that our positive, creative energy will change the world'. The Map of Greenham Common Peace Camp (1984), while mostly a practical tool for the protesting women to find their way around camp, is also a documentation of the inter-relationship of care and protest. Slogans for peace and sharp critiques of the nuclear base's activities are juxtaposed with handwritten messages conveying a strong sense of relationality. These messages indicate, for example, when and where the women can go to watch birds and cats, and where to find accessible toilets available for protesters with disabilities; all the gates of the military base are colour-coded in rainbow hues on the map. Finally, the cover and double spread from *The Greenham Factor*, a 1984 booklet published by the Greenham Print Prop as publicity for the cause, presents statements from many of the women – young and old – who were protesters at the camp. It also includes snippets of poetry and song lyrics, as well as press clippings and photos from the mobilisations and everyday life at the camp.

The art critic Geeta Kapur's seminal text 'Artists Alert'

Katya García-Antón

Introduction

of 1989 introduces the third section of the *Reader*, titled 'Collectivity and the Everyday of Solidarity'. Kapur's essay stands as an apposite call to action and resonates across the entire *Reader*. It was written in the aftermath of the murder of artist Safdar Hashmi by a politically patronised mafia, a tipping point that instigated solidarity among Indian artists on an unprecedented national scale in 1989. The deadly violence against a much-loved theatre figure while at work in a street-play in the city of Jhandapur, in the outskirts of Delhi, signalled the alarming dismantling of values enshrined in the nation's progressive constitution of 1950, a process that continues in India today with dire consequences. The foundation of the nation-wide artist collective Sahmat in 1989, the biggest and longest-lasting of its kind in South Asia, was a direct conse-quence of this incident. Hashmi's murder, and everything that lurked in the darkness behind it, was collectively denounced in the creation of Sahmat: a politico-cultural endeavour aimed to defend the heart of Indian democracy. Penned as an intro-duction to Sahmat's first exhibition and publication, 'Artists Alert' raised a national alarm for artists to ensure that their practices were 'sufficiently complex' to avoid appropriation or destruction by 'antagonist forces', as Kapur wrote. The text inspires the diversification of creativity not only when it comes to demystifying art practice, but also in finding innovative ways of fighting populism together. It celebrates the hundred artists who stood in solidarity by participating and raising funds for the burgeoning Sahmat collective. As Kapur explains it: 'The works make an exhibition, the exhibition is put to auc-tion, the money raised will go towards Sahmat projects includ-ing, among other things, opportunities for artists to diversify their practice, to participate in collective activity, and build up alternative structures of communication and action.'

Kapur's inaugural text is given further context in 'Revisiting the History of Sahmat', a conversation between Devika Singh and Ram Rahman. Singh, Curator of International Art at Tate Modern, and Rahman, curator, artist and central figure in the Sahmat collective, chart the initial vision and subsequent activities of Sahmat. The conversation focuses on decisive moments in India's recent history, including the demolition of the Babri Mosque by Hindu mobs in 1992, and the rise to

power of India's controversial party in cabinet, the Bharatiya Janata Party (BJP), led by Prime Minister Modi. Rahman details Sahmat's pertinent and innovative responses to these events, through interdisciplinary programmes, exhibitions, statements and publications, highlighting the solidarity, resilience and out-standing collective organisational skills of the artists who are united in Sahmat.

In 'Sahmat. A Making of Resistance', artist, curator and filmmaker Aban Raza gives a further view of Sahmat's polit-ical and artistic resistance to various forms of manipulated interreligious strife in India. Representing a generation of younger artists who grew up in close proximity to Sahmat (due to artistic and family connections) Raza recounts the alarm-ing mobilisation by the governing BJP (and its leader Prime Minister Narendra Modi) of the Hindu majority against other religious minorities in India. Her text highlights Sahmat's his-toric work against these events and focuses on recent devel-opments. In 2019, Modi's government removed the special status of the state of Jammu and Kashmir from the Indian Constitution, no longer guaranteeing its autonomy as a Muslim majority state. According to Raza and Sahmat, this unconsti-tutional act, together with the newly introduced controversial citizenship legislation that promotes non-Muslim immigrants from neighbouring nations while proposing to strip poor and under-privileged people in several places in India of their cit-izenship, signifies not only a threat to secular India but also to its democracy. In response, as Raza writes, Sahmat con-tributed to the multiple demonstrations in the streets of Delhi, by amplifying voices of resistance and taking a collec-tive stance against the government's unconstitutional acts. In Sahmat's exhibition 'Celebrate, Illuminate, Rejuvenate, Defend the Constitution of India at 70' (2020) artists from the collective stood in solidarity with Dalits, Adivasis, Muslims, LGBTQ persons, and Kashmiris across all generations in order to 'capture the spirit of audacity, the possibilities for the future and the dream of change through resistance that we, the peo-ple of India have solemnly resolved to uphold'.

Continuing this section's focus on the everyday of solidarity, <u>Reem Abbas</u> contributes a text titled 'Smuggling Books into Sudan. A Brief History from 2012 to 2016'. In Sudan, government regulations make it legally and financially unviable to print books, and books and magazines that are circulated in the country are surveilled and censored by various governmental institutions. Cultural censorship in general is a significant challenge to writers and artists, with many living in exile. In this text, Sudanese journalist and women's rights activist Abbas narrates the alliance forged between a publisher of Sudanese authors in Egypt, clandestine distribution networks in Sudan, authors of banned books and the resilient spirit and solidarity surrounding this network. Abbas highlights the important role of books in the absence of cinemas and theatre spaces, as powerful tools to counter the regime's propaganda of oppression, and to activate the arts as spaces for resistance (or, in Abbas' words, spaces of 'everyday solidarity'). This is the second of two collaborations in the *Reader* with international peers aimed at sharing resources and connecting research. Abbas' text came to us as a result of the powerful discursive programme 'Rising to the Surface: Practicing Solidarity Futures' (2020) conceived by curatorial colleagues Natasha Ginwala and Defne Ayas for 'Minds Rising, Spirits Tuning' in the 13th Gwangju Biennial (which opened in 2021).

This section concludes with a testimonial reflection by French author, curator, performer and film producer <u>Olivier Marboeuf</u> titled 'Dirty Faces. A Scene without a Well-Known Face'. Marboeuf narrates the dystopic experience of the Afro and Arab communities in France within the context of the terrorist attacks of 2015 in Paris and the 'Je suis Charlie' campaign that followed. At the time, he served as founding director of l'Espace Khiasma in the *bainlieu* of the city, a site that became a safe space for the many conversations held amongst his contemporaries addressing how the violent event that convulsed the nation brought into sharp focus the depth of systemic racism in French society and the French art world, continental and *outre-mer*. Marboeuf points to the toxicity underlying French institutional structures and the different paths by which one can arrive at a 'scene of solidarity'. He

describes his own experience of how 'to proceed towards an imagery of solidarity, materialising as a scene replenished with the power of all those, male and female, whom people neither wanted to see nor consider. A scene of dirty faces.' His narrative extends into a broader reflection upon French colonialism that motivated the recent production of the film *Ouvertures* with a group of young poets, writers and actors in Haiti.

The final section of the *Reader* is titled 'Situatedness. Radical Accomplices, Indigenous Epistemologies and New Technologies of Solidarity' and starts with a selection of texts and accessible recordings that offer an insight into the decades of work by the Latin-Amerikagruppene Amerikagruppene i Norge (LAG – the Norwegian Solidarity Committee for Latin America) in building a network of accomplice-relationships between various Central American communities and nations, Sápmi and Norway. Sisters Ingrid and Astrid Fadnes (active leaders in the group) were commissioned by OCA to facilitate the creation of a large-scale patchwork piece made to commemorate LAG's 40-year solidarity history. Aside from the hand-made patches, this solidarity project includes a large number of texts narrating the stories that unfold in the individual patches composing the piece[28] (published in a separate publication as an integral part of the project), as well as a related playlist of recordings and performances.

Amongst the testimonials included in the patchwork project is that of Mexican textile artist and activist Dulce Celina Ureña Hernández, who recites the lyrics of Vivir Quintana's *Canción sin miedo* (the song can be listened to by scanning the QR code printed on the page) as a manifesto for much of the work she does as an embroidery artist and activist who critiques the Mexican government's systemic suppression of the pandemic femicides and gender-based violence in the country. Southern Saami scholar and LAG member Eva Maria Fjellheim's contribution reflects upon the solidarity offered by LAG peers in Latin America to Sápmi, deliniating LAG as a social and artistic enabler of broad alliances that work particularly against colonial land-grabbing of Indigenous territories on both sides of the Atlantic. This text was written in the

28 This was commissioned specially for OCA's exhibition 'Actions of Art and Solidarity', presented at Kunstnernes Hus, Oslo 2021, and currently touring around Norway.

Katya García-Antón

Introduction

context of protests against the construction of windturbines on the mountain Stokkfjellet that would destroy an area used for calving (the most vulnerable time in the life of a reindeer) by Southern Saami reindeer herders since ancestral times. The third narrative derived from the solidarity patchwork belongs to former chair of LAG, Ixchel León. Her text narrates a violent incident in a state-run orphanage in Guatemala in 2017, where 56 young girls were locked in a room as punishment after a conflict (involving serious rape allegations) with the institution's staff. The girls set fire to mattresses in the room in order to be let out, but their captors acted too late and only 15 survived. As León emphasises, the incident is an example of Guatemala's deep structural problems. This institution, which was meant to protect disadvantaged children, was the direct culprit of their deaths. Performance artist Regina Galindo's sound performance makes tough listening, bringing together the voices of some of the mothers who lost their daughters. The sonic performance can be accessed by scanning the QR-code embedded in the text.

As part of her work in LAG, Ingrid Fadnes (Norwegian journalist and activist) met the former Minister of Culture of the Black Panther Party for Self-Defense, graphic artist Emory Douglas. Their dialogue brings further insight into the encounters of solidarity, led by Douglas, between the Black Panthers and the Zapatistas, in a project titled Zapantera Negra taking place in the autonomous Zapatista regions in Chiapas, Mexico, in 2012. In the interview, Douglas outlines some of the strongest connections between the Black Panther Party and the Zapatistas, with a focus on self-determination and resistance against an oppressive state.

Irene Soria Guzmán's text is titled 'Probably Everybody. Notes Towards Technology for Situated Solidarity'. Writing from the physical confinement caused by the coronavirus, Soria Guzmán speculates on whether the digital meta-data generated during lockdown will go down as an archaeological study of our species' behaviour 'in captivity'. Acknowledging the coronavirus as an agent furthering social inequality and affecting countries and populations disproportionately, Soria Guzmán takes the pandemic's dystopian context as a starting point from which to investigate instances of solidarity

coming from milieus of technological resistance. Including reflections on hacking and biohacking, she offers nuanced perspectives on the power-structures of the hegemonical conglomeration of 'technology from below'. With reference to the artwork *Probably Chelsea,* Soria Guzmán asserts the hacker quality of both the artist, Heather Dewey-Hagborg, and collaborator, whistle-blower Chelsea Manning. Inspired by the complexities of this artwork, whereby a wide range of possible 3D portraits generated from Chelsea Manning's DNA are made possible, Soria Guzmán asks for a new code for solidarity itself that is more 'situated' in communities, in experience, transgressing capitalist, patriarchal and gender-based norms.

The final section of the *Reader* concludes with 'Suppressed Images', written by Heather Dewey-Hagborg and Chelsea Manning, and illustrated by Shoili Kanungo. This graphic short story narrates the collaboration between whistle-blower and technologist Chelsea Manning, and artist Heather Dewey-Hagborg. The graphic story was published the day before Manning's 35-year prison sentence was commuted by President Obama in 2017. At the time of the work's making, no one had seen Manning after her transition from male to female, given the prison's strict visitor policy.

Katya García-Antón

Introduction

Political Imaginaries. The Past and Future of
Museological and Organisational Solidarities

33

1

Political Imaginaries. The Past and Future of
Museological and Organisational Solidarities

Soledad García Saavedra

The Solidarity Community
of the Museo Internacional de
la Resistencia Salvador Allende
in the Swedish and Finnish
Collections

During the mid-1970s, global artistic solidarity networks intensified through the unprecedented initiative of the Museo Internacional de la Resistencia Salvador Allende (MIRSA). Conceived as a nomadic museum without walls that disregarded borders – a museum in exile – MIRSA was established in 1975. It was preceded by the unique model of the Museo de la Solidaridad (MS), which was founded in 1971 during the Unidad Popular (UP) government of president Salvador Allende in Chile. This text looks at the profuse exchange and affinity between artists, art critics, curators and different political organisations dedicated to resisting fascism and with a shared belief in the ability to achieve collective change, in a time of great upheaval in the world marked by violent wars and dictatorships, as well as the social unrest of counterculture movements. In particular, it draws attention to the microhistories of individuals, collectives and institutions that were bound by historical, political and affective relations in remote countries such as Chile, Sweden, Finland, and their sympathy and ties with Cuba.

These fraternal affiliations were achieved through the multiform forces of solidarity and a determination to defeat human atrocities by means of collaborative action through art. The versatile itinerant museum was dispersed in different latitudes, incubated in several European and Latin American museums during the 1970s and 1980s. After the coup d'état in Chile in 1973 and the forced exile of thousands of people around the world, the museum modified its name from Solidarity to Resistance. Beginning between Havana and Paris, this brief tale circumnavigates the journey of MIRSA, which was embraced by 10 countries, among them, Sweden and Finland.

Solidarity Communities in Plural(ism)

The coup d'état, a tragic end of a social dream on 11 September 1973, was traumatic for the left-wing promoters of Chilean reforms. Survival was as difficult for those who were forced to leave the country as for those who stayed. The death of socialist president Salvador Allende marked the overthrowing of a long period of democracy, and hope for a plural, peaceful and humanist society based on the vindication of the working class and vulnerable people in a social-welfare state. After a tumultous time of sanctions and external boycotts such as the 'cool implementation' of the US, general Augusto Pinochet marshalled his military forces on the pretext of rescuing

the country from an unstable communist-driven economy, establishing instead a fearful and barbaric authoritarian regime that lasted until 1990.

The short-lived Unidad Popular, which held power between October 1970 and September 1973, left its legacy in those countries that admired the reforms that had reshaped the socialist nation. The revolutionary communist administration led by Fidel Castro in Cuba, and the Social Democratic government of Prime Minister Olof Palme in Sweden, forged bonds of international cooperation with Chile before and after the coup. Therefore, it is not accidental that both countries played an extremely committed role when it came to humanitarian help, saving lives, giving asylum in their embassies and extending shelter to refugees in their countries, never abandoning their interest and dedication to the solidarity cause. Another government that gave great support to Chilean refugees was that of president Urho Kekkonen in Finland, who bestowed humanitarian aid and sponsored the International Commission of Enquiry into the Crimes of Military Junta (International Commission) from 1973.[29]

In the first years after the coup, Cuba endorsed solidarity missions in the fight against Chilean fascism through the logistical support and economic aid of the Comité Chileno de Solidaridad con la Resistencia Antifascista, established by radical left militant Beatriz Allende, the daughter of Salvador Allende and exiled in Havana.[30] Sweden contributed funds to the movement for Chilean liberation, as well as to Beatriz Allende's committee. It also kept criticism of the 'illegal and bloodthirsty'[31] Military Junta and its violation of human rights alive in the international media.[32]

Chilean solidarity, then, was a transnational form of activism by an exile-led organisation that transformed victimisation[33] and rage[34] into collective resistance to undermine the dictatorship. The persistent endeavour to overcome authoritarian rule was an active task of small and large-scale activities, from raising money for the reorganisation of groups and movements, to diplomatic and broad-based opposition.

The creation of MIRSA on 15 April 1976[35] came about through similar forces and was co-organised by exiled intellectuals in France and Cuba, having their centre of operations in Casa de las Américas, Havana, and being dispersed through committees in different parts of the world. The heart of MIRSA was a group, close to the circle of Allende, as well as artists and art critics who were involved in the Museo de la Solidaridad (MS), an

institution that had gathered more than 600 artworks through international donations for the people of Chile.[36] The revitalisation of the Solidarity Museum was activated through a Secretariat comprised of Miria Contreras, personal secretary of Allende – exiled in Havana – who played an essential role in the actions; Jacques Leenhardt, French sociologist; authorities formerly of the Faculty of Arts in the University of Chile, all of whom were exiled in Paris; Pedro Miras, philosopher and former Dean; José Balmes, artist and former Director; Miguel Rojas Mix, critic and Director of the Institute of Latin-American Art of the University, and Brazilian art critic, Mário Pedrosa, President of the Committee of the dissolved MS.

Instead of looking for direct monetary donations as the Comité Chileno had, MIRSA called for the donation of works as a 'political and financial instrument'. Although it was an indirect way to cover the 'trials of detained people',[37] the support from the artistic sphere exceeded the urgent task of becoming a transaction for the cause; above all, it was a 'direct testimony' to artists' solidarity that could deliver 'agitation and propaganda'[38] to confront the dictatorship, cooperate with collective pressure to recover a state of democracy, and, after the overthrowing of the regime, give an opportunity to the people of Chile to appreciate the artworks gathered in the Museum of Solidarity.

From these requests and aspirations, solidarity was understood in manifold ways: it meant the generous commitment of artists and intellectuals who self-identified with the battle of left-wing Chileans in their defence of freedom and the condemnation of death and torture. From the perspective of artists, it could be grasped as an act of material and symbolic gifting that lacked any expectation of tangible return.[39] They were motivated by the possibility to participate according to their artistic position, as well as their own poetics and messages, on raising awareness of different topics.

MIRSA conformed committees in each country made up of art critics, artists, poets, intellectuals and organisations, whose purpose was to select or invite artists, to support and get involved in the initiative. The procedure of the Museum was to mount exhibitions in each country of the donated artworks, in order to achieve visibility, as well as to gather a collection framed under the name of MIRSA, hosted and selected by members of other museums and art institutions, which kept the collection in storage before a possible return to Chile.

29 Patrick Kelly, 'Transnational Solidarity', in Sovereign Emergencies: Latin America and the Making of Global Human Rights (Cambridge: Cambridge University Press, 2018), 118.

30 Tanya Harmer, 'The view from Havana: Chilean exiles in Cuba and early resistance to Chile's dictatorship, 1973-1977', Hispanic American Historical Review, 96 (1): 4.

31 See speech of Olof Palme, 14 September 1973 in Malmö, Archives of the Museum of Memory and Human Rights, Santiago, Chile, and Marco Alvarez Vergara, Tati Allende, una revolucionaria olvidada (Santiago: Pehuén, 2017), 192.

32 See, for instance, 'Swedish Ambassador Extends Shelter to Refugees of Chile's Political Storm', The New York Times, 29 September 1973.

33 Harmer, 'The view from Havana', 5.

34 Marco Alvarez Vergara, Tati Allende, una revolucionaria olvidada (Santiago: Pehuén, 2017), 192.

35 Revista Cuba en el Ballet, 1976, Vol. 7, no. 2.

36 Claudia Zaldívar (ed.) Museo de la Solidaridad Chile, donación de los artistas al gobierno popular. Fraternidad, arte y política, 1971-1973 (Santiago: Museo de la Solidaridad Salvador Allende, 2013).

37 Miguel Rojas Mix, La solidaridad hecha museo, exh. cat., MIRSA 1975-1990, MSSA, 2016, 21.

38 Call for applications to participate in the MIRSA (template letter), 1975. Archivo MSSA [Cat. 92].

39 Many artists didn't know the exact location of their work until recent exchanges with curators.

As a multi-tentacular museum, MIRSA handled committees, collections and exhibitions between 1976 and 1983 in Cuba, Panama, Colombia, France, Mexico, Spain, Sweden, Poland, Finland and Algeria. Donations arrived from artists of more than 40 nationalities, among them, Costa Rica, Canada, the US, Bulgaria, Yugoslavia, the USSR, Iraq, Mongolia and Venezuela, until 1990. Overall, the collection encompassed more than a thousand artworks, featuring heterogenic aesthetics, from conventional to experimental, from fine arts to crafts, from abstract to figurative.

The plurality of the collection is due to a political philosophy and a context of changeable situations. The collective and variable manner of conforming committees, sometimes beyond the criteria of art critics or curators (e.g. political commitments, embassies and individual participations), transformed the 'representation' of a country into a collection of divergent qualities, tastes and styles. From the perspective of a political body, pluralism was the political and revolutionary cornerstone of Allende's democratic government, in order to include everyone and to transform the structural organisation of the country from the basis of Marxist humanism.[40] By the same token, the approach of art critics, particularly Mário Pedrosa, to the artists' donations to the Museo de la Solidaridad from 1971 and 1973, had relied on an interest in and defence of different genres and styles, combining into an all-inclusive and even contradictory assemblage of artworks.[41] Therefore, and despite the ideological manipulation that was deployed and assigned to abstract or geometric art by the US cultural institutions during the Cold War, in MS, and thus, in MIRSA, formal artworks were well-received as contributions to diverse creativity. In that sense, rather than accumulating a logical and coherent collection, MIRSA embraced the union of dispersed and remote subjectivities at an international level, with the fight against dictatorship as common ground. Lastly, the enlargement of each collection into a shared community converted MIRSA into a pluralistic museum as it multiplied into collections, exhibitions and donations, and gathered a diversity of artistic languages. MIRSA's diversity, variety and adaptation aroused interactions during a hostile time that were far from the notion of relativism and lack of commitment, and strove instead to share power through the coexistence of artworks, and through identification, following Mário Chagas' ideas, of the 'Museum as an arena and battlefield that is distant from the idea of a neutral and non-political space'.[42]

MIRSA Brigade murals, Sweden
José Balmes, Enno Hallek, Jan Hafström, Stefan Teleman, Ulf Rahmberg, Hans Viksten. *Brigadmålning* (Brigade Painting), 1978. Painting on canvas, 225 x 1300 cm. Produced for the facade of Moderna Museet, Stockholm, Sweden. Donated by the artists to MIRSA. MSSA Collection. MSSA Archive.

40 See Salvador Allende's speech, 'La via chilena al socialismo', in the Congress of the Republic, 21 May 1971.
41 Letter from Mário Pedrosa to Eduard de Wilde, 10 January 1972. Archive MSSA.
42 Mário Chagas, 1ª parte – VULCÃO. *Cadernos De Sociomuseologia*, 13(13), 1999, https://revistas.ulusofona.pt/index.php/cadernosociomuseologia/article/view/323

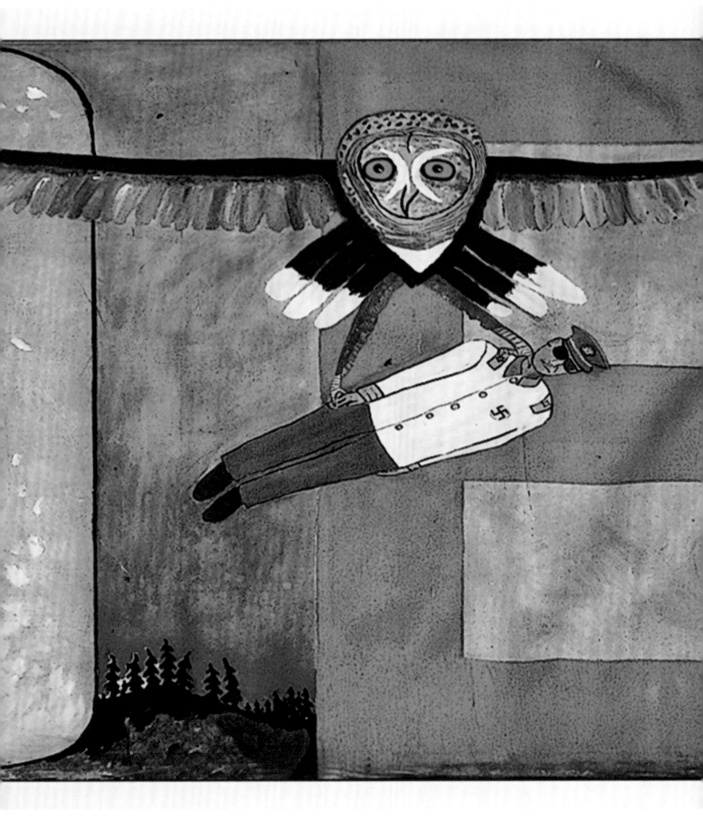

Hernando León, Marjatta Hanhijoki, Marika Mäkelä, Jarmo Mäkilä, Marila Sakari, Kari Juhani Tolonen, Reijo Viljanen, Héctor Wistuba. *Prikaatimaalaus* (Brigade Painting) 1979, mixed media on canvas, 200 × 1100 cm. Dedicated to the UNESCO proclaimed International Year of the Child, Taidehalli, Helsinki. Courtesy of MSSA.

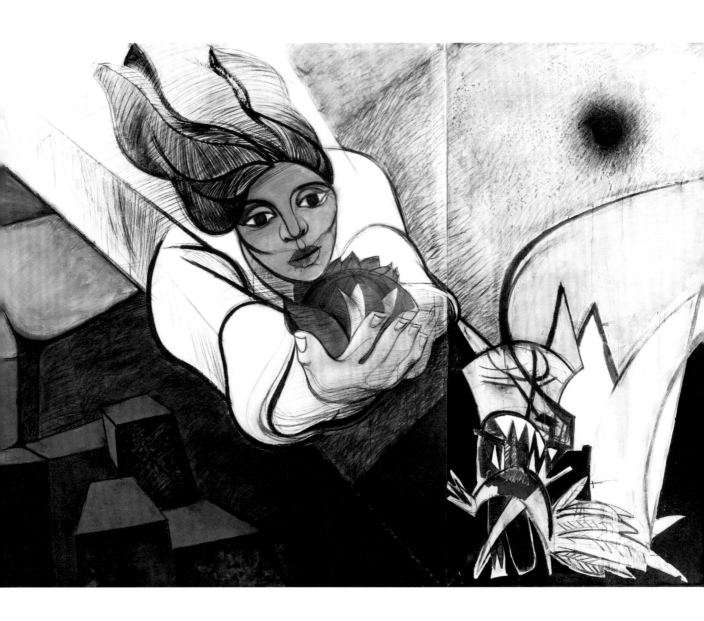

The collections of works by Swedish and Finnish artists stem from this background, and their first threads began with two women, Chilean Miria Contreras and Swedish Sonja Martinson Uppman. As previously mentoined, Contreras was one of the personal secretaries of Allende and was also the manager of art donations and loans from the Presidential palace during the UP government.[43] After the coup, she received asylum in the Swedish embassy. Her contact with Martinson started when the Swedish embassy achieved an epic feat after the regime. Acting as a mediator between the military Junta and the Cuba embassy, Swedish ambassador Harald Edelstam rescued the Cuban residency representing, under Swedish protection, the interest of the communist country in Chile, and gave asylum to more than 150 people,[44] among them, Contreras. Martinson worked in the embassy between 1973 and June 1974, and was responsible for the different diplomatic tasks: caring for the Cuban and Swedish offices and houses, where Contreras lived, alongside 75 political refugees, as well as the evacuation of the refugees to Sweden. In the 1960s she had worked for five years at the Moderna Museet in Stockholm and arrived in Santiago during the turbulent times of April 1972.

In 1974, Contreras and Martinson left Chile for Cuba, and lived in the same house in Havana. After the organisation of MIRSA, in 1977, Martinson travelled to Sweden and got in contact with her close friend Björn Springfeldt, who by that time was one of the curators of the Moderna Museet in Stockholm, and later became the president of the Swedish Committee. Martinson settled in Sweden in order to supervise the contribution of the Swedish MIRSA, joining the committee on behalf of the secretariat of Casa de las Américas in Havana. The involvement of both women, with great emphasis on arts and social justice, was key to creating networks and accomplishing the support of Nordic agents.

When the Swedish committee was defined in February 1978, MIRSA had already organised committees and exhibitions in Cuba, France, Spain, Italy, Mexico, Panama, Venezuela and Colombia. In comparison with other committees composed of political militants and leftist parties, the Swedish and Finnish commissions were joined mostly by multidisciplinary groups, affiliated to art institutions and professional associations that could open a 'window when it came to

43 Carla Macchiavello, 'Weaving Forms of Resistance: The Museo de la Solidaridad and The Museo Internacional de la Resistancia Salvador Allende', *Journal Arts*, January 2020: 10.
44 Camacho, Fernando. 'Los asilados de las Embajadas de Europa Occidental en Chile tras el golpe militar y sus consecuencias diplomáticas: El caso de Suecia', *European Review of Latin American and Caribbean Studies* 81, October 2006: 21–41.

financing'.[45] However, since political collaboration was relevant, Contreras wrote a letter to Springfeldt[46] asking him to invite Chilean communist Germán Perotti to get involved in the commission. Coming from an arts background, Perotti was deeply involved in the social art reforms in Chile before the coup, and by the time he joined Swedish MIRSA's committee, he was working in the Chilekommittén, an organisation dedicated to supporting political prisoners in Chile and refugees in Sweden.

Along with Springfeldt, Martinson and Perotti, the committee was joined by curators of films and events Monica Nieckels and Henrik Orrje from Moderna Museet; experimental film director Hélène Aastrup; art historian and member of the Association of Art Critics, Staffan Cullberg; art critic from the Göteborgs Konstmuseum, Folke Edwards; members of the Swedish National Organisation of Artists [KRO], Gitta Dannefelt-Haake and Roland Haeberlein; artists of the Academy of Arts, Enno Hallek and Åke Pallarp, and representative of the Casa de las Américas, Rebeca Narbona de Ruiz.[47]

The Moderna Museet made its exhibition space available, and the committee gathered 106 artworks donated by 55 artists[48] consisting of paintings, sculptures and graphics, which included a large collective mural (225 x 1300 cm) whose execution resembled that of the Chilean painting brigades during the Unidad Popular. Created over the course of five hectic days, the painting was made on a canvas alongside the façade of the Museum by artist José Balmes, one of the founders of the MIRSA secretariat, together with Enno Hallek, Jan Håfström, Stefan Teleman and Hans Viksten. The mural was a homage to Allende's life, as signalled by different metaphoric icons pointing towards the ideas of union, liberation and death. Called 'ALLENDEMUSEET', the show opened on 4 March with the attendance of Contreras, and the brigade's public process of painting the mural gained attention from the press. The exhibition included a complete ten-day programme encompassing Swedish and Chilean dance, theatre, music and workshops. Ticket income from the different events was destined to provide food for Chileans.

The show of the collection ended on 16 April, and it then started a long pilgrimage across 15 venues in different cities of Sweden between 1978 and 1981,[49] as well as two continental venues, first in Rantakasarmi, Helsinki, where it would coincide with the opening show of the Finnish collection, which would be followed by a

showing in Paris in 1979, becoming the most well-attendedone among all countries. The collection was highlighted in the Moderna Museet press release as a unique modern and contemporary selection of Swedish artists 'without parallel in the history of art'.[50] In the brief catalogue of the collection show hosted by the Nordic Centre in Helsinki, Springfeldt referred to the coexistence of artworks with a clear political statement and the values of 'free expression' and a 'poetic sense of life' that had been destroyed in Chile.

Under Allende's name and as elements of a collective show, the artworks could provide multiple connotations,[51] from straightforward messages about the tragedies in Chile, to a sensitive experience triggered by abstract pieces, to the ironic and melancholic meanings of depictions of power and oppression in other Third World countries and minorities. Some artists such as Bertil Almlöf, Öyvind Fahlström, Göran Gidenstan, Ulf Rahmberg, Olof Sandahl and Kjartan Slettermark donated works that were mostly produced after the coup, responding to the state of violence and its consequences, and oscillating between the denunciation of injustice and a reaffirmation of hope. Other works delivered satirical recreations of the power of the US administration during the Vietnam War, as represented in the sculptures of Anders Åberg and Hanns Karlewski. Invigorating figures in the rising movement against the apartheid regime in South Africa were highlighted in the silkscreen of Bertil Almlöf, while attentiveness to vernacular practices such as reindeer herding in the Sámi territories was captured in a silkscreen by Bror Marklund. Key figure of the 1960s avant-garde Per Olof Ultvedt donated one of his mechanical sculptures, an experimental assemblage constructed from wood. Both he and Leif Bolter, whose red spiral sculpture suspended from the ceiling was moved by a motorised mechanism, evoked through their works a distance from the dominant narrative, the poetics of continuation, and the engines of human social endeavour. Several artworks had a surrealistic appeal, while others were evanescent landscapes or conveyed intimate feelings. Despite the dissimilarities of their styles and unique characters, the transnational community of artists spoke through their artworks of their support for the survivors, their grief for the dead, the disappeared, the absent democracy, and their will to express memories and a wish for change.

Days after 'ALLENDEMUSEET' was opened, Contreras sent forms to the Moderna Musset that would be filled out

45 Author's interview with Sonja Martinson Uppman, September 2020.

46 Letter from Miria Contreras to Björn Springfeldt, 28 January 1977, F1: 82 A, Moderna Museet Archive.

47 Letter from the Swedish Committee to Pedro Miras and Miria Contreras Doc. B.1.b0012, 13, MSSA Archive.

48 Anders Åberg, Bertil Almlöf, Olle Bærtling, Torsten Bergmark, Ola Billgren, Bengt Böckman, Leif Bolter, Lena Cronqvist, Sten Eklund, Lars Englund, Öyvind Fahlström, Jörgen Fogelquist, John-Erik Franzén, Roj Friberg, Jan Erik Frisendahl, Göran Gidenstam, Gösta Gierow, Jan Håfström, Enno Hallek, Staffan Hallström, Lars Hillersberg, Einar Höste, Atti Johansson, Mona Johansson, Olle Kåks, Hanns Karlewski, Ewert Karlsson, Lars Kleen, Ulla Larson, Folke Lind, Sivert Lindblom, Lars Lindeberg, Lage Lindell, Berto Marklund, Bror Marklund, Lars Millhagen, Karl-Gustaf Nilson, Bengt Nordenborg, Thelma Aulio Paananen, Karl Axel Pehrson, Petter Petterson, Ulf Rahmberg, Torsten Renqvist, Ulrik Samuelson, Olof Sandahl, Kjartan Slettemark, Lasse Söderberg, Nils Gunnar Stenqvist, Max Walter Svanberg, Per Svensson, Pär Gunnar Thelander, Peter Tillberg, Per Olof Ultvedt, Hans Viksten, Philip von Schantz, Ulf Wahlberg, Henck Wognum, Jacques Zadig and Petter Zennström.

49 The cities of Norrköping, Jönköping, Lanskrona, Ystad and Sjöbo, Södetälje, Sundsvall, Härnösand, Luleå, Kiruna, Kalmar, Umeå, Östersund, Gävle, Falun and Nyköping.

50 Moderna Museet press release, MSSA Archive.

51 See *Sweden 1978-1983* in católogo razonado MIRSA, Santiago: Museo de la Solidaridad Salvador Allende, 2016, 363-91.

52 See Forms Museo Internacional de la Resistencia Salvador Allende. Moderna Museet Archive.

53 Liisa Flora Voionmaa, 'Colección Finlandesa en el Museo de la Solidaridad Salvador Allende, Helsinki: Tesis', 2013, 45.

54 Authour's interview with Maareta Jaukkuri, June 2020.

55 Timo Aalto, Lauri Ahlgrén, Eino Ahonen, Vilho Askola, Göran Augustson, Juhana Blomstedt, Veikko Eskolin, Heikki Häiväoja, Markku Hakuri, Marjatta Hanhijoki, Juhani Harri, Mauno Hartman, Jorma Hautala, Mauri Heinonen, Outi Heiskanen, Erkki Hervo, Outi Ikkala, Kimmo Kaivanto, Manno Kalliomäki, Aimo Kanerva, Seppo Kärkkäinen, Pentti Kaskipuro, Markku Keränen, Vladimir Kopteff, Matti Koskela, Inari Krohn, Olavi Lanu, Juhani Linnovaara, Rauni Liukko, Pentti Lumikangas, Olli Lyytikäinen, Jukka Mäkelä, Marika Mäkela, Jarmo Mäkilä, Seppo Manninen, Tuomas Mäntynen, Ukri Merikanto, Pirkko Nukari, Antero Olin, Gunnar Pohjola, Ulla Rantanen, Raimo Reinikainen, Helge Riskula, Väinö Rouvinen, Marila Sakari, Anita Snellman, Aimo Taleva, Tapio (Tapsa) Tapiovaara, Nina Terno, Esko Tirronen, Kari Juhani Tolonen, Pentti Tulla, Antti Ukkonen, Raimo Utriainen, Hannu Väisänen, Osmo Valtonen, Reijo Viljanen, Antti Vuori, Carl Wargh, Matti Waskilampi and Sven-Olof Westerlund.

56 Even though the press recorded for 116 artworks in the show, only a percentage of them were part of the auction.

by the artists, giving the reasons for their donations and the history of their works. Very few were completed. Jan Hafström and Lars Millhagen described their donations as tributes to Salvador Allende. Enno Hallek, Göran Gidenstam and Ewert Karlson expressed 'solidarity with the Chilean people and their fight against the fascist Junta'.[52] 'Solidarity' and 'fascism', the two sides of the struggle, were the most reiterated words in the records. Since only a small fraction of artists' voices are heard in this way, more in-depth layers need to be explored regarding the position and motivations that inspired their artworks and involvement in the MIRSA's crusade.

The same year in which the Swedish collection was travelling around Sweden, the Chilean artists exiled in Helsinki started to activate the idea of the Museum with the Artist's Association of Finland (Suomen Taiteilijaseura – Konstnärsgillet i Finland [STS]), in collaboration with the Society of Finland-Chile. The former were involved in Latin-American networks, participated in the International Art Association in Havana in 1972, and raised money through art auctions in 1974 for the Chilean cause,[53] even though this engagement with art donations was somewhat unusual.[54] Following a similar procedure to their Scandinavian neighbours, a specific committee was formed; however, the presidency was shared by the different artist members of the STS, Aimo Kanerva, Tapio Tapiovaara, Sven-Olof Westerlund, Heikki Alitalo and Sirkka-Liisa Lonka. Other representatives from leftist unions, human rights organisations and individuals participated as well, like critic Eino S. Repo, president of the Finland-Chile Society; Jacob Söderman, president of the International Commission of Enquiry into the Crimes of Military Junta; Heikki Varis, professor of Social Science; Olavi Hänninen, vice-president of the Central of Workers Finland; Kaj Chydenius, composer, and Maaretta Jaukkuri, who was the Exhibition and Information Secretary of the Artist's Association of Finland at the time.

After the Committee invitation was extended by the STS to artist members, more than 60[55] quickly respond to the call, creating a collection of 70 works[56] with a wide range of content from different generations of artists with diverse language directions. These ranged from those who experimented with the tragedies of World War II, to the young wave of the left. The example of the collective brigade in Chile, as at the Moderna Museet, was a stellar attraction that brought life into Helsinki. Two Chilean artists created a new large

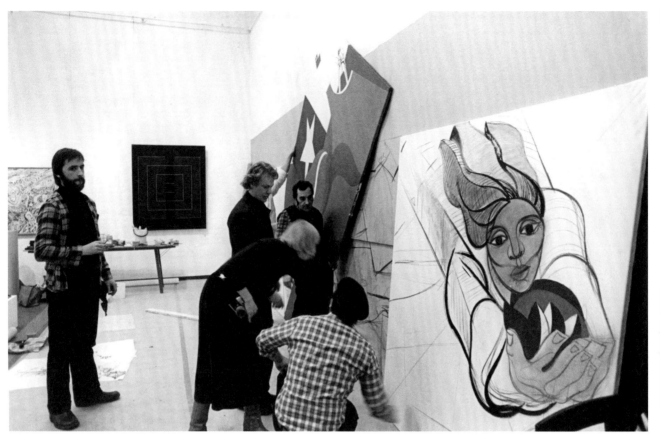

The Finnish Brigade painting the mural before
the exhibition of the MIRSA (The International
Museum of the Resistance Salvador Allende) from
5–28 January, 1979 in Taidehalli, Helsinki, Finland.
From left to right: Jarmo Mäkilä, Reijo Viljanen,
Héctor Wistuba, unidentified, Hernando León.
Photo: Seppo Hilpo Valokuvaaja. Fondo Museo
Internacional de la Resistencia Salvador Allende.
MSSA Archive.

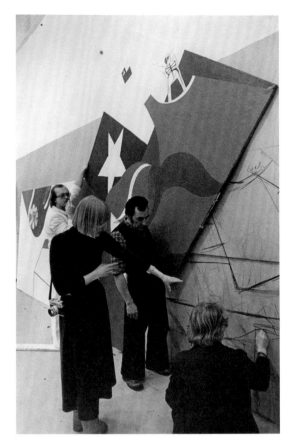

The Finnish Brigade painting the mural before
the exhibition of the MIRSA (The International
Museum of the Resistance Salvador Allende) from
5–28 January, 1979 in Taidehalli, Helsinki, Finland.
From left to right: Kari Juhani Tolonen, unidentified,
Héctor Wistuba, Reijo Viljanen. Photo: Seppo Hilpo
Valokuvaaja. Fondo Museo Internacional de la Resis-
tencia Salvador Allende. MSSA Archive.

mural during a tight schedule of four days:
Hernando León, who was exiled in the GDR
and Héctor Wistuba, exiled in Helsinki,
together with Finnish artists Marjatta
Hanhijoki, Marika Mäkelä, Jarmo Mäkilä,
Kari-Juhani Tolonen and Reijo Vilajanen.

The large painting (200 × 1100 cm) based
on a charcoal drawing, was composed from a
mixture of constructivist shapes, overlapping
canvases and a variety of styles that revealed
the distinguished and personal markings of
each maker, even though the intention was
to create a common visual narrative, as the
Chilean brigades had done. Dedicated to the
UNESCO International Year of the Child in
1979, the mural was part of the opening show
on 5 January in the Taidehalli – the main
activity centre organised by the STS – where
the Finnish collection and a group of *arpill-
eras* (colourful patchworks sewn over a small
burlap cloth) were exhibited. The *arpilleras*
were created by Chilean women whose rela-
tives were dead, disappeared or imprisoned
and whose creations were both intented to
generate income for the family, and act as a
therapeutic tool to alleviate the pain.

Followed by a press conference and
lecture by Miguel Rojas Mix, member
of MIRSA, whose talk addressed 'The
Resistance of Latin-American art',[57] the
exhibition's main attraction was, accord-
ing to the press articles, the process of
making the large painting. In contrast to the
Swedish-Chilean mural done at the Moderna
Museet, which was created with huge letters
spelling out Allende's surname covering one
large surface, the Finnish-Chilean mural
was divided into separate sections. The first
explored a painterly process that elaborated
a design depicting figures in different scales:
a hand, an octopus tail, a Chilean map, an
owl (symbol of death) flying with the dictator
hanging from its feet, while the second was
a combination of fragments by each artist
independently.

According to León, the mural was 'an
attempt towards learning to work together
and to resolve artistic matters'.[58] Combining
an experimental method and a playful
puzzle to construct a challenging piece
with a volumetric space effect, a laborious
commitment characterised the participatory
process of finding balance between different
characters, styles, idioms and methods, to
achieve a mural painting that was not free
from conflicts. Learning a lesson from past
brigades, we could come to the conclusion
that the core aspects of community engage-
ment and the difficult task of communication
and negotiation are struggles that need to
be overcome for the formation of collec-
tive action. MIRSA experimented with its

57 See Liisa Flora
Voionmaa, 'Colección
Finlandesa en el
Museo de la Solidari-
dad Salvador Allende,
Helsinki: Tesis' 9.
The conference of
Rojas Mix was pu-
blished in the Taide
magazine, as *Taiteen
vasterinte latinalai-
sessa Amarikassa*, no.
1, 1979, Helsinki.
58 See publication
of the left *Alliance
Newspaper Kansan
Uutiset*, 20 January
1979, d066, MSSA
Archive.

different assembly of artists' collections and committees; from struggling with individual approaches, to facing dominant artistic canons for the sake of social empathy with the public, surpassing personal interests for the defence and awareness of human dignity and collectively interconnecting the entire force to loudly resist crimes and injustices committed during the Chilean dictatorship.

After the restoration of democracy in Chile in 1990, the Swedish and the Finnish collections arrived in Santiago in 1991 and 1992 respectively. The Swedish works were part of the first group to return to Chile, and joined the other collections from France and Spain at the opening of the Museo de la Solidaridad Salvador Allende (MSSA) in Santiago. This would be considered the third life of the Museum from 1991 until now, renamed with a title that fused the spirit of the era of the Unidad Popular government and their ties with the exiled. The many stories about the artworks' journeys, the way they were kept in museums abroad, the management process to allow their return and the way they were received in Santiago, deserves another chapter. The possibility to recover these stories began in a new and transformative process six years ago, when the MSSA started to scratch the surface and contact the different actors who had participated in the past, through the collection and archive departments. Keeping their memory alive will enable a new generation to learn about past and upcoming solidarities, and to cultivate and put into practice the radical collective engagement that is possible and necessary in these times of global turmoil.

'To the Artists of the World'. Allende's letter at
the inauguration of the Museo de la Solidaridad
(Museum of Solidarity). Santiago, Chile, May 1972.
Fondo Museo de la Solidaridad. MSSA Archive.

A LOS ARTISTAS DEL MUNDO

En nombre del pueblo y del Gobierno de Chile, hago llegar mi emocionada gratitud a los artistas que han donado sus obras para constituir la base del futuro Museo de la Solidaridad. Se trata, sin duda, de un acontecimiento excepcional, que inagura un tipo de relación inédita entre los creadores de la obra artística y el público. En efecto, el Museo de la Solidaridad con Chile - que se establecerá luego en el edificio de la UNCTAD lll - será el primero que, en un país del Tercer Mundo, por voluntad de los propios artistas, acerque las manifestaciones más altas de la plástica contemporánea, a las grandes masas populares.

Me conmueve muy particularmente esta noble forma de contribución al proceso de transformación que Chile ha iniciado como medio de afirmar su soberanía, movilizar sus recursos y acelerar el desarrollo material y espiritual de sus gentes. Representan estas las condiciones para avanzar en el camino hacia el socialismo que ha elegido el pueblo con cabal conciencia de su destino.

Los artistas del mundo han sabido interpretar ese sentido profundo del estilo chileno de lucha por la liberación nacional y, en un gesto único en la trayectoria cultural, han decidido, espontáneamente, obsequiar esta magnífica colección de obras maestras para el disfrute

de ciudadanos de un lejano país que, de otro modo, difícilmente tendrían acceso a ellas. ¿ Cómo no sentir, al par que una encendida emoción y una profunda gratitud, que hemos contraído un solemne compromiso, la obligación de corresponder a esa solidaridad? .

Ese compromiso, que asumimos con absoluta confianza en las fuerzas de nuestro pueblo y en el apoyo que nos brindan nuestros amigos, es de perseverar sin desmayo en el proceso emprendido con el triunfo cívico de la Unidad Popular esencialmente destinado al hombre - pueblo para incorporarlo en condiciones dignas también al campo de la cultura. El Museo de la Solidaridad y la amistad de los artistas aquí representados constituye ya, uno de los frutos más puros de nuestra empresa de liberación nacional.

Mi agradecimiento, por último, a los miembros del Comité Internacional de Solidaridad Artística con Chile, que han tomado a su cargo la generosa tarea de coordinar y organizar la labor para que las obras de los artistas del mundo llegasen a nuestra tierra.

SALVADOR ALLENDE G.
Presidente de la República de Chile.

Salvador Allende

Speech at the Inauguration of
the Museo de la Solidaridad
(Museum of Solidarity), 1972

Speech given by the President of the Republic
Dr. Salvador Allende on the occasion of the
inauguration of the Museo de la Solidaridad
(Museum of Solidarity). Santiago, Chile. 17 May
1972. Fondo Museo de la Solidaridad. MSSA Archive.

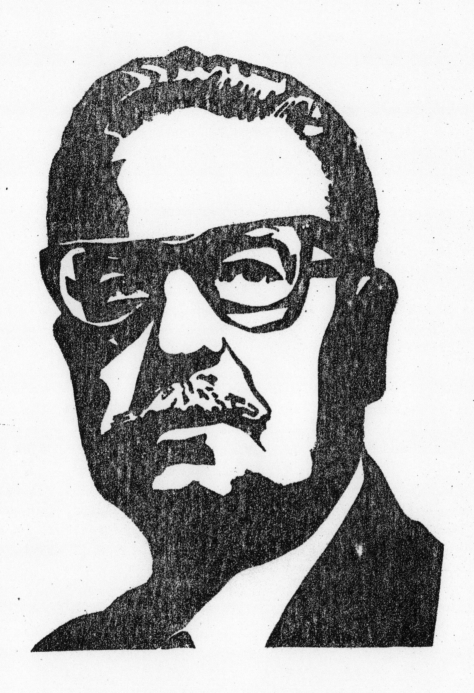

PALABRAS DEL PRESIDENTE DE LA REPUBLICA,
COMPAÑERO SALVADOR ALLENDE GOSSENS, EN LA
INAUGURACION DEL "MUSEO DE LA SOLIDARIDAD",
EN QUINTA NORMAL.

———oOo———

SANTIAGO, MIERCOLES 17 DE MAYO DE 1972.

**oficina de informaciones
de la presidencia de chile.**

Señoras, estimados compañeros: Mario Pedroza, Pedro Miras,
y José Balmes. Señores Embajadores, representantes de
países amigos. Señores Delegados a la Tercera UNCTAD.
Autoridades civiles, militares y eclesiásticas. Muy es-
timadas compañeras y estimados compañeros:

Es para mí un honor, muy significativo, recibir a nombre
del pueblo de Chile estas muestras, estos cuadros, estas obras que
nos envían, como expresión solidaria, artistas de los distintos con-
tinentes.

Quiero destacar que en la profundidad de las palabras y
en la belleza de la forma, como corresponde a un artista, el compa-
ñero Mario Pedroza, ha señalado que este es el único museo del mun-
do que tiene un origen y un contenido de tan profundo alcance. Es
la expresión solidaria de hombres de distintos pueblos y razas que,
a pesar de la distancia, entregan su capacidad creadora, sin reti-
cencias, al pueblo de Chile, en esta etapa creadora de su lucha. Y lo
hacen en los momentos en que también mi Patria es distinguida al se-
ñalársele como el lugar para que se reúnan representantes de 141 paí
ses en la Tercera Conferencia de Comercio y Desarrollo. No sólo el
pueblo de Chile, sino nuestros visitantes comprenderán, como compren-
demos todos, lo que representa para nosotros este estímulo, esta ex-
presión fraterna, esta manifestación comprensiva de los artistas del
mundo.

Comprendo perfectamente bien, que no puedo dar sencilla-
mente las gracias, aunque esta palabra tiene un contenido tan profun-
do que podría con ella expresar mis sentimientos y los sentimientos
agradecidos de los trabajadores chilenos.

Pero, siempre entendí el contenido, el alcance y la signi-
ficación que han tenido y tendrán estas demostraciones de los creado-
res de la belleza, de los plasmadores de la inquietud, en sus telas,
en sus estatuas, en sus obras.

SIGUE.-

Y, es por ello que el 1º de Mayo, en un acto de masas de
honda importancia para nosotros, cuando se congregaban los trabajado-
res de Chile, para rememorar a aquellos que cayeron, para hacer posi-
ble -entre otras cosas- que los nuestros se reunieran siendo Gobierno,
anuncié que se iba a inaugurar este Museo de la Solidaridad y leí los
nombres de aquellos que estimé representaban, no por la jerarquía,
tan sólo, de sus condiciones de creadores, sino por haber sido los
primeros, los nombres -repito- de aquellos que enviaron al Comité de
Solidaridad, con más premura, su expresión de afecto a nuestro pue-
blo y a nuestros trabajadores.

Hoy, quiero, no cumpliendo ritualmente, y en forma proto-
colar, sino porque estimo que es justo hacerlo, recordar aquí al comi-
té que integraban Louis Aragón, Jean Lamarie, Rafael Alberti, Carlo
Levi, Aldo Pelegrini, Mariana Rodríguez y José María Moreno Galván.

Quiero destacar a aquellos que como Mario Pedroza y Dani-
lo Tréllez fueron los representantes de nuestros artistas para coordi-
nar la entrega y a los compañeros José Balmes y Miguel Rojas y, ade-
más, al Decano de la Facultad de Bellas Artes de la Universidad de
Chile, Pedro Miras Contreras quienes también con su ascendiente, sus
vínculos, con sus contactos han hecho posible la materialización de
lo que hoy día podemos contemplar.

¡Qué bien lo ha expresado el compañero Pedroza!. Este no
será un museo más. Este debe ser el Museo de los Trabajadores, porque
para ellos fue donado, y cuando el Gobierno Popular que presido, lu-
chó, porque así fue, para que la UNCTAD III pudiera realizarse en
Chile, cuando el espíritu de UNCTAD, por así decirlo, sacudió a nues-
tro pueblo y se hizo posible lo que muchos no creyeron, que íbamos
a materializar la construcción de la placa y de la torre que ha
servido de edificio material para los delegados de tantos países,
entonces, avizoramos lo que será mañana esa torre y lo que será ma-
ñana esa placa. Queremos que esa torre sea entregada, y así lo
propondré, a las mujeres y a los niños chilenos y queremos que

SIGUE.-

la placa sea la base material del gran Instituto Nacional de la Cul-
tura, y, dónde mejor que allí estarán estos cuadros, estas telas
y estas obras.

Allá donde van a ir los trabajadores entendiendo que aquí,
en una nueva concepción de los derechos del hombre, y trabajando fun
damentalmente para el hombre, poniendo la economía a su servicio,
queremos que la cultura no sea el patrimonio de una elite, sino que
a ella tengan acceso -y legítimo- las grandes masas preteridas y
postergadas hasta ahora, fundamentalmente, los trabajadores de la
tierra, de la usina, de la empresa o el litoral.

Por eso, compañero Pedroza, yo le aseguro a Ud. que este
Museo no se va a desmembrar, que este Museo se mantendrá en su inte-
gridad y creo que sus palabras señalan, también, la posibilidad que
se amplíe, no porque nosotros lo pidamos, sino porque, seguramente,
muchos artistas que no tuvieron oportuna información o tiempo nece-
sario, harán la entrega generosa que Ud. mismo nos ha anunciado ya,
para acrecentar este patrimonio que desde ahora y por mandato de
los artistas progresistas del mundo integra el patrimonio cultural
del pueblo de Chile.

Quiero, finalmente, señalar que en un hombre, que por sus
años, por su prestancia y por su vida, merece que en él exprese mi
reconocimiento a los artistas progresistas del mundo, me refiero a
Jean Miró, al maestro o, a don Jean, como lo llaman los que así tie-
nen derecho para hacerlo.

El quiso, no entregar un cuadro, de los muchos o de los po-
cos que tiene en su casa, o en su galería de trabajo, él quiso crear
algo para Chile. Fue más generoso aún, él puso su inteligencia, sus
pinceles, su mente a trabajar para materializar este gallo, que como
ha dicho el compañero Pedroza:"canta una nueva alborada", a una nue-
va alborada, que es una vida distinta, en un país dependiente que rom-
pe las amarras para derrotar el subdesarrollo y con ello la ignoran-
cia, la miseria, la incultura y la enfermedad.

SIGUE.-

En Jean Miró, anciano respetado y respetable, pintor sín fronteras rindo el homenaje agradecido del pueblo de Chile, por la actitud de tantos y tantos que han comprendido lo que aquí hacemos, las metas que queremos alcanzar, nuestra dura lucha, frente a intereses poderosos -nacionales y extranjeros- que quisieran que el pueblo siguiera aherrojado y al margen de la instrucción y la cultura.

Este museo será la expresión del estímulo más hondo que sentirán desde más cerca los trabajadores. Y yo puedo decirles que el pueblo de Chile hace suyas las palabras del gran poeta nuestro, Pablo Neruda, cuando pensamos que en el mundo no debe haber fronteras y cuando él dice que "su casa sín puertas, es la tierra y las estrellas del mundo son su Patria". (APLAUSOS).

TRANSCRIPCION OIR/ TAF./ sdo.mtzg.sgm.

Ladies and dear comrades Mario Pedrosa, Pedro
Miras and José Balmes. Messrs. the Ambassa-
dors, representatives of friendly countries.
Messrs. the Delegates to UNCTAD III. Dear com-
rades:

It is to me a very significant honour to
receive, on behalf of the Chilean people, this
exhibit, these paintings, these works that the
artists of different continents send us as an
expression of their solidarity.

I wish to stress that comrade Mario Pedro-
sa, with his deep words and with the beauty of
form that befits the speech of an artist, has
pointed out that this is the only museum in the
world having such a far-reaching significance
and origin. It is the expression of the soli-
darity of me of different countries and races
who send the product of their creativeness to
the Chilean people, unrestrictedly, in this
constructive stage of their struggle, and this
in spite of the great distances between them
and us. And they do so in the same moments
when my country is also distinguished as having
been the chosen meeting place of the represen-
tatives of 141 countries at the Third Confer-
ence of Commerce and Development. Not only the
people of Chile but also our guests will under-

13

stand, as we all understand,what this broth-
erly gesture, this demonstration of under-
standing of the artists of the world means for
us.

I understand very well that it is not
enough just to say thank you, although these
words are so meaningful that they could express
my feelings and the feelings of gratitude of
the Chilean workers.

But I have always understood the contect,
the meaning and the extent of such demonstra-
tions of those who create beauty, who shape
man's anxiety through their canvases, their
sculptures, their works, in the past as in the
as in the present, and also in the future.

And that is why on the First of May, at a
public act of deep importance for us, when the
workers of Chile joined to remember those who
fell for making it possible. among other things,
for our people to meet as a government, I have
annouced the institution of this Museum of So-
lidarity and I have read the names of those
whom I considered representative, not by their
leading position as artistic creators but espe-
cially because they were the first, of those
who sent to the Committee of Solidarity the
expression of their feelings towards our pe-
ople and our workers.

Today, not as a mere ritualistic procedure
or in a protocol form but because I think it is
of justice to do it, I wish to mention here
the names of those who composed the Committee:
Louis Aragon, Lean Leymarie, Rafael Alberti,
Carlo Levi, Aldo Pellegrini, Mariano Rodriguez,
José María Moreno Galván, Giulio Carlo Argan,
Dore Ashton, Julius Starzinsky and Roland Pen-
rose.

14

I wish to stress particularly those who,
like Mario Pedrosa and Danillo Tréllez, have
acted as representatives of our artists in
coordinating the donations, and comrades José
Balmes and Miguel Rojas Mix, and also the Dean
of the School of Fine Arts of the University
of Chile, Pedro Miras Contreras, who, by their
influence, their friendships, their contacts,
have made possible the achievement of what we
can appreciate today.

How well comrade Pedrosa has said it! This
will not be just one more museum. This must be
the worker's museum, because it was given to
them, and when the Government that I preside
made efforts for it to be so, and to make it
possible for UNCTAD III to meet in Chile, when,
let us say, the spirit of UNCTAD galvanized
our people to execute what many had thought
impossible, that is, the construction of the
tower and the first plan building where the
delegates of so many countries worked, we fore-
saw what these buildings Will be tomorrow. We
want, and this will I propose, that the tower
be handed on to the women and the children of
Chile, and we want that the other building be
the center of the comprehensive National Insti-
tute for Culture. And where better than there
to put these paintings, these canvases, these
works?

It is there that the workers are going, un-
derstanding that this is a new concept of the
rights of man. And we, who work basically for
man, placing the economic resouces at his ser-
vice, we wish that culture be not the privilege
of a few but that the large masses of workers
on the fields, in the factories, in the enter-
prises or on the sea, who hitherto had been
fundamentally left aside, may have legitimate
access to it.

15

Thus, comrade Pedrosa, I assure you that this museum will not be dismembered, that it will be kept in its entirety. And I think your words indicate also the possibility of its extension not as an answer to our request but because certainly many artists who were not informed on the first moment will bring their generous contribution, as you have already announced it, to enrich this fund that already now, and by request of the progressive artists of the world, is incorporated to the cultural wealth of the Chilean people.

Before closing, I wish to stress that one man, by his age, his work and life, deserves to be mentioned as representative of the artistis of the world to whom I wish to express my gratitude. I mean to say Jean Miró, the master, or don Jean, as he is called by those who have the right to do so.

He was not content to give one of the many or of the few works that he has in his house or in his workshop; he has created something for Chile. With the greatest generosity he put his intelligence, his brushes, his spirit at work to execute his cook that, as comrade Pedrosa has said, "sings a new dawn", sings a new dawn that is that of a different day, in a hitherto dependent country that breaks its chains to defeat underdevelopment and with it ignorance, poverty, inculture and disease.

In Jean Miró, respected and respectable old man, a painter who has no borders, I render the grateful hommage of the Chilean people toward the actitude of so many others who have understood what we are doing here, the goals we aim at, our hard struggle in view of powerful interests, in Chile and in other countries wishing to see the people still under sumbis-

16

sion and excluded from instruction and culture.

This museum will be the expression of the most active impulse that workers will feel close to them. And I can tell you that the Chilean people make theirs the works of our great poet, Pablo Neruda, when we think that there should be no borders in the world and when he says that "his house without doors in the Earth, and the stars of the world are his country".

17

Mário Pedrosa

Speech at the Inauguration of the Museo de la Solidaridad (Museum of Solidarity), 1972

Speech given by Mário Pedrosa on the occasion
of the inauguration of the Museo de la Solidaridad
(Museum of Solidarity). Santiago, Chile. 17 May
1972. Fondo Museo de la Solidaridad. MSSA Archive.

DIJO MARIO PEDROSA

La idea de solidaridad que con tan airoso aplomo nos presenta el gallo miroviano no habría alcanzado el horizonte internacional así espontaneamente, sin el soplo vital emanado de esa difícil, de esa admirablemente difícil realidad chilena que Usted, Compañero Presidente, tan bien representa. Y es por eso que en este momento mismo todos nosotros tenemos -como si estuviera en nuestras manos- la idea encarnada en estos cuadros, en esas esculturas, en esos grabados y dibujos, en esas imágenes que de estas salas se desprenden, nos conmueven y van a permitir la constitución del Museo de la Solidaridad que Usted, compañero Presidente, va a instaurar.

Lo que hago aquí, ahora, es un abusivo acto de subrogación para hablar en nombre de los artistas que donaron obras suyas a Chile, cuando ningún poder subrogativo me mandaron los artistas donadores por ninguna vía material ni mucho menos por ninguno de los respectivos canales burocráticos reglamentarios. La subrogación también la tomamos en el aire nosotros, los miembros del Comité Internacional de Solidaridad Artística con Chile. Es que todo pasa, más que en el dominio mismo de la idea, en el dominio del ideal de socialismo que anima a ustedes, hombres prácticos que operan los mecanismos del Estado y las palancas del Poder, y a los artistas del mundo que manejan instrumentos de trabajo todavía personales, en su ma-

19

yoría destinados a atrapar sensaciones, vivencias, imágenes, intuiciones, "la esencia del hombre" en suma, en eterno conflicto con su existencia, al fin del cual el nombre encuentra o debe encontrar su liberación total.

Ahora, encerrada en estas salas, colgada en sus muros, está ya materializada la idea bajo cuyo calor ennoblecedor nos reunimos aquí. Esa materialización es el arte en su proceso de aparecimiento. Aparte de mirarlas, contemplarlas, admirar esas corporificaciones, de dialogar con ellas por el tacto, por los sentidos, por el pensamiento, adquirimos una nueva experiencia vivencial, un nuevo enriquecimiento cognoscivo, que es sobretodo un vehículo de la Verdad todavía trascendente en su contraste con una realidad que la niega. Y mientras la realidad que la niega. Y mientras la realidad sigue negándola, el arte sigue en su acercamiento permanente a una verdad cada vez más histórica y cada vez menos trascendente. Un día, en un punto del horizonte, los dos procesos se encontrarán, y entonces el arte será la vida y la vida será arte. De ese optimismo viven los hombres de acción, que creen en el futuro y lo quieren forjar en progreso y bienestar; y viven los artistas, que son los hombres de imaginación, que quieren crear la felicidad humana sobre la tierra.

Permítanme, también que volviendo a la primera muestra de nuestro Museo de la Solidaridad -como Ud., compañero Presidente, lo llamó en su carta a los artistas del mundo-, les diga que esperamos nuevas obras de otras partes del mundo: de los Estados Unidos, de Inglaterra, de Francia, de Italia, y otros, además de nuestros países de América del Sur, inclusive mi país, cuyo gobierno cerró las puertas de salida a nuestros artistas que quisieron demostrar su solidaridad al socialismo chileno.

Y más todavía, que estas obras aquí expuestas no están distribuídas arbitrariamente; se buscó una lógica interna que las uniese, y sus espacios corresponden en la medida de lo posible, a esa lógica. Todas las ideas o estilos del arte contemporáneo del mundo están aquí representadas. Y ustedes ve-

20

rán desde la línea lírica y creativa de Miró, hasta las obras que no piden mas contemplación pero son un llamado a la acción revolucionaria.

Lo que une indisolublemente estas donaciones es precisamente este sentimiento de fraternidad, para que jamás se dispersen en direcciones y destinos diferentes. Los artistas las donan para un Museo que no se deshaga con el tiempo, que permanezca a través de los acontecimientos como aquello para lo que fue creado: un monumento de solidaridad cultural al pueblo de Chile en un momento excepcional de su historia.

Nuestro Comité agradece, Compañero Presidente, la concesión de espacios suficientes en el edificio de la UNCTAD III para alojar el precioso acervo ya formado, al que han de agregarse las obras que están por llegar o prometidas. Esta colección hará de nuestro Museo el más rico de América Latina y el único en su género.

Los donantes quieren que sus obras sean destinadas al pueblo, que sean permanentemente accesibles a él. Y más que eso, que el trabajador de las fábricas y de las minas, de las poblaciones y de los campos entre en contacto con ellas, que las considere parte de su patrimonio. La esperanza de los artistas y nuestras es contribuir de este modo a la espontánea creatividad popular para que fluya libremente y pueda coadyuvar a la transformación revolucionaria de Chile. Es así como pensamos que el "Museo de la Solidaridad" deberá ser ejemplar en sus funciones específicas, ejemplar en sus tareas educativas y culturales, ejemplar en su accesibilidad democrática. Debe ser el hogar natural de las expresiones culturales más fecundas del Chile nuevo, consecuencia de su avance en el camino del socialismo. Este es el deseo entusiasta de los artistas del mundo que concurren para ello entregando el producto de su fuerza creativa.

Ahora no nos resta sino oir el canto del gallo de Miró, que canta con su pico abierto un canto de fe y de vigor, de

21

quien sabe que anuncia el amanecer. Que sea el nuevo amanecer de Chile; así lo esperan los artistas donantes y nosotros también.

Quisiera agradecer a Ud., Compañero Presidente, la comprensión que demuestra su respuesta a los artistas, y quisiera hacerlo en todos los idiomas de la tierra.

22

Mr. President; Ladies and Gentleman. Dear Comrades

The idea of solidarity so gallantly represented here by Miro's cock, would not have so spontaneously crossed the national boundaries were it not for the vital impulse coming from this difficult, this wonderfully difficult Chilean reality so well represented by you, comrade President. And that is why we all, at this very moment, possess -as if it were in our hands- the idea contained in these paintings, in these sculptures, in these engravings and drawings, and the images that come to us form these walls are touching to us -these works that will serve for the constitution of the Museum of Solidarity that you, comrade President, are creating.

What I am doing here now is an abusive arrogation, to speak on behalf of the artists who have donated their works to Chile, when the donating artists have not given me power for this, by any normal channel and much less by any legal or official channel. We, the members of the International Committee of Artistic Solidarity with Chile, have taken up this authorization in the air. This is because all things develop here, rather than in the field of ideas, in the field of the socialist ideal that impels you, the practical men who operate the State mechanics and the Power levers, and also the artists of the world, who deal still mostly with personal working tools, designed to catch sensations, life experiences, images, in-

27

tuitions, in sum the "essence of man", eternally in conflict with his existance, at the end of which man will reach, or must reach, total liberation.

Now, enclosed in these halls, pending from these walls, the idea under which we meet here, in its inspiring warmth, is materialized. Besides looking at these works, contemplating them, admiring them, establishing a dialogue with them through all our senses, through our thoughts, we acquire a new life experience, a new enriching knowledge, that means above all a vehicle of Truth, that is as yet transcendental in its contrast with a reality that denies it. And while reality continues to deny it, art continues to get permanently closer to a truth that is more and more historical and less and less transcendental. One day, at a point in the horizon, the two processes will meet, and then art will be life and life will be art. Of this optimistic hope live the men of action, who believe in the future and wish to mould it in progress and well-being, and the artists, who are the men of imagination, that want to create happiness for all men in this earth.

Let me, returning to our first exhibit of the Museum of Solidarity -as you, comrade President, so well called it in your letter to the artists of the world- say to you that we expect more works from other parts of the world: from the United States, from England, from France, Italy and others, besides many South American countries, including my country, of which the government has shut the exit doors to our artists who have wished to express their solidarity towards Chilean socialism.

Let me say, more, that the works here shown are not arranged arbitrarily; we have aimed at uniting them by an internal logic, and the spaces here correspond, as far as possible, to this logic. All the ideas or styles of contemporary art in the world are represented here. You will see here from the creative lyricism of Miro's line to works that do not call forth pure contemplation but are an incitement to revolutionary action.

28

This spirit of fraternity is precisely what links these donations into an indissoluble whole, so that they may never be dispersed and given different destinations and directions. The artists donate them for a museum that will not disappear as time passes but will remain at all events as that for which it was created: a monument of cultural solidarity to the Chilean people in an exceptional moment of their history.

Our Committes thanks you, Mr. President, for the destination of the necessary space in the building of UNCTAD III to lodge the valuable collection already received, to which will be added other works that have been promised and will shortly arrive. This collection will make of our museum the most important one of Latin America, and the only one of its kind.

The donors wish is that their works be presented to the public and permanently accessible to the Chilean people. More than that, their aspiration is that all workers, from factories and mines, from the poor quarters and from the fields, be put in contact with them and consider them as part of their patrimony. The artists' hope, and curs too, is that we may in this way contribute to the spontaneous creative power of the people, so that it may flow freely in support to the revolutionary transformation of Chile. Thus, we think that the Museum of Solidarity must be such as to serve as a model, in its specific functions, in its democratic and cultural tasks, in its democratic wide scope. It must be the natural stage for the most fruitful cultural expressions of the new Chile, consequent to its advance on the way to socialism. These are the most enthusiastic wishes of the artists of the world, who contribute to his end by bringing the product of their creative force.

Now we must hear the song of Miro's cock singing with its open beak, a song of faith and vigour, knowing that it is announcing dawn. That this may be the dawn of a new day in Chile; this is the hope of the donating artist, and curs too.

29

I wish to thank you, comrade President, for the good understanding you have shown in your answer to the artists, and I would like to do it in all the languages of the earth.

30

Everyone writes to the Colonel, or so an inversion of the title of Gabriel García Márquez's 1961 story *El coronel no tiene quien le escriba* (*No One Writes to the Colonel*) would suggest. First comes a fable of a retired officer who waits in vain for his promised pension. The Colonel's only diversion is a musician's funeral, the first natural death in the decade of *La Violencia* (1948–58) in Colombia. The title's inversion bends toward the September 1973 coup against Salvador Allende in Chile. The newspapers *El Mercurio* and *La Estrella* carried headlines that were later suspected of being coded messages between army officers planning the uprising. The pairing of headlines from *La Estrella,* on the final days of the coup d'état, with television images from the Non-Aligned Movement (NAM) conference happening simultaneously in Algeria, point to a breakdown in international solidarity. At the meeting, Zambia's Kenneth Kaunda said about Allende, 'We want him to receive a message from this hall: that all of us gathered here understand his problems and send him greetings, goodwill, and wish him success.' (*Two Meetings and a Funeral,* 2017). Two days after the NAM conference ended, Chile's first democratically elected Socialist President was found dead in the Presidential Palace. It was September 11th.

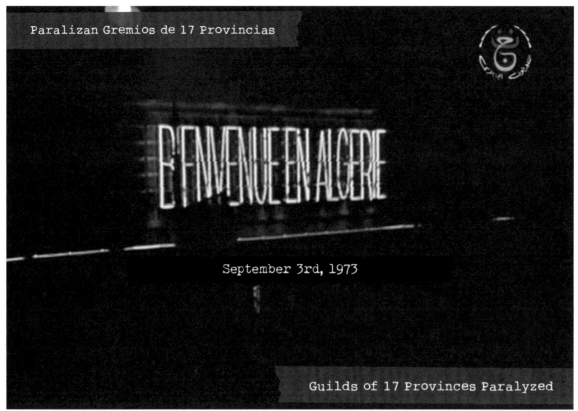

Paralizan Gremios de 17 Provincias

September 3rd, 1973

Guilds of 17 Provinces Paralyzed

15 mil son los extremistas extranjeros

September 4th, 1973

15 thousand are foreign extremists

Muertos en lucha de camioneros y policias

September 5th, 1973

Truckers and police killed in fight

Sangrientos Incidentes en Santiago

September 6th, 1973

Bloody Incidents in Santiago

Vaticinan hambre en la zona del Norte Grande

September 7th, 1973

They predict hunger in the Norte Grande area

La Oposición acusará a cuatro Ministros

September 8th, 1973

The Opposition accuses four Ministers

Cobarde ataque marxista a mujeres democráticas

September 9th, 1973

Cowardly Marxist attack on democratic women

Plantean renuncia del Parlamento y Allende

September 10th, 1973

They propose resignation of the Parliament and Allende

La paciencia femenina se ha agotado en el país

September 11th, 1973

Female patience has run out in the country

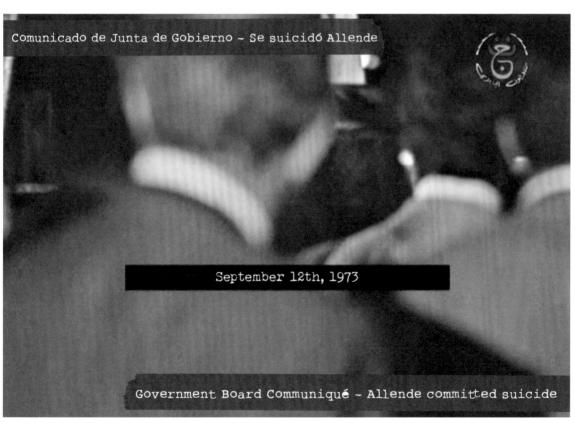

Comunicado de Junta de Gobierno - Se suicidó Allende

September 12th, 1973

Government Board Communiqué - Allende committed suicide

The 1971 Hungarian film *Guerrilla Fighters in Jordan*[59] promoted Hungary's state-managed solidarity with the unfolding Palestinian revolution. By examining this film as a case study, my aim in this essay is to understand how the same film could be both a part of the history of international leftist film, and part of the trajectory of Hungarian rightist nationalism. The early 1970s was a global moment for the Palestinian revolution, when filmmakers and artists from aligned and non-aligned countries, traversing Cold War trenches, travelled to Jordan, Lebanon and Syria to document the Palestinian movement. This essay focuses on the years 1969–71, when filmmakers and state media tried to place Palestine within publicly internationalist, but actually local-individual commitments. Just as the PLO (Palestine Liberation Organisation) temporarily unified many ideological currents while suppressing others, Cold War solidarity with Palestine took idiosyncratic, heterogeneous forms – often scattered, surprisingly, from left to right polarities.

In 1970–71, the Black September war unfolded between the PLO and the armed forces of King Hussein in Jordan, to where the PLO moved its base from Palestine following the Third Arab-Israeli War of 1967. As the Palestinian resistance movement was gaining momentum and popularity in the early 1970s, particularly after the Battle of Karameh of 1968, tensions grew between King Hussein and the PLO. The consequences of the Black September war included the expulsion of the PLO from Jordan to Lebanon. *Guerrilla Fighters in Jordan* in part chronicles this armed conflict. The film, made by the Military Studio of the Mafilm Hungarian Film Studios, came four years after the Third Arab-Israeli War of 1967, which was also a watershed moment in Eastern Bloc-Middle East relations, when all Eastern Bloc members – with the exception of Romania – cut diplomatic ties with Israel[60] and turned towards the Arab World in diplomatic relations and support.

Hungarian journalist Alajos 'Ali' Chrudinák (1937–2020) in a still from *Guerrilla Fighters in Jordan (Gerillatüzek Jordániában)*, 1971, HU OSA 424-0-1-059; Soviet Propaganda Film Collection; Open Society Archives at Central European University, Budapest.

Archival film footage showing Palestinians fleeing from Palestine to Jordan across the Allenby bridge in 1967. Original footage attributed to Palestine Film Unit (PFU) members Hani Jawharieh and Sulafa Jadallah. Still from *Guerrilla Fighters in Jordan (Gerillatüzek Jordániában)*, 1971, HU OSA 424-0-1-059; Soviet Propaganda Film Collection; Open Society Archives at Central European University, Budapest.

Archival photograph showing Palestinians guerrilla fighters. Original photo attributed to Palestine Film Unit (PFU) member Hani Jawharieh. Still from *Guerrilla Fighters in Jordan (Gerillatüzek Jordániában)*, 1971, HU OSA 424-0-1-059; Soviet Propaganda Film Collection; Open Society Archives at Central European University, Budapest.

Archival photograph, by unknown photographer, showing Leila Khaled of the Popular Front for the Liberation of Palestine (PFLP). Still from *Guerrilla Fighters in Jordan* (*Gerillatüzek Jordániában*), 1971, HU OSA 424-0-1-059; Soviet Propaganda Film Collection; Open Society Archives at Central European University, Budapest.

Alajos Chrudinák interviewing Yasser Arafat of the PLO in Ramtha, Jordan. Chrudinák's first questions were: 'Mr Yasser Arafat, in your opinion, can this crisis be solved with compromises? Does the Cairo Agreement have a future? And finally, how did the severe civil war affect the Palestinian movement?' Still from *Guerrilla Fighters in Jordan* (*Gerillatüzek Jordániában*), 1971, HU OSA 424-0-1-059; Soviet Propaganda Film Collection; Open Society Archives at Central European University, Budapest.

59 *Guerilla Fighters in Jordan* (*Gerillatü-zek Jordániában*), directed by Róbert Glósz, 1971, HU OSA 424-0-1-059; Soviet Propaganda Film Col-lection; Open Society Archives at Central European University, Budapest, http://hdl. handle.net/10891/ osa:21e302fd-ee8f-4455-bea8-8058423eedf9. The research for this essay was sponsored by Közép-Európai Egyetem (KKE, Central European University) and International Visegrad Fund. The theses explained herein represent the ideas of the author and do not neces-sarily reflect the opinion of KEE.

60 László J. Nagy, *Magyarország és az arab térség. Kapcso-latok, vélemények, álláspontok 1947-1975* [Hungary and the Arab Region. Relations. Opinions. Statements 1947-1975], Szeged: JATE Press, 2006, 119.

61 *Magyar Szemmel. Ahogyan Chrudinák Alajos látta a vilá-got* [Through Hunga-rian Eyes. As Alajos Chrudinák Saw The World], TV documen-tary and interview with Alajos Chrudinák (dir. Róbert Novák), MTVA Duna, 2020.

62 Ibid.

63 I was able to find a trace of the film's scree-ning in the week of 27 May – 2 June 1971 at Cinema Híradó in Budapest, 'A fővárosi mozik műsora' [Screening Program of Cinemas in Budapest], *Esti Hírlap*, Vol. 16, no. 122, May 26, 1971, 6. Cinema Híradó put on newsreels, documen-taries, cartoons, sport programmes. See 'Híradó Mozi' [Cinema Híradó], http:// egykor.hu/budapest-vii--kerulet/ hirado-mozi/1568.

64 I would like to thank Reem Shilleh for attributing the photograph and the footage.

65 The film was broadcast on Hunga-rian state televi-sion as part of the programme *A hét* [This Week] in 1970. MTVA Archive.

The 1971 film follows a conventional newsreel format with a voiceover from an authorita-tive male anchor, Hungarian journalist Alajos Chrudinák (1937–2020). Ali – as his friends called him – narrates the history of Palestine from biblical times up until what was then the present, framing the Palestinian revolu-tion within the anti-imperialist, anti-Zionist fight – as a just fight that is supported by Socialist Bloc countries and the 'progressive voices' of the world. Chrudinák, who in 1971 was at the beginning of his TV career, later became a widely known and popular docu-mentary filmmaker, investigative reporter and TV personality on Hungarian state television, with shows such as *Panoráma* and *Parabola*. Following his training at the Moscow State Institute of International Relations and the Department of Semitic and Arabic Studies at ELTE University in Budapest, he participated in the anti-So-viet, failed Hungarian Revolution of 1956, for which he was convicted and expelled from the Hungarian university.[61] Chrudinák spoke Arabic well, the language he used in making his TV films in the Middle East and Africa. One of his main interests was reportage from war zones. Beyond the Palestinian resistance movement, he also shot docu-mentary films in situ about the Ethio-Somali War, the Iran-Iraq War, and some of his TV documentaries that aired on Hungarian state television received international awards, most notably *War in the Sahara* (*Háború a Szaharában*, 1979) on the Western Sahara War between the Sahrawi Indigenous Polisario Front and Morocco, which won the Golden Nymph at the Monte-Carlo Television Festival in 1980.[62]

Guerrilla Fighters in Jordan is a 24-minute long film that was screened in cinemas.[63] The film combines three sources of footage: images filmed in a studio with various props, such as maps and polit-ical posters, along with a discussion, in Hungarian, with a Palestinian man who fled from Palestine to Hungary in the 1960s; archival materials, the majority of which are film footage and photographs about and by Palestinians, whose sources are not indicated in the film, but some of which can now be identified;[64] and interviews made by Chrudinák with Yasser Arafat in Jordan, with Khalid Bakdash, the Secretary General of the Syrian Communist Party in Damascus, and with a lieutenant (possibly named Walid El Kebir) of the Palestine Liberation Army in Ramtha. These excerpts come from a film that Chrudinák and his state TV film crew shot a year earlier titled *Middle East Travel Film* (*Közel-keleti útifilm*), which was aired on Hungarian State Television in 1970.[65] It

Alajos Chrudinák talking to Palestinian fighters on the road between Ramtha and Irbid in Jordan, who helped the Hungarian film crew fix a flat tyre of their car and who, according to the voiceover, advised the film crew not to go further to Irbid. The film crew carried on, however, and reached the city. Still from *Guerrilla Fighters in Jordan* (*Gerillatüzek Jordániában*), 1971, HU OSA 424-0-1-059; Soviet Propaganda Film Collection; Open Society Archives at Central European University, Budapest.

Title image still from *Guerrilla Fighters in Jordan* (*Gerillatüzek Jordániában*), 1971, HU OSA 424-0-1-059; Soviet Propaganda Film Collection; Open Society Archives at Central European University, Budapest.

Page 89
Poster paralleling Palestine and Vietnam. Publisher: FATAH, 1970. Source: The Palestine Poster Project Archives.

Page 90
Palestinian children and quote from a poem by Fadwa Tuqan. Publisher: FATAH, 1970. Source: The Palestine Poster Project Archives. [68]

66 It is likely this took place in October 1970 based on the dates mentioned in the footage of *Middle East Travel Film*.
67 Fatah (Arabic: فتح Fatḥ), formerly the Palestinian National Liberation Movement, is a Palestinian nationalist social democratic political party and the largest faction of the confederated multi-party Palestine Liberation Organization (PLO) and the second-largest party in the Palestinian Legislative Council (PLC) (Wikipedia).
68 The poem by Fadwa Tuqan is cited in John K. Cooley, *Green March, Black September - The Story of the Palestinian Arabs* (1973) (London: Routledge, 2015), 54-55. In the film *Guerrilla Fighters in Jordan*, original posters weree also displayed in the studio (published by Fatah and the Popular Front for the Liberation of Palestine (PFLP) between 1969 and 1971) to mimic the inside of Fatah/PFLP offices and show the audience the variety of posters that were produced at the time.
69 László J. Nagy, *Magyarország és az arab világ 1947-1989* [Hungary and the Arab World 1947-1989], (Szeged: JATEPress, 2017) 228. Nagy also notes, in addition to the PLO/Fatah, that Hungary financially supported the Democratic Front for the Liberation of Palestine and the Popular Front for the Liberation of Palestine.
70 James Mark and Péter Apor, 'Socialism Goes Global: Decolonization and the Making of a New Culture of Internationalism in Socialist Hungary, 1956-1989', *The Journal of Modern History* 87, no. 4 (December 2015): 866.
71 Eszter Szakács, 'Propaganda, Mon Amour: An Arab 'World' From Hungary', in Eszter Szakács and Naeem Mohaiemen (ed.), *Solidarity Must Be Defended* (New Dehli: Tricontinental; Istanbul: SALT; Eindhoven: Van Abbemuseum; Budapest: Tranzit; Gwangju: Asia Cultural Center, 2022).

is clear from *Middle East Travel Film* that the Hungarian film crew first landed in Damascus and then made its way to Jordan, to Ramtha and then Irbid in early October 1970, a few days after the two-week shelling of Palestinians in Irbid by the Jordanian Royal Army ended and the conciliation committee began its work.[66]

In Chrudinák's presentation of the Palestinian revolution to Hungarian audiences, one can discern ideological elements that are specific to his local context. In terms of the Palestinian resistance movement, Chrudniák voiced preference for political resolution over armed struggle, which was the official foreign policy of the ruling Hungarian Socialist Workers' Party at the time. Beyond Hungary's official socialist friendship with Palestine, which also included financial and military aid in the 1970s–1980s,[69] the idea of armed struggle was mostly rejected by the Hungarian state propaganda. It was stated by party officials that armed struggle could be supported theoretically but should not be considered as a relevant example for Hungary, a country that had already achieved its socialist revolution.[70] An implicit concern was that armed, anti-colonial struggles could ignite a revolt against the role of the USSR in Hungary. The film, as per Hungarian official policy at that time, acknowledged the state of Israel, with its borders of 1948, and Chrudinák, similarly to Hungarian authors around this time, attempted to differentiate between anti-Zionism and anti-Semitism.[71] Radio Free Europe (RFE) – a US anti-communist broadcasting organisation that received covert CIA funding until 1972 and targeted Eastern European countries – conducted surveys on public opinions in 1967 and 1970 about the conflicts between Israel and Palestine/the Arab World, which convey that there was little popular support from Eastern Europeans for the Palestinian cause beyond the alliance of socialist party members.[72]

While the 1971 film is conventional and didactic in its format and narration, its theme of solidarity with the Palestinian revolution was very much in tune with other socialist-communist, New Leftist, radical filmmaking aspirations at that time. In 1969, Fatah[67] commissioned, with funding from the Arab League, Jean-Luc Godard and Jean-Pierre Gorin, the Dziga Vertov Group, to make a film about the Palestinian revolution in Jordan, a few months before the Black September events.[73] They spent three months shooting in Jordan, Lebanon and Syria.[74] In 1971, Masao Adachi and Koji Wakamatsu went to Amman and Beirut to film *Red Army/PFLP: Declaration of World War* (*Sekigun-P.F.L.P: Sekai senso sengen* (赤軍PFLP・世界戦争宣言).[75]

فيتنام فلسطين

فتح ١٩٦٥ ١٩٧٠

OUT OF YOUR
CRUCIFIED GROWTH
OUT OF YOUR
STOLEN SMILE
LIFE WILL EMERGE

Fateh,1965 5 1970

72 HU OSA 300-6-
1:12, Records of
Radio Free Europe/
Radio Liberty Rese-
arch Institute: Media
and Opinion Research
Department: Adminis-
trative Files – 'The
Arab-Israeli Conflict
and Public Opinion
in Eastern Europe'
[1970] and HU OSA
300-6-2:2, Records of
Radio Free Europe/
Radio Liberty Rese-
arch Institute: Media
and Opinion Research
Department: East
Europe Area and Opi-
nion Research – 'The
Arab-Israeli Conflict
and Public Opinion
in Eastern Europe'
[1967-07]. See on
Radio Free Europe,
among others, A. Ross
Johnson, Radio Free
Europe and Radio Li-
berty: The CIA Years
and Beyond (Stanford:
Stanford University
Press, 2010).
73 Nadia Yaqub,
Palestinian Cinema in
the Days of Revoluti-
on, Austin: Universi-
ty of Texas, 2018.
74 Irmgard Emmel-
hainz, 'From Third
Worldism to Empire:
Jean Luc Godard and
the Palestine Questi-
on', Third Text, Vol.
23, No. 5, 2009: 650.
75 Yaqub, Palestini-
an Cinema in the Days
of Revolution, 81.
76 Emily Jacir,
'Letter from Roma',
Creative Time Reports
/ ArtAsiaPacific,
2013, http://
artasiapacific.com/
Blog/EmilyJacirLetter
FromRoma. See also
The World is With
Us! Global Film and
Poster Art from the
Palestinian Revoluti-
on, 1968-1980, cura-
ted by Nick Denes, at
the Barbican Cinema
and Rich Mix, London,
2014, https://
theworldiswithus.
wordpress.com/.
77 Emily Jacir,
'Palestinian Revolu-
tion Cinema Comes to
New York City', The
Electronic Intifada,
16 February 2007,
https://
electronicintifada.
net/content/
palestinian-
revolution-cinema-
comes-nyc/6759.
78 Subversive Film,
Al-Jisser: A Film
Programme. Ramallah:
Subversive Film,
2012.

79 Film Proposal
by Subversive Film,
Travelling Communiqué
in Belgrade, Museum
of Yugoslav History,
Belgrade, 2014. 80
Nick Denes, 'Between
Form and Function',
Middle East Journal
of Culture and Com-
munication, Vol. 7,
2014: 219–41.
81 Masao Adachi,
'The Testament that
Godard has Never
Written' (2002/2012),
Diagonal Thoughts,
March 16, 2014,
http://www.diagonalt-
houghts.com/?p=2067.
82 Emmelhainz, 'From
Third Worldism to
Empire', 651.
83 Irmgard Emmel-
hainz, Jean-Luc
Godard's Political
Filmmaking (Cham,
Switzerland: Palgrave
Macmillian, 2019),
101.

Besides these two well-known films, there are numerous others from 1970–71 about the Palestinian movement. In 1970, the Italian Communist Party commissioned Luigi Perelli's film *Al-Fatah Palestina (Al-Fatah: Palestine)* and in 1970, *La lunga marcia del ritorno (The Long March of Return)* by Italian Ugo Adilardi, Carlo Schelliono and Paolo Sornaga was made in collaboration with the Marxist-Leninist wing of the PLO, the Democratic Popular Front for the Liberation of Palestine (DPFLP).[76] In 1970, Syrian Kais al-Zubaidi directed the experimental short film *The Visit* about the Palestinian resistance movement.[77] The same year, the USSR made the newsreel the *Jordanian Report*, directed by Dimitri Rimarev.[78] The short film *Krv i Suze* (Blood and Tears) was likewise filmed in Jordan and produced in 1970 by the Yugoslav state newsreel production studio, Filmske Novosti.[79] Furthermore, the Palestine Film Unit (PFU), founded by Mustafa Abu Ali, Hani Jawharieh and Sulafa Jadallah, also emerged at the end of the 1960s in Amman to forge a Palestinian militant cinema, which was active under Fatah.[80]

Godard and Gorin could not finish their film in 1970. According to Masao Adachi's account, their filmmaking was disrupted by the Black September armed conflict in Jordan: on the one hand, several of their collaborators on the film died, and on the other, Godard wanted to reflect on the Black September events in the film, which was dismissed by the PLO/Fatah.[81] The film was never completed, but around 1973–74 Godard and Miéville made a new film from the footage shot with Gorin in 1970, which was released in 1976 as *Ici et Ailleurs (Here and Elsewhere)*.[82] In only a few years, significant events within the Palestinian struggle – the Munich Olympics in 1972, the Yom Kippur War in 1973, the OPEC Oil Embargo, the relocation of the PLO from Jordan to Lebanon, and the general move of the PLO/Fatah towards international diplomacy – brought about a very different world in the mid-1970s. In parallel, and also entangled with these events, 1973–74 marked the end of the 'French Cultural Revolution', the revolutionary project emerging from the 1968 events, as well as the demise of the Marxist potential of *Tiersmondisme* and anti-imperialism.[83] For these reasons, *Ici et Ailleurs* – in contrast to the original intention – relates the ultimate failure of communicating the Palestinian revolution ('here') to the French working class ('elsewhere').

In assessing the ideological grounds on which Godard and Gorin viewed and understood the Palestinian revolution in 1970 – which is the focus of this essay – the film

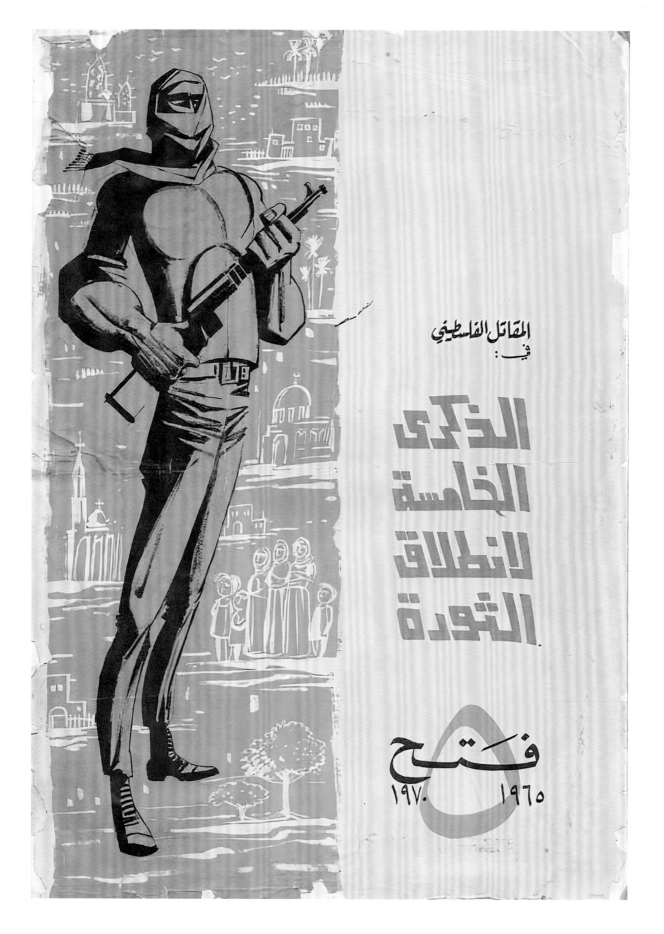

Poster using the graphic work of Mustafa al-Hallaj, commemorating the Battle of Karameh of 1968, a turning point in the Palestinian resistance movement. The poster was made on the occasion of a poster exhibition organized by the PLO in Amman, 1969 (See Denes, 2015) Publisher: FATAH, 1969. Source: The Palestine Poster Project Archives.

بمناسبة الذكرى الأولى
لمعركة الكرامة
٢١ آزار ١٩٦٩

معرض الكرامة
AL-KARAMEH

EXHIBITION

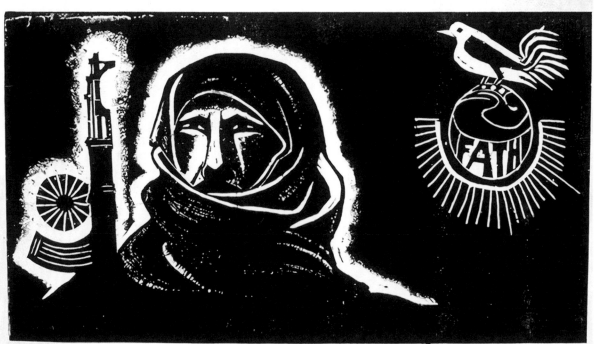

Palestine National Liberation Movement
"FAT'H"

حركة التحرير الوطني الفلسطيني
"فتح"

'The Palestinian fighter on the fifth anniversary of
launching the revolution'. Publisher: FATAH, 1970.
Source: The Palestine Poster Project Archives.

Godard in America (dir. Ralph Thanhauser, 1970) is instructive. The Dziga Vertov Group went to the US in 1970 in order to raise funds for the film they shot about the Palestinian revolution, which at that time was titled *Till Victory, Methods of Thinking and Methods of Work in the Palestinian Revolution*.[84] In *Godard in America*, the Dziga Vertov Group narrate how they wanted to present this 'new, revolutionary fact in the Middle East'. Among others, their plan was to refer to historical events, such as 1936, 1956 or the Battle of Karameh in 1969, and to parallel the Palestinian armed struggle to other fights against imperialism, such as in Vietnam, Laos, Cuba or Latin America. Based on their leftist-Maoist ideological background, they were planning to insert a Chinese film, following Chinese Communism – 'the real revolutionary line of armed struggle' – against Communist Russia's 'line of peaceful coexistence' – as well as shots of May 1968 in a Renault factory, of clashes between students, workers and police, 'to link [themselves] as French militants involved in the class struggle in France', as a form of fight against imperialism inside a capitalist country. The sequences towards the end would have focused on the figure of the fedayeen, expressing the political program of Fatah. Furthermore, as Irmgard Emmelhainz concludes, *Till Victory* would not have been a simple reporting or documentation of the Palestinian revolution – Godard and Gorin were also planning to discuss their footage with the fedayeen and Fatah in their editing – but rather a means to address the everyday practice of revolutionary methods that can be disseminated further.[85] Godard played a vital role in thematising the Palestinian struggle in France in the late 1960s, which was also embedded in the larger context of the French radical left's emergence, in conjunction with the May 1968 events.[86]

In their film, Adachi and Wakamatsu, likewise centralised armed struggle within the Palestinian Revolution; but they collaborated not with Fatah but with the PFLP, the Marxist-Leninist, radical-militant left wing of the Palestinian resistance movement. Adachi and Wakamatsu's take on the Palestinian revolution – similarly to the Dziga Vertov Group's own context – was rooted in the 1960s civil unrest and radicalisation of student movements, and their suppression in Japan, in the larger framework of the ANPO protest against the ratification of the US-Japan Security Treaty.[87] In 1971, Adachi and Wakamatsu filmed the Palestinian revolution, making parallels with the Japanese Red Army Faction, and utilising footage of the 1970 PFLP Dawson's Field aircraft hijackings in Jordan, guerilla training, and discussions with PFLP members, such as Leila Khaled or Ghassan Kanafani. Together with their signature landscape theory (*fûkeiron*), the filmmakers also included their footage of a speech by Japanese Red Army faction leader Fusako Shigenobu, who at that time was working together with the PFLP in Beirut.[88] The film advocated for the internationalisation of armed struggle. At the beginning of the film is the phrase in Japanese 'World war as the best form of propaganda' – which is a quote by Kanafani.[89] Adachi went back to Beirut in 1974 and stayed with the Palestinian resistance movement and the Japanese Red Army in exile in Lebanon for more than two decades, then was imprisoned in Lebanon in 1997, extradited to Japan in 2000 and freed two years later. As he relates in 2002: 'Our engagement with Palestine consisted above all in experimenting with militant cinema in the context of the struggle for the liberation of Palestine, while at the same time supporting the struggle in Japan, in order to create a global solidarity in favour of armed struggle.'[90]

Concomitantly with the emergence of different solidarity campaigns with Palestine, a group of Palestinian photographers and filmmakers also started to organise. As Nadia Yaqub highlights, for two decades after 1948, Palestinians had very little access to film and photography, and thus had no control over their own representation; they were seen and represented by others.[91] It was not until the late 1960s that the PFU started Palestinian militant filmmaking as documentation and as an integral part of the revolution, the audience of which was the Palestinians.[92] Elias Sanbar, in an interview with Mohanad Yaqubi and Reem Shilleh underlined that 'for a people who had disappeared in 1948, the image was not only representation, it was a way of existence. For a people who had suffered invisibility, the camera was their comeback weapon'.[93]

The Palestinian Right (الحق الفلسطيني, 1969) by Abu Ali, Jawhiareh, and Jadallah, as one of the first attempts to film the revolution from a Palestinian perspective, was commissioned by Jordanian TV, but was eventually censored and thus was never aired.[94] Even though *The Palestinian Right* is ground-breaking in its content – it talks about the injustices suffered by Palestinians and acknowledges popular armed struggle – it still employs the colonial newsreel tradition of the expert, foreign male narrator.[95] What Nick Denes describes as *The Palestinian Right*'s adherence to a colonial and Eurocentric discourse – such as

'legal positivism', citing maps, resolutions, biblical timelines and catering to a foreign audience rather than eliciting identification from Palestinians [96] – is very close to the strategies employed in *Guerrilla Fighters in Jordan*. Chrudinák also deploys various maps and cites UN resolutions in the film studio. While he also mentions the PFLP, the hijackings, displays a PFLP poster – one that also appears in the Adachi-Wakamatsu film – and a photograph of Leila Khaled, without naming her, Chrudinák maintains throughout the 'official' Hungarian state policy of peace. As he states in the film: 'The objective of the Palestinian movement is to create a democratic state, in which Muslims, Jews, Christians live together in peace.' *Guerrilla Fighters in Jordan* concludes with quotes from the poem 'ID card' by Mahmoud Darwish, recited over archival footage of Palestinian refugee camps.

After *The Palestinian Right*, Abu Ali, Jawharieh and Jadallah established the Palestine Film Unit, which was funded by Fatah and grew significantly in the 1970s with members from Iraq, Syria, Lebanon and Europe.[97] As Mohanad and Shilleh point out, within the broad ideological spectrum of the PLO – Fatah alone comprised groups aligned with Maoism, Arab nationalism, Soviet ideology as well as the right wing of the Islamic Brotherhood – PFU members followed Arab Nationalism and Maoist ideology.[98] Together with the other PFU founding member, Sulafa Jadallah – the first Arab woman cinematographer – the PFU received a large number of international requests for their images to be distributed in international coverage.[99] Thus, not only did international filmmakers produce images of the Palestinian revolution in the global media circuits, but photos and footage shot by the PFU also started circulating to international audiences. For instance, Palestinian and Arab students in Paris screened *The Palestinian Right*.[100] The *Guerrilla Fighters in Jordan* also incorporated photos and footage made by the PFU.

The Palestinian Right has only recently been identified and digitised from the archival footage that was discovered in 2008 at the Jordan–Soviet (now Russian) Friendship Society headquarters in Amman.[101] The Soviet Propaganda Film Collection at the Open Society Archives in Budapest, was digitised and made openly accessible online in 2016. It was recovered from, among other places, the House of Soviet Science and Culture in Budapest, and has been preserved through the work of Hungarian historian of Russian and Soviet cinema Anna Geréb, who offered the collection to OSA in Budapest.

84 As stated in the film *Godard in America*, dir. Ralph Thanhauser, 1970. Unless otherwise cited, all quotes and references in this paragraph are from this film.
85 Emmelhainz, 'From Third Worldism to Empire', 98.
86 Olivia C. Harrison, 'Consuming Palestine: Anticapitalism and Anticolonialism in Jean-Luc Godard's *Ici et Ailleurs*', *Studies in French Cinema*, Vol.18, No. 3, 2018: 178-91.
87 Harry Harootunian and Sabu Kohso, 'Messages in a Bottle: An Interview with Filmmaker Masao Adachi', *boundary 2*, Vol. 35, no. 3, 2008: 64-97. See also, Justin Jesty, 'Tokyo 1960: Days of Rage & Grief: Hamaya Hiroshi's Photos of the Anti-Security-Treaty Protests', *MIT Visualizing Cultures*, 2012.
88 Eric Baudelaire, *The Anabasis of May and Fusako Shigenobu, Masao Adachi and 27 Years without Images*, Libretto, as part of the installation, 2011.
89 Harootunian and Kohso, 'Messages in a Bottle', 90.
90 Adachi, 'The Testament that Godard has Never Written'. See more on Adachi, the Japanese Red Army and Eric Baudelaire's project: Naeem Mohaiemen, 'All That is Certain Vanishes Into Air: Tracing the Anabasis of the Japanese Red Army', *e-flux Journal*, No 36., 2015, www.e-flux.com/journal/63/60915/all-that-is-certain-vanishes-into-air-tracing-the-anabasis-of-the-japanese-red-army/.

91 Yaqub, *Palestinian Cinema in the Days of Revolution*, 25.
92 Ibid., 51.
93 Mohanad Yaqubi, 'The *Militant* Chapter in Cinema', in Georg Schöllhammer and Ruben Arevshatyan (ed.), *Sweet Sixties: Specters and Spirits of a Parallel Avant-Garde*, Berlin: Sternberg Press, 2013, 259.
94 Kay Dickinson, *Arab Film and Video Manifestos. Forty-Five Years of the Moving Image Amid Revolution* (Cham, Switzerland: Palgrave Pivot, 2018), 91. The Palestine Film Unit made *With Sweat, With Blood* in 1971. I was not able to access this film, and am therefore referencing the earlier film from 1969, *The Palestinian Right*.
95 Denes, 'Between Form and Function', 222.
96 Ibid.
97 Ibid., 223.
98 Reem Shilleh and Mohanad Yaqubi, 'Reflections on Palestinian Militant Cinema' in Marco Scotini and Elisabetta Galasso (ed.), *Politics of Memory. Documentary and Archive* (Berlin: Archive Books, 2017), 100.
99 Yaqubi, 'The *Militant* Chapter in Cinema', 253.
100 Ibid., 254.
101 Anastasia Valassopoulos, 'The international Palestinian Resistance: Documentary and Revolt', *Journal of Postcolonial Writing*, Vol. 50, no. 2, 2014: 148-62. The film project and some of the films are available here: http://afilmarchive.net/.

In addition to agency, the preservation and rediscovery of the films that were made between the 1960s and the 1980s is paramount to Palestinian militant filmmaking. It was in 2011 when Mohanad Yaqubi discovered that the 1,500 metres of footage shot by the PFU was located in Rome, where it had been since its smuggling out of Lebanon in 1977.[102] Yaqubi's film *Off Frame AKA Revolution Until Victory* collates the newly found footage made by the PFU together with other archival film footage and soundtracks, to 'tell the story of people in search of their own image'.[103] As the director pinpointed, while, 'for the outside world, these films represented a model of a people in struggle, explaining why they are fighting and against whom ... for Palestinians these films marked the transformation of their identity, from a refugee to that of a freedom fighter'.[104] Contemporary art and film projects such as by Mohanad Yaqubi and Reem Shilleh of Subversive Film, Eric Baudelaire, Emily Jacir, as well as Naeem Mohaiemen, Ho Rui An or Raqs Media Collective, in addition to the work of formal historians, not only reconstitute archival filmic materials, but also interpret the roads to the present moment in light of the failed revolutions, and the price that had to be paid for them after 1972, 1989, 1993, 2001 and finally 2011.

* * *

In order to begin to understand how *Guerrilla Fighters in Jordan* fits into the history of rightist nationalism in Hungary, a look at its creator, Alajos Chrudinák, is illuminating. For two decades Ali was the media face of state socialist Hungary's friendship with the 'Arab World'. Nonetheless, around the same time as *Guerrilla Fighters in Jordan* was made, he started engaging with another ideological line in his TV films that went beyond the permitted perimeters of socialist ideology. He began to foreground the otherwise silenced status of Hungarian national minorities, who – due to the significant changes of borders in Eastern Europe after the First World War treaties – had been residing outside of Hungary as citizens of its neighbouring countries (Romania, former Czechoslovakia, former Yugoslavia). The question of Hungarian national minorities, their utopic, revisionist unification across present-day borders, in a 'Greater Hungary', constituted an important line of anti-communist, 'oppositional' discourse against the totalitarian Hungarian-Soviet regime in the 1980s, and still today is a cornerstone of nationalism in Hungary.

In 1972, a year after *Guerrilla Fighters in Jordan*, Chrudinák made his first TV documentary in Transylvania, Romania, about Hungarian national minorities, from which – as Chrudinák recounts – half was cut out by the socialist Hungarian editor, while the TV producer labelled him a nationalist for making this documentary.[105] In Hungarian leftist state socialism, any kind of individualised identity – religious, regional, ethnic, generational, gender – was inhibited, and only social roles and identification with affiliations such as the Proletariat of the World or the Socialist Brotherhood of Nations were encouraged.[106] Therefore, national identity and nationalism as an ideological line – which was reduced to a rightist ideology as the 'enemy' – was suppressed between 1949 and 1989.

Already in a 1996, six years after the 'democratic transition' of Eastern Europe, in the study 'The Changing Facets of Hungarian Nationalism', the authors, sociologists György Csepeli and Antal Örkény, register the rise of rightist nationalism in Hungary, which they identify as an 'unintended consequence of the practice of "building socialism"' in the socialist era between 1949 and 1989.[107] Read from this perspective, the figure of Chrudinák emerges precisely at this contradictory intersection of building rightist nationalism through state socialism. Under the auspices of the socialist state, he produced numerous TV documentaries aligned with the socialist ideology of supporting Palestine and the Arab World against imperialism. Within this same socialist framework, he also made several TV documentaries that focused on the suppression of Hungarian national minorities – an ideological trajectory that would become rightist nationalism after the Cold War and state socialism ended in Hungary in 1989. Chrudinák subsequently became in the 1990s an important and famous character for the political right and nationalism, and he was active within these circles until the mid-2000s. Thus, one can infer from today's vantage point that his solidarity with Palestine – which he maintained throughout his life – was not so much a shift from left to right as a position that had always been right-oriented. And this right-leaning ideology was in in the 1970s–1980s one of the 'opposition' discourses of the totalitarian regime, from an anti-communist standpoint. This had far-reaching consequences for Palestine solidarity since it became locked into a rightist ideology in popular opinion in Hungary, and one of its 'channels' was Chrudinák himself. For instance, in 2009, a Hungarian right extremist MP (Jobbik)

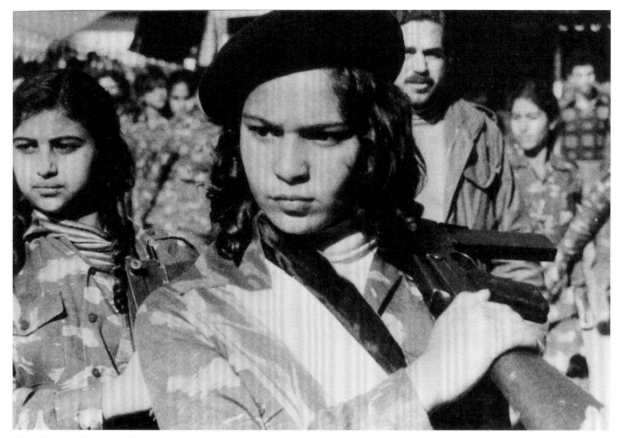

Film still from *Off Frame AKA Revolution
Until Victory,* dir. Mohanad Yaqubi, 2015
© Idioms Film. The original photo was taken
by PFU member Hani Jawharieh. Image
courtesy of Hind Jawharieh.

102 Sheyma Buali,
 'A Militant Cinema.
 Mohanad Yaqubi in
 Conversation' Ibraaz,
 2 May, 2012, www.
 ibraaz.org/
 interviews/16.
103 *Off Frame AKA
 Revolution Until
 Victory*, dir. Mohanad
 Yaqubi, 2015.
104 Mohanad Yaqubi,
 *Off Frame AKA Revolu-
 tion Until Victory*,
 2015, http://
 idiomsfilm.com/
 movies/off-frame/.
105 Árpád Szőczi,
 *Temesvár: A romá-
 niai forradalom
 kitörésének valódi
 története* (Timisoara:
 The Real Story Behind
 the Romanian Revolu-
 tion) (Bloomington:
 Universe, 2013), 221.
106 György Csepeli
 and Antal Örké-
 ny, 'The Changing
 Facets of Hungarian
 Nationalism', *Social
 Research*, Vol. 63,
 No. 1, 1996: 272.
107 Ibid., 255.

appropriated a rudimentary form of anti-colonial discourse as well as the metaphor of equating the oppression of Hungarians and Hungarian nationalism with the oppression of Palestinians.[108]

Yet 2015 marked another turning point in the changing facets of Hungarian nationalism. The so-called 'refugee crisis' was used by the current right-wing government, on the one hand, to launch a xenophobic, anti-Arab, anti-Islam political campaign. On the other hand, and not unrelatedly, the Hungarian government sought out stronger relations with Israel. In July 2017, Benjamin Netanyahu made a historic visit to Budapest; he was the first Israeli prime minister to travel to Hungary since 1989. Furthermore, Hungary sent a delegation to the US Embassy's relocation to Jerusalem from Tel Aviv in May 2018. Consequently, after 2015, extreme right parties have largely abandoned their pro-Palestinian stance. It is precisely in today's vacuum of Palestine solidarity in Hungary that Chrudinák's complex and contradictory oeuvre is pertinent to scrutinise. Seeing the case study of *Guerrilla Fighters in Jordan* – Palestine solidarity on the basis of a personal, oppositional, becoming-rightist ideology, embedded in the larger framework of leftist state socialism – in contrast to other, critical-radical leftist films made at the same time along different commitments in support of the Palestinian resistance movement shows that Palestine solidarity in the Cold War was more complex than simply a homogenous leftist ideology.

108 András Tóth – István Grajczjár, 'A nemzeti radikalizmus: A jobboldali radikalizmus negyedik hulláma Magyarországon ['National Radicalism: The Fourth Wave of Right-wing Radicalism in Hungary], in Zsolt Boda, András Körösényi (ed.), *Van irány? Trendek a magyar politikában* [Is there a direction? Trends in Hungarian politics] (Budapest: Új Mandátum, date?), 93.

Naeem Mohaiemen
and Eszter Szakács

Traces

Susan Meiselas, Magnum Photos: Sandinista guerrillas reading news about their homeland in their local newspaper, *La Prensa*, in a mountain training camp north of Esteli, Nicaragua, 1979. Sandinistas from the Sandinista National Liberation Front (FSLN) led a popular insurrection that overthrew the Somoza dynasty in 1979 and established a revolutionary government in its place. The FSLN ruled until their election defeat in 1990, having spent most of the decade fighting a war against the CIA-funded 'Contras'. Image courtesy of Susan Meiselas.

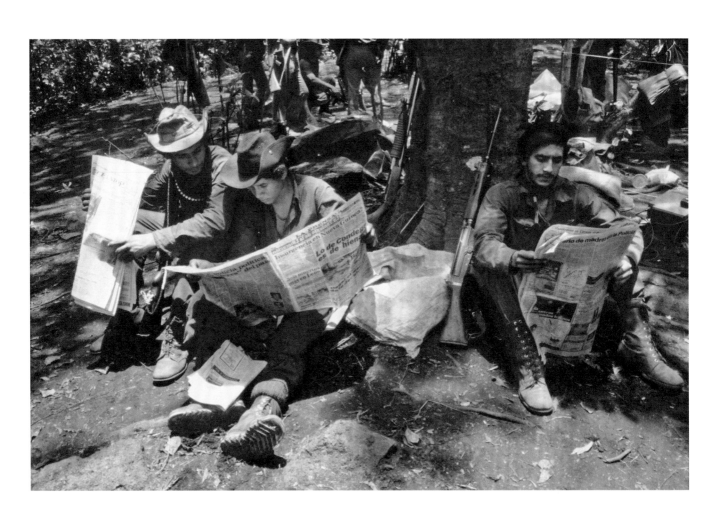

Susan Meiselas, Magnum Photos: US-supported National Guard soldiers at the Elite Basic Training School (EEBI), Managua, Nicaragua, 1978. EEBI was founded in 1976 by Anastasio Somoza Portocarrero, son of Nicaraguan dictator Anastasio Somoza Debayle, after returning from training in the US Army school for psychological and special warfare at Fort Bragg. The National Guard fought the Sandinistas fiercely, but by 1979 they were cut off from military aid from the US and Israel, and the regime collapsed after Somoza fled to Miami. Image courtesy of Susan Meiselas.

Stevan Labudović (1926–2017), President Josip Broz Tito's cameraman. This image is from Labudović's last visit to Algeria in December 2014. Labudović spent three years as Yugoslavia's envoy with the FLN, filming the Algerian war. Image courtesy of Mila Turajlić's research and film project *The Labudović Reels* (2022).

→
Sadık Karamustafa, *İşkence onları kurtaramaz*. Torture cannot save them. Journal cover. Istanbul, 1977. From Farah Aksoy's interview with Sadık Karamustafa about his graphic designs for the weekly leftist journal *Bağımsız Türkiye* Independent Turkey, published by Türkiye Emekçi Partisi (TEP) Labor Party of Turkey. Image courtesy of Sadık Karamustafa.

BAĞIMSIZ TÜRKİYE

6
17-1-1977
250 krş.

Haftalık Siyasi Gazete

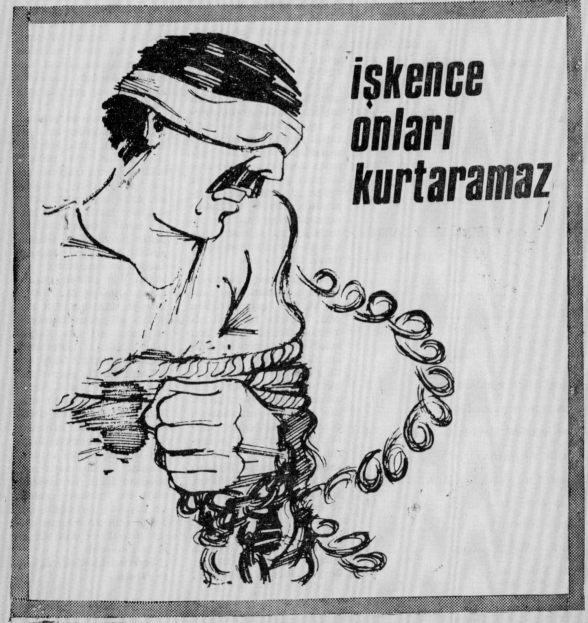

işkence onları kurtaramaz

Cecilia Vicuña in front of her installation
A Journal of Objects for the Chilean Resistance at Arts
Meeting Place, Covent Garden, London, July 1974.
Unknown photographer. Image courtesy of England & Co
Gallery.

Cecilia Vicuña, *Fidel y Allende*, 1972,
oil on canvas, 72 x 59 cm. Image courtesy
of England & Co Gallery.

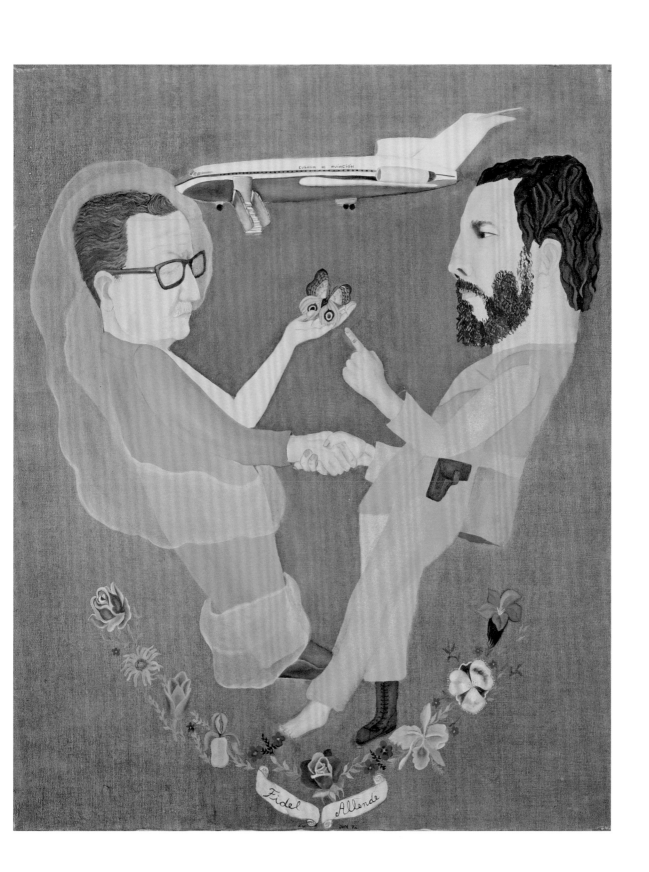

Poster from the archive of Thomas Leeuwenberg, who was active in leftist circles in the Netherlands and collected the then contemporary posters.

This poster reads, in part: 'Month of Solidarity with the People of Korea / US Imperialist aggressive troops, get out of South Korea'. Image courtesy of Collection of the Van Abbemuseum, Eindhoven. Photo by Hanneke Wetzer.

Art and Solidarity Reader

‘Away With Dutch Colonialism in Surinam'. Poster from the archive of Thomas Leeuwenberg, who was active in leftist circles in the Netherlands, and collected then contemporary posters.

Image courtesy of Collection of the Van Abbemuseum, Eindhoven. Photo by Hanneke Wetzer.

WEG MET HET NEDERLANDS KOLONIALISME IN SURINAME

ATLANTIC OCEAN

PARAMARIBO

FRENCH GUYANA

GUYANA

BRAZIL

PUBLISHED BY THE INTERNATIONAL UNION OF STUDENTS

Naeem Mohaiemen and Eszter Szakács

1. Political Imaginaries

Martha Rosler, *A Simple Case for Torture, or How to Sleep at Night,* video, 62 min, 1983. Exhibited as part of Artists' Call Against US. Intervention in Central America, Millennium Film Archives and Downtown Community Television, New York, 1984. Rosler was a member of the steering committee of Artists' Call. Image courtesy of Martha Rosler.

Forough Farrokhzad's 1935–1967 *The House is Black* (1962) is a key work of Iranian New Wave cinema. Her poem *Let Us Believe in the Dawn of the Cold Season,* published posthumously after she died in a car accident, was considered one of the best-structured modern poems in Persian. Iranian poet Fatemeh Shams claims that when people left Iran after the 1979 Islamic revolution, '[they] took three books with them: Saadi, Rumi, Forough'. Drawing by Tings Chak, 2020, Courtesy of Tricontinental: Institute for Social Research.

Saida Menebhi (1952–1977) was a Moroccan poet and activist of the Marxist revolutionary movement *Ila al-Amam*. In 1975, she was sentenced to prison for 'anti-state' activities. She died on the 34th day of a hunger strike at the age of 25. During Morocco's 'Years of Lead' women militants were a large portion of those disappeared and imprisoned. Drawing by Tings Chak, 2019, Courtesy of Tricontinental: Institute for Social Research.

→
Marilyn Nance, FESTAC '77. African and African-American Artists hosted by Professor Agbo Folarin in Ile Ifé, Nigeria, January, 1977. From Left to Right: Oghenero Akpomuje, Frank Smith, unidentified, Winnie Owens-Hart (with camera), David Stephens, Patricia Phipps, unidentified, Napoleon Jones-Henderson, Viola Burley, Tyrone Mitchell, Agbo Folarin (holding child, Abiola Folarin), Charles Abramson. Kneeling: Bisi Fabunmi, Yinka Adeyemi, unidentified. Festac '77, also known as the Second World Black and African Festival of Arts and Culture (the first was in Dakar, 1966), was an international Black Solidarity festival held in Lagos, Nigeria. Image Courtesy of © Marilyn Nance.

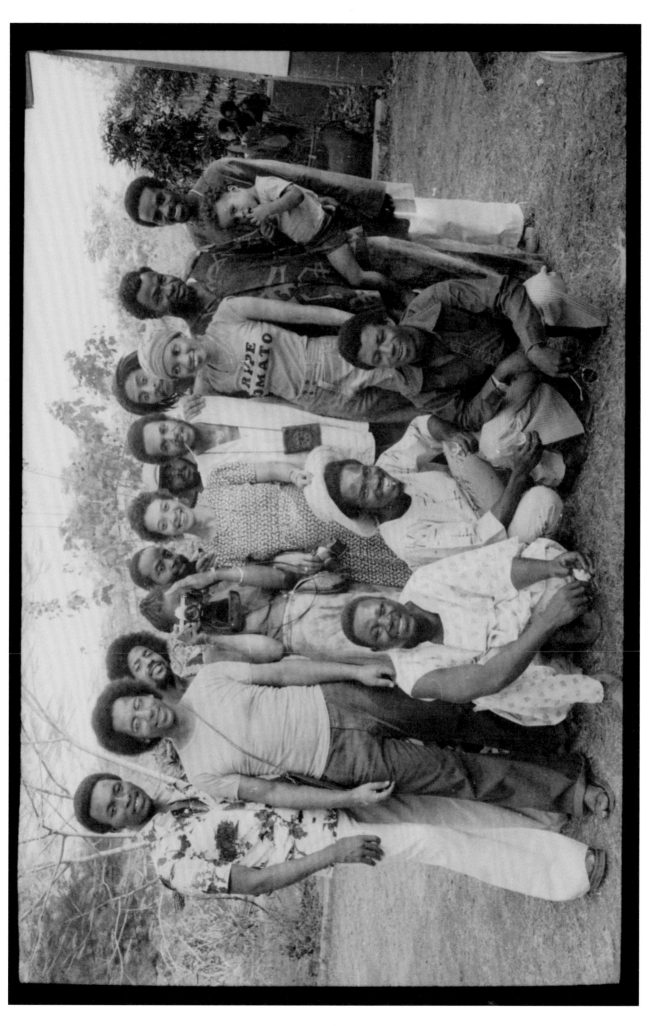

1. Political Imaginaries

Naeem Mohaiemen and Eszter Szakács

[109] An edited version
of this interview
appeared in *Mail &
Guardian* (Johannes-
burg) of 27 May 2020.

Can you talk about the timing of your publishing project on Festac? The festival took place at the beginning of 1977, after a difficult planning period. What is its continued relevance to the diaspora, in particular now?

Ntone Edjabe: In the first decade of the 2000s, we experienced a wave of gruesome attacks across the continent on the 'Familiar Other'. We saw this in Côte d'Ivoire, Senegal, Nigeria, Sudan, Kenya, across the Great Lakes and, of course, during the Afrophobic violence in South Africa of May 2008. It's a depressingly long list and the reasons are specific to each context, but it seems that what's continuously and violently contested is, 'Who belongs where?', the perennial question of the nation-state in Africa since the Independence period. And by extension, the question of the circulation of Black people in our world. These questions have been at the centre of our work since the first issue of *Chimurenga*. But I think the most immediate trigger for this project was the failure of South Africa's World Cup in 2010 – we knew Bafana Bafana [South Africa's national team] weren't going to win it and that it wouldn't deliver all the jobs-jobs-jobs promised. The developmental logic was unsustainable. The justification for the megalomaniac spending for an event of that scale had to be cultural – to alter, fundamentally, the way Africans see themselves and how the world sees us. Instead, we produced that 'waka-waka' nonsense. But it wasn't enough to point to the failure of the imagination: we began to research global cultural events that the continent had hosted in the twentieth century, that were not restricted by the instrumental logic that guided South Africa's World Cup.

Like Pan Africanism, it's a story that begins in the diaspora and moves to the continent with the wave of independence of the 1960s – first in Nkrumah's Ghana in 1958 with the All African Peoples Conference. These gatherings take a cultural slant, with the First World Festival of Negro Arts (Fesman) in 1966 in Dakar, and eight years later at the Pan-African Cultural Festival (Panaf) in Algiers. Festac '77 in Lagos marked the closing of this festival decade, and perhaps the end of Pan Africanism as a state project – so we wanted to look into that.

But the importance of Festac '77 goes beyond chronology. Each of these festivals is remembered as a singular moment in the history of the country in which it took place, always the first of its kind and ideologically dissonant. Whereas Dakar '66 manifested as a platform for Negritude's ideals of Black culture, Panaf '69, mandated by the OAU (Organisation of African Unity), looked to culture as a tool of liberation and development. However, individually and as a cluster, they functioned as laboratories for the development of new, worldwide politics and cultures. Their shared aim was to look beyond the binaries established by the cold and hot wars (East-West, North-South), and give form to universalisms that had emerged since the Haitian revolution. In other words, to institutionalise the Black world.

I think the specificity of Festac '77 is in its attempt to reconcile what Tejumola Olaniyan called the political and cultural paradigms in Pan Africanist thought and practice. This is also the tension I see between Africans on the continent and those from its diaspora, in which 'African' has come to mean the former and 'Black' the latter. These divisions were of course amplified by the invention of fields such as African Studies and Black Studies in the realm of knowledge production. Anyway, following Olaniyan's logic, Dakar '66 would have been 'cultural' (Black), and Algiers '69 'political' (African). Festac '77, according to this logic, would be both Black *and* African, hence the renaming of the festival.

To circumvent the limits of nativism and Afro-radicalism, Festac '77 imagined Black solidarity as inclusive. So people and communities from the Black diaspora as well as postcolonial African states would be represented. The tension between these modes of affiliation, Black/African (and plenty of others), is what the festival is all about – it simultaneously presents and celebrates the art of statelessness

and state-art, while putting all forms of political representation under pressure.

For example, members of the AfriCOBRA arts collective are part of the US delegation – except the US isn't invited, only Black Americans. They're not there as members of AfriCOBRA either, because artists are invited as individual members of a recognised political community. They end up representing a country that exists only in the Black radical imagination – Black America. But it gets better. The only state symbol at their disposal is a flag – Marcus Garvey's flag of Pan Africanism, which is itself a challenge to the idea of the nation-state. On the other hand, the South African born Miriam Makeba was a citizen of nine countries (excluding South Africa at that time) and represented them all at Festac '77. The poet Mário Pinto de Andrade, one of the founders of Angola's MPLA, appeared at the festival instead as Guinea-Bissau's minister of culture. That's the beauty and depth of the mess that Festac '77 makes visible.

The work of producing Pan Africanism as a political reality is ongoing and, sadly, what we currently celebrate as 'Africa Day' is the reduction of that project into a manageable bureaucracy in the OAU – now the AU (African Union). But the questions – who is Black? What is Africa? – are very much alive in the cultural realm. One of the questions we ask through this project is, can a past that the present has not yet caught up with be summoned to haunt the present as an alternative?

KS How did you approach the research for this? Was there a central source that provided much of the material or were you calling on existing networks across the Black worlds for material?

NE The Centre for Black and African Art and Civilisation in Lagos is an important resource to understand Nigeria's investment in Festac '77 – three successive military governments carried the project. It was founded by General Obasanjo in 1979, to act as custodian of the Festac archive and it holds many important planning documents and recordings of performances. But no central archive can contain the enormity of this event. Like the map in Jorge Luis Borges's famous parable 'On Exactitude in Science', it would need to be as big as the territory.

My colleagues and I are generally more interested in inserting ghosts into the archive than merely reproducing it. Today, the National Theatre in Lagos, which hosted many of the Festac performances, feels like a haunted space, like a monument to unrealisable dreams. What's important for us isn't the reiteration of the actual past, but the persistence of what never happened, but might have. My main collaborators at Chimurenga and on this project, Stacy Hardy, Bongani Kona, Graeme Arendse, Duduetsang Lamola, Ben Verghese, Dominique Malaquais and Akin Adesokan, are writers, artists, design-ers, DJs. So music, speculative cartography, fiction are all valid tools to advance research work. The other thing is that in long-term research such as this, we have to integrate our everyday activities – for instance, we published an edition of the *Chronic* in 2015 that examines divisions between North and sub-Saharan Africa, which was a central and divisive issue at Festac '77.

This is the paradox of Festac '77. Some of our most important writers, artists, thinkers participated – 17,000 at official count. Many of them speak of it as a paradigm shift, one of the most impor-tant events they've attended. The impact of the event is somewhat visible in their artistic and political choices, yet it seldom appears as a full story. Audre Lorde and Jayne Cortez published poems, Wole Soyinka wrote an essay, and the event appears in a few memoirs. This intrigued me – the people who experienced Festac '77 seemed unwill-ing to write it, as if bound by an unspoken nondisclosure agreement. And so its stories circulated in the manner of a family secret – a family of millions of people.

On the other hand, there are at least 40 music albums about Festac '77. It refuses to be written, it resists analysis, but it's spoken, sung and performed on record more widely than any other event I've researched. So our primary archive was never hidden – it was the dispersed recordings produced by the likes of Orchestre Poly-Rythmo de Cotonou, Gilberto Gil, Tabu Ley Rochereau, Syli Orchestre National, King Sunny Adé and many more. Together, these LPs consti-tute a sound-world in which the memory of Festac is as active as it is missing in print.

Working through sound requires an embrace of opacity: there's always too much information – and never enough. I think it helps to feel surrounded by the sound, to surrender, when attempting to write stories too big, too personal, to be perceived in their fullness. Indeed, some stories are bigger than storytelling. Black music is not only the largest and most sophisticated archive at our disposal, it's also an efficient laboratory for the rebuilding of archives that are primarily inscribed in bodies.

We wanted to tell stories of Festac '77 through those who partici-pated. But it's practically impossible to determine who was there from official records. For example, a group of South African artists and activists led by the writer Molefe Pheto travelled to Nigeria unin-vited and without visas. At the Lagos airport they were welcomed as 'Soweto revolutionaries' and let into the country – in fact, escorted to the festival village as VIPs. Their names don't appear in official docu-ments, but everyone else saw and envied them. Fortunately, Pheto likes to tell this story and it reached my ears via the curator Khwezi Gule.

Gathering these stories had to be collective and public work – this kind of crowd-sourcing also served as peer-review system. We would organise events and invite people who were rumoured to have been at Festac '77 to help to identify companions in the images we collected. It didn't always go well – in one instance some of his colleagues 'identified' the bass player William Parker in Marilyn Nance's extensive photographic documentation of the US delegation. I hurriedly wrote to Parker to request an interview, only to learn it wasn't him. But we thought he should have been at Festac and so he was!

Learning about who was there (or wasn't) became a way of producing an alternative history of our world, a way to learn about the influence of Cheikh Anta Diop in the shaping of cultural policy in post-independence Gabon; or the struggles by the likes of Ngũgĩ wa Thiong'o and Micere Mugo to produce a national theatre in Kenya; or to wonder how on earth the Sun Ra Arkestra found themselves on a plane bound for Lagos, alongside the feminist poet and warrior Audre Lorde, the modernist painter Beauford Delaney, and Louis Farrakhan of the Nation of Islam. Just imagine! Mind-boggling stuff.

KS Why, and at what point, did Toni Morrison's *The Black Book* become the inspiration in terms of method of presentation for your book on Festac?

NE Initially we imagined the book as a collection of essays to be edited by Akin Adesokan and myself. We produced a few drafts of this book, but none felt right. There was no music, and the people were left out. Another project had begun to take form in our minds – a publication that could be heard as well as read. A book that would represent the array of verbal and visual texts we'd received from our elders – the spoken anecdotes, newspaper reports, essays, advertisements, music sheets, posters, diary pages, artworks – and the stuff we'd made up.

Stories would have no beginning or end; everyone would be speaking at the same time and in their language. It would be polyvo-cal, polyglot, polyrhythmic and many more plurals; it would demand close listening. It would have no chapters or sections; it would begin wherever the eye falls. It would have many contradictions. It wouldn't distinguish between new writing and older material. It would present each story as an invitation to produce more stories. Some stories

would include a byline, others not; some pages would be numbered, others not. There would be a system, but it would be as unpredictable as the cataloguing of a private jazz collection, or read in all directions like Dumile Feni's scroll. It shouldn't feel precious but everyone should want to keep it – it should rest on the kitchen table with the family photo album. Every Black person should recognise something in it – anything – and read from there. Everyone else can join in too, but they must know when to leave. It should be read in groups. No one should be able to read it entirely – unless they speak at least nine languages. This book could only be made by many hands, page by page.

Encountering Toni Morisson's *Black Book* was a revelation. It was a blessing. She'd produced it in 1974 to tell the story of African Americans over three centuries. *The Black Book* is a mystery, so perfectly choreographed that everything feels random. All the cues are buried in the reader's own mind. We sat by her feet and learned to play jazz. We had to give up on the possibility of all connections being meaningful and understood; some just had to be felt. Where would we feature Jayne Cortez's poem on Nigerian-American relations? Would it go with the report on the 1973 oil crisis in *The Black Panther Intercommunal News Service* – a crisis that enriched Nigeria and made Festac '77 possible? Or would it sit near Ama Ata Aidoo's story of meeting Cortez at the food queue in the Festac Village?

KS How far do you see Festac's tentacles stretch, both in terms of how it shaped ways in which the arts could be mobilised towards liberation (with particular reference to South Africa) and in how it reshaped diasporic connections years into its future?

NE Nigeria's involvement in the anti-apartheid struggle is well documented – the Pan Africanist Congress (PAC) had an office in Lagos since the 1960s. And in the aftermath of the June 16 uprisings, Tsietsi Mashinini and his Soweto Students Representative Council comrades were hosted by the Obasanjo government. Thabo Mbeki was then deployed to Lagos to woo the Nigerians, with his first task being to lead the ANC delegation at Festac '77. The South African liberation movement was there in its fullness – PAC chief diplomat David Sibeko was there; ANC President Oliver Tambo dropped in for the closing ceremony.

The festival took place in the middle of the war that some historians describe as 'cold', but which was very hot in these parts. The Chimurenga struggle was intensifying in Zimbabwe and civil war was ongoing across the white redoubt in Southern Africa, instigated, of course, by the apartheid regime. The inauguration of Jimmy Carter as US president took place a week into Festac '77, and he immediately dispatched his UN Ambassador Andrew Young to Lagos, who did his best there to avoid Agostinho Neto, the leader of socialist Angola. There are photographs in which the VIP section looks like a seating of OAU general assembly. Festac '77 was definitely a space for palace-political work.

But major political moves also took place on the performance stage. For instance, Mbeki managed to unite a cross-generational group of South African artists and ANC activists behind a single project led by the composer and trombonist Jonas Gwangwa – a dramatisation of the recent June 16 events featuring music, dance, poetry and popular theatre. The success of this performance led to the formation of the Amandla Cultural Ensemble, a powerful, roving organ for mobilising international support for the struggle the following decade. The Medu Art Ensemble was also founded by Festac '77 alumni, and the Culture and Resistance Conference, which they organised in 1982, was modelled on the Lagos festival. All of this led to the establishment of the ANC's department of arts culture. This is just a brief outline to indicate the immediate repercussions of Festac '77 on the South African liberation movement. One could argue that the event was similarly influential for many participating groups and countries.

By declaring itself a 'Black' country in its constitution of 1804, Haiti changed the rules – a republic could be Black, just as western liberal democracies assume their whiteness. The emergence of continentalism at the Pan African Conference of Manchester in 1945, which culminated with the founding of the OAU ('Seek ye first the political kingdom', as Nkrumah famously put it), allowed many African leaders to sidestep this issue. Post-Biafra Nigeria reimagined itself as a Black state for the time of a festival – the experience of Black people from all over the world gathered in Lagos for a month, without White approval or supervision, cannot be underestimated. Consider this: Festac '77 facilitated the symbolic and temporary return of the largest number of Black people to the continent. And so the burning question was: is this a festival of people or a festival of states? In other words, is it the second Fesman (Dakar) or the second Panaf (Algiers)? Senegal, for example, threatened to boycott the festival if North African countries, 'Arabs', were invited. This was a conundrum that Nigerian writer Wole Soyinka characterised as 'saline consciousness' at the Festac Colloquium – the belief that everything that's bounded by sea water on the continent is necessarily African, and that everything outside it is not. As a compromise, the festival had to be renamed 'World Black *and* African Festival of Arts and Culture', to include the North Africans.

But the issue simply wouldn't go away. Brazilian activists confronted their government – why were so few Black artists, intellectuals and organisations in their country's delegation? Sudanese intellectuals asked, what of 'Black *and* Arab'? Indigenous Australians claimed they were neither Black nor African and departed shortly after the opening ceremony. People took these questions home to reshape cultural politics and, in cases like Brazil, Cuba, Australia and others, to initiate a national debate on race.

The question of 'national culture', anticipated by Frantz Fanon in the *Wretched of the Earth,* also raised its head at Festac '77. Before the festival, only a few African states had established national cultural institutions beyond what was inherited from the colonial state. Gabon's National Theatre, Zaire's National Ballet and Cameroon's National Orchestra, for example, were founded in preparation for Festac '77. This brought intellectuals and artists face to face with the state in irreversible ways. Festac '77 became the platform on which the old confrontation between poets and politicians would take place – and between both groups and 'the people'.

Kenyan writer and academic Ngũgĩ wa Thiong'o was detained in Kenya during Festac '77, even though his play, *The Trial of Dedan Kimathi,* written with Micere Mugo, was presented at the festival by the very government that imprisoned him. Togolese writer Yves Dogbé was jailed and tortured for a speech he *planned* to give at the Festac Symposium. The Ugandan playwright Byron Kawadwa was killed by Idi Amin's goons for his piece at Festac '77. Sadly, there are many more examples.

Typically, Nigerian musician and activist Fela Kuti took this opportunity to organise a 'counter-Festac' at his club, the Shrine, in which everyone was invited to berate the Nigerian military government at will, as well as their own. A week after the festival, the Nigerian police responded with full force, destroying Fela's home and killing his mother.

By using the famous Benin ivory mask 'Head of Queen Idia' as the festival emblem, and making an official request for its return from the British Museum, Festac '77 politicised the question of restitution of African artefacts held in western institutions. Faced with British refusal to return the loot, the Nigerian government then commissioned the descendants of the original carvers to produce new versions of the mask, based on photographs of the mask held in Britain. Another wicked twist in the tale of Dr Satan's Echo Chamber.

Johannesburg, May 2020.

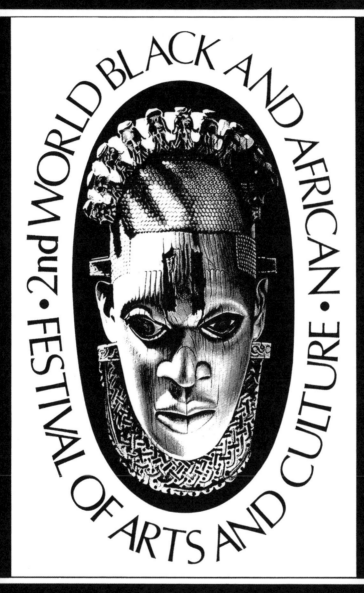

festac '77

2nd WORLD BLACK AND AFRICAN · FESTIVAL OF ARTS AND CULTURE ·

NIGERIA
LAGOS · KADUNA
15th JANUARY – 12th FEBRUARY 1977

Pages 119–129: Excerpts from the book *FESTAC '77: The 2nd World Black and African Festival of Arts and Culture*, a publication by Chimurenga, published by Chimurenga and Afterall Books, in association with Asia Art Archive, the Center for Curatorial Studies, Bard College and RAW Material Company, 2019. Courtesy of Chimurenga.

Ntone Edjabe in Conversation with Kwanele Sosibo

1. Political Imaginaries

The Battle of the Mask

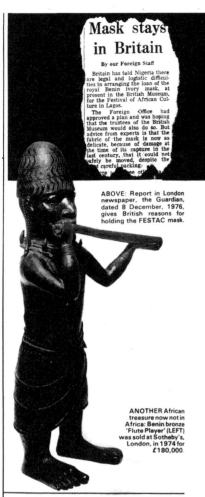

ABOVE: Report in London newspaper, the Guardian, dated 8 December, 1976, gives British reasons for holding the FESTAC mask.

ANOTHER African treasure now not in Africa: Benin bronze 'Flute Player' (LEFT) was sold at Sotheby's, London, in 1974 for £180,000.

Nigeria has been trying to recover from Britain the 16th century ivory mask (BELOW) which has been adopted as the FESTAC emblem. Britain says cannot give it back. DRUM reports

A DIPLOMATIC row is likely between Nigeria and Britain over the British Museum's refusal to lend the Benin Mask to the second World Black and African Festival of Arts and Culture which is staged in Lagos next month. The 16th century ivory mask is the festival's emblem.

After the Nigerian Observer had reported that the British Museum had agreed to lend the mask to FESTAC, the museum issued a statement saying that due to the mask's physical condition, they had ruled out its loan to Nigeria or anywhere else.

The mask, which was worn by Benin kings at coronations, has emerged as one of the finest examples of African art. It was first worn by King Overamwen, who was deposed at the fall of the Benin Empire in 1897.

Nigerian historians say that the mask was removed in the same year by the British Consul-General of the Niger Protectorate, Sir Ralph Moor, and taken to Britain. The British Museum insists that the mask was bought from Professor C. G. Seligman, a private collector, in 1910.

The Nigerian Government's request for certain bronze objects from Benin which are also in the museum is under consideration, says the museum.

The mask is exhibited in a glass case at a controlled temperature. The tiara formation at the crest of the mask is made of ten stylised heads and symbolises the king's divine supremacy and sovereignty. The two incisions on the forehead, which were originally filled with iron strips, are royal tattoo marks. Round the neck, the artist has carved the coral bead collar which is a common feature of the king's paraphernalia.

The ivory mask is one of a set of four. Two others are in private hands in the United States and Britain, and the third is in the Museum of Primitive Art in New York.

Many European colonialists have over the years taken away several hundred priceless African art objects as souvenirs. Ten years ago prices for African antiques escalated in Europe and the United States, and items changed hands for hundreds of pounds.

African governments are committed to retrieving and maintaining their priceless heritage. While they have been negotiating for the restitution of some collections in museums in Europe and the US, some African governments have committed themselves to buying back valuable pieces when they come up for sale.

The Asante Traditional Council recently bought a gold embroidered cap which had belonged to King Kofi Kalkari for £2,250 at an auction at Christie's in London. The Nigerian Government, which purchased some Benin bronzes from the British Museum during the 1950s, has continued to buy unusual pieces when they become available.

By contrast, in Uganda, Milton Obote ordered the destruction of all kings' regalia when he overthrew monarchy in 1967. Regalia, which included crowns, thrones, drums and robes used by four kings — some dating back to the 15th century and worth millions of Uganda shillings — were burned in broad daylight.

Other important African antiques exhibited at the British Museum include the Asante golden stool used by Asante kings — which Ghana has asked to be returned but without any success, a bronze figure of a hunter from Benin, the 16th century bronze head of a Queen Mother from Benin, and a 13th century brass head representing an early Oni of Ife excavated at Ife in 1938.

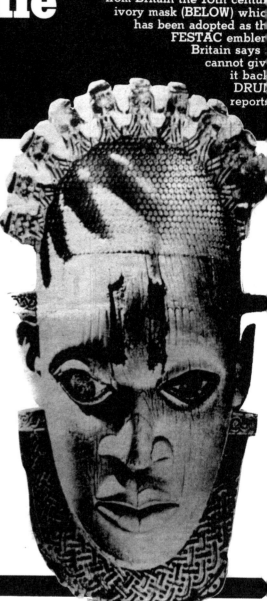

UK will not lend treasure

By PETER HILLMORE

The British Museum denied a report yesterday from Lagos that it has agreed to lend the Nigerian Government a priceless 16th century Benin mask. The mask is the emblem for the World Festival of Black and African Arts and Culture, to be held in Lagos in January.

The Nigerian Government has also been demanding the permanent return of the mask, which was taken from the ancient city of Benin during a punitive British expedition in 1897. The ivory mask was worn by the kings of the Benin kingdom.

A statement by the British Museum said the Lagos report came as a surprise, and the mask could not be lent "on conservation grounds alone."

The Museum also said it could not return the mask to the Nigerian Government, under the terms of the British Museum Act. A change in the law would be required and, as a spokesman explained, "the trustees of the Museum are not pressing for a change." He said that negotiations were going on with the festival organisers for the possible loan of three other masks from Benin.

The dispute about the emblem for the Second World Black and African Festival of Arts and Culture is only one of the problems facing the organisers. The festival was originally meant to have been held in 1970, but the Biafran war prevented this. The second date was December, last year, but after the overthrow of General Gowon, the new rulers postponed it to the new date, January 15 to February 12, 1977. After the change of government, the new rulers also uncovered a financial scandal about the festival's cost.

The scale of the programme has been reduced, but it still looks as if FESTAC will be a major cultural event. There will be 15,000 participants and a large number of exhibitions and musical events.





FESTAC WON'T BE BOGGED BY SYMBOL

Fingesi meets diplomats

THE FESTIVAL SYMBOL won't be changed nor would its absence from Nigeria affect FESTAC programme, Commander Promise Fingesi declared yesterday.

"Whether or not the mask is released, as far as we are concerned, the festival will go on," he added.

The decision to use the ivory mask now in London was taken by the International Festival Committee of FESTAC.

And the committee had no intention to change its decision, Commander Fingesi told a special meeting of representatives of foreign countries in Nigeria.

He, however, informed them that diplomatic moves had been intensified by the government to retrieve the mask.

"It makes no difference if it is not released, any way" he added.

The ambassadors were told that Nigeria considered the festival "a momentous event of our time."

Apart from its uniqueness, he said, the objectives which the nation had before could not be taken lightly by anyone associated with the festival.

He went on: "In addition to the great objectives, this festival has a characteristic uniqueness. This can be visualised in terms of its effort to incorporate all heterogeneous human elements identifiable to the black and the African world as well as all peoples of the world with African heritage."

A festival of such magnitude, he said, was bound to reflect certain complexities and certain manageability problems.

"However, every effort will be made in spite of certain problems and difficulties to ensure that this festival is a resounding success," he said.

So far, 42 countries had paid up their registration fees for the festival. This number was made possible by Upper Volter which had just sent in her fee.

He said a number of other countries had also indicated their desire to pay within the next few days.

In terms of entries for events, exhibition and colloquium. Commander Fingesi said representations have been very encouraging.

IT CAME to me as a "shock" as the front page of the Sunday CHRONICLE of October 24, 1976 made known that the Benin Ivory Mask, the chosen approaching FESTAC '77 may not leave the British Museum for the festival in Lagos.

The two reasons said to have been given by the first Secretary Information at the British High Commission in Lagos are:

(1) that "the British Museum is controlled by trustees appointed under the Museum Act of 1963 and does not receive instructions from the government. For this reason the British Government is not in a position to simply order the return of the mask to Lagos for the FESTAC".

(ii) that "the Ivory mask is extremely fragile. It is maintained in the British Museum in condition of meticulously controlled temperature and humidity. No one can ascertain its possible reaction to a change in climate and jolts of a long journey down here".

For students of history, it could be recalled that the Ivory Mask was among the 2,500 Ivory and Bronze booty of the British raid on Benin Kingdom, some months after the Bini Massacre of 1897.

Acting Consul General Phillips had arrogantly decided to visit Benin without waiting for approval and in defiance of the Order by the Oba's messengers who told them not to enter Benin until after the great Igue festival during which the Oba was not to receive any man who was not a Bini. Well, what his arrogance and disregard for Oba Overamwen's order earned him, is in the pages of history.

Britain Should Return Its 'Booty' For FESTAC

by
F. J. EKAIYAH
University of Calabar

It was then that the more powerful Britain, in an act of aggression Overran the Kingdom ostensibly to " civilise" the Binis. But it has become clear that not only did they have an eye in the destruction of those Africans who refused to be subservient to the British, but were envious of the rich Bini cultural artifacts, thousands of which became their loot.

Now, Nigeria, the rightful owner of this Ivory Mask is requesting Britain to allow her the use of the mask strickly for the World Black and African Cultural Festival (FESTAC), but Britain is on the way to refusing!

I am not at all satisfied with the weak reasons given for the failure to return the mask.

What Mr Christopher Denne means by the mask's "reaction to a change in climate and jolts of long journey" eludes my understanding. Surely he does not want to tell us that the hot, humid, tropical, climate of Nigeria's Lagos will come to damage the mask. Does he? The mask was made in Nigeria and not in Britain.

The mask survived years under this hot humid condition without damage. How then is it possible for it to be damaged during the festival? If changes in climatic conditions were to adversely affect the mask it would have been the 'British Type' which is far from the climatic condition of the mask's "home".

And what ever "meticulously controlled temperature and humidity", the mask is maintained in Britain, must be a micro-tropical climate created to suit this tropical mask. The mask is coming back to its natural tropical climate to remain for a few weeks and would not even need such micro-climate.

The question of its reaction to a long journey is another point to think of. One might like to ask whether Britain is longer in distance now than it was in 1897! If there is no geographical cum historical proof that this has happened within the past 79 years (1897 — 1976), I see no reason why the mask could travel from Benin, under the careless hands of those marauding British troops, to Britain in that unfortunate period, but cannot travel that same distance under the extremely careful hands of Nigerians and with today's much improved means of transportation, back to Lagos.

Hence I see these reasons as deceptive and Mr Denne should know that Nigeria is not in for a play of politics of deception and diplomacy.

I feel that what Mr Denne would have told the press, of which he was sure would be relayed to the public, would have been his first reason — that "..... the British Government is not in a position to simply order the return of the mask to Lagos for the FESTAC".

That to my own opinion, alone, would sound better, afterall most Nigerians would not be surprised to have such an answer from Britain.

I am therefore using this media to appeal to the Federal Military Government to use all available means to see the need of returning this Symbol of the widely publicised FESTAC, for display during the festival.

The BM may lose its loot

by PEARSON PHILLIPS

THERE'S a little yellow idol to the West of Russell Square that could put the evil eye on some delicate areas of diplomacy in the coming months.

The 81 non-aligned nations who have a summit meeting in Colombo, Sri Lanka, next August, are said to be going to resolve that cultural and historical treasures allegedly spirited away during the brash hey-day of Imperialism should be returned.

At the top of Sri Lanka's own list of missing desirable artifacts is the delicious, buxom, twelfth - century bronze idol, the Bodhisattra Tara, currently occupying a privileged stand in the British Museum's oriental section. She is likely to be something of a test case. Animated by a burgeoning desire to illustrate their cultural past, other members of the non-aligned group are compiling their own lists.

The British Museum has adopted a posture of inscrutable silence in the face of this threat which, if logically pressed home, would strip the Museum's shelves and showcases almost bare.

It shelters behind section 3, sub-section 4, of the British Museum Act 1963, which says that 'objects vested in the trustees as part of the collections of the Museum shall not be disposed of by them. . . .' There would have to be fresh Acts of Parliament before a single item left their collection, unless it was an exact duplicate of something already held, or was 'unfit to be retained.'

When nations have asked for their treasures back before the British Museum's trustees have refused to budge. The case of the so-called Elgin Marbles from the Acropolis, Athens, is the best-known example. But in recent years there has been a slight change in the situation.

The growth and expansion of the Museum exactly mirrored the growth of the Empire. From 1823 the Bloomsbury premises were stocked and extended with the gifts of eminent soldiers, administrators, missionaries and scholars.

The Tara bronze is a typical case. She came from Sir Robert Brownrigg, an Irish professional soldier who was sent to govern Ceylon in 1811. At that time the British controlled only a few settlements on the coast. The King of Kandy held the interior

Sir Robert collected a force, defeated the King, annexed his kingdom, and sent the royal throne, sceptre and orb back to Britain.

The regalia was handed back to Sri Lanka before independence. But the Tara bronze, 'found near Trincomalee' as the Museum catalogue puts it, and presented by Sir Robert in 1830, remains.

The steam behind the non-aligned countries' proposed resolution is a growing taste among their members for objects which demonstrate a pre-colonial cultural heritage they can be proud of.

A leader in the field is President Mobutu of Zaire, who has denounced the 'thieves' who denuded his country of works of art (most of it ended up in Brussels).

The second Black and African Festival of Arts and Culture (Festac 77) due to be held in Lagos, Nigeria, next January is a manifestation of the same mood. It will help 'the black man feel an instinctive and spontaneous pride in belonging to a race which possesses a rich cultural heritage, some of which has been purloined and exhibited in museums all over the world.'

The Nigerians react most bitterly about the Benin bronzes and other art works, 2,500 of which were brought to Britain after the burning and sacking of the old city of Benin by a punitive expedition in 1897.

The British Museum has a fine collection of these bronzes, including a seventeenth-century plaque ('presented by the Foreign Office 1898'). But of most current interest to Nigeria is the sixteenth - century ivory mask worn by the Benin kings on ceremonial occasions. This was mysteriously acquired by the consul - general of the Niger Coast Protectorate, Sir Ralph Moor, in 1897. It can be seen on exhibition in the Burlington Gardens Ethnography Department of the Museum.

Ironically, this piece has been chosen as the emblem of Festac '77. The city of Benin has its own small museum, but most of the exhibits are copies bearing the legend 'Original in the British Museum.'

(right margin, vertical text:) Ntone Edjabe in Conversation with Kwanele Sosibo 1. Political Imaginaries


After checking out the art exhibits of all the nations represented in the National Theatre, I kept coming back to the works of Malangatana Ngwenya. Everywhere I went afterward I told people that I wanted to meet the monster artist from Mozambique named Malangatana, because I really dug his concept of man as a natural force, and his ability to deal with Western techniques within an African sensibility.

We were introduced in the National Theater by an Oriental man from Mozambique who said Malangatana was looking just as hard for me. Malangatana and I got along well and we spent the next three days together. By day we attended art exhibits where he would explain the Africanness of form, the political implications of symbols and icons in each picture, while I did the same from my background; at night we would do drawings for each other talking of the similarities and differences in line and rhythms to better understand each other's strokes. Despite being an artist of international reputation and minister of culture for Mozambique, he is one of the warmest people and one of the best teachers I have ever had the privilege of knowing. At the end of this learning encounter, we gave each other several drawings. I am sure on both exchanges, that I got the best of the deal. Thank you, Malangatana

- Nelson Stevens

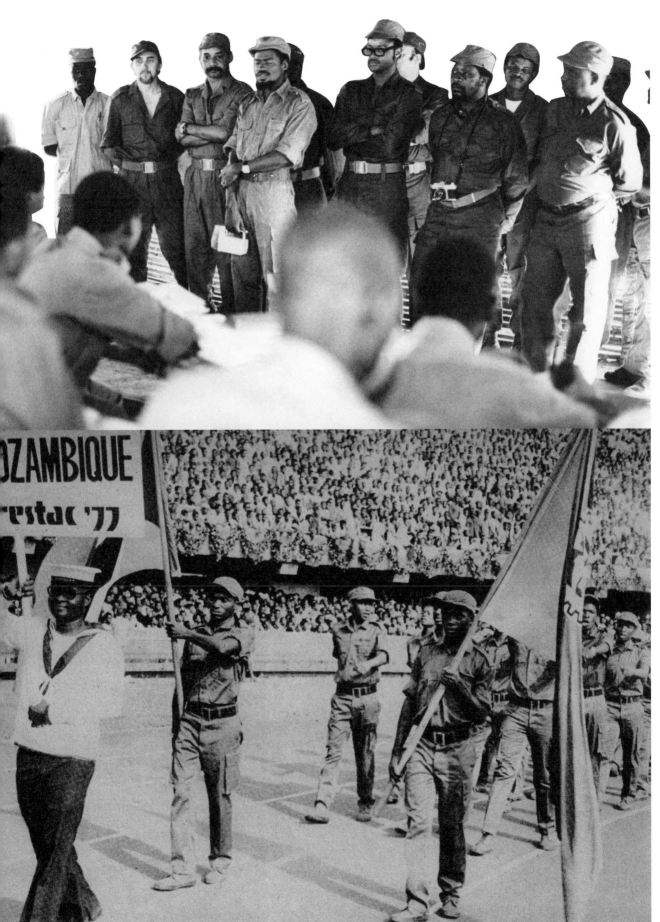

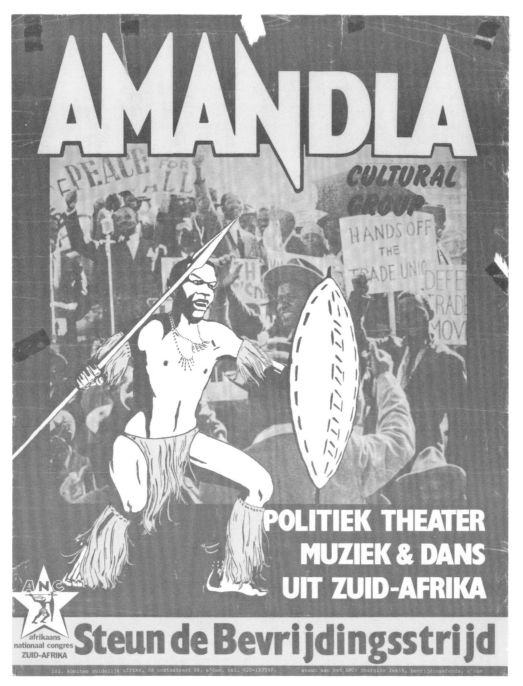

**POLITIEK THEATER
MUZIEK & DANS
UIT ZUID-AFRIKA**

afrikaans
nationaal congres
ZUID-AFRIKA

Steun de Bevrijdingsstrijd

inl. komitee zuidelijk afrika, da costastraat 88, a'dam. tel. 020-183598. steun aan het ANC: postgiro 26655, bevrijdingsfonda, a'dam

By RICHARDS MWANZA

AMANDLA-in the South African language of Zulus - means "power is ours" and the visiting African National Congress cultural ensemble lived up to their slogan when they stormed Ndola's Hindu Hall last week.

The ensemble proved to a packed audience that they were a "rare" commodity both in their sketches and in music terms to earn several thunderous applauses from more than 700 fans who thronged the joint.

The touring troupe now on their last leg of the frontline states tour to rally support for the struggle against the South African racist regime revealed their determination of "Aluta Continua" in such cuts like "Songena", and "Siyalwa" which exposes the fighting spirit of the ANC.

"Malibane" was one among many tunes which sent the crowd wild when vocalist Ndonda Khuze, accompanied by a bevy of beauties tore the stage apart to show the group's militancy with a vow never to succumb to racist pressure.

"We are here to explain to our brothers and sisters the idea of our struggle in the African National Congress in order to liberate the oppressed majority in South Africa.

"We can only do this better through poems, drama, traditional dances and made to disclose the evil intentions of our enemy," said leader of the ensemble Actwell Malekeza.

The group, which is based in Luanda, has already been to Mozambique and Tanzania.

The group was formed in 1978 and since then, they have participated in the 11th Youth Festival in Havana, Cuba.

Mr Harry Chileshe drove into the city from luanshya with his wife. They were not able to see the performance because they could not buy any tickets.

Asked what made them arrive late for the show, he replied: "We didn't know that they had switched the venue to the Hindu Hall so we went to Lowenthal first and that was why we could not get to the place early enough."

Amandla impressive

THERE were mixed feelings of joy and sadness to the hundreds of people who turned up-to-watch the Amandla troupe of the African National Congress of South Africa giving their last show of their tour at the Diamond Jubilee Hall in Dar es Salaam on Monday night.

The performance, a combination of South Africa's traditional Ngomas of the Tsonga, Xhosa and Zulu tribes, poetry and revolutionary songs moved the audience. It was not a surprise when Vice President Aboud Jumbe who was the guest of honour could not

withhold his emotions and moved to the stage to shake hands with all the participants at the end of the show. And at the end of the show which seemed to have come too sudden, the troupe members were singing "Mandela...Mandela, the imprisoned ANC leader.

The most emotional incident was when the brutal South African police shot dead a nine-year old boy held on the arms of a comrade during the 1976 Soweto youth uprising while actor Ndonda Nkhuze broke down singing.

All in all, everyone in the audience praised the actors of

Amandla the Angola based ANC cultural group for their stage management, no nonsense time wasting, superb music, stage effect, choice of costumes and stamina, most of which could be copied by many Tanzania troupes.

At the end of the performance, the troupe's political Commissar — Comrade Attwell Magekeza told the audience of an escalating struggle by the masses of the Black people who are determined to destroy every facet of the oppressive apartheid system in South Africa.

We built this cultural ensemble from our base in Angola, which was associated with the military. This shows the dynamics. When we built that group we said: 'Where do we find the people who are sufficiently disciplined and organized?' We went to the military camps, where the culture of South Africa continued to thrive. The culture of liberation. The soldiers were writing liberation songs and liberation poems, motivating their military perspective through culture. Amandla was organized there.

– Lindiwe Mabuza

Amandla besöker Sverige:

Kamp mot förtryck i Saltsjöbaden

Eleverna i Saltsjöbadens samskola hade långväga besök i veckan. Det var kulturgruppen Amandla som kom för att visa Saltsjöbadseleverna ett stycke frihetskamp förmedlat med mycket sång, dans och musik.

Amandla som betyder makt är en grupp av ungdomar som flydde från Sydafrika efter händelserna i Soweto 1976. De ingår i ANC — African National Congress — en organisation som går i spetsen för, raskampen i Sydafrika. ANC har ett brett folkligt stöd i landet där fyra miljoner vita på olika sätt förtrycker den svarta majoriteten på 22 miljoner.

Förtrycket tar sig uttryck främst i åtskillnadspolitiken — apartheid — som innebär att de svarta inte har rösträtt eller fullständiga medborgerliga rättigheter, att de inte får bo eller arbeta i samma områden som de vita utan hänvisas till s.k. hemländer. Hemländerna är ofruktbara områden utan service eller kommunikation.

Följden av politiken blir att det råder stor barnadödlighet, hög arbetslöshet, stora löneskillnader och åsiktsmässigt förtryck av de svarta i Sydafrika.

■ I EXIL
Det är den verkligheten medlem-

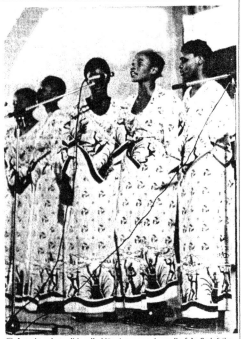

□ I starkt gula traditionella klänningar gav Amandla från Sydafrika ett smakprov på afrikansk kultur och frihetskamp.

□ Den populära Stöveldansen, har utarbetats av gruvarbetare i Sydafrika där den dansas mycket

marna i gruppen Amandla flydde från 1976, då flera av deras kamrater dödats i Soweto. Amandla lever nu i exil i bl a Tanzania och Zambia. Och har nyligen inlett sin första turné. Gruppen har besökt Tyskland, Holland, Norge och flera platser i Sverige bl a Samskolan i Saltsjöbaden.

De gav en förkortad version av sitt sång och dansprogram för fascinerade elever. I traditionella dräkter framfördes sånger, danser och kortare dialoger om hur kampen för frihet drivs framåt. Det var färgstarkt, suggestivt och medryckande, och säkert är Amandla mycket välkomna åter till Samskolan. ANNA LARSSON

AMANDLA (ANC CULTURAL GROUP) 'Amandla' (Melodiya Russian Imp)****

"OUT OF the crucible. Warrior army of a new age. Despising gas, batons, bullets. Defying centuries of slavery. Advancing without care on armoured cars. Striking metal with clenched fists. Warrior cry 'Amandla rising in every throat.

So begins this, in many ways, extraordinary record. A sonnet reflecting real-life struggle, the blood-chilling yet heartwarming stanza above is intoned, over a spiritual blues of trombone dimensions, by B Kagaole with the dignified delivery of a man who knows his cause is just and the solid resilience of one who will never give up his fight.

That fight is the emancipation of South Africa from the obscene tyranny and torment of apartheid. And it's an interesting fact that this message to us is delivered via Russia with love. Yeah, very interesting.

Since this elpee is probably the first Soviet pressed vinyl to be reviewed in, at least, Sounds, it would be tempting to dwell on this facet. But to do so would denigrate the important work of the artists involved.

So, before they reach for their poison pens, let's pre-empt this mag's Russophobes and say save it, scumbags.

'Amandla' means several things. It denotes 'Power' in the Zulu language. Given the repertoire of this outfit, that amounts to 'Power To The People'. And in this case, to coin Lennon, all one can answer is 'Right on!'

Cultural group of the outlawed African National Congress, whose main aim is the liberation of the horn of the Bright Continent from the bloated sickness of the Boers, Amandla the band are graced with musicians and singers who took part in the Soweto uprisings of '76.

Under threat of imminent long-term detention by the authorities, the artists fled the state-of-sin. Since then, with the guidance of trombonist Jonas Gwanga, Amandla have toured the Warsaw Pakt, Cuba, Scandanavia, and left-inclined African countries like Tanzania and Mozambique.

What the band offer are strongly emotive songs encompassing the broad sweep of styles which seep with tears and pride out of the townships. From raw jazz-inflected laments through Zulu jive to exquisite accapella flights. The tribal runnings are both affectionate and affecting.

Translated in Russian and English on the sleeve, the lyrics deal with the brutality of life for black people in SA and call for solidarity. They sweat reality, unlike some revolutionary rhetoric. The aroma of cordite and screams of innocents percolate from between the verses. Both frightening and positive.

This record is proof that politics and music mix well Indeed for the dispossessed like Amandla, guitars and voices are the most influential weapons for change available short of resorting to (justifiable, perhaps) murder.

America invades us with Cruise; the Soviets with music. Which would you choose? Makes 'Duck Rock' seem like the qwackery it is.

Distribution by Earthwork: 162 Oxford Gardens, London W10.

JACK BARRO

Literary shows and the missing 'giants'

AFRICAN Literature cannot be found only in books. This was proved during the readings and recitals of the literary shows which have just ended at the National Theatre, Iganmu, Lagos, when the audience was treated to a variety of activities. The performances ranged from poetic recitals and chanting, readings of short stories and excerpts from novels, to dramatic displays, music and dances.

Literary shows were some of the principal events organised for the FESTAC. There were two categories of shows. One was readings and recitals. The other, "Encounters".

★ ★ ★

The first category was no doubt aimed at providing a forum at which well-known black writers could get directly to the audience and people for whom they are writing. In this way, Africa and her black brothers and sisters would not only be brought to an awareness of their rich cultural heritage but would also be made to realise the need for more creative artists.

The second programme, "Encounters", was an informal symposium in which a panel of five writers a day have been holding discussions on different topics on Black Literature. The discussions were opened to the public. The "Encounters" began on February 3 and will be wound up today.

✿ ✿ ✿

Many representatives were present at the literary shows to do their countries and the black world as a whole, proud. Notable among them were Lenrie Peters of Gambia, Kofi Awoonor Amata Aido from Ghana, Sikhe Gamara from Guinea, Jayne Cortez from the USA, Issa Traore from Mali, Karanta from Niger, Dobru from Surinam, Ted Joans from the UK and Zulu Sofola from Nigeria. Some writers who were unable to attend the shows were represented by some delegates. Some of such writers were Agostinho Neto of Angola, Sekou Toure of Guinea and Senghor of Senegal.

The subjects dealt with transcended all boundaries. The startling similarity of the themes depicts not only the fact that all the blacks have a common colonial experience but also that they are spiritually united.

The poets did not forget their suffering brothers. In Jayne Cortez's poem "SOWETO", for instance, she congratulated the black citizens and owners of Soweto and encouraged them to continue their fight for freedom.

Ted Joans of the UK zone read about seven poems. Although some of the poems dealt with general contemporary issues, they all had black overtones. He stole the show during his recital. The thrilled audience beamed with

By CAROLINE NWANKWO

pride and nodded and clapped with great applause as he read his poems. When he was leaving, he was mobbed and was not freed until he made a promise to read again. Two of his sensational poems were "The Nice colored Man" and "The Reward".

In "The Nice colored Man", Ted pawns with the word Nigger.
"Nice Nigger Educated Nigger
Never Nigger Southern Nigger
Clever Nigger Northern Nigger Narty Nigger
Unforgettable Nigger......
Black Ass Nigger Half White Nigger
Big Stupid Nigger Big....
Nigger Real Nigger Brave......"

In this poem in which "Nigger" is repeated every other word, Joans invests 'Nigger with both good and bad qualities. He has chosen the word 'Nigger' because he knows that it is one of the words to which the Blacks are most sensitive. By abusing the word 'Nigger' he urges the Blacks to be thick-skinned to any derogatory term. He will not want the Blacks' progress to be interrupted by any foreign inferences.

In his other poem, "The Reward" Joans recounts the experience of the black people born outside Africa. Where they cannot return home physically he urges them to return spiritually, intellectually and materially.

✿ ✿ ✿

Joans is a painter poet, jazzman, traveller. Joans has been to all parts of the continent, and travelled round the world reciting his poems. He has published many poems, including "A BLACK POW-WOW OF JAZZ POEMS". It must be remarked that all the well-known Nigerian poets, novelists and playwrights were conspicuously absent. The names of Chinua Achebe,

Wole Soyinka and Cyprian Ekwensi, used to advertise the programme drew a number of fans. Everyday, they showed up to listen to the beautiful voices of their idols but went back home disappointed. Not only were these authors physically absent, texts were nowhere to be found in the four walls of the Literature office.

Many questions are raised in the minds of the public. Were these writers ever well-informed of the Literary shows in which they were supposed to do their country proud? If they were, why would they have refused the call of the motherland in this life-time historical event? Many thanks should go to Lindsay Barret, Mrs Zulu Sofola, Abubakar Bamijoko, Lari Williams, Neville Ukoli and a host of others who came to Nigeria's rescue. They are young writers to be proud of.

✿ ✿ ✿

Some countries who did not present texts came out with dances and music. Some came with both. Swaziland came with two different dances. The first dance was the animal dance. They depicted the close relationship between the dancers and the animals. In the war dance, a tale of how they shook off the colonial cloak was enacted. Guinea, Senegal and Togo came with both texts and dances. As the Senegalese read poems, they reinforced them with dances and music. In that way they were able to sustain the audience's interest throughout their rather long performance.

Language is no barrier to Literature. Somalia produced two poets who wrote in Somali. Although some of those poems had been translated, they preferred to read them in Somali so as to retain the flavor and sweet melody of the composition. One of the poems "FESTAC" is specially devoted to FESTAC.

Prior to the Literary shows, one would hardly believe that the black world could boast of so many writers. Not less than five countries and 10 writers made presentations daily. Although the shows were supposed to end by 12.00 noon, no one ever stepped out of the Cinema Hall 11, the venue for the shows, before 2 o'clock p.m.

'AN ENCOUNTER' TO REMEMBER

THE Cinema Hall two of the National Theatre heated up as the "Encounters" began. Never since the beginning of literary shows had the hall witnessed such a large audience.

The topic for discussion was "Aesthetics of Black and African Literature." Sitting on the stage were members of the panel representing different black and African countries. Dr Kofi Awoonor was the chairman and sitting around him were Dr. Njoku of Nigeria, Professor Turner of the United States of America, Dr. Lenrie Peters of Gambia and Dr. Palmer from Ghana.

The chairman opened the symposium by listing some fundamental dangers that are inherent in the topic itself. Those he said are our present historical condition viz-a-viz our past our relationships within the total global situation which are defined by politics, economics and other factors, and our future goals and aspirations as writers who must express the reality and dreams of our people. He added that "no aesthetic system, as it naturally pertains to an artistic creation, escapes to constitute a comment upon the ideological condition or direction of the society with which it deals."

He noted that every aesthetic system has a political connotation and that had resulted to two clearly observable historical aesthetic systems — that created by the ruling classes and used as an instrument of oppression and that created by the people constituting as part of their own clear vision, as part of their aspiration towards that better world which it mirrors.

At this point Dr Njoku cut in. He wondered if at all one could hold to any aesthetic concept. What constitutes the beautiful? he asked. He said that a writer should be individualistic, he should be a genius and should be indifferent As far as he was concerned, whatever came out of a writer's creation in relation to the people is mere consequential.

Dr Eustace Palmer came up with his dynamism of aesthetics. "The concept of beauty is not static" he quoted He is of the opinion that since aesthetics encloses history and global situation, emphasis should not be on total rejection of Western values and their ideas of form and artistry He reminded the people that our traditional artists had their own concept of form and artistry. He then urged the modern artists to follow their footstep. He advised that since African aesthetics abounds in African culture and values, the ordinary people should be asked to give their own concept of beauty.

Professor Turner of USA does not believe in only one aesthetic. He advises black writers to use a style in which they can communicate well to their people. He noted with regrets that critics assumed that all or most Afro-American writers imitated the forms respected in Euro-American Literature. "Critics need to re-examine older Afro-American work to determine whether any of these reveals a previously unsuspected derivation from Afro-American Cultural styles and traditions," he pleaded.

As for language, he encouraged the use of any appropriate dialect irrespective of the language being labelled as colloquial or non-standard by traditional teachers.

Lenrie Peters came up with a broad definition of aesthetic. "Aesthetic does not stop at 'beauty'. He illustrated this fact with Benin mask. He said that although the Western world did not see the Benin Mask as a beautiful object, they recognised its aesthetic value and treasured it as a good piece of art. He observed that the African writer is in a dilemma because he is imposed with the adopted system of the Western World. "The African writer should not be put in a straight jacket" he stressed. He urged them to be creative and to produce work that is natural to

By Caroline Nwankwo

them. He regretted the fact that modern writers shy away from villages and thus from sources of original materials.

In rounding up, the chairman clarified and added some other points. He agreed with some panelists who subscribed to the idea that the writer be individualistic and also with those who said that the writer be chauvinistic. He said that any work of art should have both form and function. He rebuked the black writers and critics who have failed to come out with a definite form and thought pattern and accused them of being lazy.

The question of language was not neglected. Like Wole Soyinka, the chairman called for an adoption of Swahili. In this way, he said, authors will increase their number of readers. No opposition was raised.

Although no definite solutions were found as to the aesthetics of black and African literature, the discussion was stimulating and provoked a lot of questions and contributions from the members of the audience. I must say that the chairman's liveliness and brilliant approach contributed in sustaining the discussion which lasted more than three hours

Cyprian Ekwensi, ed. *FESTAC Anthology of Nigerian New Writing*. Lagos: Cultural Division, Federal Ministry of Information, 1977. x + 246 pages.

The Second World Black and African Festival of Arts and Culture (FESTAC) was such a well-ballyhooed extravaganza that one expects to find in the official monument to it the best available testimony to the literary vigor of Nigeria. As far as quantity and variety are concerned, one is not disappointed. The anthology contains a literary feast in eight courses that include poetry, fiction, and criticism among other genres.

In the preface the editor pertinently observes, "It is perhaps a sign of the 70s that more poetry is being written today than a decade ago," an observation borne out by the preponderance of poems in the collection. Predictably, a lot of the poetry is pedestrian, trite, or simply bad and often unabashedly imitative of earlier works.

The old masters who appear in person rather than by proxy include Amos Tutuola, Chinua Achebe, Ola Rotimi, John Munonye, Kalu Uka, Onuora Nzekwu, Emmanuel Obiechina, and Donatus Nwoga. Most of the contributors, however, appear in print for the first time. The anthology is meant to be a response to "the lonely cry of aspiring Nigerian Poets, Essayists, Critics and Novelists for an indigenous outlet," and it functions as an "olympic proving ground for future champions" as well as a forum for experimentation by established writers.

The only criteria employed in selecting entries are adherence to "the Black and African theme" and limited (or no) previous publication, not literary imagination or critical acumen. In practice the theme proves so elastic as to be virtually universal; and the material is only partially new; the attitudes and concerns therein are recognizably perennial.

The section on criticism is a catchall for different sorts of writings, including the highly speculative and, to me, spurious catalogue of "African [especially Yoruba and Igbo] Words in Bible and Quraan." The existence of the sort of connection suggested in the article between these African languages and Hebrew is tantalizing, and one hopes in vain for the disciplined linguistic and etymological reasoning that alone can validate the argument by the Reverend Modupe Oduyoye.

This section, however, also contains articles in which Donatus Nwoga, Emmanuel Obiechina, and Kalu Uka usefully advance the process of defining an African aesthetic. Examining such novels as *A Man of the People*, *The Beautyful Ones Are Not Yet Born*, *The Interpreters*, and *The Voice*, Donatus Nwoga observes that alienation is often an avenue of escape for the artist and social critic. It is not enough, he argues, that the writer realistically portrays a state of anomy; the practice of realism should transcend accurate description, and the writer's outrage should not be an end, but the material with which he midwifes a better society. Given the inchoateness of the new African societies, he continues, the African writer must not be content with "crying failure instead of supplying values."

Emmanuel Obiechina's "Politics in Some African Novels," excerpted from a forthcoming book, offers a persuasive political explanation for the moral confusion that permeates the African novel. He suggests that the modern African is in a quandary because of the asynchronous developments of social conventions and political reality. The importance of European political mechanics disrupted the old kinship-oriented relationships and their built-in sanctions, but their underpinning practices—"dashes" and bribes—continue. The writer's perception of his role in society is based on an a priori dichotomy between himself and the politician. Because the politician is prone to corruption, the writer assumes the role of the vigilant "custodian of moral conscience." Unfortunately, the analysis does not tackle the intriguing instances of writers who are also politicians or have been co-opted in various capacities into the circles of power.

Kalu Uka's "Drama in Nigerian Society" addresses itself to the linguistic and economic factors that Nigerian drama must accommodate to become truly national. While the multiplicity of mutually exclusive languages and the lack of an affluent middle class are generally accepted facts of Nigerian life, another thesis in the article is not and deserves the author's welcome assertion. In response to the Nigerian theater historians who have demonstrated a penchant for seeing "traditional drama" where no such thing exists, Kalu Uka debunks the construction of masquerades, festivals, and other such rituals as drama. These traditional elements, he says, are not yet drama, "but the huge legacy upon which drama may draw. . . . One should not mistake the promise of huge dividends . . . for the fulfilled formal fact."

On the whole, the anthology's greatest value is that it does something that FESTAC itself failed to do—offer all classes of people an opportunity to participate in the celebrations and thereby feel a part of the tribal gathering. A Sunday Nwakammu might have had to run the gauntlet of armed soldiers just for a glimpse of the favored few as they were chauffeured to the National Theater, but in

The anthology sponsored by the government and put together hastily by Cyprian Ekwensi in New York is so shoddily designed, so filled with errors, and so muddled in scope that no self-respecting artist will recommend it.

Femi Osofisan, *Nostalgic Drum*

the pages of the anthology he can hobnob with university professors and other members of the elite. As for the obviously indifferent overall quality and chaotic organization of the book, well, the editor candidly demurred on these points in his preface. His intentions are more populist and democratic than aesthetic.

I cannot, however, resist making these closing observations. Nigerian English literature can no longer be said to be in its infancy as it now encompasses as many as three generations. It has established certain traditions and standards that, I believe, must be taken into account by would-be writers and their mentors. The laissez-faire attitude adopted towards the pioneering writers by indulgent editors and publishers seems outdated and, therefore, untenable as an excuse for an editor's suspension of literary judgment. Because his editorial function was simply to assemble the entries and facilitate their publication, without benefit of copy editing or proofreading, the anthology too often reads like a practical joke at the expense of the bombast of the festival it commemorates. If the hope expressed in the preface is fulfilled and the anthology does become an annual publication it will certainly prove a boon to aspiring Nigerian writers; but I hope that the editor will consider the proposition that perhaps not everything written by every hopeful writer deserves publication.

Oyekan Owomoyela

OVERTURE [from Festac Cantata No. 4]

Ayo Bankole

The cantata was ready before FESTAC. I remember Ayo Bankole running around editing, correcting, re-typing, and re-printing so that the work will be ready for FESTAC. It was the actual performance of the cantata that was not ready for FESTAC. He had to put together an orchestra, a choir, and soloists.

It was not received with the kind of fanfare that we know works like that should get, but it started something great in Lagos. Classical music in Lagos had a very small but select group of connoisseurs. These were wealthy men who were members of The Lagos Musical Society, that later became MUSON. This was how great their respect was for what Ayo and the others like him did.

— Joy Nwosu

Choral Fugue [from Festac Cantata No. 4]

CHORUS [from Festac Cantata No. 4]

Bass Solo [from Festac Cantata No. 4]

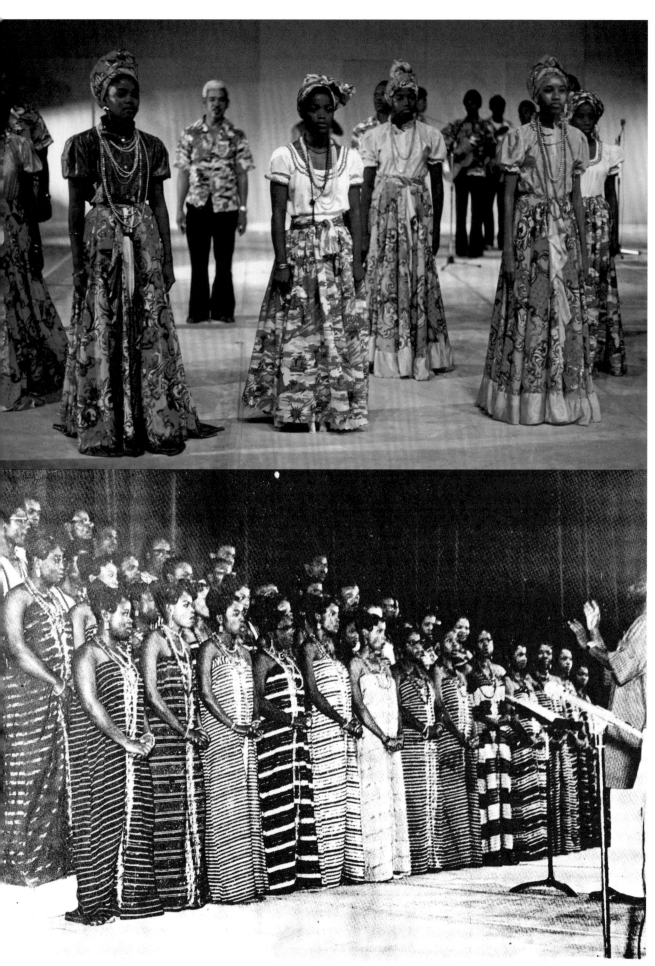

Ntone Edjabe in Conversation with Kwanele Sosibo

1. Political Imaginaries

Selected texts from IKON –
Creativity and Change
Second Series # 5/6.
A Special Double Issue:
Art Against Apartheid –
Works for Freedom, 1986

Alice Walker
The People Do Not Despair.
An Introduction to Art Against
Apartheid (1986)

The People Do Not Despair

An Introduction to

Art Against Apartheid

ALICE WALKER

I remember the afternoon that I became viscerally aware that millions of black human beings remain in slavery on this planet. A young black activist invited me to see some South African films about the lives of black women; he hoped, after seeing them, I would write a review. I said of course. Then I saw the films. I believe they were three: "South Africa Belongs to Us," "You Have Struck a Rock," and "Crossroads: South Africa." In each film I could see the incredible suffering of the people. See the pain and bewilderment of the adults, female and male, and the infinite devastation of the children. I saw the men forced to leave their families for work in the gold and diamond mines, then turn, often, to drunkenness in an effort to forget; I saw the women living in cells and closets at the beck and call of the white man and his woman and child day and night; everywhere I saw the children, playing in the streets, in garbage, eating whatever their frantic little hands found. They would grow up to replace their parents as workers in the mines and kitchens of South Africa. There was no other plan for them—except the Bantustans (i.e., "African Homelands") set up for "surplus" blacks by the white South African government. These "Homelands" made the urban ghettos look attractive. Barren, dry. No grass. No fields. Poor housing. Insufficient water. The kind of food, in other countries, reserved for livestock. The people in the Bantustans sagged as they walked: they understood they were "removed" to these places to rot.

I tried hard to hang on to the optimism inspired by the rebellious, singing women in one of the films as they refused to accept the pass laws for women in the 1950s, but my heart was reeling from the realization that my eyes were beholding modern day slavery and massive physical, spiritual and cultural genocide. I realized I was witnessing the destruction of the "Indians" of Africa.

I staggered home from these films and attempted to coordinate my thoughts sufficiently to approach my pen. I could not. I felt a terror and a sorrow and an anger that, for a period, nearly conquered my ability to respond positively to what I had seen. What I now, only too painfully, *and as a full adult*, understood: Slavery was alive. Genocide was not dead.

I never wrote reviews of the films. After a while, the young activist ceased to question me about them. I couldn't explain my inaction to him, either; I marvelled that he could show these same films, and others even more piercing, over

Selected texts from IKON – Creativity and Change Second Series # 5/6. *A Special Double Issue: Art Against Apartheid – Works for Freedom*, 1986

and over, many times a week, and remain among the sane. It was as if my soul had sustained a blow that sent reason into retreat. It was nearly a year before I could act in solidarity with the people of South Africa consistent with my dreams.

That first effort, too, I remember. I chose to introduce these same films to a large group of mostly white people ("hip" ones), in the village of Mendocino, near the valley where I live. Also on the program was a beautiful black sister from Oakland who had recently returned from South Africa where she was a guest of the African National Congress and had worked with several women's groups. Her name was Pearl Alice Marsh and she stood before us, the very model of black intelligence, commitment and womanhood, and her face, her voice, her confidence in the people of South Africa gave me the energy to also address the crowd. The people do not despair, she said. But how hard it was still to say to a room full of well-off and well-meaning whites that my people are still in slavery: give up your Kruggerands!

For the first time I felt what the black abolitionists of our country must have felt, even more overwhelmingly, as they toiled to raise white people's consciousness about slavery in the decades preceding the Civil War. I said a prayer of thanks to them for speaking out during even harder, more white dominated times than these. Like them, very much their daughter, as I felt myself to be that day, I managed, but afterwards I was thoroughly sick. One of my friends, a white woman, walked with me out to the cliffs overlooking the ocean and attempted to massage my headache away. The irony of this too seemed to make my headache dance.

I do not tell this story to invite either empathy or annoyance. Having lived through a period of brokenness, where South Africa is concerned, I now cheerfully and with full confidence in South Africa's future, function. In writing about that time I remind myself how fragile and humanly vulnerable we all are. Of how hard it sometimes is to confront what scares us to death—and to life. Like the other artists in this anthology I add my voice, my testimony, to the sometimes hidden, unexpected debilitation evil does in the world. But I know too, as they do, the restorative power of a sister's resolute travel and presence (bringing back both the message and the attitude), a brother's persistent work and voice, a comrade's attempt to heal. South Africa will be free because we are a people whose very "disabilities" have forced us to become able. And we have not forgotten our own tragic past enough to find rest acceptable while our brothers and sisters live it. These are two of the things I love most about us: they have been hard lessons, but maybe we truly are learning them.

Selected texts from IKON –
Creativity and Change
Second Series # 5/6.
*A Special Double Issue:
Art Against Apartheid –
Works for Freedom,* 1986

Audre Lorde
APARTHEID U.S.A (1986)
and *Sisters in Arms* (1986)

Audre Lorde
APARTHEID U.S.A.

New York City, 1985. The high sign that rules this summer is increasing fragmentation. I am filled with a sense of urgency and dread: dread at the apparently random waves of assaults against people and institutions closest to me; urgency to unearth the connections between these assaults. Those connections lurk beneath the newspaper reports of teargassed funeral processions in Tembisa, South Africa, and the charred remains of Baldwin Hills, CA, flourishing Black neighborhood leveled by arson.

I sit before the typewriter for days and nothing comes. It feels as if underlining these assaults, lining them up one after the other and looking at them squarely will give them an unbearable power. Yet I know exactly the opposite is true—no matter how difficult it may be to look at the realities of our lives, it is there that we will find the strength to change them. And to suppress any truth is to give it power beyond endurance.

As I write these words I am listening to the UN Special Session considering the 'state of emergency' in South Africa, their euphemism for the suspension of human rights for Blacks, which is the response of the Pretoria regime to the increasingly spontaneous eruptions in Black townships across that country. These outbursts against apartheid have greatly increased in the last 11 months since a new SA constitution further solidified the exclusion of the 22 million Black majority from the South African political process. These outbreaks, however severely curtailed by the SA police and military, are beginning to accomplish what Oliver Tambo, head of the African Nationalist Congress, hoped for in his call to make South Africa under apartheid "ungovernable."

So much Black blood has been shed upon that land, I thought, and so much more will fall. But blood will tell, and now the blood is speaking. Has it finally started? What some of us prayed and worked and believed would—must—happen, wondering when, because so few of us here in america even seemed to know what was going on in South Africa, nor cared to hear. The connections had not been made, and they must be if African-Americans are to articulate our power in the struggle against a worldwide escalation of forces aligned against people of color the world over; institutionalized racism grown more and more aggressive in the service of shrinking profit-oriented economies.

And who would have thought we'd live to see the day when Black South Africa took center stage on the world platform? As Ellen Kuzwayo, Black South African writer would say, this is where we are right now in the world's story. . . . Perhaps this is how Europe must have felt in the fall of 1939, on the brink. I remember that Sunday of December 7, 1941 and the chill certainty that some threat endured on my six year old horizon had been finally made real and frontal. August 6, 1945. Hiroshima. My father's tears who I had never seen cry before, and at first I thought

Selected texts from IKON – Creativity and Change
Second Series # 5/6. *A Special Double Issue: Art
Against Apartheid – Works for Freedom,* 1986

it was sweat—a 46 year old Black man in his vigor yet only seven years away from death by overwork. He said, humanity can now destroy itself, and he wept.

That's how it feels, except this time we know we're on the winning side. South Africa *will* be free, I thought, beneath the clatter of my waiting typewriter and the sonorous tones of the United Nations broadcast, the USA delegate, along with the one from Great Britain, talking their rot about what 'we' have done for Black South Africa.

South Africa. 87% of the people, Black, occupy 13% of the land. 13% of the people, white, own 85% of the land. White South Africa has the highest standard of living of any nation in the world including the USA, yet half the Black children born in South Africa die before they reach the age of five. Every 30 minutes six Black children starve to death in South Africa. In response to questions about apartheid from a white USA reporter, a white South African reporter retorts—'you have solved the problem of your indigenous people—we are solving ours. You called them indians, didn't you?' Apartheid—South Africa's Final Solution patterned after Nazi Germany's genocidal plan for European Jews.

We must learn to establish the connections instantly between consistent patterns of slaughter of Black children and youth in the roads of Sebokeng and Soweto in the name of law and order in Johannesburg, and white america's not so silent applause for the smiling white vigilante who coolly guns down four Black youths in the New York City subway, or the white policemen guarding the store of a Middle Eastern shopkeeper who kills three Black children in Brooklyn in a dispute over one can of Coca Cola.

Made more arrogant daily by the connivance of the US dollar and the encouragement of the US policy of constructive engagement, South African police jail and murder six year old children, kick 12 year old Johannes to death in front of his garden, leave 9 year old Joyce bleeding to death on her granny's floor. Decades of these actions are finally escalating into the world's consciousness.

How long will it take to escalate into our consciousness that it is only a matter of location and progression and time and intensity from the molotov cocktails that were hurled into brush in Los Angeles starting the conflagration that burned out Baldwin Hills, well-to-do Black neighborhood—53 homes gone, 3 lives. In California, USA, where the Aryan Brotherhood and the Order and the Posse Commitatus and other white racist survivalist groups flourish rampant and poisonous, fertilized by a secretly sympathetic law enforcement team.

Eleanor Bumpers, 66, Black grandmother, evicted from her Bronx New York Housing Authority apartment with two shotgun blasts from NYC Housing police.

Allene Richardson, 64, gunned down in her Detroit apartment house hallway by a policewoman after she was locked out of her apartment and a neighbor called the police to help her get back in.

It is ten years since a policeman shot 10 year old Clifford Glover early one Saturday morning in front of his father in Queens New York, eight years since another white cop walked up on Thanksgiving Day to Randy Evans, while he sat on his stoop talking with friends, and blew his 15 year old brains out. Temporary insanity, said the jury that acquitted that policeman. Countless others since then, Seattle, New Orleans, Dallas. This summer, Edmund Perry, 17, Black, graduate of exclusive white schools, on his way up via Stanford University and a summer job

in banking, judged by an undercover policeman's bullet in his chest. Our dead line our dreams, their deaths becoming more and more commonplace.

In 1947, within my memory, apartheid was not the state policy of South Africa, but the supposedly farout dream of the Afrikaner Broederbond. Living conditions of Black South Africans, although bad, were not yet governed by policies of institutional genocide. Blacks owned land, attended schools. With the 1948 election of the Afrikaner white supremacy advocate Malik and the implementation of apartheid, the step by step attack upon Black existence was accelerated, and the dismantling of any human rights as they pertained to Black people. Now, white South Africans who protest are being jailed and brutalized and blown up, also. Once liberal english-speaking white South Africans had to be conned into accepting this dismantling, lulled long enough for the apparatus which was to insure all white privileged survival to be cemented into place by H. Verwoerd, its architect and later, SA Prime Minister.

Now Johannesburg, city of gold, sits literally upon a mountain of gold and Black blood. After a Sharpeville, why not a Soweto? After a Michael Stewart, young Black artist beaten to death by transit police, why not a Bernard Goetz? After a New York Eight Plus, why not a Philadelphia, where the Black mayor allows a white police chief to bomb a houseful of Black people into submission, killing eleven people and burning down a whole Black neighborhood to do it. Firemen refused to douse the flames. Seven of those killed were children. Police pinned them down with gunfire when the occupants sought to escape the flames. Making sure these Black people died. Because they were dirty and Black and obnoxious and Black and arrogant and Black and poor and Black and Black and Black and Black. And the Mayor who allowed this to happen says he accepts full responsibility, and he is Black, too. How are we persuaded to participate in our own destruction by maintaining our silences? How is the american public persuaded to accept as natural the fact that at a time when prolonged negotiations with Arab freedom fighters can effect the release of hostages, or terminate an armed confrontation with police outside a white survivalist encampment, a mayor of an american city can order an incendiary device dropped on a house with seven children in it and police pin down the occupants until they perish? Yes, African Americans can still walk the streets of america without passbooks, for the time being.

In October 1984, 500 agents of the Joint Terrorist Task Force (see what your taxes are paying for?) rounded up eight middle-income Black radicals whose only crime seems to be their insistence upon their right to dissent, to call themselves Marxist-Leninists, and to question the oppressive nature of this US society. They are currently imprisoned, and being tried in a Grand Jury proceeding that reads like the Star Chamber reports, or the Spanish Inquisition. Twenty-two months of round the clock surveillance has so far not provided any evidence at all that these Black men and women, some grandmothers, were terrorists. I am reminded of the Johannesburg courts filled with cases brought against Black clericals and salesgirls accused of reading a book or wearing a t-shirt or listening to music thought to be sympathetic to the African Nationalist Congress. Two years hard labor for pamphlets discovered in an office desk drawer. How is the systematic erosion of freedoms gradually accomplished?

What kind of gradual erosion of our status as US citizens will Black people be persuaded first to ignore and then to accept?

In Louisville, Kentucky, Workman's Compensation awards $231. weekly disability payments to a 39 year old sanitation supervisor, white, for a mental breakdown he says he suffered as a result of having to work with Black people.

A peaceful, licensed march to the Haitian Embassy in New York to protest living conditions on that island, and the imprisonment of three priests, is set upon by New York City mounted police and trained attack dogs. Sixteen people are injured, including women and children, and one man, struck in the head by hooves, may lose his eye. The next day, no major newspaper or TV news station carries a report of the incident, except for the Black media.

In New York, the self-confessed and convicted white ex-GI killer of at least six Black men in New York City and Buffalo is quietly released from jail after less than one year, on a technicality. Christopher had been sentenced to life for 3 of the murders, and never tried on the others. White men attack 3 Black transit workers in Brooklyn, stomping one to death. Of the three who are tried for murder, two are sentenced to less than one year in prison, and one goes scot-free. So the message goes, stock in Black human life in the USA, never high, is plunging rapidly in the sight of white american complacencies. But as African Americans we cannot afford to play that market; it is our lives and the lives of our children.

The political and social flavour of the African American position in the 80's feels analogous to occurrences in the Black South African communities of the 50's, during the postwar construction of the apparati of apartheid, reaction, and suppression. Reaction in a large, manipulated and oppressed population, particularly one where minimal material possessions allow a spurious comparison for the better to one's neighbors—reaction in such a population is always slow in coming, preceded as it is by the preoccupation of energies in having to cope daily with worsening symptoms of threatened physical survival.

There has recently been increased discussion in the African American community concerning crime and social breakdown within our communities, signalled in urban areas by highly visible groups of unemployed Black youths, already hopeless and distrustful of their or their elders' abilities to connect with any meaningful future. Our young Black people, sacrifice to a society's determination to destroy whoever it no longer needs for cheap labor or cannon fodder.

A different stage exists in South Africa, where a cheap labor pool of Blacks is still pivotal to the economy. But the maintenance of the two systems are closely related, and they are both guided primarily by the needs of a white marketplace. Of course no one in the United States government will openly defend apartheid, they don't have to. Just support it by empty rhetorical slaps on the wrist and solid financial investments, while honoring South African orders for arms, nuclear technology, and sophisticated computerized riot control mechanisms. The bully boys stick together.

I remember stories in the 60's about the roving growing bands of homeless and predatory *tsotsis*, disenchanted and furious Black youths roaming the evening streets of Sharpesville and Soweto and other Black townships.

The fact that African Americans can still move about relatively freely, do not yet have to carry passbooks or battle an officially named policy of apartheid, should not blind us for a minute to the disturbing similarities of the Black situation in each one of these profit-oriented economies. We examine these similarities

so that we can devise mutually supportive strategies for action, at the same time as we remain acutely aware of our differences. Like the volcano which is one form of extreme earth-change, in any revolutionary process there is a period of intensification and a period of explosion. We must become familiar with the requirements and symptoms of each period, and use the differences between them to our mutual advantage, learning and supporting each other's battles.

Every year over 500 million american dollars flow into the white South African death machine. No matter what liberal commitment to human rights is mouthed in international circles by the US government, we know it will not move beyond its investments in South Africa unless we make it unprofitable to invest in South Africa. For it is economic divestment not moral sanction that South Africa fears most. No one will free us but ourselves, here or there. So our survivals are not separate, even though the terms under which we struggle differ. African Americans are bound to the Black struggle in South Africa by politics as well as blood. As Malcolm X observed more than 20 years ago, a militant free Africa is a necessity to the dignity of African American identity.

The mendacity of the US Ambassador to the UN as he recited all the 'help' this country has given to Black South Africans is matched only by the cynicism of the South African president who self-righteously condemns the spontaneous violence against Black collaborators in the Black townships, calling that the reason for the current state of emergency. Of course, it is the picture of Blacks killing a Black that is flashed over and over across the white world's TV screens, not the

PHOTO: DAWOUD BEY

images of white SA police firing into groups of Black schoolchildren, stomping 12 year old Johannes to death, driving over Black schoolgirls. And I think about my feelings concerning that Black mayor of Philadelphia, and about Clarence Pendleton, Black man, Reagan-appointed head of the Federal Civil Rights Commission and mouthpiece of corruption, saying to young students at Cornell University, "the economic pie is just too small for everyone to have a fair share, and that's not the function of civil rights." Eventually institutional racism becomes a question of power and privilege rather than merely color, which then serves as a blind.

The connections between Africans, and African-Americans, African-Europeans, African-Asians, is real—however dimly seen at times—and we all need to examine without sentimentality or stereotype what the injection of Africanness into the socio-political consciousness of the world could mean. We need to join our differences and articulate our particular strengths in the service of our mutual survivals, and against the desperate backlash which attempts to keep that Africanness from altering the very basis of current world power and privilege.

PHOTO: DAWOUD BEY

SISTERS IN ARMS

The edge of our bed was a wide grid
where your fifteen year old daughter was hanging
gut-sprung on police wheels
a cablegram nailed to the wood
next to a map of the Western Reserve.
I could not return with you to bury the body
reconstruct your nightly cardboards
against the seeping Transvaal cold
I could not plant the other limpet mine
against a wall at the railroad station
nor carry either of your souls back from the river
in a calabash upon my head
so I bought you a ticket to Durban
on my american express
and we lay together
in the first light of a new season.

Now clearing roughage from my autumn garden
cow-sorrel overgrown rocket gone to seed
I reach for the taste of today
The New York Times finally mentions your country
a half-page story
of the first white south african killed in the "unrest"
not of Black children massacred at Sebokeng
six-year-olds imprisoned for threatening the state
not of Thabo Sibeko, first grader, in his own blood
on his grandmother's parlour floor
Joyce, nine, trying to crawl to him
shitting through her navel
not of a three week old infant, nameless,
lost under the burnt beds of Tembisa
my hand comes down like a brown vise over the marigolds
reckless through despair
we were two Black women touching our flame
and we left our dead behind us
I hovered you rose the last ritual of healing
" It is spring," you whispered
" I sold the ticket for guns and sulfur
 I leave for home tomorrow"

and wherever I touch you
I lick cold from my fingers
taste rage
like salt from the lips of a woman
who had killed too often to forget
and carried each death in her eyes.
Your mouth
a parting orchid
"Someday you will come to my country
 and we will fight side by side?"

Keys jingle in door ajar threatening
whatever is coming belongs here
I reach for your sweetness
but silence explodes like a pregnant belly
into my face
a vomit of nevers.

Yaa Mmanthatisi turns away from the cloth
her daughters-in-law are dyeing
the baby drools milk from her breast
she hands him half-asleep to his sister
dresses again for war
knowing the men will follow.
In the intricate Maseru twilights
quick sad vital
she maps the next day's battles
dreams of Durban sometimes
visions the deep wry song of beach pebbles
running after the sea.

 Audre Lorde

*Mmanthatisi: warrior queen and leader of the Sotho people
during one of the greatest crises in South African history.*

Selected texts from IKON –
Creativity and Change
Second Series # 5/6.
*A Special Double Issue:
Art Against Apartheid –
Works for Freedom, 1986*

Beth Brant
Mohawk Trail (1985) and
For All My Grandmothers (1985)

Mohawk Trail
BETH BRANT

There is a small body of water in Canada called the Bay of Quinte. Look for three pine trees gnarled and entwined together. Woodland Indians, they call the people who live here. This is a reserve of Mohawks, the People of the Flint. On this reserve lived a woman of the Turtle Clan. Her name was Eliza, and she had many children. Her daughters bore flower names—Pansy, Daisy, Ivy, and Margaret Rose.

Margaret grew up, married Joseph of the Wolf Clan. They had a son. He was Joseph, too. Eight children later, they moved to Detroit, America. More opportunities for Margaret's children. Grandpa Joseph took a mail-order course in drafting. He thought Detroit would educate his Turtle children. It did.

Joseph, the son, met a white woman. Her name is Hazel. Together, they made me. All of Margaret's children married white. So, the children of Margaret's children are different. Half-blood. "Half-breed," Uncle Doug used to tease. But he smiled as he said it. Uncle was a musician and played jazz. They called him Red. Every Christmas Eve, Uncle phoned us kids and pretended he was Santa. He asked, "Were you good little Indians or bad little Indians?" We, of course, would tell tales of our goodness to our mothers and grandmother. Uncle signed off with a "ho ho ho" and a shake of his turtle rattle. Uncle died from alcohol. He was buried in a shiny black suit, his rattle in his hands, and a beaded turtle around his neck.

Some of my aunts went to college. Grandma baked pies and bread for Grandpa to sell in the neighborhood. It helped to pay for the precious education. All of my aunts had skills, had jobs. Shirley became a dietician and cooked meals for kids in school. She was the first Indian in the state of Michigan to get that degree. She was very proud of what she had done for The People. Laura was a secretary. She received a plaque one year from her boss, proclaiming her speed at typing. Someone had painted a picture of an Indian in headdress typing furiously. Laura was supposed to laugh but she didn't. She quit instead. Hazel could do anything. She worked as a cook, as a clerk in a five and ten-cent store. She made jewelry out of shells and stones and sold them door to door. Hazel was the first divorcee in our family. It was thrilling to be the niece of a woman so bold. Elsie was a sickly girl. She didn't go to school and worked in a grocery store, minded women's children for extra money. She caught the streetcar in winter, bundled in Grandma's coat and wearing bits of warmth from her sisters' wardrobes. When she died, it wasn't from consumption or influenza. She died from eight children and cancer of the womb and breast. Colleen became a civil servant, serving the public, selling stamps over the counter.

After marrying white men, my aunts retired their jobs. They became secret artists, putting up huge amounts of quilts, needlework, and beadwork in the fruit cellars. Sometimes, when husbands and children slept, the aunts slipped into the cellars and gazed at their work. Smoothing an imaginary wrinkle from a quilt, running the embroidery silks through their roughened fingers, threading the beads on a small loom, working the red, blue, and yellow stones. By day, the duti-

Selected texts from IKON – Creativity and Change
Second Series # 5/6. *A Special Double Issue: Art
Against Apartheid – Works for Freedom*, 1986

ful wife. By night, sewing and beading their souls into beauty that will be left behind after death, telling the stories of who these women were.

My dad worked in a factory, making cars he never drove. Mama encouraged dad to go to school. Grandma prayed he would go to school. Between the two forces, Daddy decided to make cars in the morning and go to college at night. Mama took care of children for money. Daddy went to school for years. He eventually became a quiet teacher. He loved his work. His ambition, his dream, was to teach on a reservation. There were so many debts from school. We wore hand-me-downs most of our young lives. Daddy had one suit to teach in. When he wore his beaded necklace, some of the students laughed. His retirement came earlier than expected. The white boys in his Indian History class beat him up as they chanted, "Injun Joe, Injun Joe." My mama stopped taking care of children. Now she takes care of Daddy and passes on the family lore to me.

When I was a little girl, Grandpa taught me Mohawk. He thought I was smart. I thought he was magic. He had a special room that was filled with blueprints. When and if he had a job, he'd get out the exotic paper, and I sat very still, watching him work. As he worked, he told me stories. His room smelled of ink, tobacco, and sometimes, forbidden whiskey. Those times were good when I was a little girl. When Grandpa died, I forgot the language. But in my dreams I remember— *raksotha raoka: ra'.**

Margaret had braids that wrapped around her head. It was my delight to unbraid them every night. I would move the brush from the top of her head down through the abundance of silver that was her hair. Once, I brought her hair up to my face. She smelled like smoke and woods. Her eyes were smoke also. Secret fires, banked down. I asked her to tell me about the reserve. She told me her baby had died there, my father's twin. She told me about Eliza. Eliza had dreams of her family flying in the air, becoming seeds that sprouted on new ground. The earth is a turtle where new roots bear new fruit. "Eliza gave me life," Grandma said. Grandmother, you have given me my life.

Late at night, pulling the quilt up to cover me, she whispered, "Don't forget who you are. Don't ever leave your family. They are what matters."

*my grandfather's story

For All My Grandmothers

A hairnet covered her head
a net
encasing the silver
a cage
confining the wildness.
No thread escaped.

Once, hair spilling,
you ran through the woods
hair catching on branches
filaments gathered leaves
burrs attached to you.
You sang.
Your bare feet skimmed the earth.

Prematurely taken from the land
giving birth to children
who grew in a world that is white.
Prematurely
you put your hair up
covered it with a net.

Prematurely grey
they called it.

Hairbinding.

Damming the flow.

With no words, quietly
the hair fell out
formed webs on the dresser
on the pillow
in your brush.
These tangled strands
pushed to the back of a drawer
wait for me
to untangle
to comb through
to weave the split fibers
and make a material
strong enough
to encompass our lives.

Beth Brant

Selected texts from IKON –
Creativity and Change
Second Series # 5/6.
*A Special Double Issue:
Art Against Apartheid –
Works for Freedom, 1986*

Barbara Masekela
*Interview Conducted by
James Cason and Michael
Fleshman* (1985)

BARBARA MASEKELA

BARBARA MASEKELA's poetry is published in Somehow We Survive *(Thunder's Mouth Press). She taught African literature and women's literature at Rutgers from 1972–82. She is an active member of the ANC Women's Section in Lusaka and has represented the ANC in several international meetings. She was born in 1941.*

My name is Barbara Masekela, and I am the administrative secretary of the African National Congress Department of Arts and Culture. Previously our department fell under the Education Department but due to the pressure of work in that department and because of the growth in the needs of our school in Tanzania and the various educational projects we have in our movement, it was decided that culture needed its own office to concentrate only in that field.

Q. When was it formed exactly?

The Department of Arts and Culture was formed toward the end of 1982, but even before that we had the Ad-Hoc Committee for Culture. It dealt mostly with *Amandla*—a very exciting group of ANC cadres who first came together in 1977 at FESTAC in Nigeria. They were part of the ANC delegation to that great festival of African culture. They have since become a full-fledged theatre group which does music and dance, both traditional and modern, poetry, drama and agitprop theatre. They were never professionals, but very talented. They have thus been received very warmly and enthusiastically internationally. Their depiction of the criminality of apartheid, as well as of various aspects of our struggle has been very effective. They portray the history of the ANC as well as project our ideas for a united democratic culture in a free South Africa.

I don't need to tell you how some of the most brilliant and profound political speeches and resolutions fall on deaf ears, while music and dance due to its immediacy can have a remarkable and lasting effect. *Amandla* has to date performed in Sweden, Denmark, Norway, Zambia, Mozambique, Angola, Tanzania, FRG, Holland, Brazil and the Socialist countries. In July they had two performances at the World Youth Festival in Moscow. They have just completed a three-month tour of the U.K. after which they proceeded to Ghana and Nigeria. We hope it won't be too long before they can come to the United States and Canada.

Q. Why haven't they been to the U.S.?

You need a large capital investment for a group like *Amandla* who number thirty. And then of course there's the political message that they carry. It is not watered down, but quite explicit about the suffering, courage and determination of our

Selected texts from IKON – Creativity and Change
Second Series # 5/6. *A Special Double Issue: Art
Against Apartheid – Works for Freedom,* 1986

people through the years of struggle. *Amandla*, as well as being a showcase of the wealth and diversity of South African culture, is also a documentary of our struggle.

The group is very talented despite the fact that under apartheid they could not benefit from an artistic education which is the preserve of the whites. We are proud of *Amandla*, because like other formations in our country they demonstrate that despite oppression, repression, even murder, talent not only abounds but asserts itself in many ways within our people. Above all that talent is often linked to the concept of freedom, which cannot ever be buried.

Q: *In addition to* Amandla, *what other activities do you undertake?*

Whatever we do in the ANC, we have this aim in mind—not only to overthrow the apartheid regime and every vestige of its criminal policies, but also to establish a united, non-racial democratic state. Thus we view our task as also setting the foundations for the infrastructure of the future—in culture, in education, etc.

One day soon when we go home we will have to grapple concretely with among other things cultural institutions and issues, such as the legacy of Bantustanisation which has attempted to divide our people and deny our cultural unity. So one of our tasks in the cultural department is to find ways and means to assert the real, the authentic culture of South Africa. For instance, *Amandla* uses all the languages and dances of South Africa. There is no emphasis on one region or the other because in the Freedom Charter we say South Africa belongs to all who live in it. Believe it or not, some people fail to understand that we mean to take over all of South Africa and that we regard whatever achievements in technology as ours because we built all those museums, theatres, galleries and whatever and we mean to run them. So we must train people in all those fields.

We are now at the stage of running workshops in theatre, poetry, and the different crafts as a way of initiating our training. It is also a way of identifying persons with particular interests and talents. Further we have identified several institutions where the younger people can begin formal study in the performing arts. It is also in this area that we are relying on solidarity groups to help us find scholarships. When qualified, these trained cadres will be our first, own qualified art teachers.

Cultural activity inside South Africa is varied and extensive and it is essential that the liberation movement keep in step with these developments, and be in a position to contribute in all ways necessary to further development. Of course, in our view cultural work is integral to the entire political programme of the movement, and in this context we see no separation between what is happening inside and outside the country. Let us look at the cultural boycott, for instance: it has, to a large extent, been spearheaded and supported by people inside South Africa. But the racists try to give the impression that it emanates from outside. When the great singer Ray Charles went to South Africa to perform, he found that he had such a small audience, and he is a man who is greatly revered in cultural circles at home in South Africa. But people just felt that they could not support his venture there. And they took a stand.

Q: How strong would you say the cultural boycott is in South Africa right now?

Very, very strong. But the regime is making a concerted effort to establish a Black middle class very quickly. And these blacks have no political power or rights. All they qualify for is conspicuous consumption and its inevitable status symbols. They are the ones who go to Sun City. But to the majority, hard-working poor, Sun City is an obscenity and quite irrelevant. They are the ones who suffer the greatest burden of apartheid. They support the cultural boycott. They have analyzed the situation correctly, and they can see that these artists who are brought to South Africa to come and perform for them are really a sop, something to placate them, lull them, so that they won't think of the real issues. These artists are, in fact, used to advance the public relations of the racist regime—to salvage the regime from international isolation. But then even the Nazi Hitler sought the glamour of entertainers to camouflage his crimes against humanity, and apartheid is akin to Nazism in innumerable ways.

Q: It's interesting in the United States the South Africans have particularly targeted Black musicians to bring to South Africa.

The whole propaganda system of the apartheid regime is very systematized and sophisticated. And since they can not kill the liberation movement and because we are growing from strength to strength, one of the ways that fascists always try to hit you is to lower your morale. What more obvious method can they use to achieve this than utilize Black Americans as an instrument to demoralise us? Consequently, they have made a special effort to recruit black artists and sportsmen from the United States and the Caribbean to break the boycott. The massive sums they give them as remuneration are the sweat and blood of black workers in South Africa. On the other hand, it would be as painful for us if someone like Pete Seeger went to South Africa or any other peoples' artist who had used his talent to promote the cause of working people. Is it not true that many factories closed in the United States are opened in another guise in South Africa where profits are much higher because of slave wages and lack of workers' rights? And is not that money invested in our country to bolster the racists who repress and kill us? We are not naive, thus we are not demoralised.

Much to the disappointment of the apartheid propagandists, a significant number of these cultural mercenaries, once they leave their plush hotel rooms, begin to understand they have been had, and that the color of their skin places them in a position where they count for nothing in apartheid land.

On the more positive side, let us acknowledge that there are happily more principled artists, many of whom have turned down millions of dollars rather than soil their hands with blood money. Their example is an inspiration and encouragement to our fighting people. I am here referring to people like Roberta Flack, Harry Belafonte, Third World, Diana Ross and many others, black and white, who have said, "NO" loud and clearly to apartheid. It would be remiss to omit South African artists abroad who have refused to be lured back to South Africa and who give of their time and talent to hasten the day of liberation in South Africa.

Q: *You've worked with the group* Amandla, *and you've also been involved with training people. You've been trying to collect and promote the culture that is in South Africa today, as well as working on the Cultural Boycott. Are there other things that your department does as well?*

Last year in June we brought out our, that is the ANC, Cultural Journal, *Rixaka* which will be a quarterly publishing poetry, fiction, interviews, essays, reviews and commentary by South African and anti-apartheid writers. We have many writers in the ranks of the ANC like Keorapetse Kgositsile, Barry Feinberg, Mongane Serote, Mandla Langa and many others. We would particularly like to show off our young writers in the movement.

We would also like to bring books, films, etc., from the outside world to our people. For example, many, many documentaries have been made of the situation within our country that many of us have not had the opportunity to see. So we have been asking for assistance from friends for video machines and tapes so that our cadres can see directly the connection between the work they are doing and the results at home.

Further we would like to have access to good films made all over the world whether they are Russian, American, Italian, Cuban or whatever as a way of keeping appraised of other cultures, not to mention for recreational and entertainment purposes. Video is a great boon to a program like ours. Artists Against Apartheid groups internationally can play a very important role in this area and that of music, including musical instruments.

On the other hand, we will soon be extending invitations to artists in performing arts to come and run workshops with us, once our Cultural Centre in Tanzania is habitable. We want to develop cultural workers who can serve future

PHOTO: FRANK DEXTER BROWN

South Africa. Consequently, we have been working on including a cultural core into our school syllabus so that our pupils and students can begin studies in different performing and visual arts at an early age to prepare them for higher cultural studies.

One of the prevailing notions about culture is that it is limited to entertainment and/or recreation. But for us, the very fact of being a liberation movement, of resistance to our oppressors is in itself an act of culture, a part of our cultural heritage. It is something which has helped us to survive, which continues to sustain us.

Functioning as a department in this area also has its own peculiarities in that our work overlaps with that of other units. We have to observe strict consultation with other ANC Departments and work closely and cooperatively with them. For instance, what I referred to earlier, introducing a cultural core to our educational syllabus means that we have to work very closely with our Education Department, with publications we have to confer closely with our colleagues in Information and Publicity and so on. Thus we prefer to use the term "cultural worker" because it is not only the artist who does cultural work.

There is no doubt about the political importance we attach to cultural work. The area of film, even popular film which is pure recreation, we still view as an educational tool. It becomes an excellent starting point for political discussions. Thus we are not only interested in showing political films. For instance, something like "Four Hundred Blows" by Truffaut is an acknowledged classic. It is about the human situation, it depicts something—I don't want to use the word "universal" because you find sometimes in American intellectual circles the word "universal" is used to exclude anything particular, like a Black, you know. The reality unfortunately in Africa today is that people see mostly Western films. There are great filmmakers like Dusmane Sembene from Senegal whose films are

PHOTO: FRANK DEXTER BROWN

not seen widely because they do not fit into the preconceived film distribution system. This is where you see how we are hooked askew to a wider world. Viewed clearly, you also see a loss on the part of audiences all over the world, who themselves, because of a monopolist film distribution system have not got access to Sembene or others like him who have a valid message to make. We all get a selective view of reality. We talk so much of global politics, global this and that, but in fact we are still subject to a parochialism of the past. And in the ANC, while prosecuting the struggle is a priority, we are also fastidious about keeping up a world view.

Q: *What kind of culture, as an ANC person, would you wish to have in an independent, liberated South Africa?*

It is rather difficult to define or describe it, because culture is something that evolves. And it evolves out of the parts that make us a people, out of the political, economic and sociological conditions that prevail at different stages of struggle and even struggle after victory. In the ANC we are trying to mirror what we consider the best that has been produced in the world, to depict and project the pitch and tenor of our people, our history. Our struggle represents the raw material from which we will fashion our art. We are confident of the correctness of our principles and of the eventual outcome. We will win.

There is light music. There is serious music. There is traditional music. We want all of that. We want it all in all disciplines. We want it for our whole country and our people are determined to fight for it and daily our blood flows for it in our land. What it will evolve into is something we cannot predict, but it is imperative that it unify our people, reflect their lives. Thus guided in this way we can make an effort to shape it harmoniously. And because the majority of our population is black, to a large extent the products of culture will reflect that fact. We will take the best and discard the useless and regressive. When we are free in our country, when we are running the cultural institutions we will have more to say and to do in order to shape our country's destiny. And we will be guided by our people.

Edited from an interview conducted and taped by James Cason and Michael Fleshman in Lusaka, 12/6/84 and revised and brought up to date by Barbara Masekela, December 1985.

The photos are of Namibian children at a SWAPO refugee camp, Nyango, Zambia. ANC and SWAPO refugee settlements are similar in the type of support provided to refugees from both South Africa and Namibia.

Noor Abuarafeh, Ali Hussein Al-Adawy and Lara Khaldi. A Conversation

Solidarity and the Non-Exhibitable

Noor Abuarafeh, Ali Hussein Al-Adawy and Lara Khaldi. A Conversation

1. Political Imaginaries

Below is an email exchange between three colleagues about solidarity and the museum. When the editors invited them to contribute to this *Reader,* the three were engaged in a heated discussion on their weekly show, 'Farewell to Museums', on Radio Alhara about solidarity and the museum. This conversation is an extension of that ongoing discussion, which was prompted by questions around whether an emancipatory museum is possible and what it could look like.

Dear Lara and Ali

There are two ideas that intrigue me in regards to museums and solidarity. First, the reason why solidarity is always attached to different forms of representations, such as museums, protests, exhibitions, etc., which means that we always think of solidarity as something to be watched by a spectator, an undefined spectator. Or maybe we play the role of both the representer and the spectator? The second question is, how can solidarity be an action, not as representation, but as part of the event? How can it be directly effective? Or is symbolism essential to the essence of solidarity? Thinking of this brings to mind the book *The Undercommons: Fugitive Planning and Black Study*.[110] Being in solidarity with a group of people usually means that this group is marginalised by the system. Therefore, should one be in solidarity with this specific group, or should the action be against the system?

Noor

Dear Lara and Noor

I'll attempt to draw a theory of solidarity, art and museums.

'Solidarity' is a highly charged term that is comfortably situated in the political sphere, where politics has an authoritarian superficial meaning that stems from 'police' and acts as an environment for power dynamics. So, when X is in solidarity with the case of Y, this means that X is more powerful than Y in the wider political conflict, and Y is less powerful (marginalised as Noor mentioned) and only represented through the case of Y. The subjects of Y are invisible, have no voice and are without agency, as we can learn from Yassin Haj Saleh's 'critique of solidarity', since the whole equation/system of solidarity is dominated by X, the more powerful.

Here, art is politicised and injected as a part of larger propaganda media campaigns where solidarity means sympathy, expressed through the aesthetic tool of sensational montages of images, objects and information that leave spectators with tears that soon dry and quickly consumed emotions that maintain the status quo without any questions or ambiguities.

This all happens under the hegemony of the ideology of museums, where conflicts are mummified and everyday lives are frozen as exhibited objects from the past. So the sympathy effect is accelerated while the questions of when and where the theatre of solidarity is performed only make sense on the political level of power dynamics.

But if we could think of solidarity in a different way. According to Jacques Ranciere's 'Politics of Aesthetics', the artistic sphere becomes one of the few environments where politics can function radically in terms of the question of power – it could mean the deconstruction of power or the emancipatory speculation of power. Here, solidarity means a very complicated ongoing process, which always starts with 'here and now' to go beyond spatial and temporal boundaries until we reach radical equality through developing pedagogies, methodologies and redistributing the fictions of the stereotypes around X and Y.

The new planetary order after COVID-19 may make one question the economy of solidarity. What do you think of donor art institutions and museums in solidarity with different audiences and artists from various production directions? And with the Beirut explosion issue, how do you see solidarity campaigns by artists to renovate demolished institutions and museums? In both situations, what I find really interesting is to see artists working in solidarity with other artists far away from institutions, at least for a while.

On a different note, COVID-19, as an exception without a deadline, causes the spatial to become temporal, with subjects represented digitally on algorithmic cyber clouds. This really shows the precariousness and fragility of artistic labour, which is already so obvious with artists from southern contexts who earn their living by doing several jobs in different fields.

110 Stefano Harney and Fred Moten, *The Undercommons: Fugitive Planning and Black Study* (Wivenhoe / New York / Port Watson: Minor Compositions, 2013).

Noor Abuarafeh, Ali Hussein Al-Adawy and Lara Khaldi. A Conversation

1. Political Imaginaries

Novel Coronavirus also confirms that fragility when we observe the donor economy, which was traditionally criticised in the pre-COVID world as a neoliberal condition that conquers art. With COVID-19, it almost appears as the only solution to support precarious artists from different production trajectories (commercial, international or regional art institutions or state-funded public institutions) with temporary grants.

COVID-19 makes me ask the question, isn't it about time that artists and cultural practitioners forgot about their transcendental privileged position of building sympathy, which they mask through the magic of aesthetic gesture by naming it 'solidarity' with the human miseries on the planet only to defend their privileges? Instead, they should engage more and conquer donors and art institutions so they see themselves as decision-makers and precarious art and cultural workers who themselves need solidarity. They should initiate a real, complex, equal solidarity with their precarious human/non-human peers, trying to develop their awareness and care of the production specificities of the different positions in global capitalism.

Ali

Dear Noor and Ali,

Yes I agree there is a problem of representation here. As Noor points out, whenever we speak about solidarity, it remains at the symbolic or representational level. It does materialise, but in exhibitions and artworks about solidarity projects in the past, which relegates it, as Ali mentions, to history. In a sense, our solidarity is not only relegated to the past, but is with the past! One of the institutions of this large production of solidarity, as in the past, is the institution of the museum. When we received this invitation, we were discussing this as part of our weekly show on Radio Alhara, 'Farewell to Museums' and wondering how the museum was producing this culture of solidarity as past, but also whether there are other forms that could undo that and whether the museum could be a tool to take part in an emancipatory process. One of the first problems that occurs in the museum is that it's very much a national institution; not only in the narratives it presents, or how it frames international collections, but in the reproduction of the institution of the nation state. The museum assumes it can preserve and protect collections; it has sovereignty over objects and people. It's also the institution that houses public treasures, but in order to do so, it must be powerful enough to claim them. So in order for a history of an international solidarity to enter the museum, it must first be a sovereign entity.

The second issue is the problematic of time. A couple of weeks ago, I attended a talk by Rolando Vázquez [111], where he was speaking about how modernity produced linear time, and how modern temporality is a strategy of domination, where the past becomes a fixed entity with only documentary value. Museums as we know them today are a product of this time technology – where everything inside is relegated to the past, where justice and solidarity only happen in the past, where we are denied return, continuity and access to those actions. But then how can we think of the museum and of solidarity outside of the modern construct of time?

Lara

Hello Lara and Ali

It's interesting the definition of 'solidarity' that Ali mentioned based on Ranciere's *Politics of Aesthetics,* especially the notion of 'here and now' that's very alive and open to different possibilities. And what you mentioned, Lara, in regards to the modern construct of time. In a way 'here and now' is the complete opposite of the essence of what a museum is. According to this, when solidarity happens inside a

111 www.uu.nl/staff/
RDVazquezMelken

15 October 2016
Jerusalem Show: Before and After Origins
Group Show — Gallery Anadeel Jerusalem

١٤ تشرين الأول ٢٠١٦
على أبواب الجنة: ما قبل وبعد الأصول
معرض جماعي – جـاليري قناديل

Pages from Noor Abuarafeh's novel, *The Earth Doesn't Tell Its Secrets' – His Father Once Said* (Sharjah Art Foundation, 2017), containing photos of collected dust from various Palestinian cultural institutions 2016–2018.

Noor Abuarafeh, Ali Hussein Al-Adawy and Lara Khaldi. A Conversation

1. Political Imaginaries

27 October 2016
Open Gallery #4: FEAR
Group show — Al Hoash Art Court **Jerusalem**

٢٧ تشرين الأول ٢٠١٦
تمييز الأنماط
معرض جماعي – مؤسسة عبد المحسن القطان

museum, it somehow dies, but the act of establishing a museum in solidarity is different. It goes beyond the symbolic level, since establishing the museum in solidarity is the act of solidarity itself.

One of the things that the three of us have discussed before is the possibility of an emancipatory museum, and how the idea of the museum always leads us to look at different forms of potential mueums that are more relevant to the present than to the past, which drives me to ask, why should we call these different forms a museum at all? Perhaps there are different existing forms that can keep memories better than the museum does, especially in a context like Palestine, where everything related to its history and memory is a target.

Noor

Dear Noor and Ali

Yes, great how you put the question Noor – how do we keep the memory alive? – in the sense that it's not a memory of solidarity but a continued act of solidarity that we strive for. I find acts of commemoration to be great in this respect, like how Palestinians return to their destroyed villages on the anniversary of the Nakba, fulfilling an ongoing desire, if only for one day or one hour. There's something actual about it rather than representing it in a museum with documentary images. In an interview with Salman Rushdie, Edward Said speaks about the unmaking of hegemonic institutionalised narratives through the repeated telling of stories by the underdog. He says: 'There seems to be nothing in the world that sustains the story. Unless you're telling it, it's going to drop and disappear; it needs to be perpetually told and retold, whereas the other narrative is there and is institutionalised.' [112] I would add to this that it's not only the retelling of a story that's at stake here, but also the attempted act of return. So how is solidarity still practised, or how could histories of solidarity be presented? Should they be? And how could they have a direct link to the present?

Lara

Dear Lara and Ali

One of the things that I'm thinking of in regards to what Ali was mentioning about the artists and their solidarity during COVD-19 and the Beirut great explosion is the radio projects that emerged during that period and undertook solidarity actions aginst what was happening. These actions varied from streaming intensely day and night, or not streaming at all as an act of solidarity. I'm thinking especially of Radio Alhara, as it's the one that I've been following during this period. Listening to the radio was never something I did in my daily life before, and in a way that gave me the chance to think about it as something fresh, as if it were a new medium, an immaterial medium that has two destinations. One is telling and the other is listening. There's something in the idea of the 'live telling' that makes it very alive. It's not recorded, you can't postpone listening to it, and it keeps on generating. Even if a memory is shared on the radio and then it's re-shared, it's never told the same way: the memory keeps refreshing itself and the storyteller searches for untold details that were missing from the first story, and every time it's retold more details are revealed. In an archival image, on the other hand, everything is inside the photo. These are the only things that the photo can tell you about that specific memory, and it will keep on telling you the same, like a declaration of what you should remember. The story that's told on a radio also generates enormous images, but they're in the listener's imagination. In a country under colonial power I can't think of anything better than radio to preserve memories of those things that we're always afraid will be forgotten, targeted, stolen or burned. Perhaps we should ask how radio could function in order to preserve memories.

Noor

112 Edward Said interviewed by Salman Rushdie at the Institute of Contemporary Arts in London (September 1986) www.youtube.com/ watch?v=vAmLNc_4VtE

Noor Abuarafeh, Ali Hussein Al-Adawy and Lara Khaldi. A Conversation

1. Political Imaginaries

Dear Noor and Lara

The interesting point you're raising here, Noor, brings to mind two questions regarding the input of an online radio and memory as a model with a collective solidarity core. How could we keep an almost non-institutional reproducible archive of radio for the future, like an online archive, as a creative common – not as an original, protected, material, auristic copy in museums – that interested audiences could decode/destroy/download/reproduce/subvert/play with/experiment on.

How could we keep this online radio away from the usual art economies/institutions that we always depend on to produce/work/live/circulate our artworks and discourses? I believe that what we do in our leisure time for free, as a collective solidarity gesture on an online radio, is also labour/production and part of the dominant contemporary art economy, which is in turn part of 24/7 hyperlinked capitalism. So in a way it fuels our positions, production and circulation within it and vice versa, since we also depend on the usual art economies. We could be part of an online radio where we could really perform this collective solidarity, experiment more, enjoy it more and be more critical and less production-based. So, the well-known parasitic methodology still functions as the convenient formula for the critical/artistic paradox. My main concern here is how we can keep the idea of an online radio even with an online archive of radical political aesthetics inspired by immaterial media and applications of volatile and ghostly appearances that are hard to capture. Once it's materialised/aestheticised/commodified/institutionalised/shown in the conventional loops of art and discourse, it's radically depoliticised.

Ali

Hi Ali, hi Noor,

When we were speaking about Radio Alhara, we were thinking about one particular programme. It was the Fil Mishmish weekend event, where musicians and cultural producers from all over the world played music on Radio Alhara in solidarity against the plan of annexation of further parts of the West Bank by the Israeli military. It was an interesting case, where the musicians in a sense dedicated their already existing and ongoing music production at that moment to making a statement together. What mattered wasn't only the passing moment of the now, but also the framing of different practices and sounds and forms under one discourse. And of course, yes, once it's aestheticised – even as we're doing in our discussion here – then it is depoliticised. So if we think of solidarity as the radical moment of revolt; of wanting to destroy an existing power mechanism while not yet knowing what's to come, it is then only a moment. I'm trying to remember a conversation with our friend Dirar Kalash, where he says something quite interesting about jamming and improvisation in music that way. When you improvise together in music, so many moments are quite disappointing, but you need them in order to set structures, and then the moment comes when it works: something completely new to everyone has come out, but it's fleeting and unrepeatable. Maybe the takeaway is that even as models to learn from, histories of solidarity fail because they can't be repeated, only recorded as an aesthetic moment to 'enjoy'. What if the museum of solidarity were this place of improvisation?

Lara

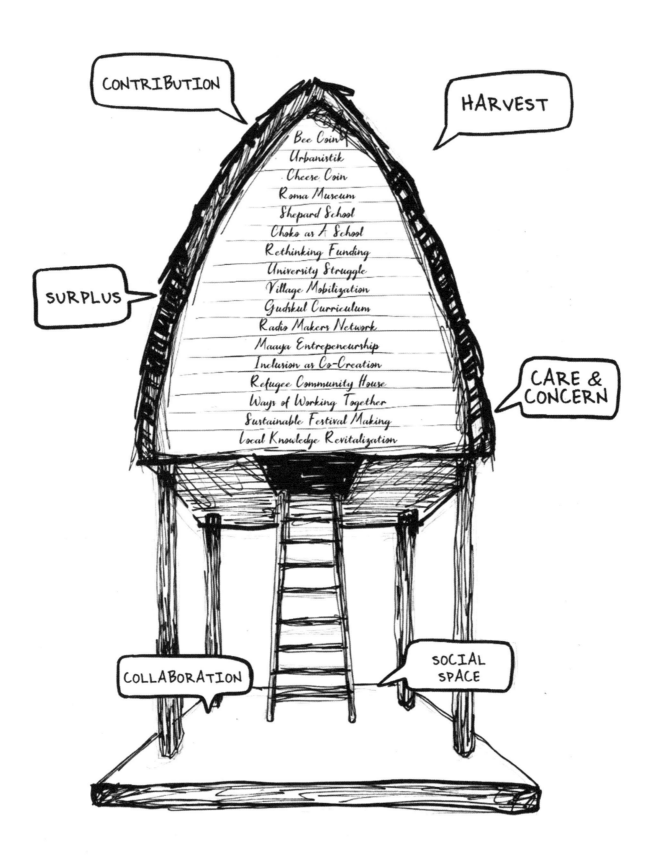

Institutional constituencies. Diagram by the author.

This contribution is gathered from a process of harvesting certain parts of our *lumbung*-ing process.

Lumbung (directly translated as rice-barn) is a collective model with which ruangrupa and other Jakarta-based collectives have been experimenting for resource governance. It is based on a concept where resources such as knowledge, space, time, networks and finance are treated as surplus to be shared with others. It is where sustenance is understood and enacted as a collective practice. Like a body, if one part is hurting, it affects the whole.

Harvesting is a vital part of our *lumbung* practice. Continuing the thread of agricultural analogies, harvesting is when the resources are gathered to be enjoyed not only by oneself but also with others. In principle, the form of harvests follows this sensibility, no matter with whom you are sharing resources.

For this contribution, I am harvesting from two sessions hosted by two initiatives, Jatiwangi art Factory (JaF) and INLAND. In preparation for documenta fifteen (Kassel, Germany, 2022), for which ruangrupa is acting as the collective artistic director, we began by asking nine different initiatives from various places on the globe to join our processes. JaF and INLAND are two of these nine. In order to introduce them, as well as to fertilise affinities, trust and friendship between the initiatives, we came up with hosting sessions where one initiative acts as a host for the others. In theory, each host has total freedom as to how to anchor the sessions, but it is noteworthy that the word 'host' can also mean 'a large number of people or things' (as in 'a host of sparrows'), or even 'angels regarded collectively' (as in God as the 'Lord of hosts'). This fact brings challenges when one acknowledges that a host can only be content when his or her guests are happy.

To build affinities and trust between each *lumbung*-er, the Artistic Team of documenta fifteen (consisting of ruangrupa and five of our friends, namely Andrea Linnenkohl, Ayşe Güleç, Lara Khaldi, Frederikke Hansen and Gertrude Flentge) endorse any initiatives from each context in order to activate communication between each other. We feel the need to balance leadership and to release control. This fact has brought in several formats of correspondence, notably the Radio Alhara channel,[113] which at the time of writing has conducted four Sarha with Lumbung Friends sessions.

The 100 days in the summer of 2022 known as a documenta edition can be considered a grand celebration of multiple harvests, hosted together by many art initiatives from a multitude of contexts. We are inviting the public at large to enjoy, consume and learn from what we have harvested together so far. A large and vital step of a collective *lumbung*-ing process, documenta fifteen is part of a cycle. It is preceded by other sharing processes and most importantly will continue post-documenta fifteen.

This specific contribution is one of these precedents of the 100 days of documenta fifteen, where I am sharing what I deem useful for readers. It comes not only from my readings of JaF and INLAND, but also from OCA as an institution-as-practice, and from the heavily biased lens of ruangrupa. It can be considered a close reading of a larger body of text in the making, for which I cannot claim sole ownership. I am merely a constituent, a fellow reader, who is sharing what has caught my deeper attention within a community. The following are stories, not theories.

THE MEAT

JaF, Thursday 9 July 2020 from Jatiwangi, Majalengka, West Java, Indonesia, via Zoom

We started working with JaF with two intentions: ice-breaking and setting an example. From the beginning of the *lumbung* process, and for many years previously, JaF has been a constant in ruangrupa's ecosystem. It can do what ruangrupa cannot (and of course, vice versa), no matter how hard we sometimes try to emulate each other. By inviting JaF to host the first session, we were hoping that group's mastery of space, media, bodies, time and use of humour, and particular use of the English language (most would label it 'broken'), could act as a breaker for others to follow suit. Working on a documenta edition should, above all, be fun.

They did not disappoint. Their use of the rectangular architecture of the Zoom platform was a good example. With the assistance of cable extensions for both audio-in and audio-out, they managed to cram their collective bodies into one display. They even staged acoustic concerts several times. The challenge of listening to multiple bodies, for which Zoom had time and again proved to be challenging, if not impossible (because it automatically cuts the volume of one when another is speaking) was amended by this single collectivising move.

Entitled 'Research Investigation of Distillation (sic) Participatory Non Profit Engagement in the Context of Autopsy Development Spicy Sustainability Over Firing Artistic Practice Based On True Story 2020', JaF's sessions translated their sensibilities and methods of praxis through multiplicities – of bodies, spaces and voices. They do a good deal of singing, so it was apt that they hosted several sessions with musical starts, finishes and commercial breaks (advertising their sellable products – bricks and potato chips) in between. As a group of people who itch if

113 https://yamakan. place/palestine/ accessed 9 September 2021.

they are not working together on building an event at any given time, they consider themselves 'festival addicts'. I myself wonder how they manage under the current circumstances, where collecting bodies in a confined space is limited. I know ruangrupa is hurting.

How to translate collectivities to a rectangular Zoom environment. Diagram by the author.

INLAND, Friday 7 August 2020 from
Inland Village, Northern Spanish
mountains, via Zoom

We let the process of hosting evolve organi-
cally. One way of doing this is to ask the previ-
ous host to pick an initiative to act as the next.
JaF voted for INLAND.

Looking at it from context of the framing
of subject matter, this selection made sense.
For us urbanites, JaF and INLAND were valuable
allies, since they are all about promoting rural
issues: pastoral aesthetics, the difference
between the terms 'farmer' and 'peasant',
particular working ethics. These did not come
naturally for me personally, having been born
and raised in a metropolitan setting.

Our interest in inviting INLAND on the
journey on which we are embarking together
was, in a sense, architectural. We deemed their
understanding, therefore use, of space to be
something from which we could learn.

We found enriching their ability to frame
their practice as contemporary, and even as art.
From different types of education to crypto-
currency, together we could answer slowly but
surely the question frequently posed to a praxis
like ours: when all is said and done, where is (or
what about) the art?

If it is our intention to campaign for insti-
tutional aesthetics (in praxis), at a time when
neither institutional critique nor relational
aesthetics (god forbid social practice) are
viable any longer, INLAND has been showing
how the global contemporary art world could
be (ab)used in achieving this goal. They not only
talk the talk, but really understand how to walk
the walk.

Relying heavily on their 'architect-art-
ist-visionaire' Fernando García-Dory in their
external communication, including us, INLAND
staged their hosting session during a siesta
break from their undisclosed mountainside
location, with additional faces and voices.
They used analogies, frequently leaping from
theories to practices, while advocating a recla-
mation of the use and meaning of peasantries,
the ownership of production tools in the hands
of the workers and the importance of land,
to question its mode of ownership. Gudskul's
cooperative process was able to learn a lot
from this method.[114]

114 Gudskul Eko-
 sistem consists
 of many elements:
 artists, curators,
 art writers, mana-
 gers, researchers,
 musicians, directors,
 architects, cooks,
 artistic designers,
 designers, fashion
 designers, street ar-
 tists and individuals
 with various other
 kinds of expertise.
 This variety makes
 Gudskul an affluent
 and dynamic ecosys-
 tem. Gudskul also
 houses a multitude
 of collectives with
 differing practices
 and artistic media:
 installation, archi-
 ve, video, sound,
 performance, media
 art, public parti-
 cipation, printma-
 king, graphic design,
 education, etc. This
 variegated bunch also
 enriches the issues
 by involving parties
 in many collaborative
 projects, socially,
 politically, cultu-
 rally, economically,
 environmentally or
 even educationally.
 https://gudskul.art/
 en/about/ accessed 17
 November, 2020.

Pasteur analogy for building democratic institution.
Diagram by the author.

BUN 2 (out of 2)

In true *lumbung* spirit, based on its values,
I deem this contribution and its results as a
surplus to be stored and shared in a common
pot, spanning beyond the knowledge and
reflections I have tried to share on these pages.
If there is any knowledge or value deemed
useful by the reader, it is not necessarily my
knowledge/value. It is our value together,
slowly built through time. As a writer/contrib-
utor, I merely act as a channel for a specific
reading to come out and crystallise somehow.

Since I cannot take the credit for this
contribution, it makes sense for me to treat
the remuneration OCA offered for filling these
pages as a resource to be shared with the rest
of my colleagues, comrades and friends. The
amount might not be significant, given the
ambition and scale of our operation (we intend
to grow the number of *lumbung* members to
around 20 by the time documenta fifteen goes
public in 2022), but if we continue to treat
resources this way, we could crowdsource
lumbung further. Inviting others to be

contributors to the whole picture. With this
contribution, not only I am channelling *lumbung*
to OCA, but I am making OCA a contributor
to *lumbung*. Contributing, therefore is made
reciprocal, no longer a one-way street.

By stating this blatantly, it is my hope that
readers will get a better understanding of
lumbung not only in representation, but also
in practice. Anyone else interested in taking
this bait should get in touch and let our stories
continue … together.

Lumbung surplus illustration as per October 2020, by
Daniella Fitria Praptono, built upon an original sketch by
Iswanto Hartono.

For some time, I have been contemplating the history of the evolution of museums, particularly in the US, and how they operate today. Amidst calls for diversity, equity and inclusion, there is no way around confronting neutrality as a persistent ideology within the museum. In a sense, the expertise of the museum is what is trusted; that it selects art and makes exhibitions that are educational, that instruct its publics. However, there are many structures that undergird these selections, and ways in which they are presented and interpreted by the museum, that are directly oppositional to any desire for diversity and inclusion. The problem lies in several registers, the first in the fact that these structures are unseen and unacknowledged, and that they undeniably privilege those of a specific class, race, ability, education, and social condition. The second relies on the fact that all museums and cultural spaces are fundamentally collective enterprises: many people making cultural work possible through their collective and individual efforts. If we, as a society, truly want to undo barriers to inclusion, we must face this false neutrality and over-emphasis on individualism and dismantle it.

In tandem with unveiling the myth of neutrality and recognising the collective nature of cultural space, the public's role in our 'public institutions' must be seen in order to recognise that the public is powerful, even in the context of late capitalism, when power seems ever more concentrated in the hands of a few. In order to enact better structures and spaces, imagining what they might look like is crucial. Neutrality is a veil for wielding and maintaining power, and because it is veiled it becomes invisible and 'just the way things are'. This is the status quo that requires resistance. Culture workers and publics must forge further, engaging in a far more inclusive conversation about our collective desires for cultural and civic spaces, how these might be enacted in myriad ways throughout a diverse ecology of museums, and what this might mean for public support in all its forms.

Undoing and redoing our cultural space is urgent, since institutions are being called upon by their staffs and their publics, as well as funding agents, to change according to their own specific histories. These changes must cultivate care for society and culture, in all its exquisite difference, divergence and oddity. It is necessary to make change now, in the present, in ways that reject relegating all potential healing to a possible or unachievable future, but rather begin to embody this future now by:

1) Collectively imagining our way towards cultural space
2) Re-examining the structures that uphold museums, from governance and fiduciary commitments, to programmatic and staffing structures, towards different ways of working
3) Remembering that art and museums already shape (and are shaped by)

society, so by shifting the ways culture works, society can shift as well; and that
4) If we desire a cultural commons that supports a complex, vibrant populace, we have to engage that populous in culture and the structures that enable it.

But how to get there?

I do not have the whole answer. If I did, it would certainly be the wrong answer because while I have a lot of experience in this field, this experience is mine alone, and while others might share aspects of it, this work must intentionally go beyond the 'insiders' to make this enterprise successful. I have been fortunate to have spent hours talking and arguing with many artists and thinkers with jubilant and radical practices to help identify potential paths forward.

Among the first steps is to connect a variety of networks that already exist with one another so that the questions are framed differently, and make clear how these networks operate, sometimes in parallel. The people who work inside institutions are pushed to the breaking point as it stands, so to make this collective imagination viable, the pace of cultural production must radically slow down. Recalibrating the sources of funds for cultural spaces is essential, particularly ensuring that public funds balance private philanthropy. Priority must be given to identifying the people who must be part of this conversation, both internal and external to the museum. The work must be done collectively, bottom up, in cahoots with key top-down allies. Allies and co-conspirators at the 'top' can help marshal resources that will be necessary to implement from the bottom up. These groups must engage in a process in which we agree and do not agree. They must acknowledge that it may be strategic and beneficial to not know, to be left in the dark, and to be at odds, engendering a productive agency, sifting the ideas of What, to the ideas of How. In other words, imagining collective desires together, and perhaps above all, entering into this inevitably contentious space with care for one another and ourselves.

In Chantal Mouffe's words, culture workers and audiences can 'find ways to use [cultural institutions] to foster political forms of identification and make existing conflicts productive. By staging a confrontation between conflicting positions, museums and art institutions could make a decisive contribution to the proliferation of new public spaces open to agonistic forms of participation where radical democratic alternatives to neoliberalism could, once again, be imagined and cultivated.'[115]

I've recently embarked upon an experiment to do some of this work through a partnership with the Brooklyn Public Library called the Art & Society Census, which launched in December 2020 and will be ongoing through the spring of 2021. The idea is to gather as

broad a public as possible to address several key questions about what people desire from cultural institutions and experiences. The initial questionnaire is broadly framed with queries that attempt to open various routes to contemplate what culture means and how it works in society: Describe a cultural experience that got under your skin. What made it important to you? What do you desire from culture that you don't see happening? While these are the general parameters of the questions, they will be fine-tuned and tested with the breadth of staff at the BPL, from librarians to volunteers. They will be distributed via the BPL over 60 branches throughout Brooklyn, via their connections to Brooklyn's public schools, and via the online media platform Hyperallergic. It is centrally necessary that the people of Brooklyn, and beyond, are invited to participate in this discussion, on their own terms. We hope to receive thousands of answers, which we will sort, tabulate and analyse, reviewing the results with a working group comprising Library staff and members of the public who wish to be more intensively involved. From there, a series of public discussions and workshops will be planned, each addressing the central issues raised via the questionnaires, intentionally centring the responders' voices, rather than those of experts inside cultural institutions. This is important as a first step towards developing, at minimum, a borough-wide or city-wide conversation about culture. We, as organisers, want to see what unfolds, what is desired, how a broad public envisions cultural institutions and their offerings, what they love or hate about them, what they desire most. Actually hearing and seeing these desires is the very first step in making recommendations for shifts, not only in the programmatic approaches that cultural spaces might take, but also in the ways in which they engage with their publics and, quite literally, how they function.

The Art & Society Census is partially inspired by artists Maia Chao and Josephine Devanbu, who launched the pilot of an ingenious way to approach questions of who participates in museum culture called Look at Art. Get Paid (LAAGP), in 2016 at the Rhode Island School of Design Museum (RISD) in Providence. This initiative is a socially engaged art project that pays people who wouldn't otherwise go to art museums to visit one as guest critics of the art and the institution, flipping the script between the institution and its public, the educator and the educated, the paying and the paid. LAAGP are also in the midst of expanding this pilot programme from the RISD museum to four museums in Massachusetts.

The most intriguing aspect of the original iteration of LAAGP at the RISD Museum is its direct approach to asking people what they think, doing so ethically by paying them for their time, and taking seriously what museums can learn from people outside the field. It fundamentally reverses a dynamic that is so

stubbornly baked-in to museum methodology that commits the museum to a constant broadcast of information, facts, ideas and content that the public may or may not desire, or be equipped, to absorb. All of this pushing out of information leaves little room for what publics might contribute to the museum from their experiences and knowledges, and, importantly, eliminates any chance for an actual exchange of information or ideas. In reversing this dynamic, LAAGP helps identify the real, and sometimes unexpected, stumbling blocks to visitor access and engagement. Among their first priorities was to centre people of colour living in Providence in their cohort, given the whiteness of the institution with which they were partnering. Their findings are largely related to representation, language access, and alienation, which was manifested on multiple levels.

Chao and Debanvu said:

> there was a general feeling amongst critics that the museum is 'addressing a certain kind of person' – namely white people and people with money. Throughout our conversations, the topic of belonging featured prominently, and one critic said, 'maybe this place isn't for me'. Another critic articulated that they just didn't feel like they had 'bandwidth for another white space'. When discussing what changes the critics would like to see, most agreed the museum would have to better represent POC [people of colour] in their collection, improve language accessibility, advertise in their neighborhoods, and make the experience less intimidating ... Critiques were wide-ranging, but many critics discussed the lack of effective signage; the silence and stillness of the galleries; their desire to touch the art; the arbitrary and stiff social codes for looking at art; their general discomfort in the space; and their acute awareness of being surveilled ... Representation was a major area of concern for guest critics ... Language issues came in really strong.[116]

Some 'critics' made specific programmatic suggestions like holding community cookouts at the museum; another, a sign-maker, suggested he could help with their signage issues. LAAGP took these suggestions to facilitate their ultimate goal, which isn't to convert people into museum-goers but rather *to provide entry-points for those who wish to participate*. These critics are now working with local artists to implement their suggestions at RISD.

One of the most forlorn comments they relayed came from critic, Samanda Martínez who said, '*Están cuidando más a las imágenes que a nosotros*' / 'They're taking better care of the paintings than they are of us'.

115 Chantal Mouffe, 'The Museum Revisited', *Artforum*, www.artforum.com/print/201006/the-museum-revisited-25686 (accessed 18 March 2020).

116 All LAAGP quotes are from my interview with them: Laura Raicovich, 'A Unique Program Pays You to Visit Museums as a Guest Critic', *Hyperallergic*, 27 June 2019.

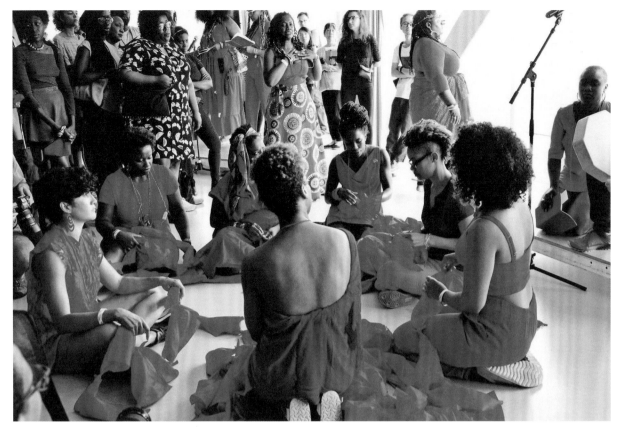

'Black Women Artists for Black Lives Matter' (2016). Photo: Maria Koblyakova.
Courtesy New Museum, New York.

An advertisement for *Look at Art. Get Paid,* a public bus in Rhode Island, 2016.
Photo courtesy of the artists.

Dona Heng's multi-media installation, *Security Checkpoint* calls attention to the relationship between identity and security in institutional spaces. *Security Checkpoint* is a replica of a TSA security checkpoint – complete with stanchions, walk-through metal detectors and a conveyor belt scanner. Visitors must wait in line to be ushered through the installation, bringing to centre stage an experience of security that 'typical museum-goers' might not otherwise consider. Photo: Norlan Olivio.

Guest critics from the pilot of *Look at Art. Get Paid* have a group discussion after their first visit to the RISD Museum (2016). Photo: Ian Faria.

For any museum professional, this is a heart-breaking statement, and one that might motivate real change. Ms Martínez, along with the other 'critics', noted the security and cameras signalling the value of what was held in the museum, and also inferring that these objects might need protection from *them*; some noted the lack of other 'inner city' visitors and works by artists of colour on view; and the lack of Spanish-language labels or guides or advertisements in their neighborhoods. All of this was alongside a perception that the museum welcomed publics who already knew the protocols of how to dress and enter and act inside the museum, but didn't necessarily make it comfortable for those who didn't. The reality, LAAGP points out, is that most museums and cultural organisations know what these barriers to entry are; resolving them is not typically prioritised institutionally, but rather left at the bottom of to-do lists by overwhelmed, disheartened, and/or unmotivated and uninterested staff. LAAGP hopes that the personal nature of the critiques provided by the guest critics can materialise the alienation to an extent that inspires substantive change. That the very people who make up the institutions being critiqued know the barriers to entry, paired with the fact that they might have an idea of how to address these barriers, but also need the direct engagement with their publics to do so, is an essential reality.

What interests me about the potential for the Art & Society Census, and of LAAGP, is that obvious, simple solutions might be identified by actually asking publics direct questions, and that the answers might shift the approaches that programmers, curators and administrators take in imagining and implementing their work. Museums directly implementing programmatic ideas that are crowd-sourced is not what I'm calling for (although I'm certainly open to great ideas emerging from the process). Rather, I believe that museum workers and artists can be inspired by the information and perspectives expressed through such projects to allow whole worlds to open up that address the entire experience of entering the museum. Further, an opening of cultural space to reciprocal flows of knowledge and information can constitute practices of care for both the people who comprise the institution and its publics. After all, the offerings that the public might provide, while inevitably critical of institutional practices, can be the key to undoing ways of working that produce harm.

From an institutional perspective, to create space to embody these forms of care, the single most important and impactful way to make change is to radically slow down. The pace of cultural production is simply too fast. How many exhibitions are truly necessary or even desirable in a single year? How many public programmes? More is sometimes just more, and not better. Already thin human resources are stretched beyond their capacities

to function at the speed with which our cultural organisations install new exhibitions, invent new projects and plan events, talks, performances, etc. How do all of these things get done better and more deeply, with greater care, not just faster, not just more?

Slowing down is crucial because it creates more space and time to make decisions, longer consideration and thinking as well as taking the time to engage more people in the process, such as staff members and additional stakeholders, to do more of the work that would feed into making cultural space more inclusive.

Take, for example, the situation in which the Walker Art Center in Minneapolis, and artist Sam Durant, found themselves during the installation of his work *Scaffold* in 2017. Durant's sculpture had been added to the museum's collection after it had been first exhibited in Kassel Germany at Documenta 13. In Germany, the work was installed outside, in a park, and comprised a two-storey wood and steel construction vaguely reminiscent of a chunky play structure, particularly in its parkland location. The sources for the shapes that compose this sculpture, however, were much more fraught than its presence implied. Durant had mimicked and combined the designs of gallows used in seven US government-sanctioned executions carried out from 1859 to 2006. Through this hybrid form, he hoped to reveal the racialised implications of the US criminal justice system over time. Specifically, the sculpture depicted the gallows for seven different executions that included the following condemned people: 'abolitionist John Brown (1859); the Lincoln Conspirators (1865), which included the first woman executed in US history; the Haymarket Martyrs (1886), which followed a labour uprising and bombing in Chicago; Rainey Bethea (1936), the last legally conducted public execution in US history; Billy Bailey (1996), the last execution by hanging (not public) in the US; and Saddam Hussein (2006), for war crimes at a joint Iraqi/US facility'. The seventh gallows referenced the one used for the Mankato, Minnesota execution of the 'Dakota 38' in 1862. This moment represents a nadir of Native American life under colonial violence. As Durant remarks on his website description of the work, 'The Mankato Massacre represents the largest mass execution in the history of the United States, in which 38 Dakota men were executed by order of President Lincoln in the same week that the Emancipation Proclamation was signed.'

When the work was installed, in 2017, at the Walker Art Center's newly expanded Sculpture Garden in Minneapolis, Minnesota, it was this last representation that hit hard. The artwork was met with intense public outcry led by many local Indigenous groups. Their anger was directed at both the artist and the institution for not having the foresight to understand that exhibiting a work depicting the history of pain and trauma inflicted on Dakota ancestors by

the US government, and still resonant in their lives today, would re-inscribe that suffering. Kate Beane, a Dakota woman who works as a community liaison for the Minnesota Historical Society told *Hyperallergic*:

> When I first saw it, I had this huge anxious feeling and broke down in tears. I don't think the Walker or the artist took into consideration what kind of impact a structure like that would have on a community of people who have been impacted by historical trauma. We do this over and over and over again. We get a lot of backlash about it and it's tiring work. And then something like this still happens.[117]

For protestors, not only was this painful history inappropriate for the Sculpture Garden in Minneapolis, which is situated on unceded Dakota land, but it was also deemed by some to be inappropriate for a white artist to use such symbolism in his work.

Both the Museum and the artist apologised, and then took things a step further. Durant gave the intellectual rights to *Scaffold* to the Dakota people. 'I have no intention of making a representation of that again', said Durant. 'They asked me, "How do we know you won't do this again?" I said, "That makes perfect sense. It's yours. You decide what happens to it."'[118] And they decided to burn it.

So while this ceding of artistic control is a form of care, it is responsive to an impossible situation. Perhaps we should ask how a more careful process might have been enacted by the institution from the outset. Imagine that prior to the acquisition of the work there had been more *time* to think through what the larger public might have a particular stake in the piece, in its conceptual and historical reference points and its possible readings. Who would be particularly interested in these ideas? Conversations with Dakota members could have taken place to contemplate the artwork prior to its installation and indeed, prior to its acquisition by the museum. Perhaps the artist could have been invited to convene conversations and other forums to hear from and talk with a diversity of members of the people of Minneapolis. Imagine further that the time had been taken to cultivate Indigenous voices in the first place, given the fact that the Walker sits on unceded Dakota land. Imagine that those conversations created conditions of a willingness to engage, if not trust. Rather than another committee to meet with or box to tick, this scenario could establish entirely different processes of decision-making. Imagine the investment in such decisions and processes might produce, and how programming around the work could flow from there. Given how it transpired in real life, I bet many of the people involved in the aftermath would have been deeply interested in an alternative process,

even if they came to the conclusion that this wasn't the right artwork for the Walker. That surely would have been preferable to the mess and pain of the actual events.

Imagine too, having conversations at the board level about the acquisition of such a work with Indigenous elders who serve on the board itself. Imagine paying those elders for their time and expertise, as corporate boards do for their board directors. The occasions for learning between philanthropists and community members of all kinds could multiply. Imagine how the direction of the institution might shift if board members represented all different kinds of interests and were not only in positions of power for the funds they were able to contribute. Perhaps those making such contributions would be even more interested in attending meetings, and learning other ways of imagining what it is to be a fiduciary, or determining what the qualifications are for a 'good' board member. The tenor of these questions would shift by virtue of expanded and recalibrated participation. The people who would be interested in donating the time or money required to be involved on such a board might evolve.

In this mindframe of care, I can't help but think of artist Simone Leigh's 'Free People's Medical Clinic' (2014), which proposed, on many registers of medicinal and restorative practice rooted in Black feminism, that critical theory, alongside gathering in an intentional space, could be medicine, could be curative. For her project, which was produced by Creative Time and Weeksville Heritage Center, Leigh converted the former home of Dr Josephine English into a temporary clinic. English was the first African American woman licensed to practice gynaecology and obstetrics in New York State, and delivered all the children of Betty Shabazz and Malcolm X. Borrowing the name of her project from the Black Panthers' efforts to foster community health care, Leigh celebrated under-recognised and unseen Black healers including the Order of the Tents, a secret society of Black women founded during the US Civil War. The desire to actually provide care in the form of acupuncture, yoga, massage and other restorative practices was firmly embedded in the project, but it also offered practical workshops (such as Navigating the Affordable Care Act and HIV Screening), classes with joy-inducing potential (including a Black folk dance class), and community-specific activities (like Black Magic, which was limited to queer/trans audiences only). Subsequent to this project, she devised 'The Waiting Room' (2016) during a residency at the New Museum, in which she continued deeply addressing Black subjectivity by offering the residency to a newly formed group, Black Women Artists for Black Lives Matter (or BWA for BLM) to manifest performances and discussions in the wake of the intensity of anti-Black violence in the US, particularly as it was manifested over

117 Sheila Regan, 'After Protests from Native American Community, Walker Art Center Will Remove Public Sculpture', *Hyperallergic*, 29 May 2017.

118 Andrea K. Scott, 'Does an Offensive Sculpture Deserve to Be Burned?', *The New Yorker*, 3 June 2017.

RISD Museum staff watch a documentary featuring the
critiques generated by *Look at Art. Get Paid,* during the
pilot program in 2016. Photo: Ian Faria.

Simone Leigh, *Free People's Medical Clinic,* 'Funk, God, Jazz, and Medicine:
Black Radical Brooklyn', 2014. Photos by Shulamit Seidler-Feller, Courtesy of
Creative Time.

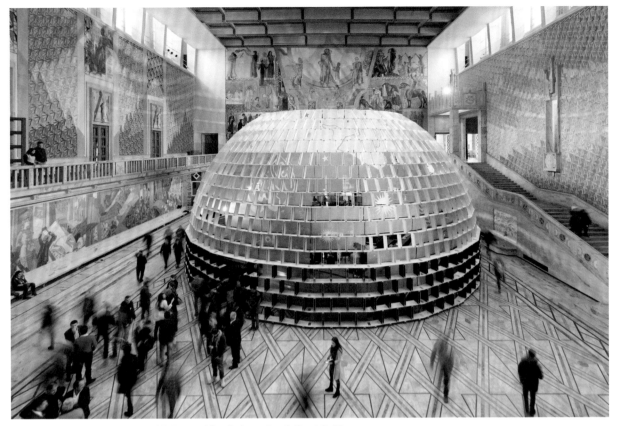

Democratic Self-Administration of Rojava and Studio Jonas Staal, *New World
Embassy: Rojava*, 2016. Produced by Oslo Architecture Triennale: *After Belonging*
URO/KORO, Norway. Photo: 001-003 Istvan Virag, 004-006 Nieuwe Beelden
Makers.

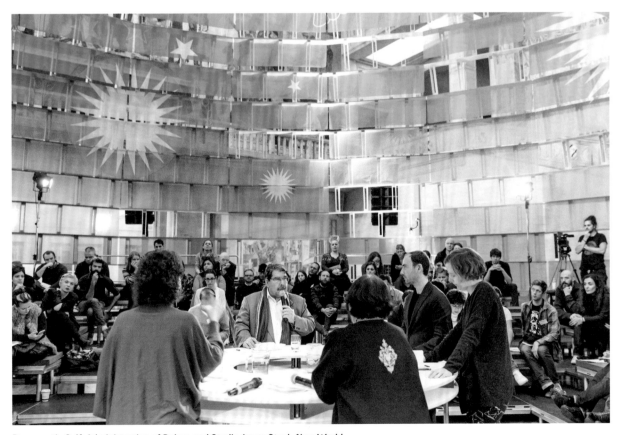

Democratic Self-Administration of Rojava and Studio Jonas Staal, *New World
Embassy: Rojava*, 2016. Produced by Oslo Architecture Triennale: *After Belonging*
URO/KORO, Norway. Photo: 001-003 Istvan Virag, 004-006 Nieuwe Beelden
Makers.

the previous year. These ways of thoughtfully navigating needs, desires, care and celebration within a cultural space are deeply inspiring, and map potentialities not only for radical inclusion, but also for the ways in which transformation might require, at key junctures, the exclusion of the dominant culture to achieve a restorative condition.

* * *

Another artist whose work has inspired me is Jonas Staal, a Dutch artist whose broad practices I have been following for some years. His interest in assemblies and gatherings is central to his work, from the New World Summit, a series of conferences planned in various geographies to gather stateless and marginalised peoples (some of whom are considered 'terrorists' for their beleaguered relationships to their own states) to his deep work in building an actual public parliament building with the Syrian revolution in Rojava. There are many intriguing facets to this artist's practice, but it is his work on propaganda I want to highlight here. In his recent book, *Propaganda Art in the 21st Century*, he lays out how propaganda has been used over time to consolidate power and wealth for the gain of a few. Staal's provocative proposition is whether we can, via a multitude of creative processes, imagine and perhaps create a propaganda that is fundamentally committed to equity and mutual liberation. What might that look like?

Staal argues that re-engaging in studies of propaganda and propaganda art would help us reveal the covert propagandas that remain invisible to us, like the manifestations of the myth of neutrality within cultural space. He makes a compelling case for propaganda today serving as a crucial tool to engage in 'hybrid, conflictual, and transformative' practices that open 'categories of belonging and identity that bypass the capitalist and patriarchal state as the hegemony of identity formation'. He further writes:

> reactivating propaganda and propaganda art studies can be only one part of the answer to our present-day crises, conflicts and deepening precarity. Yes, we need to understand who authors our world in our name, but we also need to gain control over the means of production through which our realities are constructed in order to make new ones … Understanding that a master narrative is false does not stop it from having effect. It demands a new master narrative of our own: a story about where we come from, who we are, and who we can become.[119]

I experienced with beautiful clarity the possibility of who we can become through one of Staal's works. The event took place in late-November 2016 as the realities of Trump's Presidential victory were setting in, while the revolution in Rojava (The Autonomous Administration of North and East Syria) seemed so full of possibility. For two days, a Temporary Embassy for Rojava was convened inside the ornate City Hall of Oslo, Norway. It was, as Stall said, 'a stateless embassy for a stateless democracy: aiming to contribute to a transdemocratic politics beyond the traditional boundaries of the nation-state'.[120] We sat within a perforated domed structure built of a plywood lattice and brightly coloured flags, invited by Staal and co-ambassadors Asya Abdullah (Co-Chair of the Democratic Union Party, PYD), Sînem Mohammed (European Representative of the Democratic Self-Administration of Rojava), Salih Muslim (Co-Chair of the Democratic Union Party, PYD), Bassam Said Ishak (President of the Syriac National Council, SNC), and Aldar Xalîl (Executive Council Member of the Movement for a Democratic Society, Tev-Dem). They presided over presentations held round a circular table at the centre of the pavilion, ranging from practical discussions on participatory democracy to cultural policy and imagination. Staal and his studio physically built a temporary structure to an unrecognised state within a civic building of an internationally recognised state. It was created to convene Rojavan revolutionaries profoundly engaged in self governance alongside thinkers and imaginers of all stripes, and was an attempt to make real and tangible the collective desires of those assembled. Beyond the physical site and the formal presentations that produced vibrant ideas and debates, this time spent in common and the discussions that resulted, in various languages, across difference, over shared meals, through dancing and late nights, brought us together to prove to ourselves that we could exist in a different world. And perhaps as we co-habitated this space of imagination, we could materialise an emancipatory propaganda to invite others not part of this initial cohort, in the hope of eventually making it real together. In more than one way, this project embodied a fierce carefulness that was reflected in all aspects of its realisation.

Cultural space has the potential to embody these forms of care; to be a location, a scaffold for the collective exploration of how diverse publics might participate in the re-imagination of who, what and how contemporary society desires to function, how it treats its members, and how and what it creates and destroys. Artistic production can help us make sense of it all. This historical moment demands that museums and cultural space actively participate in the change necessary to create a more equitable world. Museums are not neutral.

119 Jonas Staal, *Propaganda Art in the 21st Century* (Cambridge, MA: MIT Press, 2019), 188–89.

120 Jonas Staal, 'New World Embassy: Rojava', http://www.jonasstaal.nl/projects/new-world-embassy-rojava/ (accessed 17 October 2020).

2

Toufoul Abou-Hodeib

The Travelling Scarf and Other Stories. Art Networks, Politics and Friendships Between Palestine and Norway

181

On 6 February 2019, I held in my hands for the first time a letter from the Plastic Arts Section of the Palestinian Liberation Organization (PLO) addressed to Kunstnernes Hus (Arists' House) in Oslo. The letter concerned the logistics involved in organising an upcoming exhibition of Palestinian art in Oslo in 1981. What struck me most about the document was the letterhead: official, present and organisational, it made that much more real an entire epoch of history that I had not directly experienced. The curious thing is that this encounter – my first with an official Palestinian document after several years of researching Palestinian history – took place in Oslo in the archives of a Norwegian national institution, rather than in Palestine or Lebanon, where the PLO was based at the height of its activity before the Israeli invasion of Lebanon in 1982. In reality, such a Palestinian archive does not exist as an institution, but as traces scattered here and there across the globe, in private collections and research institutions. It exists as rumours of sightings in the Algerian desert. It exists as recollections aging with an aging generation. In order to produce the official and definitive history of the PLO, one would have to embark across many borders on a quest whose mobility would be interrupted, if not entirely blocked, depending on your passport and political activism, by the realities of geopolitics and non-finalised borders.

And yet there I was, sitting in Oslo, holding an official letter from an organ of the PLO, the Plastic Arts Section. This was significant for me as a historian and as a Palestinian. As a historian, it presented an opportunity to write part of the official history of the PLO not based on rumours, hearsay and afterthought, but as it happened – a history about a national struggle in its transnational context of solidarity. As a Palestinian, this was a rare moment when I could take those names, faces and snippets of conversation I had caught during my childhood in Beirut and relate them to a larger story – to place myself in the stream of a broader history, so to speak, through my own archival work. But the folder I found in the Norwegian archive fell short of that. Those letters, typical objects of the historian, remain lacking. There was much in them that could inform that official history in its larger international setting, with the details of organisation and funding all complicated by the politics of the Left and secret police surveillance in Oslo. Yet, here and there, there were hints of more: personal modes of correspondence and forms of address that did not speak of cost and effect, but of individual encounters and personal transformation. These bits were scant and did not constitute the focus of the correspondence, yet they stood out against the dreary language of getting things done. But what happens to the official narrative of organisational history when one gets closer to the persons and the personal behind the letters?

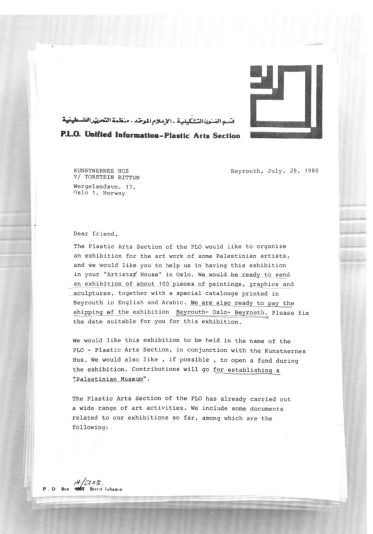

Letter to Kunstnernes Hus in care of Thorstein Rittun from Mona Saudi, 28 July 1980. From Kunstnernes Hus' archive held by Norway's National Museum Documents Archive (Dokumentasjonsarkivet/NMFK/KH/Dba/L0008).

The year 1979, the 20th anniversary of the Declaration of the Rights of the Child, was proclaimed by UNESCO as the International Year of the Child. Stressing the importance of the well-being of children as a vital part of economic and social development, the proclamation urged special attention for children in 'the most vulnerable and particularly disadvantaged groups'.[121] On that occasion, the offices of the Ghassan Kanafani Cultural Foundation in Denmark and Norway cooperated with Mona Saudi, artist and head of the PLO's Plastic Arts Section, in publishing *Children's Testimony in Times of War*, a book of Palestinian children's drawings from the Palestinian refugee camp of al-Baqaa outside Amman, Jordan. Saudi, freshly returned from her art studies in France, had collected the drawings between 1968–69. The children's drawings had been published in book form twice in Arabic, the first time by the PLO and the second by Saudi herself, before this third edition took on a wider international dimension and came out in Danish, Norwegian and Swedish. Illustrations for the book were made by the artist Vladimir Tamari, a Palestinian refugee from the 1948 war who had been living in Beirut and, at the time of the third edition, had settled in Japan.[122]

Founded in 1974, the Ghassan Kanafani Cultural Foundation is a Lebanese-registered NGO focusing on education and culture for Palestinian children and youth. It is named after the Palestinian author, journalist and leading member of the Marxist-Leninist Popular Front for the Liberation of Palestine (PFLP), Ghassan Kanafani. Kanafani was assassinated in 1972 by Mossad, the Israeli secret services, by a car bomb that also took the life of his teenage niece. Despite the fact that Yasser Arafat's party Fatah dominated the PLO, and despite the rivalry between Fatah and the PFLP, the Ghassan Kanafani Cultural Foundation's cooperation with Mona Saudi in the publication of children's drawings was but one instance of cooperation between the two. In fact, the ideological disagreements of grand politics and superpower alignments within the Left, both on the Palestinian and Norwegian sides, did not hinder several such cooperations in Norway. Like the official PLO letters, the book *Children's Testimony in Times of War* discloses transnational networks of solidarity centering on art and culture, this time highlighting how those networks crisscrossed the ideological frontlines of official history. But how did solidarity with Palestinians take on a cultural form? And why did it travel along those specific overlapping networks of arts and politics?

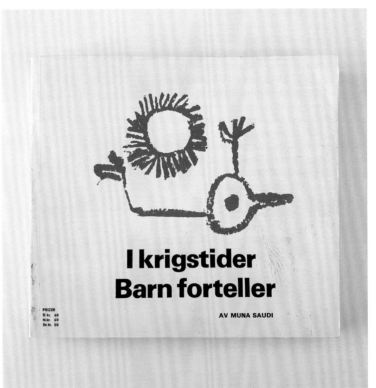

Mona Saudi, I krigstider: *Barn forteller* (Oslo: Ghassan Kanafani's Cultural Foundation Norway, Third Edition, 1979). Courtesy of Toufoul Abou-Hodeib.

121 United Nations General Assembly, Resolution 31/169, 'International Year of the Child', 21 December 1976.
122 For more, see 'Vladimir Tamari: Interview with Rasha Salti', in *Past Disquiet: Artists, International Solidarity and Museums-in-Exile*, ed. Kristine Khouri and Rasha Salti (Warsaw: Museum of Modern Art in Warsaw, 2019), 183–89.

In the autumn of 1981, Samia Halaby took the trip from New York to Oslo to participate in the exhibition of Palestinian art at Kunstnernes Hus. In Oslo, she was joined by other participating artists who had flown in especially for the exhibition: Mona Saudi, Muhammad Hajras, Kamal Boullata and Mustapha Hallaj. Born in Jerusalem in 1936, Halaby was one of many Palestinians forced to flee their homes in 1948. The family escaped to Lebanon for a few years, before settling in Cincinnati, Ohio. At the time of the exhibition, Halaby had been living and working as an artist in New York. Together with other visiting artists, she was taken around Oslo, introduced to Norwegian artists and shown around their studios. At the time, Halaby was struck by the visible presence of women artists on the tour, which to her resembled more the Palestinian art scene than the New York art milieu of which she was also part.[123]

During their visit to Oslo, both Halaby and Saudi stayed with Vesla Lange-Nielsen, a pro-Palestinian activist who had travelled to Beirut several times by 1981 and who was one of the activists behind the office of the Ghassan Kanafani Cultural Foundation in Oslo. At some point during the visit, Halaby admired one of Lange-Nielsen's scarves. Lange-Nielsen offered it to her, explaining that she had made it herself. At first, Halaby hesitated to take it, but upon Lange-Nielsen's insistence, they came to the agreement that the scarf would be a shared object between them, which Halaby would use for some time before returning it to its original owner. Though the scarf itself has become an object of the past, traces of its trajectory remain with us today. It travelled with Halaby from Oslo to New York, where it stayed with her for a few years at her home and studio in Tribeca, before taking the reverse trip by itself, and finding its way back to Lange-Nielsen in Oslo.[124] Unlike the official letters and the book of children's drawings, the scarf is a lost object of history and can only be captured in Halaby's story, but it still traces a different set of relationships between individuals enabled, but not satisfactorily explained, by networks of art and politics. How did the political, cultural and the personal come together through acts of solidarity? And if the scarf could speak, what would it have to tell us about its journey?

* * *

At first glance, these three vignettes seem to belong to different orders. One is about organisational history, the second is about politics and art, and the last is about personal relationships. But if the personal is political, as second-wave feminists brought to the fore in the 1960s, together those three vignettes highlight the other direction of this statement:

Exhibition catalogue for *Palestinske Kunstnere* at Kunstnernes Hus and Christianssands Kunstforening (now Kristiansand Kunsthall) (Oslo / Beirut: Kunstnernes Hus / Plastic Arts Section – Unified Information – P.L.O., 1981). Courtesy of Toufoul About-Hodeib.

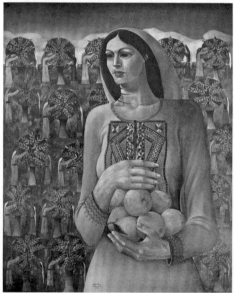

‘Palestinske Kunstnere’ exhibition poster. Image: Unknown title by Suleiman Mansour, unknown date.

namely, that the political is very much personal. Without examining the personal relationships of the people behind the institutions and the people behind the art, the vignettes make only partial sense. As the materiality of art forms and objects crisscrossed, they were animated by personal relationships and even friendships. Across various geographies, networks of politics and culture, they came together to generate a specific kind of solidarity where the small object of the everyday and objects of art carried the kind of significance that the greater subject of politics flattened out. How did those disparate geographies of Norway, the USA, Japan, Lebanon and Palestine come together? And how did they come to revolve specifically around artistic and cultural forms of expression?

* * *

To put these vignettes in a wider picture, one can begin by looking at how Palestine went global in the 1970s within the scene of anti-imperialist solidarity, on a par with support for Vietnam. In the late 1960s, and within the space of a few years, the perception of the Palestinian issue transformed from one of a refugee crisis to an established cause with the New Global Left. As early as 1966, the Solidarity Conference of the Peoples of Africa, Asia, and Latin America in Cuba, also known as the Tricontinental Conference, incorporated Palestine into its revolutionary agenda.[125] The Six-Day War in 1967, and Israel's occupation of the West Bank, Gaza and the Sinai Peninsula, was formative for the experience of a whole generation in Europe and the United States, and fed into a reformulation of the image and role of Palestine in politics within the framework of the anti-imperialist idiom of the 1968 generation. In the case of Palestine, 1967 and 1968 – the war and the student revolt – were but two faces of the same moment that engendered a phenomenal shift in what 'Palestine' meant. The word no longer evoked only nameless people living in the squalor of refugee camps and appearing wretched and destitute in black and white photos. It became increasingly associated with the revolutionary struggle and militant leftism of a new generation of Palestinians. Within the framework of anti-imperialist, leftist protest forwarded by the Tricontinental, 'Palestine' became a buzzword in transnational solidarity.[126] At the intersection of the revolt of a generation, the political mobilisation of workers, and the transnational network that tied together struggles from civic rights in the US to anti-fascism in Chile, the Palestinian cause found a home.

But this political timeline remains impoverished without its cultural undercurrent. For our three vignettes to make sense, another timeline and another side of transnational solidarity with Palestine need to emerge. What the Tricontinental Conference did for the left in terms of politics, the Pan-African Festival in 1969 did for culture. The fierce debates that took place during the festival spelled the death of Negritude, with its strictly African connotations, opening up African culture to a wider anti-imperialist reading.[127] It is not insignificant that the festival was held in Algiers, dubbed the 'Mecca of Revolution', and a point of overlap between the African continent and the Arab world.[128] There, the Palestinians were present too, together with the Black Panthers, further expanding the overlap between geographies of solidarities and deepening their reach even outside the non-aligned world and into the heart of countries such as the US.

As the idiom of culture opened up to wider interpretation within an anti-imperialist framework, the stakes in cultural representation became even higher. Members of the PLO at Algiers, as well as many others around the world, witnessed the streets of the Algerian capital fill with the jubilant colours, voices and choreographies of the cultures of the different nations present.[129] Within that cultural shift and in the decade that followed, the PLO developed a variety of cultural endeavours to represent and give form to what being Palestinian meant, as well as to present it to the world. According to Palestinian leftists, there was no art but committed art, and this, together with other aspects of the Palestinian National Movement, formed the multifaceted struggle in which they partook. As Yasser Arafat, chairman of the PLO, was often quoted saying: 'The Palestinian Revolution is not merely a rifle, but also a social, cultural, and industrial struggle'.[130]

123 Interview with Samia Halaby (New York), 14.12.2019.
124 Ibid.
125 Sune Haugbølle, 'Entanglement, Global History, and the Arab Left', *International Journal of Middle East Studies* 51 (2019): 302.
126 Anne Garland Mahler, *From the Tricontinental to the Global South: Race, Radicalism, and Transnational Solidarity* (Durham NC: Duke University Press, 2018).
127 Samuel D. Anderson, '"Negritude Is Dead": Performing the African Revolution at the First Pan-African Cultural Festival (Algiers, 1969)', *The First World Festival of Negro Arts, Dakar 1966: Contexts and Legacies*, ed. David Murphy (Liverpool: Liverpool University Press, 2017), 143–60.
128 See Jeffrey James Byrne, *Mecca of Revolution: Algeria, Decolonisation, and the Third World Order* (Oxford: Oxford University Press, 2016).
129 See Mériem Khellas, *Le premier festival culturel panafricain. Alger 1969: une grande mess populaire* (Paris: L'Harmattan, 2014).
130 'Samed: Sons of Martyrs for Palestine Works Society', *Palestine: PLO Information Bulletin*, January 1977: 32.

It was within this context that Mona Saudi started the Plastic Arts Section of the PLO, and its first major project was the International Art Exhibition for Palestine in the winter of 1978 in Beirut. Comprising around 200 works donated by artists from 30 countries, the exhibition was meant to be the beginning of a collection for a museum in exile, touring the world until one day it could be housed in a museum in a future Palestinian state.[131] By the time of the Oslo exhibition in 1981, Saudi could boast in her letter to Kunstnernes Hus, of international exhibitions organised by the Plastic Arts Section in Tokyo, Moscow and Tehran. Exhibitions of drawings by Palestinian children had also been organised in these cities, in addition to France and Italy.[132] To accompany the 1979 publication of the book *Children's Testimony in Times of War,* the Ghassan Kanafani Cultural Foundation had organised an exhibition of children's drawings to tour Norway, starting with the Oslo School of Architecture and Design and accompanied by posters, children's books and photographs, the last supplied by the PLO's Palestinian Cinema Institution.[133] But exhibiting and publishing the drawings of refugee children was of a different order from an exhibition at a prestigious art venue in Oslo. For networks of art and politics to come together, something more than compassion or ideological compatibility was required. There was a need for mutual recognition, and for that, something would have to happen on the Norwegian side as well.

* * *

By the time of the 1978 international exhibition in Beirut, Norwegian eyes were already turned to Palestine. Over the past decade, the political leanings of the '68 generation created a fertile ground in Scandinavian countries for pro-Palestinian activism within the New Left. The unwavering support that Israel had generated in the west after the horrors of the Holocaust became known was being questioned after Israel's 1967 phenomenal victory in the Six-Day War. The image of Israel as victim made way to its image as aggressor, one aligned with the imperialist US at that. Visits to kibbutzes in Israel were being replaced by visits to Palestinian refugee camps in Jordan and Lebanon. And the image of Palestinians as 'Arab refugees' was replaced by that of a people struggling for liberation from oppression and for the right to a homeland.[134] In short, the political fervour of Left-wing solidarity and anti-imperialism formed the experience of a new generation disillusioned by the politics of its parents.

These new dynamics in politics generated an increased mobility of Norwegian and Palestinian individuals towards each other. From those living and active in Norway to others who travelled there to address

From left to right: Vesla Lange-Nilsen, Mona Saudi and Erik Paulsen. Amman, 1986. Courtesy of Mona Saudi.

Mona Saudi and Thorstein Rittun. Oslo, 1981. Courtesy of Mona Saudi.

Norwegians directly, Palestinians became more than just an unvaried group of militants or refugees supported only from a safe distance. They became individuals with individual stories. On the other hand, Norwegians travelled to and lived in Palestinian refugee camps as health workers and solidarity activists. From Peder Martin Lysestøl and Finn Sjue, who were instrumental in the founding of the first solidarity organisation with Palestine in Norway, to the physician Ebba Wergeland, Norwegians opened up the networks that brought even more Norwegians to the Palestinians where they lived, and introduced them not only to issues of health and politics, but also to the multitude of cultural projects in which Palestinians were engaging as an intrinsic part of their political struggle.[135] When these networks of politics and culture were mobilised, they moved along with people, acquaintances and friendships that came together at a specific political moment, generating transnational solidarity movements within the global Left.

Through her engagement with Palestine since the 1970s, Vesla Lange-Nielsen travelled to the Middle East, where she met Mona Saudi. In 1971 in Oslo, she had also met Anni Kanafani, Ghassan Kanafani's Danish wife and one of the founders of the Ghassan Kanafani Cultural Foundation in Beirut, and later in Copenhagen.[136] This encounter led eventually to the establishment of an office for the Foundation in Oslo – an office consisting primarily of individual activists, a postbox and a letterhead. Lange-Nielsen was a member of the Marxist-Leninist solidarity group, the Palestine Committee, but it was on the Ghassan Kanafani Foundation's letterhead that she communicated with both Kunsternes Hus and the Plastic Arts Section of the PLO. It was also Lange-Nielsen who first transmitted Saudi's letter to Kunstnernes Hus, gauging the institution's interest in holding an exhibition of Palestinian artists.

In reply to Saudi's letter, Thorstein Rittun, the director of Kunstnernes Hus at the time, explained that members of the governing board of the art venue were interested, but knew close to nothing about the Palestinian art scene. He suggested that representatives of Kunstnernes Hus make a visit to Beirut in order to come to an informed decision.[137] The trip to Beirut in February 1981 was facilitated by Lange-Nielsen and entailed a programme set by Saudi, where Rittun and two of his colleagues from Kunstnernes Hus met with Palestinian artists and activists. The Norwegian visitors left with a list supplied by Saudi of potential artists for the exhibition, as well as an impression of Palestinian art that ran contrary to their initial expectations. In an interview with *Palestina-nytt*, the information bulletin of a Norwegian solidarity group, The Palestine Front, Rittun explains: 'We had imagined a lot of battle scenes and propaganda in the

131 Archives of the National Museum of Art, Architecture, and Design, Oslo (hereafter ANMAAD), Kunstnernes Hus, Dba-L0030. Letter from Mona Saudi to Thorstein Rittun, Beirut, 28 July 1980. In the 1981 exhibition in Oslo, primarily Palestinian artists were featured. Their works were chiefly shipped from Beirut, but also from the US, Japan, Syria and Israel. They were first exhibited in Oslo and then in Kristiansand at Christiansands kunstforening from 17 January – 7 February 1982. The works that were not sold during this tour were then shipped back to Beirut, with Kunstnernes Hus and the PLO splitting the shipping costs. ANMAAD, Kunstnernes Hus, Dba-L0030. Letter from Steinar Gjessing to Mona Saudi, Oslo, 8 March 1982. In contrast, the 1978 exhibition in Beirut consisted of works by international artists from around the world, donated for the Palestinian cause and as the nucleus for a Palestinian museum in exile. Kristine Khouri and Rasha Salti uncover these lost stories of political solidarity around and beyond the 1978 International Art Exhibition for Palestine in their documentary and archival project, *Past Disquiet*, which has resulted in several exhibitions and publications, including the book *Past Disquiet: Artists, International Solidarity and Museums-in-Exile*.

132 ANMAAD, Kunstnernes Hus, Dba-L0030. Letter from Mona Saudi to Thorstein Rittun, Beirut, 28 July 1980.
133 'Sånn er det å vokse opp I flyktningeleir!' *Klassekampen*, 22 November 1979.
134 For more on this shift and the start of solidarity with Palestine in Norway, see Finn Sjue and Peder Martin Lysestøl, 'Et akutt behov for solidaritet', *Fritt Palestina* no. 2 (2019): 6–19.
135 On these early encounters between Norwegian and Palestinian activists, see Sigvart Nordhov Fredriksen, 'Discovering Palestine: How Norwegian Solidarity with Palestine Emerged in the Transnational 1960s', Master's thesis (University of Oslo, 2020).
136 'Sånn er det å vokse opp I flyktningeleir!', 1979.
137 ANMAAD, Kunstnernes Hus, Dba-L0030. Letter from Thorstein Rittun to Mona Saudi, Oslo, 3 October 1980.

negative sense. This was far from the case. The dream of Palestine is recurrent in the artworks, and some [artists] are also interested in and work with problems of form.'[138]

The result of this trip was not only continued collaboration between Kunstnernes Hus, Lange-Nielsen and Saudi, leading to the exhibition in Norway later that year, but also a change in the modes of address in letters between Saudi and Rittun: from 'Revolutionary greetings' to 'In Friendship and Solidarity'. Saudi was also given the trust and freedom to commission the exhibition, as well as to design and print its poster and catalogue in Beirut before shipping them off to Norway. Without the trip to Beirut, facilitated through the friendship between Saudi and Lange-Nielsen, the exhibition would have ended up very differently, if it had taken place at all. When the exhibition finally opened, the Norwegian version of Saudi's introduction to the catalogue was based on a Danish version, probably translated by Kanafani, who had also collaborated on the book of Palestinian children's drawings in 1979.

Then there is the friendship between Saudi and Halaby. Saudi was travelling to Armenia for another exhibition just before the opening of the Oslo one. She therefore suggested to Rittun that her 'good friend' Samia Halaby should arrive ahead of the opening to help set up and talk to the press before Saudi herself arrived.[139] Halaby had grown up in the United States. But in the 1970s, within the context of growing leftist politics in that country, she became more active in establishing relations with Palestinian artists in the Middle East, including Saudi. Given Saudi's friendship with Lange-Nielsen, both Saudi and Halaby stayed at Lange-Nielsen's apartment while in Oslo, where Halaby admired the scarf, and Lange-Nielsen offered it to her.

The scarf, an object of the everyday that carries little political or artistic meaning, illuminates the bonds of friendship and familiarity that undergird the entire story of solidarity through cultural and artistic collaborations. The various friendships and personal ties that were formed across geographies – between Saudi, Lange-Nielsen, Rittun, Halaby and Kanafani, amongst others – mobilised networks of art and politics, even fostering new forms of solidarity in the overlap between the two. Through these relationships, the exhibition came to be, the book of children's drawing was published in three Scandinavian languages, and the story of the scarf survived even when both the ideological landscape of the Cold War era and the radical forms of solidarity that came with it had long given way to a different kind of world.

138 'Palestinsk kunstutstilling til Oslo', *Palestina-nytt* no. 2 (1981).
139 ANMAAD, Kunsternes Hus, Dba-L0030. Letter from Mona Saudi to Thorstein Rittun, Beirut, 8 September 1981.

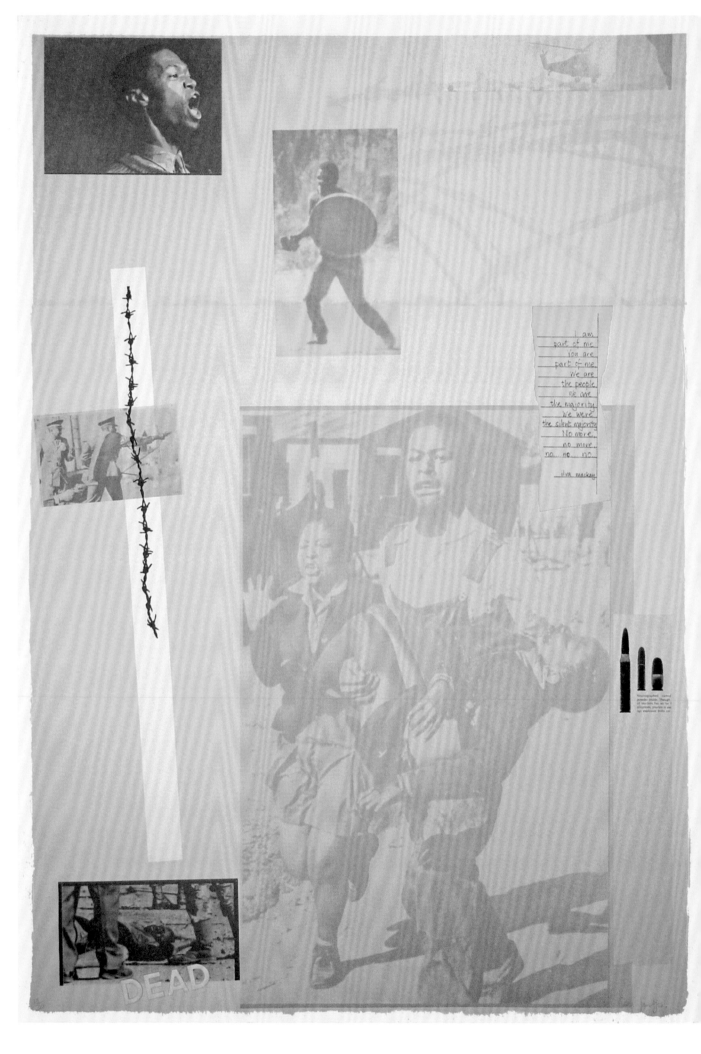

I am
part of me
you are
part of me
We are
the people
We are
the majority
We were
the silent majority
No more,
no more
no.. no.. no.

ilva mackay

DEAD

The struggle against apartheid was originally a local South African issue that began with the formation of the African National Congress (ANC) in the early 1900s. Over 60 years, this local struggle grew to become a global movement, dovetailing with the American Civil Rights movement in the 1960s as both became issues of international concern. During my second stay in the UK, from 1982 to 1998, the intellectual trajectory of 'a new internationalism' in visual art was starting to push back the dominance of western Eurocentric thinking. One of its ideas was making local art global. Visual cultural institutions in the UK and elsewhere were being criticised for their myopia towards contemporary art production in non-western cultures as valid contributions to human development. I promoted the concept of a new internationalism. It led to the creation of the Institute of International Visual Arts (Iniva) in London.

The exhibition 'Art Contre Apartheid' in the early 1980s was a grand gesture of cultural and political solidarity. But it was also a dynamic example of making a local concern global. Upholding the principle that contemporary art from all cultures contributed to a global understanding of human rights, it was a rare event for institutions coming to terms with diversity in the 1980s.

As I write, the Black Lives Matter (BLM) movement echoes the same local to global shift experienced in the 1980s. The big difference in 2020 is the speed of information change. Daily TV and digital video reports of mass activities in support of the BLM movement make it feel as if one is watching change in real time. BLM activities headline news across the globe. Citizens of the world who are in solidarity with it have rapidly established a global community whose every member wants racism and inhumanity to stop, and not just in the US.

When South Africa's anti-apartheid struggle reached its peak in the mid-1980s, artists around the world felt a need to support the oppressed. And today, artists are once again asking themselves 'What can I do to show my solidarity with the global movement of BLM?' The operative word in this question then and now is 'show'. It is a test of the artist's *raison d'être*, as well as contemporary art's value in culture. The politically concerned artist feels impelled to do more than just march with fellow demonstrators. There is a need to distinguish an artistic response from the greater public outcry. Maybe this is an attempt to reclaim visual art's once mythical status as the avant-garde of any social-cultural movement, whether in the time of Donald Trump or Margaret Thatcher and Ronald Reagan. Black Lives Matter will undoubtedly become a resource for new artworks, and one cannot yet imagine how artists worldwide will show their solidarity with it.

In the time of Thatcher artists had a plan. It grew out of an event in the mid-1970s that set in motion a global outcry against the apartheid regime and its police, coalescing into an international solidarity movement for the oppressed people of South Africa. There had always been support for South Africa's political struggle. The UN had passed numerous resolutions against the apartheid government. Throughout the twentieth century, anti-apartheid and civil rights movements had petitioned first the League of Nations and then members of the UN, who supported the only government practising legalised racial discrimination, to cancel their relations with it. These appeals met with little success. By contrast, the African Union had always demonstrated unflinching solidarity, as had the non-aligned states and the former Soviet Union. In Western Europe, there were boycotts against South African produce such as wine and Outspan oranges and there were numerous demonstrations against South Africa participating in world sport events. Not until South Africa's state police shot and killed protesting black school children in June 1976 did the number of people and governments grow into a vociferous outcry of solidarity for the anti-apartheid struggl. The Soweto uprising brought a seismic shift in international support for the anti-apartheid movement world wide. And this called for some visual cultural event that would help consolidate an ever growing global solidarity.

Artists felt a need to infuse political culture with images that underlined the humanitarian spirit of solidarity. Those whose work addressed societal iniquities wanted a broad platform that would reveal the growing artistic solidarity with South Africa's political struggle.

Mainstream art institutions of most European states were neither willing nor ready to build this platform. Two Paris-based artists, the Frenchman Ernest Pignon-Ernest and the exiled Spanish painter Antonio Saura, initiated a project that appealed to a broad range of artists. It immediately received the help of the Paris UNESCO office, who arranged for them to address the UN General assembly in New York. Their idea was to show the world that local artists from around the globe were willing to stand up for the key principles of the Declaration of Human Rights. They asked for the help of the UN to create a substantial collection of contemporary international art that would be given as a gift to the first government of South Africa elected through universal suffrage. This truly international collection of art would tour the world until there was a democratic government in South Africa elected by all its people. The tour would support the growing international solidarity against apartheid world-wide, keeping it in step with global musical events against apartheid and racism and the international cultural boycott initiated by the ANC.

Gavin Jantjes, *No More*, 1977. Courtesy of the artist.

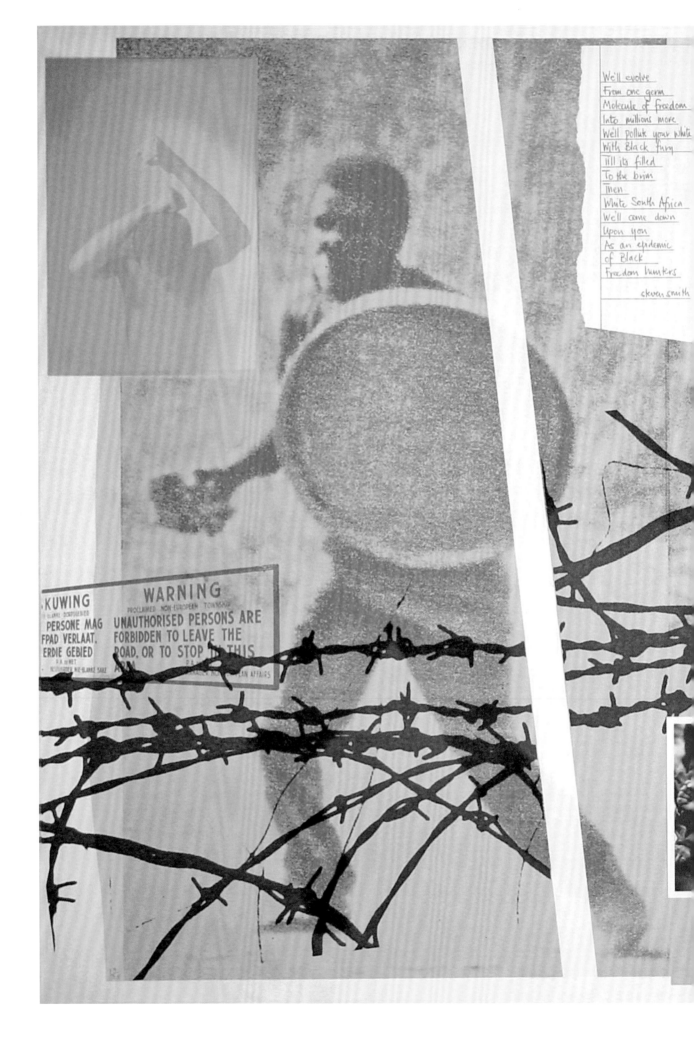

We'll evolve
From one germ
Molecule of freedom
Into millions more
We'll pollute your white
With Black fury
Till its filled
To the brim
Then
White South Africa
We'll come down
Upon you
As an epidemic
of Black
Freedom hunters

steven smith

KUWING
PERSONE MAG
FPAD VERLAAT,
ERDIE GEBIED

WARNING
PROCLAIMED NON-EUROPEAN TOWNSHIP
UNAUTHORISED PERSONS ARE
FORBIDDEN TO LEAVE THE
ROAD, OR TO STOP IN THIS

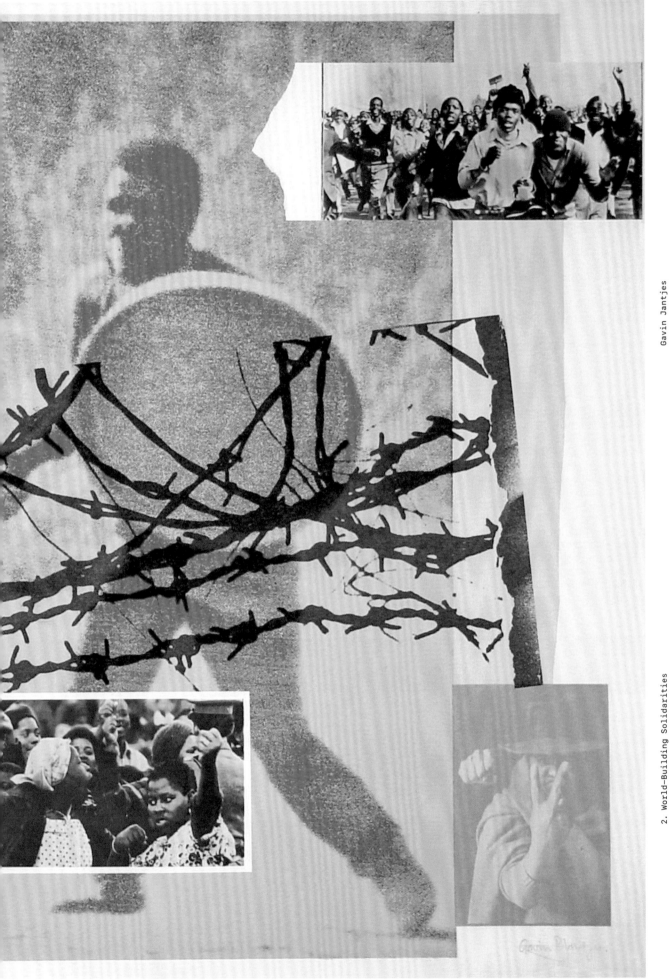

Gavin Jantjes, *Freedom Hunters*, 1977. Courtesy of the artist.

Their proposal, to make conventional exhibition displays that required transportation and storage and public relations, was a costly enterprise. But it was well-received, and financial support was given. It was particularly significant that the UN trusted the power of art to the advancement human rights and the skill of two artists, not bureaucrats, to uphold its beliefs in human suffrage. The proposal of Pignon-Ernest and Saura also received additional financial help from the governments of Finland and Sweden, the UN Special Committee Against Apartheid and UNESCO. To move their project forward, they created the Committee of Artists of the World Against Apartheid with the help of the Association Française d'Action Artistique and the French Foreign Ministry. Members of the artists' committee would each invite 10 international artist friends to donate a work for the collection. The Committee of Artists would act as custodians of the collection until it was finally handed to the first democratically elected government of SA.

Pignon-Ernest and Saura were not blind to the task ahead of them. They had little experience of developing anything on such a scale. But this did not deter them. With the tacit understanding that most mainstream visual institutions in Western Europe were reluctant if not antagonistic to offering their exhibition galleries as a platform, they used the clout of their artistic personalities to persuade institutions to help.

Because this was an artist-led enterprise and not an institutional one, the normal hierarchy and prejudice of Western European art institutions that regularly excluded the work of artists foreign to the Western Eurocentric canon, did not apply. With Committee members trusting their fellow artists, the project opened to a new and broader international response. Just who would participate in this act of international solidarity was not established by museum curators but by Pignon-Ernest, Saura and the Committee of Artists against Apartheid. However, this was the early 1980s and knowledge of the extent and quality of global artistic practices was limited to what each member of the committee brought to the discussions about participation. Networks of personal and artistic friendships built the list of possible artists to approach. My name was added to it by the English artist Joe Tilson, who was my neighbour and former teacher. The lack of female artists is a distinct feature of the collection and reflects the time. Of the 86 participating visual artists there were only four Africans and one South African – me – one African American (Mel Edwards) and a small number of artists from South America. The South African artist Gerard Sekoto, who lived in Paris, could not be found because he was homeless and confined to a mental hospital. There were many others Africans who could have been included: El Loko in Germany, Ernest Mancoba in Denmark and in the UK, Dumile Feni, Pitika Ntuli, Louis Maqhubela, Ibrabim El Salahi and Uzo Egonu, amongst others. If one were to repeat this project today, some 40 years later, the number of female artists and artists from Africa and the other four continents would outnumber those from Europe. One can honestly say that the racism and sexism of the 1980s art world tainted what was a very noble project.

Artists from the invited group, together with some members of the Committee of Artists Against Apartheid formed a special group, 15 Artists Against Apartheid. Their intention was the production of a portfolio of graphic art to be be sold as both a signed limited edition and an unlimited poster edition. These two products would help raise the funds needed to maintain the exhibition tour and to care for the collection. An exhibition catalogue was proposed to function more as an information tool about apartheid and the UN's endeavour to seek a peaceful resolution to its end than as a fundraiser. Some of the worlds most prominent scholars, philosophers, poets and writers in solidarity with the project added their voice via the catalogue.

The exhibition 'Art Contre Apartheid' opened at the Petit Palais in Paris in late 1983. Before the opening, Jacques Lang, then Cultural Minister of France, instructed all visual arts institutions in France receiving a state grant to exhibit the posters made by the 15 Artists Against Apartheid on International Human Rights Day. This nationwide advert announced the Paris exhibition to the people of France and the world. After the Paris opening, the collection toured six countries around the world before it was offcially handed to the first democratically elected South African parliament in Cape Town at its opening on 8 February 1996. The hope of all the participating artists was that the collection would be housed in a special museum, or alternatively would become part of the South African National Gallery collection in Cape Town. But there was no money for a new museum then and possibly never will be. There was no solidarity from the gate keepers at the National Gallery. Its director Marilyn Martin and the National Gallery Board shattered the hopes of the international artists by declining to add the gift to its collection.

One may ask how it was possible for a state-run institution to refuse such a valuable and prestigious gift. With the safeguarding of all state employees' jobs during the transition period of the first democratic South African government, the values and prejudices of the old racist regime prevailed. Having ignored any art that criticised the apartheid state, the National Gallery's functionaries had to prevent an anti-apartheid collection from entering a state (another way of saying 'white') institution.

The parliament decided to display the collection in the halls and passageways of its buildings, replacing the art (mostly portraits and busts) of the defeated apartheid regime.[140] I was invited by Gordon Metz, who was responsible for the first installation of the collection onto the walls of the parliament building, to witness the takedown of the old apartheid art and the installation of the international collection. It was a moment that I shared with my widowed mother. I had been present at the very first opening of the collection in Paris and I participated in its opening in Amsterdam. But this was different. My emotion was celebratory. The installation of all 86 artists' work in this most important building of the nation was high drama, a funeral and a birthday party all at once. As the old regime's artworks were taken down and wrapped in shrouds of bubble wrap, there was a double sense of passing. In those corridors of power the images of former members of a hated regime were replaced by artworks that stood for humanity. I felt that all those artists I had met through this project of international solidarity were standing with my mother and me. They were smiling as we were. An act of solidarity was reaching its goal.

After two years in the house of parliament, the collection was moved to the Centre for Humanities Research at the University of the Western Cape (UWC), where it is used as a valuable educational and exhibition resource today. The project of Pignon-Ernest and Saura brought the work of unknown international artists to the attention of South Africans and it now provides an example of the social dynamics of solidarity to new generations of students and scholars. Most of the international artists who donated their work to the collection would never have exhibited their work in South Africa while the apartheid regime was in power. Many of them did not make socially critical or political art. They donated what each thought relevant. Some made a special work. Most simply gave what they had available to give. This made for a very mixed collection of artworks that did not coalesce around any theme. The collection is nonetheless a superb example of twentieth-century international art. Its singular value remains the idea of solidarity: the single-mindedness of the contributing artists in their opposition to the injustices apartheid inflicted on South Africans and all of humanity. They provide an example of how to confront racism, segregation and all forms of brutal state oppression with its opposite. Whether their work signalled an abstract, emotional response or depicted the reality of South Africa's everyday, each of them wanted to raise a flag of warning to the perpetrators and all those that have followed. And they all supported the principle that South Africa should be ruled by a government elected by all its people. This is why the collection was not received by President Mandela or the African National Congress (ANC) but the parliament. It was formally handed to Frene Ginwala, then Speaker of the National Assembly. She had been incorrectly informed that the collection was being sent from UNESCO in Paris, and wanted the French President to hand over the collection to the National Assembly. But I persuaded her to contact Ernest Pignon-Ernest at the last minute to bring him to Cape Town for the handover of the gift. Antonio Saura was too ill to travel. And it was fitting that the collection's first presentation to a South African public was in the building that housed those elected representatives. During the exhibition period, the parliament building was opened to the general public with daily guided tours. The transparency of the new government allowed visitors not only to witness the generosity of artists who were in solidarity with their struggle, but also for the first time to see inside the house where the laws of their land are drafted.

The two editions of prints and posters made by the 15 Artists Against Apartheid succeeded in their goal to raise funds for the tour, storage and the conservation of the works. The poster edition in particular made it possible for the average citizen to purchase a reproduction of a work from the collection and thereby contribute in the smallest way possible to the funds needed to tour the collection. It allowed those museums that faced diffculties presenting the exhibition in their normal programme to show some solidarity with the idea of freedom of expression. The support of the Galerie Maeght in Paris, and its network of museum and private print collectors, was central to the success of the limited-edition prints. The gallery put its publication resources at the disposal of 15 Artists Against Apartheid, 10 of whom were regular exhibitors at Maeght. The group came together to sign the edition over a period of two days, a memorable occasion that enabled us to meet each other and share thoughts on the role art can play in political change.

The organisation Artists of the World Against Apartheid kept each artist informed as the collection toured the world, asking them where possible to attend the openings. To keep an exhibition on tour for 12 years is in itself a feat of endurance. Pignon-Ernest and Saura, with the support of Chantal Bonnet, showed their solidarity over this long period. Their dedication cannot be underestimated; working most times without pay to keep the idea alive is testimony to their solidarity.

Standing in the state halls of the House of Parliament on that day in 1996, with the project coming full circle, Pignon-Ernest must have felt it had all been worth it. The solidarity of which he and Saura had once dreamt had not only grown with every stop the collection made as it travelled the world, but it now stood as an example of what art can be beyond the gallery, the museum and the studio.

140 See https://youtu.be/2gnZHKiB0xI accessed 10 September 2022 Cyril Ramaphosa comments on the removal of apartheid-era paintings from the Houses of Parliament, Cape Town, 1994, while artist Gavin Jantjes talks about their substitution with his works and others in the collection.

Yásnaya Elena Aguilar Gil

Making a Territory of Collaboration Possible. Art, Solidarity and Indigenous Peoples

Yásnaya Elena Aguilar Gil

Hacer posible un territorio de colaboración. Arte, solidaridad y pueblos indígenas

I first became aware of Norwegian artist Gitte Dæhlin while contemplating a face on the cover of the book *Conjuros y ebriedades. Cantos de mujeres mayas* (*Incantations. Songs, Spells and Images by Mayan Women*, in its English edition), an exquisite work produced by Taller de Leñateros (Woodlanders' Workshop) in San Cristóbal de las Casas, Chiapas, southern Mexico, a place that sits in the middle of a region with a strong Indigenous population and is known through the uprising of the Zapatista Army of National Liberation (EZLN) in 1994.

The face gazing back at me from the book cover was not a simple portrait photograph: the image is a sculpture rendered from a type of cardboard that gives form to a face, a female face, with features I identify in myself as a Mixe woman who, against the background of the mountain town to which I belong, runs her fingers across the physiognomy of this book with eyes, a book that watches you. Inside the book are the incantations and spells of Mayan women, received in dreams and conveyed in a communal corpus of poetry residing in collective memory. Later, over time, I was able to explore the figure of Gitte Dæhlin further, familiarising myself with her body of work, her sculptures and her social commitment to denouncing injustices perpetrated against the local population and railing against the appalling situation suffered by indigenous refugees who arrived from Guatemala at the beginning of the 1980s, an exile caused by the war and genocide inflicted in their country.

The Mayan face looking back at me in the book-cover sculpture was cast by Gitte Dæhlin in a distant land and safeguards the words of Mayan women from the Chiapas highlands. The sculpture belongs to a vast oeuvre that cannot be read without the backdrop of the 20 years she spent living in San Cristóbal de las Casas and her commitment to denouncing social issues. One of the book's coordinators, the US-born poet Ambar Past, learned the Mayan language Tzotzil and was able to translate the incantations of Mayan women such as Loxa Jiménez, María Tzu, Verónika Taki Vaj, Pasakawalak Kómes and Manwela Kokoroch, among others, who make art through the spoken word that sits miles away from the world of writing. The process of assembling this book, combining sculpture and poetry, incantations from dreams, and writing and translation, bears witness to the collaboration between women born in different geographical coordinates and social situations, sometimes sharply contrasted and intersected by macro-systems such as colonialism and capitalism. This process of joint artistic creation gave rise to *Conjuros y ebriedades. Cantos de mujeres mayas*, one of the most distinctive and, as Mexican writer Elena Poniatowska avows, one of the most beautiful books in the world. Artistic creation, as it is called in western language, fashions spaces in which people are able to subvert, or imagine subverting,

Un rostro que resguarda palabras

La primera vez que supe de la artista noruega Gitte Dæhlin fue contemplando un rostro que resguarda la portada del libro *Conjuros y ebriedades. Cantos de mujeres mayas*, una exquisita pieza producida por el Taller de Leñateros en San Cristóbal de las Casas, Chiapas, en el sur de México, un lugar que se encuentra en medio de una región con mucha población indígena y que es conocida también a raíz del levantamiento del Ejército Zapatista de Liberación Nacional (EZLN) en 1994.

El rostro que me contemplaba desde la portada del libro no era la simple fotografía de una cara, la portada es una escultura realizada en un tipo de cartón que toma las formas de un rostro, femenino, en cuyos rasgos puedo reconocerme como una mujer mixe que en medio de las montañas del pueblo al que pertenezco, recorre con los dedos las facciones de un libro con ojos, de un libro que te mira. Dentro del libro, se pueden hallar los cantos y los conjuros de mujeres mayas que fueron soñados por ellas y así transmiten un corpus poético comunal que reside en la memoria colectiva. Después, con el tiempo, pude investigar más sobre la obra de Gitte Dæhlin, pude conocer su obra, sus esculturas y su compromiso social con la denuncia de las injusticias cometidas contra de la población local y de la terrible situación que atravesaban los refugiados de pueblos indígenas que habían llegado de Guatemala a principios de los años 80 del siglo pasado, un exilio provocado por la guerra y el genocidio que se estaba perpetrando en ese país.

El rostro maya que me observaba en la escultura del libro fue moldeado por una artista de tierras lejanas, Gitte Dæhlin, para resguardar las palabras de mujeres mayas de los Altos de Chiapas; esta escultura forma parte de una vasta obra que no puede leerse sin los veinte años que la artista pasó en San Cristóbal de las Casas y su compromiso con la denuncia social. Una de las coordinadoras del libro, la poeta Ambar Past, nacida en Estados Unidos, aprendió una de las lenguas mayas, el tsotsil, así pudo traducir los conjuros de mujeres mayas como Loxa Jiménez, María Tzu, Verónika Taki Vaj, Pasakawalak Kómes, Manwela Kokoroch entre otras mujeres que hacen arte con la palabra lejos del mundo de la escritura. El proceso de elaboración de esta obra que conjuga escultura y poesía, conjuros soñados, escritura y traducción, es una evidencia de colaboración entre mujeres que nacieron en distintas latitudes y situaciones sociales, a veces incluso contrastantes, y atravesadas por macro-sistemas como el colonialismo y el capitalismo. De este proceso de

oppressive relationships in today's world. Therefore, in this text I will put forward ideas around the possibilities that art has openeed up to knit together ties of solidarity with respect to the struggle of Indigenous peoples from this corner of the world. The book that gazes out through the face moulded by Gitte Dæhlin is one such demonstration of these artistic spaces of collaboration, where art can only come into being through solidarity.

A Seized Word

In Mexico, the place from which I write these lines, the word 'solidarity' has lost much of the force of its positive connotations preserved in other languages and contexts. During the six-year Carlos Salinas de Gortari Administration, from which the uprising of the Zapatista Army of National Liberation in Chiapas came to pass, a major official project was created in the late 1980s and early 1990s called the National Programme of Solidarity (PRONASOL). It constituted a programme of social aid that was often used for electoral gain and related to cases of corruption. The programme was aimed most notably at Indigenous peoples while a process was gestating that would culminate in the reform of an Article from Mexico's Constitution to allow the sale of communal land that, in many cases, was in the hands of indigenous communities. The National Programme of Solidarity was the social face of a government that, in

141 The song *Solidarity* was commissioned for the Programa Nacional de Solidaridad (PRONASOL) [National Program of Solidarity] in 1989 as part of the official propaganda of the government of Carlos Salinas de Gortari, President of Mexico back then. https://youtu.be/hCbnnewabpE accessed 17 August 2021.

practice, exacerbated social injustice. From the media, official propaganda employed the word 'solidarity' recurrently to speak of government projects. Singers were called upon to give voice to a song called 'Solidarity', used ad nauseum by governmental propaganda, radio and TV advertisements. A vast number of monuments symbolising the Solidarity Programme were scattered across the country.[141]

Thus, the word 'solidarity' was expropriated by the country's official discourse, its profound meaning snatched from daily use and its frame of reference inscribed in a system of meanings that were a far cry from social struggles, from art, and from people bolstering structures of collaboration to resist injustices. To express solidarity, in Mexico we began to use synonyms: 'collaboration', 'camaraderie', 'brotherhood', and words that were not tainted by the official conceit.

Yet, I believe it is possible and necessary to dislodge the word 'solidarity' and include it once again in a world of greater social justice. There is a need to reincorporate the word into the set of its original connotations, and to bind it anew to processes of artistic creation that can regenerate its most profound meanings.

creación artística conjunta surgió Conjuros y ebriedades. Cantos de mujeres mayas, uno de los libros más peculiares y, como dice la escritora mexicana Elena Poniatowska, uno de los libros más bellos del mundo. La creación artística, como se llama en lenguas occidentales, genera espacios en los que es posible que las personas puedan subvertir o imaginar subvertir las relaciones de opresión del mundo actual. En este texto plantearé algunas ideas en torno de las posibilidades que el arte ha abierto para tejer lazos solidarios en relación con la lucha de los pueblos indígenas de esta parte del mundo. El libro que mira desde un rostro moldeado por Gitte Dæhlin es una de las muestras de esos espacios artísticos de colaboración en donde el arte sólo puede nacer de la solidaridad.

Una palabra secuestrada

En México, desde donde escribo estas líneas, la palabra solidaridad ha perdido mucho de la fuerza de sus connotaciones positivas que conserva en otras lenguas y contextos. Durante el gobierno de Carlos Salinas de Gortari, sexenio durante el cual se dio el alzamiento del Ejército Zapatista de Liberación Nacional en Chiapas, se creó un gran proyecto oficial a finales de los años 80 y principios de los 90 del Siglo XX llamado "Programa Nacional de Solidaridad" (PRONASOL). Se trataba de un proyecto de asistencia social que, en muchas ocasiones, fue utilizado para conseguir ventajas electorales y estuvo relacionado con casos de corrupción. Este programa se dirigía en especial a los pueblos indígenas al mismo tiempo que se gestaba un proceso que culminaría con la reforma a un artículo de la Constitución del país para permitir la venta de las tierras ejidales que, en muchos casos, estaban en manos de los pueblos indígenas. El Programa Nacional de Solidaridad fue el rostro social de un gobierno que en los hechos agudizó la injusticia social. Desde los medios de comunicación, la propaganda oficial utilizaba, una y otra vez, la palabra "solidaridad" para hablar de los proyectos del gobierno; distintos cantantes fueron convocados para entonar una canción llamada "solidaridad" que fue repetida hasta el cansancio como propaganda gubernamental, así como los distintos anuncios publicitarios en radio y televisión.[144] La geografía del país fue sembrada con gran cantidad de monumentos que simbolizaban el programa Solidaridad.

De este modo, la palabra "solidaridad" fue expropiada por el discurso oficial, esta palabra y su profundo significado fue arrebatada del uso cotidiano y su referente fue inscrito en un sistema de significados que se hallaban lejos

144 Canción "Solidaridad" comisionada por el Programa Nacional de Solidaridad (Pronasol) en 1989 como parte de la propaganda oficial del gobierno del entonces presidente de México Carlos Salinas de Gortari. https://youtu.be/hCbnnewabpE visto el 17 de Agosto, 2021.

Asymmetrical Worlds

Is it possible to subvert power relations through solidarity in art in a deeply asymmetrical world? The relationships between people and, therefore, artists are mediated by large, hugely overlapping systems that include patriarchism, which generates sexism; colonialism, giving rise to racism; and capitalism, occasioning classism. These major systems are so entangled in reality that they operate as one sole mass, so that it is difficult to make out where the effects of one system start and another end. The artistic endeavour is not alien to these systems, which must be considered in order to create spaces of collaboration with the potential to question oppressive operations. Despite individual will, the people who make art are placed inside systems that put them in historically asymmetrical positions, which is why conceiving of the possibility of solidarity in art points to the need to create spaces in which social asymmetries can be reconsidered, at least for a time. It also leads us to consider that solidary art between people and communities placed asymmetrically by systems of oppression must always have these systems present to contemplate subverting them. If they are not taken into account, there is the danger that solidarity-seeking art verges on condescending charity and improper cultural appropriation, thereby fortifying structural asymmetries rather them throwing them into crisis. Art that decries systems of oppression, shines the spotlight on them or calls systems into question can become solidary art.

Solidary artistic creation has been key to the denouncement of oppressions suffered by Indigenous peoples – artistic advocacy has managed to condemn attacks on Zapatista communities in Chiapas, to name one example. The world's indigenous communities are people who have been subjected to colonisation and, in the process of structuring today's nation states, have remained constricted in a state or country that has generally denied them their right as nations without states. Under this premise, the Indigenous category is neither a cultural nor a strictly identity category; it is a historically situated political category. Of the thousands of years of Mixe history, for 500 years we have been called 'Indians', and, subsequently, we have spent 200 years since the creation of the Mexican state categorised as 'Indigenous'. Consequently, 'Indigenous' becomes a historical position inside the colonialist system, and not an essential characteristic. Seven hundred years ago, my people were Mixe people just as today, but they had not become 'Indigenous'. This fact raises a possibility: the possibility of a future in which we can continue to exist as Mixe people, as Mayan people, as Tzotzil people, without being considered Indigenous people, for the system of oppression propping up the 'Indigenous' category no longer works. Art can contemplate and imagine the possibilities of such a world.

de las luchas sociales, lejos del arte y lejos de las personas que mantenían estructuras de colaboración para resistir a las injusticias. Para expresar solidaridad, en México comenzamos a utilizar sinónimos: "colaboración", "compañerismo", "hermandad", entre otras palabras que no estuvieran contaminadas por el tufo oficialista.

Sin embargo, a pesar de lo sucedido, creo que es posible y necesario, desapropiar la palabra "solidaridad" y volver a incluirla en un mundo de significados cercanos a la creación y a la posibilidad de construir un mundo con mayor justicia social; es necesario volver a traer esa palabra al conjunto de sus connotaciones originales y, para cumplir con esa tarea, ligarla de nuevo a los procesos de creación artística que puedan regenerarle sus sentidos más profundos.

Mundos asimétricos

¿Es posible subvertir las relaciones de poder por medio de la solidaridad en el arte en un mundo profundamente asimétrico? Las relaciones entre las personas y, por lo tanto, entre los artistas, están mediadas por grandes sistemas profundamente imbricados como lo son el patriarcado que genera machismo, el colonialismo que ha generado el racismo y el capitalismo que ha generado el clasismo. Estos grandes sistemas se hallan tan mezclados en la realidad que operan como una sola masa en la que es muy difícil determinar dónde comienzan los efectos de un sistema o donde terminan los de los otros. El quehacer artístico no es ajeno a estos sistemas y es necesario tomarlos en cuenta para poder generar espacios de colaboración que tengan el potencial de cuestionar el funcionamiento de las opresiones. A pesar de la voluntad individual, las personas que hacen arte se hallan colocadas dentro de sistemas que los coloca en posiciones históricamente asimétricas. Por esta razón, para plantear la posibilidad de la solidaridad en el arte implica necesariamente crear espacios en los que las asimetrías sociales puedan ser replanteadas al menos momentáneamente.

Podemos pensar que un arte solidario entre personas o comunidades colocadas asimétricamente por los sistemas de opresión necesita tener siempre presente esos sistemas para poder plantear subvertirlos. Si no se toma esto en consideración se corre el riesgo que el arte que pretende ser solidario toque los límites de la caridad condescendiente, de la apropiación cultural indebida y que así fortalezca las asimetrías estructurales más que ponerlas en crisis.

One of the consequences of having been organised hierarchically as 'Indigenous' in Mexico, inside the system of colonial domination, is that the materials required for the correct operation of the capitalist system are extracted from our land. In this country, the state authorisations granted to mining companies and companies impacting our territories are large in number and are the grounds for multiple cases of resistance and struggles for ecosystems and life upheld by Indigenous peoples. When art can establish solidarity between initiatives and artists placed in different hierarchies by colonial systems, there is a need to spell out and draw attention to processes expropriating ecosystems and territories that underpin operations of plundering and oppression. I strongly believe that an approach that is aware of these asymmetries can generate suitable spaces of collaboration where art can emerge as solidary art. The proof, fortunately, is vast. It is true that art does not make social symmetries vanish, but it can become essential once more to signpost them and accentuate the solidarity needed in creating symmetrical and respectful relationships.

Territories of Collaboration

To set forth territories of collaboration in which solidary art can thrive, there is also a need to bear in mind that art is simply the western manifestation of multiple and varied processes of aesthetic creation, like the world's cultures. Forming the art canon in occidental tradition is explained, to a large degree, inside the patriarchal, colonialist and capitalist system: art history has chiefly focused on the work of male artists racialised as white and selected from heavily hierarchised social classes. In contrast to the creative phenomena of many Indigenous peoples, today the same artistic production in western culture is understood within the logic of capitalism: artworks are products with a monetary value and are turned into a commodity to be bought and sold. The notion of authorship is also important in the current climate since the system of artistic production orbits around the idea of author and, in that regard, a series of legal frameworks, created to protect the copyright of the said author which, if breached, can have serious legal repercussions. In this way, art is understood inside an economic and legal framework.

Conversely, in the aesthetic phenomena of Indigenous peoples, creative processes are inscribed into different logics. Akin to the incantations of Mayan women mentioned at the start, aesthetic creations are tied to dreams, healing processes, individual and community rituals, and with these different roles creations seldom become commodities that can be valued inside capitalist market logic. Moreover, the idea of authorship is not constricted by a legal framework granting official recognition to individually attribute a work. For instance, the Tzeltal shaman incantations (also Chiapas

El arte que denuncia los sistemas de opresión, que los pone en relieve o que cuestiona los sistemas es el que puede convertirse en arte solidario.

En el caso de las opresiones que sufren los pueblos indígenas, la creación artística solidaria ha sido muy importante en la denuncia de las opresiones. El acompañamiento artístico ha logrado denunciar los ataques a las comunidades zapatistas en Chiapas por mencionar un ejemplo. Los pueblos indígenas del mundo son aquellos pueblos que sufrieron colonización y que en el proceso de conformación de los estados-nacionales actuales quedaron encapsulados en un estado o país que, en general, ha negado a los pueblos indígenas sus derechos como naciones sin estados. Bajo esta premisa, la categoría indígena no es una categoría cultural ni solamente identitaria, es una categoría política históricamente situada. De los miles de años de historia mixe, quinientos años hemos sido nombrados "indios" y después de la creación del estado mexicano llevamos casi doscientos años categorizados como "indígenas". En este sentido, "indígena" se convierte en una posición histórica dentro del sistema colonialista, no es un rasgo esencial. Hace setecientos años, mi pueblo era el pueblo mixe como lo es ahora, pero aún no se había convertido en "indígena", este hecho mismo plantea una posibilidad: la posibilidad de un futuro en el que podamos seguir existiendo como pueblo mixe, pueblo maya, o pueblo tsotsil sin que seamos considerados pueblos indígenas porque el sistema de opresión que sostiene la categoría "indígena", ha dejado de funcionar. El arte puede plantear e imaginar las posibilidades de un mundo así.

Una de las consecuencias de haber sido jerarquizados como "indígenas", en México, en el sistema de dominación colonial es que los insumos necesarios para el funcionamiento del sistema capitalista son extraídos de nuestros territorios. En este país, las concesiones que el estado ha otorgado a compañías mineras o a empresas que afectan nuestros territorios son numerosas y a ello se deben las múltiples resistencias y luchas por los ecosistemas y por la vida que los pueblos indígenas han sostenido. Cuando el arte puede plantear solidaridad entre iniciativas y artistas que el sistema colonialista ha colocado en distintas jerarquías es necesario enunciar y poner sobre la mesa los procesos de afectación de los ecosistemas y los territorios de los pueblos pues son parte fundamental de cómo funciona el despojo y la opresión. Creo firmemente que un acercamiento consiente de todas estas asimetrías puede generar espacios de colaboración adecuados donde el arte puede surgir como arte solidario. Las evidencias, por fortuna, son muchas. Es verdad que no hace que las simetrías sociales desaparezcan, pero el arte se puede volver

dwellers) compiled in the book *La palabra fragante: cantos chamánicos tzeltales* (The Fragrant Word: Tzeltal Shamanic Chants), by Spanish anthropologist Pedro Pitarch, reflect community heritage, whereby each specialist in processes of healing the body preserves a poetic corpus in the form of chants that is constantly being recreated and does not fall within the logic of copyright in the sense of individual authorship.[142]

Tzeltal shamans' processes of healing are bound to the poetry they use in chants, and differ significantly from literary art. As John Guillory points out in his book *Cultural Capital: The Problem of Literary Canon Formation*, while western literature began towards the end of the eighteenth century with the rise of the bourgeoisie – alongside capitalism – poetic creation in many Indigenous communities is closely linked to other community logics, to healing and dreams – as in Mayan incantations – to rituals, the call of natural elements or the protection of land, such as the poetry of the Mixe people.[143] Western tradition has been witness to an assembled system of validation and the creation of a canon that is part of the market (works to be sold), an academic system that studies artistic phenomena, a system of biennials, festivals and international awards that recognise an artwork and a person as an artist.

In many Indigenous communities, the systems of validation in the community that recognise the 'practitioners' of poetry and

other aesthetic manifestations such as traditional dance or the creation of ceremonial masks are put in place differently: when people are recognised as specialists in practising a tradition, it is conceived as a collective tradition that can always be subject to intervention or innovation, innovation that will also come to form part of collective property. It is important to note that the poetic and community corpus of these specialists does not need writing, for the support comes through the memory of everyone safeguarding it. Experts in creative processes are always linked to the purposes needed for the community in which they arise: shamans adept at healing for the Tzeltal people; conjurations needed for a particular purpose for Mayan women; *huehes* in Zapoteca tradition, using poetry to make marriage possible; *xëëmaapy* in Mixe culture to give words as an offering to nature to protect territory, water and natural elements, to mention but a few examples. Poetic manifestations play specific roles that are of great value to the social context in which they were created; in each context, these specialists have different names, just as experts in aesthetic manifestations receive the generic name 'artists' and specific name 'poets' in the west.

In the face of these differences there is a need to examine the possibilities of collaboration between such divergent aesthetic traditions to create spaces of solidarity. One such possibility is illustrated in the process of putting together *Conjuros y ebriedades*, for

142 Pedro Pitarch, *La palabra fragante: cantos chamánicos tzeltales*. Mexico City: Artes de México, 2013.
143 John Guillory, *Cultural Capital: The Problem of Literary Canon Formation* (Chicago: University of Chicago Press, 1993).

fundamental para evidenciarlas y poner de relieve la solidaridad que necesita de crear relaciones simétricas y respetuosas.

Territorios de colaboración

Para plantear territorios de colaboración en donde pueda florecer el arte solidarios es necesario también tomar en consideración que el arte es solo la manifestación occidental de procesos de creación estética múltiples y variados como lo son las culturas del mundo. La formación del canon artístico en la tradición occidental se explica en gran medida dentro del sistema patriarcal, colonialista y capitalista: la historia del arte se ha enfocado sobre todo en el trabajo de autores varones racializados como blancos y que se seleccionan desde clases sociales altamente jerarquizadas. A diferencia de lo que sucede en los fenómenos creativos de muchos pueblos indígenas, en la actualidad, la misma producción artística de la cultura occidental se entiende dentro de la lógica del capitalismo: las obras artísticas son productos que tienen un valor monetario y, convertidos en mercancías, pueden comprarse y venderse. La noción de la autoría es también muy importante en la actualidad, el sistema de producción artística gira en torno de la idea del autor y al respecto se han creado una serie de marcos jurídicos que protegen los derechos de autor y que, si se infringen, pueden acarrear serias consecuencias legales. El arte entonces se entiende dentro de un entramado económico y legal.

Por el contrario, en el caso de los fenómenos estéticos de los pueblos indígenas, los procesos creativos se inscriben en lógicas distintas; como en el caso de los conjuros de las mujeres mayas que mencioné al principio, las creaciones estéticas están ligadas a sueños, procesos de sanación, rituales individuales y comunitarios; con estas distintas funciones las creaciones rara vez se convierten en mercancías que puedan ser cotizadas en la lógica del mercado capitalista. Por otro lado, la idea de la autoría no está constreñida por un marco legal que otorgue reconocimiento oficial de la atribución individual de una obra. Por ejemplo, los cantos chamánicos tzeltales (que habitan también en Chiapas) recogidos en el libro La palabra fragante: cantos chamánicos tzeltales por el antropólogo español Pedro Pitarch constituyen un patrimonio comunitario, cada una de las personas especialistas en los procesos de sanación del cuerpo resguarda un corpus poético en forma de cantos que está siendo constantemente recreado y que no se inscribe dentro de la lógica de los derechos de autor entendidos como autoría individual.

which Dæhlin crafted the front-cover face and in which Ambar Past, Xalik Guzmán and Petra Hernándes were named 'fathermothers' of this colourful book-artwork. I believe it is possible to posit that the book is a solidary translation that created a propitious space for shaping a symmetrical territory. On one side, we encounter the conjurations and incantations inhabiting the dreams of Mayan women through a support not in writing, but in memory and orality, the supports in which these creations are contained; and on the other, the process of translation – or maybe 'passage' would be a more appropriate word – in which these oneiric and oral creations are captured in a written support and take the form of a book. The book eschews logics of mass production and is crafted as an artisan object. There is a process in which the incantations and conjurations pass over to the logic of book creation, yet it is a book created by hand and one that nurtures voices in both the original languages and the language into which it is translated. The book as an artefact and as a process is an example of the possibilities of creating a territory of collaboration where the people who are part of Indigenous populations can encounter those placed in privileged places of expression by dominant systems. The book and Dæhlin's face on the cover creates a middle ground that becomes a point of convergence between writing and memory and writing and dreams, between two systems of aesthetic creation. Once this meeting point has been built,

solidarity that needs symmetrical relations can issue forth with a capacity to consider a world that is possible.

Solidary art is at once necessary and vital because, in addition to its power to denounce, it has the potential to create spaces that halt, transiently at least, asymmetries in which systems of oppression have positioned populations and peoples – spaces with the potential to bring back the word 'solidarity' and divest it of its state-imposed burdens. Solidary art can say 'no' emphatically to systems ordering reality and create territories awaiting action, where a different world can at least be articulated, and, in this articulation, can lay bare the injustices of the world in which we live. That is what I recall as I contemplate, once again, the face safeguarding the incantations and dreams of Mayan women from Chiapas. I consider the possibilities of collaboration for women situated in different places by hierarchies of oppression to form creative spaces together and – why not? – in solidarity that is both fitting and necessary, where all women's voices and gazes are necessary and complementary. That in itself is an incantation.

Los procesos de sanación que los chamanes tzeltales se ligan con la palabra poética que los chamanes despliegan en los cantos y que se diferencia del arte literario en gran medida. Mientras que la literatura occidental, como apunta John Guillory en su libro titulado *Cultural Capital: The Problem of Literary Canon Formation*, comenzó hacia finales del siglo XVIII con el surgimiento de la burguesía, es decir, acompañando al capitalismo, la creación poética en muchos de los pueblos indígenas se halla estrechamente ligada a otras lógicas comunitarias, a la sanación, a los sueños como en el caso de los conjuros mayas, a los rituales y al llamado de los elementos de la naturaleza o a la protección del territorio como sucede con la palabra poética en el pueblo mixe. En la tradición occidental, se ha armado un sistema de validación y de creación de un canon del que forma parte el mercado (las obras pueden venderse), un sistema académico que estudia el fenómeno artístico, un sistema de bienales, festivales, premios internacionales que reconocen a una obra y a una persona como artista.

En muchos de los pueblos indígenas, los sistemas de validación que reconocen en comunidad a los "ejercedores" de la palabra poética y de otras manifestaciones estéticas como las danzas tradicionales o la creación de máscaras rituales se constituyen de otra manera: aun cuando se les reconoce como personas expertas en ejecutar una tradición, ésta se concibe como una tradición colectiva que puede estar sujeta siempre a intervención e innovación, innovación que pasará, a su vez, a formar parte de la propiedad colectiva. Es importante apuntar también que el corpus poético y comunitario de estos especialistas no necesita de la escritura, su soporte es la memoria de todas las personas que la resguardan. Las personas expertas en los procesos creativos están siempre ligadas a funciones necesarias a la comunidad en la que surge: chamanes expertos en sanación para el pueblo tzeltal, conjuros necesarios para conseguir un fin para las mujeres mayas, huehes en la tradición zapoteca en las que se utiliza la palabra poética para hacer posible un matrimonio, xëëmaapy del pueblo mixe que ofrendan su palabra a la naturaleza para la protección del territorio, del agua y de los elementos naturales, por mencionar algunos ejemplos. Las manifestaciones poéticas tienen funciones determinadas que son muy valiosas para el contexto social en el que fueron creados. En cada contexto, estos especialistas tendrán nombres distintos, así como en occidente estas personas especialistas en las manifestaciones estéticas reciben el nombre de "artistas" en general y "poetas" en particular.

Ante estas diferencias, resulta necesario plantearse cuáles son las posibilidades de colaboración entre tradiciones estéticas tan distintas entre sí para crear espacios solidarios. Una posibilidad ha quedado ilustrada en el proceso de elaboración del libro *Conjuros y ebriedades. Cantos de mujeres mayas* para el que la artista Gitte Dæhlin construyó un rostro en portada y en el que Ambar Past, Xalik Guzmán y Petra Hernándes se nombran "padremadres" (padre + madre) de este peculiar libro-pieza de arte. Creo que es posible postular que este libro se trata de una traducción solidaria que creó un espacio propicio para crear en un territorio simétrico. Por un lado, hallamos los conjuros y cantos de mujeres mayas que habitan en los sueños de ellas y que no tienen un soporte en la escritura, la memoria y la oralidad son los soportes en los que estas creaciones están contenidas, por otro lado, hay un proceso de traducción, tal vez "traslación" sería una palabra más adecuada, en la que estas creaciones oníricas y orales se plasman en un soporte escrito y adquieren la forma de un libro. Este libro escapa de las lógicas de la producción en serie y se crea como objeto de forma artesanal. Hay un proceso en el que los cantos y los conjuros pasan a la lógica de la creación de un libro, pero es un libro que se crea con las manos y mantiene las voces tanto en el idioma original como en el idioma al que ha sido traducido. Este libro como artefacto y como proceso ejemplifica las posibilidades de crear un territorio de colaboración en el que personas que pertenecen a pueblos indígenas puedan encontrarse con personas que fueron colocadas en lugares de enunciación privilegiados por los sistemas dominantes. Este libro el rostro moldeado por Gitte Dæhlin en la portada crea un espacio intermedio que se convierte en un punto de encuentro entre la escritura y la memoria, entre la escritura y los sueños, entre dos sistemas de creación estética. Una vez que ese punto de encuentro se ha construido, la solidaridad que necesita de relaciones simétricas puede surgir con su capacidad de plantear un mundo posible.

El arte solidario es necesario y fundamental porque además de la potencia de su denuncia tiene el potencial de crear espacios que suspenden, al menos temporalmente, las asimetrías en las que los sistemas de opresión han colocado a los pueblos y a las personas. Tienen el potencial de traer de vuelta la palabra "solidaridad" y quitarle las cargas que el estado le impuso. El arte solidario puede decir un rotundo "no" los sistemas que están ordenando la realidad y crear territorios en suspenso en los que un mundo distinto pueda al menos ser enunciado y, en esa enunciación, hacer evidente las injusticias del mundo en el que vivimos. Eso es lo que recuerdo mientras contemplo, una vez más, el rostro que resguarda los cantos y los sueños de las mujeres mayas de Chiapas, las posibilidades de colaboración de mujeres colocadas en lugares distintos por las jerarquías de opresión que crean espacios creativos en conjunto y, por qué no, en solidaridad, una solidaridad propia y necesaria, en donde las voces y las miradas de todas son necesarias y complementarias. Eso ya en sí mismo es un conjuro.

Voy a dar un azadonazo en tu cara, Tierra Sagrada.
Voy a meterme en tu cuerpo.

Voy a enterrar tu santo cuerpo.
Voy a meterme en tu carne.

Voy a sembrar mi milpa.
Voy a sembrar mi trabajo.

La mitad de mis padres,
la mitad de mis madres,

cargan en sus manos,
cargan en sus espaldas,

algo que está vivo,
algo que está completo.

Sus redes están llenas,
sus morrales tienen cosas adentro.

Les pesan sus costales
cuando van por donde andan.

Voy a dar un azadonazo en tu cara.
Voy a meterme en tu cuerpo.

Quiero que llenes mi jícara, Tierra Sagrada.
Quiero que llenes mi olla.

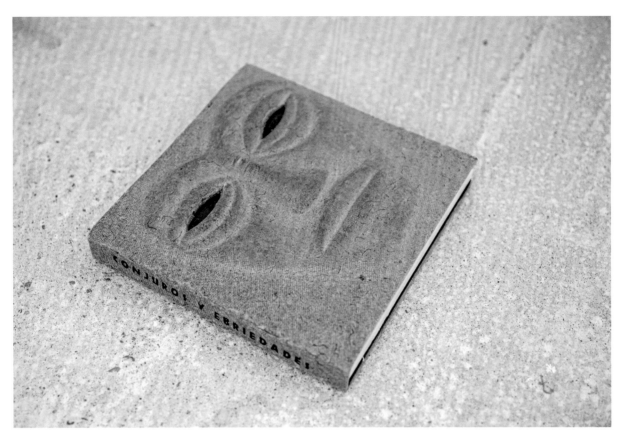

Conjuros y ebriedades: cantos de mujeres mayas, edited by Ámbar Past, Xalik Guzmán Bakbolom and Petra Hernándes (San Cristóbal de Las Casas: Taller leñateros, 1998). Photo: Eirin Torgersen.

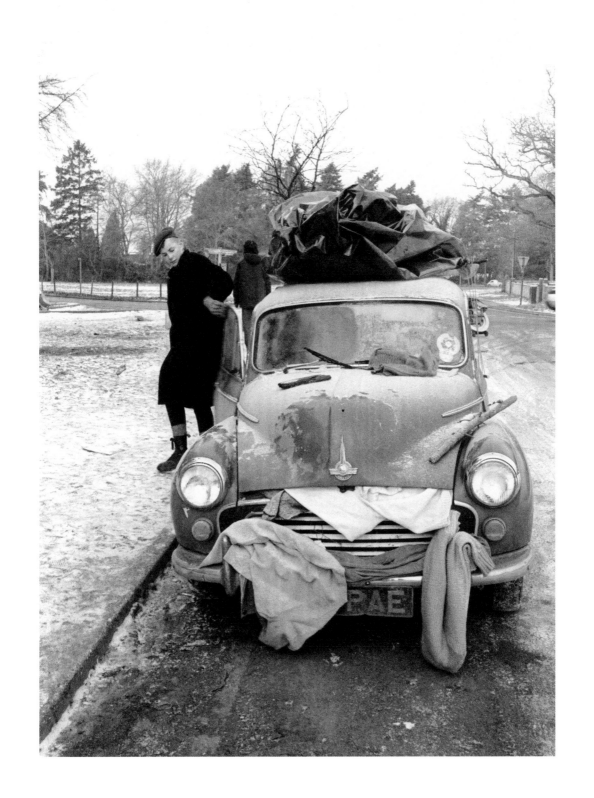

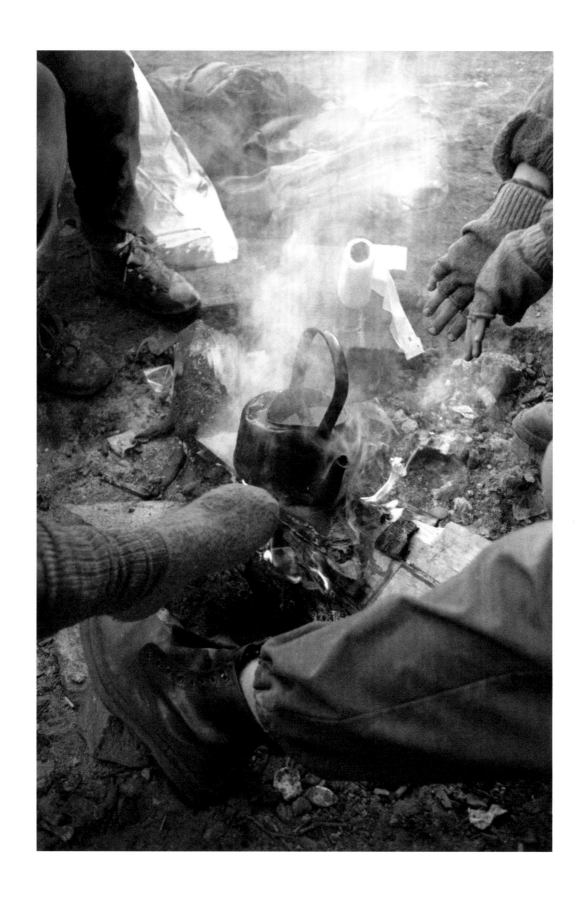

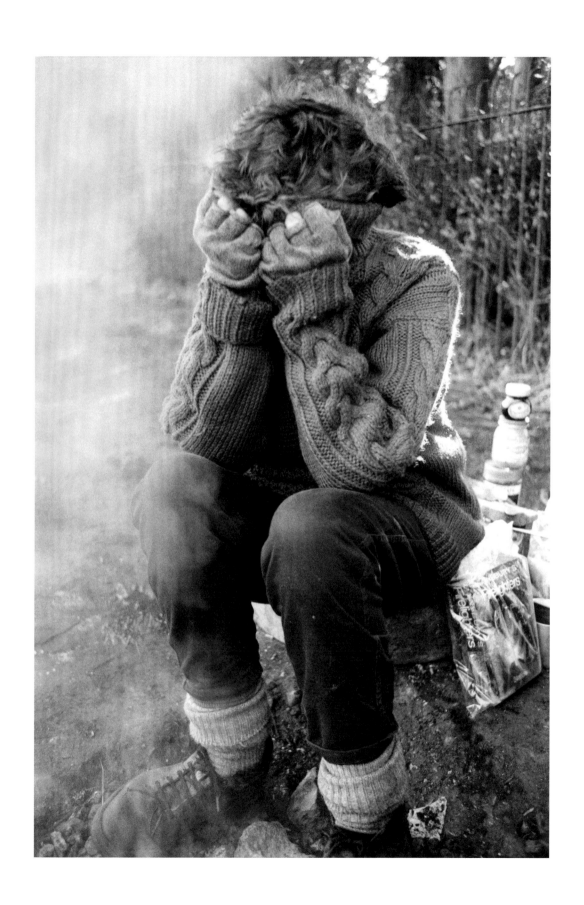

Wendy Carrig

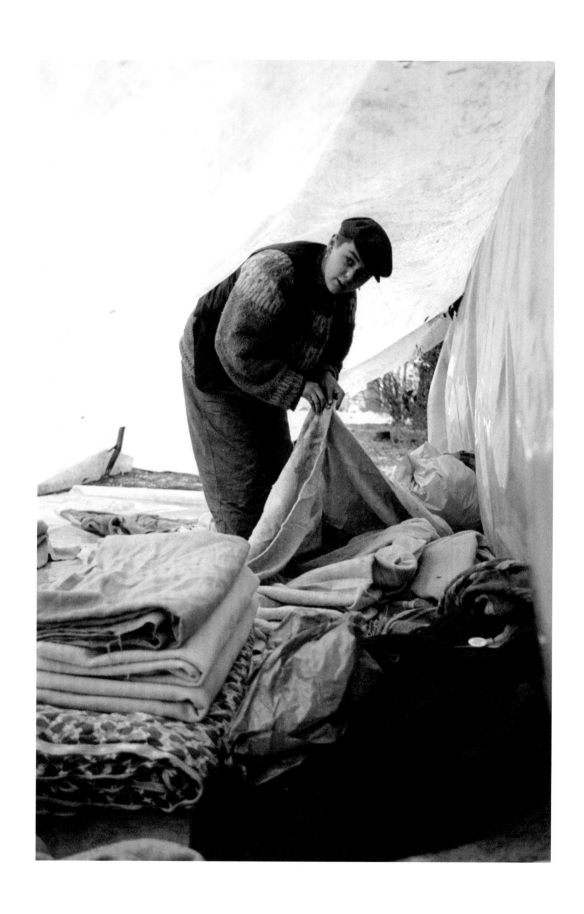

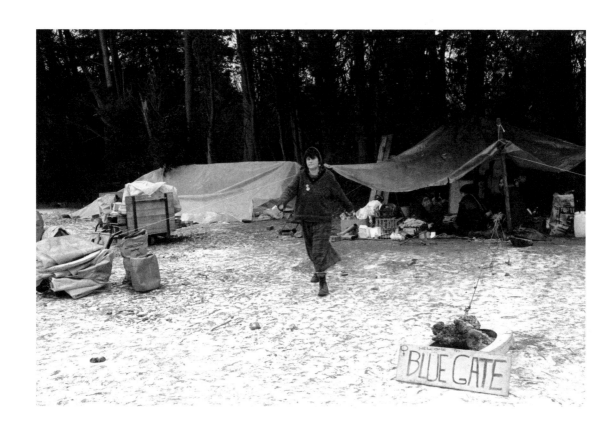

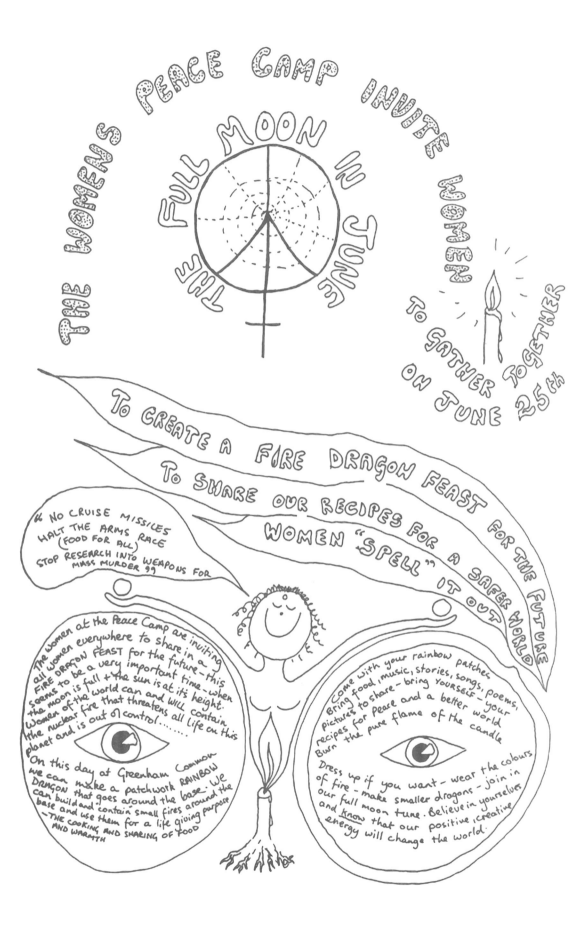

Invitations to *The Fire Dragon Feast for the Future*, at Greenham Common Peace Camp, Midsummer 1983. From the files of Mie Bak Jakobsen, Women for Peace. http://www.fredsakademiet.dk/abase/sange/greenham/sigrid.htm accessed 20 August 2021.

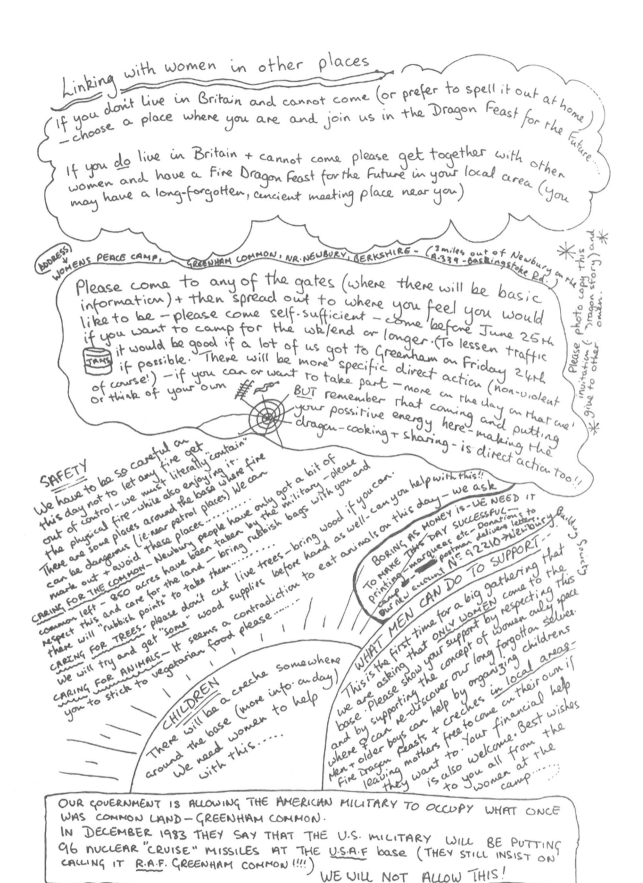

Linking with women in other places

If you don't live in Britain and cannot come (or prefer to spell it out at home) — choose a place where you are and join us in the Dragon Feast for the Future...

If you do live in Britain + cannot come please get together with other women and have a Fire Dragon Feast for the Future in your local area (you may have a long-forgotten, ancient meeting place near you)

(ADDRESS) WOMENS PEACE CAMP, GREENHAM COMMON, NR. NEWBURY, BERKSHIRE — (3 miles out of Newbury on the A.339 - Basingstoke Rd.)

Please photo copy this invitation ('Dragon story) and give to other women.

Please come to any of the gates (where there will be basic information) + then spread out to where you feel you would like to be — please come self-sufficient — come before June 25th if you want to camp for the wk/end or longer. (To lessen traffic it would be good if a lot of us got to Greenham on Friday 24th if possible. There will be more specific direct action (non-violent of course!) — if you can or want to take part — more on the day on that one) or think of your own BUT remember that coming and putting your positive energy here — making the dragon — cooking + sharing — is direct action too!!

SAFETY
We have to be so careful on this day not to let any fire get out of control — we must literally "contain" the physical fire — while also enjoying it. There are some places around the base where fire can be dangerous (i.e. near patrol places) We can mark out + avoid these places.........

CARING FOR THE COMMON — Newbury people have only got a bit of common left — 850 acres have been taken by the military — please respect this and care for the land — bring rubbish bags with you and there will "rubbish points" to take them.........

CARING FOR TREES — please don't cut live trees — bring wood if you can. We will try and get "some" wood supplies before hand as well — can you help with this!!

CARING FOR ANIMALS — It seems a contradiction to eat animals on this day — we ask you to stick to vegetarian food please.........

BORING AS MONEY IS — WE NEED IT TO MAKE THIS DAY SUCCESSFUL — printing — marquees etc — Donations to camp — postman delivers letters OUR NEW account N° 92210→Newbury Building Society

WHAT MEN CAN DO TO SUPPORT —
This is the first time for a big gathering that ONLY WOMEN come to the base. Please show your support by respecting this we are asking that by supporting the concept of women only space and by supporting the concept of women only space where ? can re-discover our long forgotten selves. Men + older boys can help by organizing childrens Fire Dragon Feasts + creches in local areas — leaving mothers free to come on their own if they want to. Your financial help is also welcome. Best wishes to you all from the women at the camp......

CHILDREN
There will be a creche somewhere around the base (more info on day) We need women to help with this......

OUR GOVERNMENT IS ALLOWING THE AMERICAN MILITARY TO OCCUPY WHAT ONCE WAS COMMON LAND — GREENHAM COMMON.
IN DECEMBER 1983 THEY SAY THAT THE U.S. MILITARY WILL BE PUTTING 96 NUCLEAR "CRUISE" MISSILES AT THE U.S.A.F base (THEY STILL INSIST ON CALLING IT R.A.F. GREENHAM COMMON !!!!) WE WILL NOT ALLOW THIS!

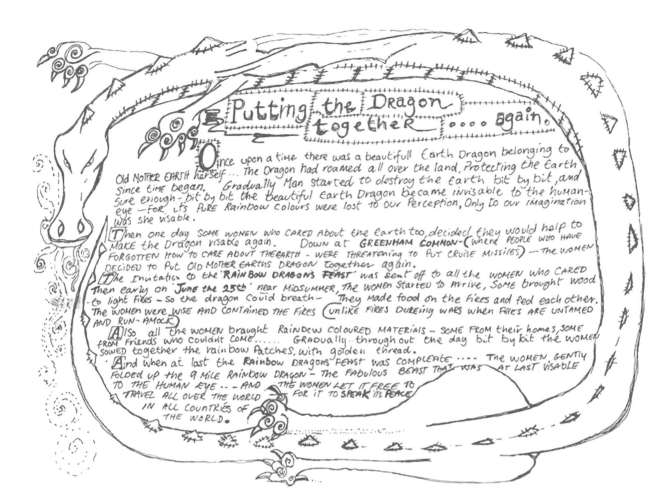

Putting the Dragon togetheragain.

Once upon a time there was a beautifull Earth Dragon belonging to Old MOTHER EARTH herself ... The Dragon had roamed all over the land, Protecting the Earth since time began. Gradually Man started to destroy the earth bit by bit, and sure enough - bit by bit the beautiful Earth Dragon became invisable to the human-eye - For its PURE Rainbow colours were lost to our Perception, Only to our imagination was she visable.

Then one day SOME WOMEN who CARED About the earth too, decided they would help to make the Dragon visable again. Down at GREENHAM COMMON-(where PEOPLE WHO HAVE FORGOTTEN HOW TO CARE ABOUT THE EARTH - WERE THREATENING TO PUT CRUISE MISSILES) — THE WOMEN DECIDED TO PUT OLD MOTHER EARTHS DRAGON Together again.

The Invitation to the 'RAINBOW DRAGONS FEAST' was sent off to all the WOMEN WHO CARED Then early on 'JUNE the 25th' near MIDSUMMER, The women started to arrive, Some brought wood to light fires - So the dragon could breath— They made food on the fires and fed each other. The WOMEN were WISE AND CONTAINED THE FIRES (UNLIKE FIRES DUREING WARS when FIRES ARE UNTAMED AND RUN-AMOCK)

Also all the WOMEN braught RAINBOW COLOURED MATERIALS - SOME FROM their homes, SOME FROM friends who couldnt COME...... GRADUALLY through out the day bit by bit the WOMEN SOWED together the rainbow Patches, with golden thread.

And when at last the RAINBOW DRAGONS FEAST was COMPLEATE THE WOMEN GENTLY FOLDED UP the 9 MILE RAINBOW DRAGON - The FABULOUS BEAST THAT WAS AT LAST VISABLE TO THE HUMAN EYE ... AND THE WOMEN LET IT FREE TO TRAVEL ALL OVER THE WORLD FOR IT TO SPEAK ITS PEACE. IN ALL COUNTRIES OF THE WORLD.

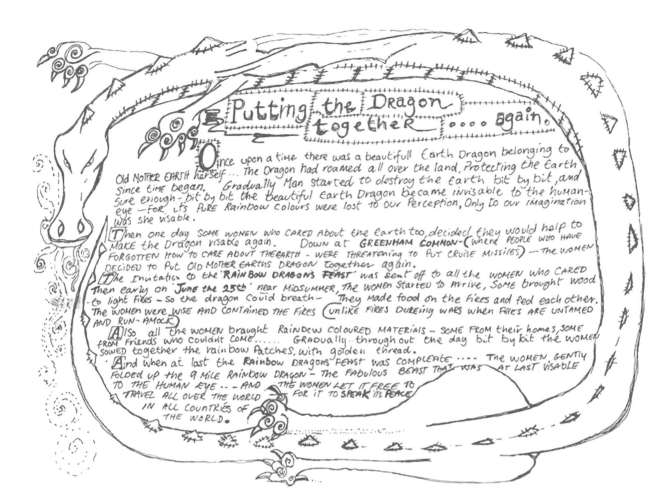

Art and Solidarity Reader

Map from the booklet prepared by unnamed Greenham women in 1984, from the archive donated to MayDay Rooms by Gwyn Kirk. Reprinted by permission of the donor and MayDay Rooms.

234

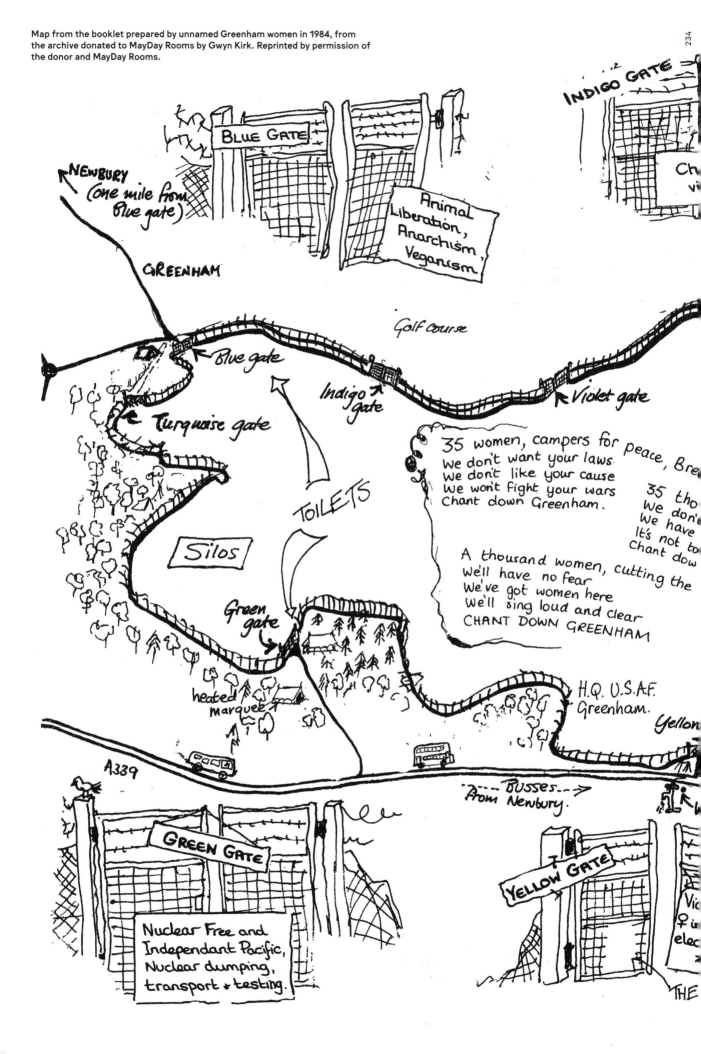

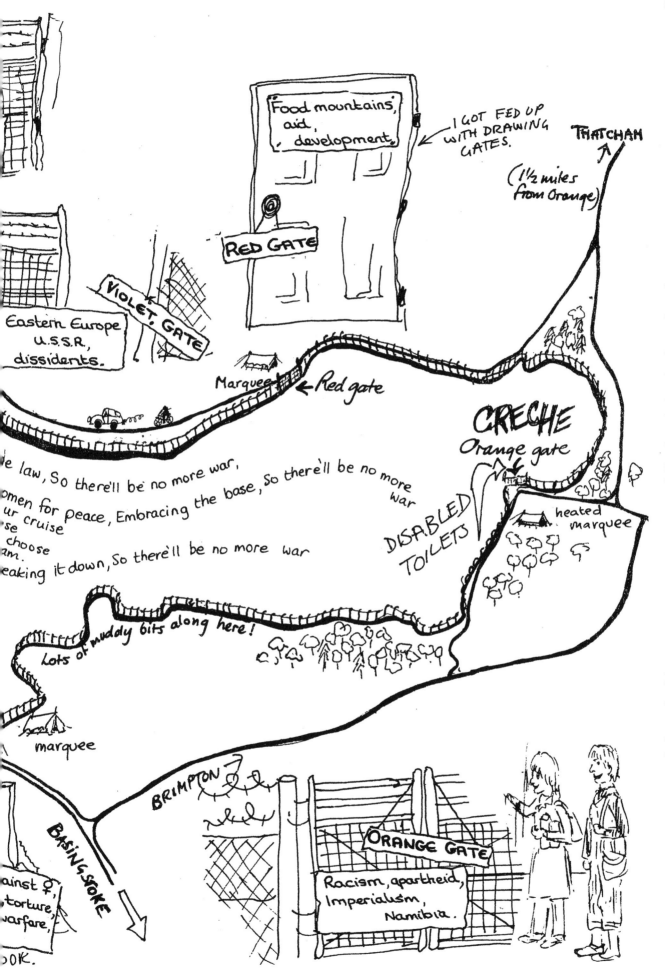

'Food mountains', aid, development.

I GOT FED UP WITH DRAWING GATES.

THATCHAM

(1½ miles from Orange)

RED GATE

VIOLET GATE

Eastern Europe U.S.S.R., dissidents.

Marquee ← Red gate

CRECHE Orange gate

DISABLED TOILETS

heated marquee

e law, So there'll be no more war,

omen for peace, Embracing the base, So there'll be no more war

ur cruise

se

choose

am.

eaking it down, So there'll be no more war

Lots of muddy bits along here!

marquee

BRIMPTON

BASINGSTOKE

ORANGE GATE

Racism, apartheid, Imperialism, Namibia.

ainst of

torture,

arfare,

OK.

Facsimiles from the Greenham Common Peace Camp

2. World-Building Solidarities

The Greenham Factor, 1984 was a booklet containing photos, stories and testimonies, published by Greenham Print Prop. It was used as a fundraising source and as publicity for the cause and was available at many info shops and radical bookstores.

THE
GREENHAM FACTOR

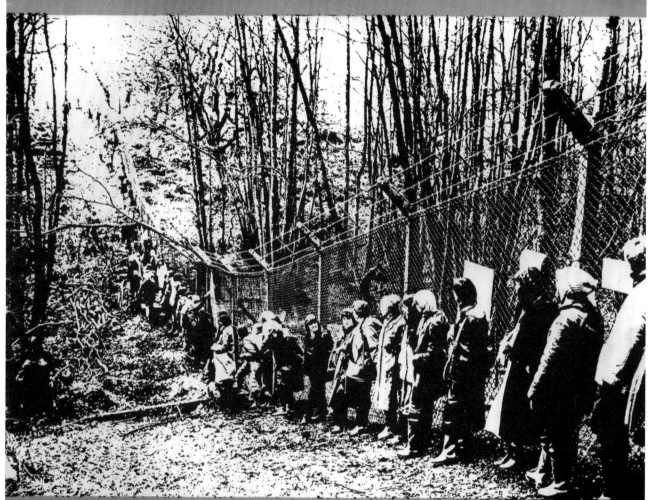

It is impossible to ignore the emergence of a new factor in recent opinion polls on the nuclear issue: the women of Greenham Common.

£1
INCLUDES POSTER

'The idea of the march was a little notice in Peace News about a women-led march from Copenhagen to Paris which I noticed whilst on a leaflet writing party to persuade our Council to go nuclear-free (they did). What a nice idea to have one here — everyone agreed, but no one wanted to "do" it because it would be too much work. Nor did I, but the idea just refused to go away so in the end I gave in to persistent internal pestering and announced that I would walk from somewhere in Wales to somewhere, like Greenham Common, in England with anyone else that wanted to come.

About forty of us assembled in Cardiff on August 26th, and the first thing that struck us was our variety. The more we discovered of ourselves the more impressed we became — by the numbers of women, for instance, for whom coming on the march had been difficult, involving elaborate arrangements over child-care or jobs, or giving up a holiday. Simply to discover that this prim-looking grandmother, this cheerful G.P., this nervous schoolgirl, this single-parent mother of five, took the threat to our future seriously enough to respond to a call to action coming not from any known organisation but from an unknown indivi-

dual living in an obscure rural corner of these isles gave us courage. This faith is important, for the potential of "the movement" to rise to the rhetoric about The Greatest Challenge in the History of Mankind is no more than the potential of these miserable individuals, with dinner to cook and too much to do already, and a deep-seated lack of faith in themselves and others ...

By the second half of our long walk in the heat wave, the atmosphere was like a kind of force-field within which obstacles served only to strengthen determination and

policemen relaxed, became human and danced with us to the tune of "No More Hiroshimas" . . . What I believe we experienced was something of that creative spirit, that power of mimesis, evoked by our distant ancestors when they drew pictures to overcome their fear of the huge powerful animals that surrounded and threatened them — the woolly mammoth, the sabre-toothed tiger. They drew it and danced and in this way they came to believe it *could be done* — these powerful creatures could be killed.'

Ann Pettitt

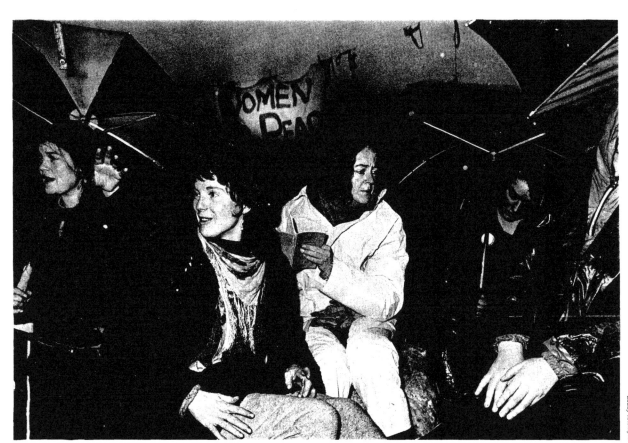

Lesley McIntyre

'We aren't going away. We'll be there for as long as it takes.'

1981

August 28 - Sept 5 - 'Women for Life on Earth' march from Cardiff to Greenham Common, a distance of 110 miles.

Sept 5 - Four women chain themselves to the fence at the main gate. They demand a live televised debate on Cruise between women on the march and a Ministry of Defence (M.O.D.) representative. From this direct action, the Women's Peace Camp is born.

Dec 12 - A march in the snow into Newbury to join a torchlight procession of Newbury people on the anniversary of the NATO decision in 1979 to accept US controlled Cruise missiles in Britain (and other European countries).

Dec 21 - Women prevent work on sewers, which are part of Cruise preparations, by sitting in front of machinery.

1982

Jan 18 - 'Keening' outside House of Commons on opening of Parliament to warn politicians to rethink nuclear policy.

Jan 20 - Newbury District Council gives camp two weeks eviction notice.

Feb 1 - As part of eviction strategy, women at the camp decide only women will live there, and men are invited to visit during the day.

March 21 - Celebration of Spring Equinox. About 10,000 people go to base to protest against Cruise missiles. 24-hour blockade by 300 women. 34 arrests.

May - High Court eviction order. Women block gate for two weeks until camp is forcibly removed from council-controlled common land. It takes 9 hours to destroy completely the camp which moves to Ministry of Transport (M.O.T.) land nearer to road. 5 arrests and 4 women spend week in prison because they refuse to keep the peace in the terms of the court.

June 6 - Greenham women speak at CND rally in Hyde Park.

June 7 - 80 women stage die-in outside Stock Exchange. All roads to Stock Exchange are blocked for 15 minutes during rush hour.

June 8 - Women keen warning to MPs as

Reagan speaks at House of Commons.

August 6 - Hiroshima Day. 10,000 stones are placed on Newbury War Memorial.

August 9 - Nagasaki Day. Women enter base and give commander an origami crane, symbol of hope for peace.

August 27 - M.O.T. eviction order ultimatum. Women occupy M.O.D. sentry box and sing-song answer the phone until 18 are arrested and charged with 'behaviour likely to cause a breach of the peace'.

Sept 28 - Second eviction. M.O.T. dumps thousands of rocks over camp to prevent women from returning. Camp begins again on original piece of council land.

Oct 3 - Sewage pipe work stopped by women who lie down in front of machines and in ditches woven over with webs until they are dragged away and arrested.

Nov 15 - Sentry box trials. 23 women go to prison for 14 days.

Nov 17 - Sewer pipe trials. More women go to prison for 14 days for breach of the peace.

Dec 12 - At least 30,000 women embrace the 9 mile fence around the base and shut it down. Fence is decorated with symbols of life.

Dec 13 - Blockade of all gates. Some women go into base and plant snowdrops.

1983

Jan 1 - At daybreak women climb over fence and dance on top of silos. 44 are arrested.

Jan 17 - Women lobby MPs and sing in House of Commons.

Jan 22 - 3 women arrested for putting up tent at Blue Gate.

Jan 24 - 15 women arrested for blockading Green Gate.

Feb 7 - Heseltine visits Newbury. Much action.

Feb 15-16 - New Year's trials.

Feb 21 - Blue Gate tent trial.

Feb 28 - Green Gate blockade trial.

March 10 - High Court order for third eviction. Women move camp again - back to M.O.T. land - a distance of 50 yards.

from Jill Tweedie. *Guardian* 16.11.82.
'Men accuse women of being emotional about the nuclear menace. I came here because of the little girl who took nine hours dying in her mother's arms after Nagasaki, her skin hanging off, saying "Mama, I'm cold". And because of the napalmed girl running down the road in Vietnam. I need no other reasons, and those seem to me quite logical.'

A grandmother, Greenham Peace Camp

'I'm forty-four. I can't stand much more of this.'

Arlene, Greenham Peace Camp

'I have borne and nursed three children and as a mother I will continue to insist on the right to life of both my own and every other child on this planet – including the 12 million who die every year of starvation while we spend £11 million a minute on arms. As a woman I will continue to defy the British state's policy of pre-meditated mass murder and as a historian I demand the *opportunity* for history to continue.'

Susan, Rhondda Valley

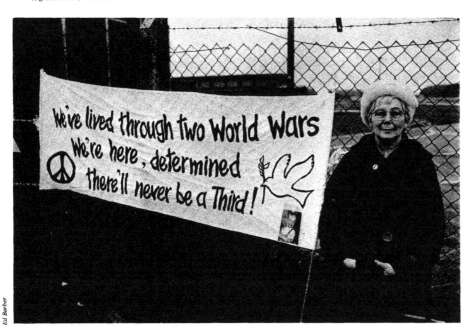

Ed Barber

'I'm not a feminist and I'm not radical. I'm just a woman who's fighting for her life. It's that simple for me. I have nothing to lose and everything to gain.'

Simone, Greenham Peace Camp

'A woman in Russia is the same as myself, the same emotions, leading the same sort of life. In no way will I be part of anything that will murder her . . .'

Sarah, Greenham Peace Camp

'They say better dead than Red, and I say I don't want the world to end because *they* would rather be dead.'

'Studying philosophy began to look like some kind of luxury. We stopped at Molesworth and I knew then that someone had to be living at these bases permanently. I went away planning how to get back. It was an odd feeling hearing about the Greenham women and knowing people were doing what was just a figment of our imagination. We had planned to come at Easter but when we heard the Greenham women were digging in for the winter, it seemed rather weak-kneed to wait. So we arrived here on December 28th (1981).'

Jean, Molesworth Peace Camp

'I cannot teach Peace Studies as a subject because they would be "political". War, though, is on the school curriculum under the subject of History.'

Inger, Greenham Peace Camp

'I am a pacifist and member of the Society of Friends and it seemed to me that the women of Greenham were doing something for me, something I'd be doing myself if I was younger. But I went down to the fence and put my grandchildren's picture on it. It seemed the only thing I could do.'

Connie, Newbury court, 15th Feb. 1983

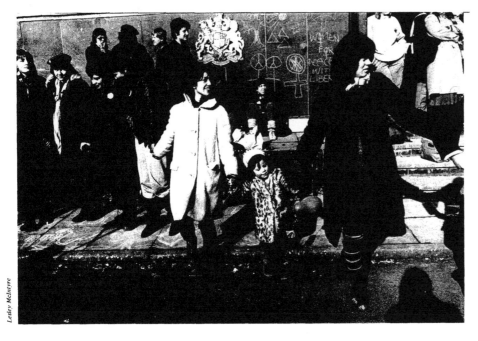

Lesley McIntyre

PROTOCOL 1, ADDITIONAL TO GENEVA CONVENTION 77

Article 51
The civilian population as such as well as individual civilians, shall not be the object of attack. Acts or threats of violence the primary purpose of which is to spread terror among the civilian population are prohibited.

A recent opinion poll showed that the majority in Britain does not want Cruise here. Democratic government is an expression of a civilized society. We want to safeguard our civilization and halt the erosion of its democracy.

'I remembered something someone had told me about a community in Africa, how it deals with one of its clan who has done something antisocial, against the code of the people. The person is surrounded by all the other members of the community, and surrounded by statements of support and recognition. Each of the people remembers good things about the person, things about who they are and what they have done, right back to their birth. This goes on until the person in the centre gets enough affirming and good feelings, until they believe in themselves and in Life and no longer need to do damage. Surrounding the base with our calling and messages of love for Life reminds me of the community surrounding the antisocial individual.'

Sarah, Greenham Peace Camp

Facsimiles from the Greenham Common Peace Camp

2. World-Building Solidarities

'I stayed because there were so few at the beginning. Then I started reading, I had time there you see, and I realised what a big thing we were up against and how immoral and wasteful and upsetting the whole thing was and that most people didn't realise. I began to see that we're getting less and less free. My father always said it's a free country. Yet it's not.'

Effie, Greenham Peace Camp

Call themselves a peace demonstration, he snarled, when they won't let men in? All that twaddle about mankind being on the brink, yet these females exclude us. Pretending we'd cause violence, huh. Personally, I'd shoot them all, bang bang bang.

Jill Tweedie (Dear Martha)

WHAT IS GREENHAM COMMON?

An airforce base was first sited at Greenham Common during the Second World War, an area of common land being taken over by the Ministry of Defence. Although the airfield fell into disuse for some years after the war, the land was never returned to the council, and in 1951 the land was purchased by the Ministry of Defence against the wishes of the local authorities. Some time later the base was leased to the Americans and for a period it was quite openly an American base called USAF Greenham Common. All of the personnel currently serving there are American, but they are protected by the British MOD police and the name RAF Greenham Common is used again.

In December 1979, the British government announced that 96 Cruise missiles would be sited at Greenham Common in December 1983. Another 20 are to be sited at Molesworth in East Anglia in 1986, and these missiles will be deployed around the country in the event of a crisis.

'It is difficult for many women to learn that they can change things on their own, without men, and that is why they feel helpless in the nuclear crisis. We have all changed since we came here. We know we can survive on our own, run our own camp, and we know that we have the strength to stand up for what we believe in. We know that Cruise missiles won't arrive here, because we can stop them.'

Sarah, Greenham Peace Camp

'When I was about twelve, I read *The Diary of Anne Frank*, about a kid who was the same age as I was. And I went to my mother and said: "How could these things have happened?" And she said "People didn't know they were happening." And I knew that was a lie.'

Arlene, Greenham Peace Camp

> '**We fought World War I in Europe, we fought World War II in Europe and if you dummies will let us, we will fight World War III in Europe.**'
>
> *Admiral Gene Le Rocque, former U.S. Strategic Planner.*

'This is the only issue that matters. It does not matter if your kids clean their teeth or have good food or that you have a good married relationship which is good for the kids if we are not going to survive.'

Dr Helen Caldicott.

'I have never been able to accept the reasons for the belief that any class of nuclear weapons can be categorized in terms of their tactical or strategic purposes.'

Earl Mountbatten

'You cannot be a conscientious objector in the next war.'

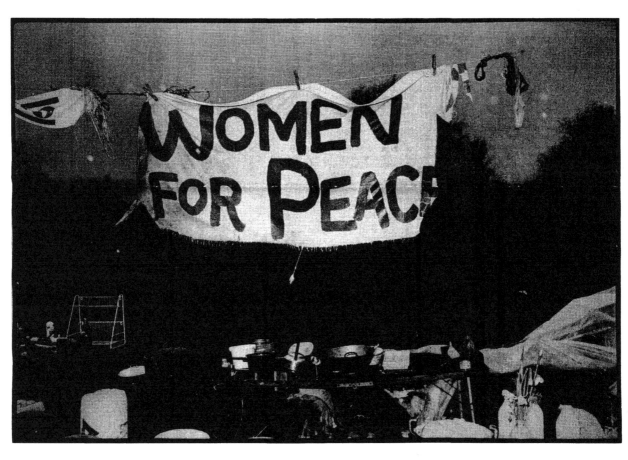

Lesley McIntyre

'Most of the women are wearing rough trousers and coats and boots, muddied from the road; one anomalous creature has many petticoats, white and lacy, and as they yank her out her skin is exposed. Swept aside, she gets up as the others do and runs to lie down again in front.

As you watch the women coming forward to lie in their prostrate ranks under the army cars, to be wrenched out, returning inexorably around and forward, lying down again and again — "Someone's going to get hurt!" a male journalist cries enthusiastically; the violence is only just contained but still they come — gradually you see them like the waves of the sea, unstoppable as the tides.'

Sally, 15th Feb. 1983

'Having been on a number of demos, I was more impressed by this (the women blockading the gates) than any number of marches along Princes Street, Edinburgh. The emphasis is on action and not on orderly marching under police direction; no one made speeches — there was no need for that; the organisers weren't constantly referred or deferred to, and the inhibitions I've felt before along with the hopelessness associated with many protest marches was not there.

I was aware of an amazing lack of pretension and strong all-embracing feelings. The songs and music keep the atmosphere of the action going; morale was so high!'

Jane, NALGO rep, Newbury court

'I've been accused of being cruel and hard-hearted for leaving my children behind, but it's exactly for my children that I'm doing this. In the past, men have left home to go to war. Now women are leaving home for peace.'

Sarah, Greenham Peace Camp

December 13th

'On the night of the 12th, a beautiful silver pyramid was erected right outside the main gate, and after a very short and fitful night's sleep inside it, I settled down in front of the gate with about 15 other women and the blockade was on. It was about 5.30a.m., and we were all in a picnic mood, much too hyped up to be sleepy. The support we were given was endless: plastic sheeting and sleeping bags to sit on, blankets to put over our knees, and a constant supply of hot drinks and food.

When the sun rose it became a beautiful day: cold, but sunny and bright and cloudless. Inevitably, the press arrived: What were we hoping to achieve? Would we succeed? What about the Russians?

When I heard, later on in the morning, that all the gates had been successfully blockaded, I turned to the woman next to me and we hugged and kissed triumphantly . . .

A mass of about 100 overcoated (to cover up their ID numbers) police emerged from one of the base buildings and walked rapidly towards us. I was very afraid, and I could feel the fear from the others. Deb took my hand and we all spontaneously sang 'You Can't Kill the Spirit'. The police in front began to pick women up and drag them roughly away. The gate opened further, Deb's hand was torn from my grasp, and I saw her being crushed between the gate and the pavement. No woman cried out, or attempted to fight, or abused the police. Then came my turn. I went limp as soon as I felt their hands on me. They dropped me and I thought it was all over, but suddenly I felt my thumb grasped hard. I was dragged along by it and half thrown, half dragged against the fence. All around us women were crying with anger and shock, or shouting out their fury.

Once all the vehicles had left the base, the police disappeared. The remains of the beautiful silver pyramid lay by the side of the road, torn and spoiled. Women who minutes before had been hauled around and hurt, sang out their hope.'

Toni

'We're talking about life and death. We're not talking about images. I mean it won't matter when you're dead whether you were a good conservative chap or a radical feminist — you're just dead. And this is life and death.'

Simone, Newbury court

'30,000 pairs of eyes looking through the wire fence at a few huts, a man with a dog, and a police car every now and again. Is this our enemy? I hear a buzzing in my ears as a helicopter flies overhead, they are watching us, observing our reactions as we cry because we have completed our chain, or seeing us smile as we fall into the mud or hug one of our sisters.'

*Dorothy McDowell
unemployed feminist from Liverpool*

I thought it might have been something which had nothing to do with the war, the collapse of the earth, which it was said would take place at the end of the world and which I had read about as a child.

Yoko Ota, Hiroshima

'If we don't use imagination nothing will change. Without change we will destroy the planet. It's as simple as that.'

Lesley, Greenham Peace Camp

'Many of our national leaders seem to live in a schizoid world of, on the one hand, planned death by massive genocide and, on the other, a primitive fear of death when they are personally faced with its reality. This contradiction can be explained by the powerful defense mechanism "death denial": we all survive by pretending we will never die. Males are particularly adept at the denial of unpleasant emotions. Perhaps it is this defense mechanism that sublimates the urge to survive and allows politicians to contemplate "first strike capabilities" or limited nuclear war —'

Dr. Helen Caldicott/'Nuclear Madness'.

The Second Eviction, 29/9/'82

'It was the first day that I felt I had any control over my life.'

(Woman speaking at Workshop in Action Space, London)

In the same week that 30,000 women encircled the base, the Russians announced a policy of launch on warning and news leaked that NATO's European military command was moving from West Germany to Britain.

'We had been daily expecting this eviction for a month but when it happened, all our dread left us.

Women having breakfast in the kitchen caravan were informed first, at about 10 a.m. Cheerfully and calmly, these women spread the word around the camp to women in other caravans and tents. Soon everyone was packing up tents and bedding and hiding them, looking for places to put the things we would need for the next stage in the camp's life — the stage where we could continue to maintain our presence without shelter — the stage the authorities thought would finally destroy our determination to stay.

How wrong they have proved to be.

Saucepans, cutlery, cash and bedding were packed into vehicles — we hid our standpipe very carefully. Meanwhile it rained solidly. More than thirty policemen stood around as the bailiffs' cranes lifted our seven caravans onto transporters and took them away to a compound near Hungerford.

There were eleven of us there that day but we did not feel outnumbered. Some of us spoke to the press and took photographs — we all linked arms and sang:

'You can't kill the spirit
She is like a mountain
Old and strong
She goes on and on . . .'

Greenham Common Newsletter

'That day of gentle peace was one I'll carry to my grave. Greenham Common will never be a "bleak" place again.'

Sheila, 12 Dec. 1982

Dec. 12th: Message received — the base is surrounded.

'The military is the most obvious product of patriarchy. For the same social and historic reasons men have usually taken the lead in the Peace Movement, but when this leads to a confrontation situation, men confronting men, this becomes a microcosm of the original problem. At the Women's Peace Camp, with the support of both women and men, women are exploring a different way to deal with the weighty problem of disarmament . . . '

Greenham Common Newsletter

'The decision to have only women actually living in the camp is partly tactical, as they feel the authorities treat them differently when men are not present, seeing them as less provocative. The camp, however, has always been a "women's initiative". This is not because the women are hostile to men, but because they feel the need for space to develop their own ways of working. They see more hope for the future in the political processes emphasized by the women's movement – shared decision-making; non hierarchical, leaderless groups; cooperation and non-violence – than in the hierarchical and authoritarian systems that prevail in mixed groups. They want a chance also to develop skills they are not normally expected to acquire: organizational and practical ones; and to express those characteristics normally devalued in society at large: caring, compassion, trust. Human characteristics which they feel all of us should reclaim if we want to survive.'

Dr. Lynne Jones, from Keeping the Peace

' . . . women in general in British politics have been conservative with a small 'c'. On this issue they're clearly more radical than men.'

Joan Ruddock.

'Having women's actions in my view has got nothing to do with excluding men. It's got to do with, for once – *including* women. It's so women, who've been told that they can only function in one small closed-in area to do with children and nurturing, can come out of those areas and take part in politics and actually begin to affect and change the world, and that's Why Women. It's got nothing to do with excluding men.'

Katrina, Greenham Peace Camp

'We understand that men also want to demonstrate in their own way their opposition to the nuclear threat. They can do this without undermining the achievement of the Women's Peace Camp. There are very many military establishments and armament factories which need to be brought to the public eye by having Peace Camps set up outside them. The multiplication of Peace Camps around the UK would be a more fruitful way of showing the scale of the danger of war, extending public debate, and eventually achieving the aim of *all of us* who are trying to save the world from destruction. We must spread our wings.'

Aggie, Greenham Peace Camp

The bomb dropped on Hiroshima was code-named 'Little Boy' and the one on Nagasaki, 'Fat Man'. In NATO language, protective clothes for troops are called 'Noddy suits', soldiers are 'human assets', and dead civilians are 'collateral damage'.

'Mamma was bombed at noon
When getting eggplants in the field,
Short, red and crisp her hair stood,
Tender and red her skin was all over.'
Michio Ogino, 10 yrs., Hiroshima)

'The authorities, when faced with organised non-violent women, do not know how to deal with us. They are trained to react to aggressive behaviour. So far they have tried to frighten us and stifle our right to express our opinions by harrassment, evictions and token imprisonment. We want women to come here to Greenham to gather strength and learn how not to be intimidated by the authorities and unsupportive men.'

Aggie, Greenham Peace Camp

'Women have for too long provided the mirrors in which men see their aggression as a heroic quality with themselves magnified larger than life.

*Nottingham WONT
from* Keeping the Peace

'One of the lifts I got down here was from a guy. The whole time he argued with me about nuclear missiles. At the very end he said, I find this whole situation really bizarre, I'm giving you a lift to a demonstration against nuclear missiles and I'm a missile engineer'.

Jane 15th Feb. 1983

Lesley McIntyre

'What we're saying is that women are powerful: we can all come out and say *You can't do this to us.'*

Sarah, Greenham Peace Camp

'I can remember meeting a Japanese woman in London while I was expecting my second child. She told me that members of her family had died at Hiroshima. She said that when a woman became pregnant in Hiroshima she was given no congratulations but people waited in silence for 9 months until the child was born to see if it was all right.'

As a result of the two small atomic bombs dropped on Hiroshima and Nagasaki, at least 200,000 people were killed. Many died instantly, many died more slowly over the following months. Thirty-two years later there were 366,523 people still registered as suffering from the effects of those bombs.

The Home Office envisages an attack on Britain would be in the order of 22 mega-tonnes — the equivalent of 13,000 bombs of the sort dropped on Hiroshima.

'If it is necessary to leave the shelter at any time when fallout is still present, then stout boots or shoes and an outdoor coat should be worn.'

Protection Against Nuclear Weapons, leaflet of the Scientific Advisory Branch, Home Office, March 1980

ARTICLE II OF GENOCIDE CONVENTION

In the present Convention, genocide means any of the following acts committed with intent to destroy, in whole or in part, a national, ethnical, racial or religious group, as such:

(a) Killing members of the group;

(b) Causing serious bodily or mental harm to members of the group;

(c) Deliberately inflicting on the group conditions of life calculated to bring about its physical destruction in whole or in part;

(d) Imposing measures intended to prevent births within the group;

(e) Forcibly transferring children of the group to another group.

'If we are successful, and Cruise never comes, it doesn't mean the Russians will have carte blanche to just come in and walk all over us. How are the Russians going to come and occupy Europe with all the problems they've got — and China at their back? It isn't that simple. If we disarm it would put tremendous pressure on the Americans and on the Russians. We're just a front at the moment, a limited theatre of war: there will be nothing afterwards for us so we've nothing to lose.'

Simone, Newbury court

'In today's world 1.5 billion people lack access to professional health services. Over 1.4 billion people have no safe drinking water. More than 500 million people suffer from malnutrition. But world governments spend twice as much on armaments as on health care. . .
In our modern arms economy, military research consumes the creative efforts of over 500,000 scientists and engineers world-wide and gets more public funds than all social needs combined.'

Dr. Helen Caldicott/'Nuclear Madness'

Rats live underground in 'natural' nuclear shelters, e.g. sewers. Some strains of rat are resistent to radiation. The last estimate of the rat population in Britain was 100 million. A rat can have up to 800 baby rats per year. Rats spread diseases like typhus, rabies, roundworm, bubonic plague and lassa fever. For any survivors of a nuclear war rats be as much of a problem as the fight for uncontaminated food and water.

'A child formed from an egg or sperm cell mutated by radiation in a dominant way will show the results of mutation. It may spontaneously abort or, if it survives pregnancy, it may turn out to be a sickly, deformed individual with a shortened life-span. If this person then reproduces, statistically, half of his or her children will inherit the dominant gene and its deformities.'

Dr. Helen Caldicott/'Nuclear Madness'.

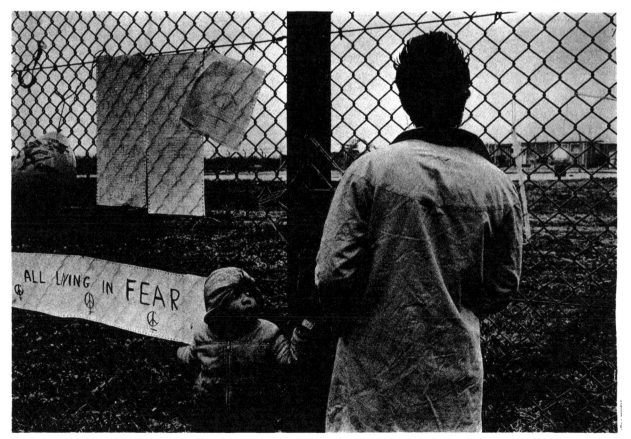

'Mummy, why are the policemen guarding the bombs which are going to kill people but not the people who want to stop the bombs?'
Alice, aged 5

Lord Louis Mountbatten, Strasbourg, May 1979: 'In the event of a nuclear war there will be no chances, there will be no survivors — all will be obliterated . . . I am not asserting this without having deeply thought about the matter. When I was Chief of the British Defence Staff I made my views known. I have heard the arguments against this view, but I have never found them convincing. So I repeat in all sincerity as a military man I can see no use for any nuclear weapons which would not end in escalation, with consequences no one can conceive . . . As a military man who has given half a century of active service I can say in all sincerity that the nuclear arms race has no military purpose. Wars cannot be fought with nuclear weapons.'

'In choosing sites for the mass graves it would be important to avoid additional contamination of the water supplies.'

'If a death occurs while you are confined to the fall-out room place the body in another room and cover it as securely as possible. Attach an identification. You should receive radio instructions on what to do next. If no instructions have been given within five days, you should temporarily bury the body as soon as it is safe to go out, and mark the spot.'

From 'Protect and Survive' the Gov. handbook that 'tells you how to make your home and your family as safe as possible under nuclear attack'.

Damage estimation of a 10 megatonne explosion at ground level from epicentre:—

for ¾ mile, a crater ¼ mile deep; then
for 2 miles, total destruction; then
for 7 miles demolition of tall structures, everything that can burn does so; then
for 15 miles fires connecting in built-up areas/woodland; then
for 20 miles, fires and most streets blocked with wreckage; then
for 30 miles fire, damage, flying debris, radiation burns on exposed or lightly covered skin;
for 80 miles (depending on wind direction) corridor 20 miles wide, death to those exposed to radioactive fallout;
for 100 miles (depending on wind direction) corridor 30 miles wide eventual death of 90% of people in open air or under light cover.

'Einstein said, "If there's a *fourth* world war it'll be fought with bows and arrows." Personally I'm less optimistic than Einstein. He didn't take account of genetic damage. I mean, how d'you fire a bow and arrow with dorsal fins?'
From 'Bang' by Jennifer Phillips and Jill Hyem

5 megatonnes = 1 million tons of TNT = *all* the bombs, shells and mines used by *all* countries during World War II.

'The drainage of urine and the burying of faeces into the ground ... would be infinitely preferable to allowing random distribution over the surface of the ground ... living conditions would not be conducive to bowel control and regular habits.'

Environmental Health in War' annex to Home Office Circular ES 8/1976.

Dr. John Gofman, distinguished ex-nuclear physicist, discoverer of uranium 233: 'Many people have said nuclear war means the end of the world, and I don't think that's true. I think there will be lots of survivors. There will be lots of misery for countless generations in terms of genetic mutation.'

'The lie that we have all come to live — the pretense that life lived on top of a nuclear stockpile can last . . . In this timid, crippled thinking, 'realism' is the title given to the beliefs whose most notable characteristic is their failure to recognize the chief reality of the age . . . 'Utopian' is the term of scorn for any plan that shows serious promise of enabling the species to keep from killing itself.'

Jonathan Schell

Lesley McIntyre

'I just felt I could no longer stand in front of the children and talk about their future when I didn't believe in my own.'

Jayne, a teacher, Greenham Peace Camp

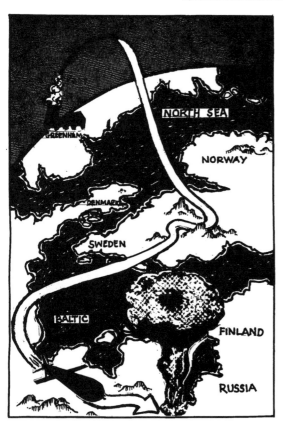

'Military and national leaders are now planning to increase the nuclear weapon presence in Europe. In addition to the already present:
— 2,500 nuclear gravity bombs of the US Air Force,
— 3,800 rounds of artillery projectiles with nuclear warheads allocated to the US Army,
— 400 nuclear warheads located on the Poseidon submarine fleet offshore,
— 670 Pershing 1A missiles, lance missiles, and Hound Dog air-launched missiles,
— 700-1,000 British and French nuclear warheads,

NATO leaders want now to deploy 108 Pershing II missiles and 464 ground-launched cruise missiles.

Rosalie Bertell
Nurnberg Tribunal Feb. 1983

'We're right in the middle of reality here, aren't we? It's no good pretending it's going to be easy.'

Jayne, Greenham Peace Camp

'The arms race can kill, though the weapons themselves never be used. . . By their cost alone, armaments kill the poor by causing them to starve.'

Vatican statement to UN, 1976

'You see, I really fancy some grand-children'.

Fran, Greenham Peace Camp

'There are no roads leading to peace. Peace is the road.'

M. Gandhi

Greenham Common in Berkshire is one of the two sites chosen for 160 Cruise missiles, the first of a new generation of nuclear weapons, due later this year. Because of their size, they cannot be verified by satellite. Because of their size, they can be carried into Greenham in a laundry van. A Cruise flies close to the ground avoiding normal radar. It contains a lightweight computer with a map of Europe and Russia imprinted on its memory. The USA's Global Positioning Satellites over Europe can change and redirect flight continuously, thus assuring a high degree of accuracy. Once launched a Cruise will reach its target with the destructive force of 15 Hiroshima bombs. Cruise is officially called 'a defensive weapon', its 'strength' being that it can be launched from mobile launchers — so that the only way for the Russians to retaliate would be by blanketing the entire country with nuclear bombs.

In response to the Member for Swindon, Mr. David Stoddard, who urged 'The Secretary of State to keep these updated nuclear weapons well away from Swindon' Mr. Pym responded, 'The siting of these weapons in no way affects the vulnerability or otherwise of a particular place. It is a mistake for anyone to think that the siting of a weapon in a particular place . . . makes it more or less vulnerable. We are all vulnerable in the horrifying event of a holocaust.'

(Hansard, 15th Jan. 1980)

STOP CRUISE!!

'Once they're in, they're in, it's not easy to remove them again; it just means a lot more sterile, polarized, academic debate. And the reason we've stepped up actions at the camp, and are putting so much energy into the here and now, is that when the transporters come, our job is to sit here and stop them going in. We've got to do everything we physically can to put ourselves in front of them.'

Barbara, Greenham Peace Camp

Near simultaneous detonation of half the world's stockpile would remove 70% of the world's ozone layer exposing survivors to deadly ultra-violet radiation, eliminate certain crops and reduce the yield of still cultivatable areas. Temperatures would drop several degrees causing other climatic changes.

'What has concentrated NATO thinking however has been the realisation that western strategy risks a loss of credibility. Many argue that, even at present, if deterrence broke down and Warsaw Pact forces crossed the East German border, NATO might have to go nuclear very quickly to avert defeat — in one estimate, within 3 or 4 days.'

Jon Connell, Defence Correspondent,
Sunday Times, 13th March 83

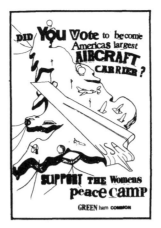

'If it is really true that the Cruise missiles are a complete one key force, are we not approaching George Orwell's famous era when Britain was "Airstrip One"?'

Field Marshall Lord Carver,
House of Lords, 18th Dec. 1979.

'An attack by the Soviet weapons now targeted on Britain would produce an estimated 38.6 million deaths and 4.3 million casualties. By the time the radiation hazard had fallen to acceptable levels for rescue attempts (14 to 21 days) most of the seriously injured would have perished from haemorrhage, secondary infection or radiation sickness compounded by dehydration, exposure and shock . . . It is apparent that any schemes in existence would be completely inadequate to deal effectively with such a situation.'

Report of the British Medical Association
Board of Sciences and Education Inquiry
into the Medical Effects of Nuclear War,
April 1983.

'The idea and amazing energy of going over the fence via ladders and clinging on to the silos came from one woman, but became the excitement and energies of a hundred or more women. Nearly the whole area round the silos is encircled by row upon row of barbed wire fence, apart from one small stretch where there *was* just one fence. Standing before the fence, we would need to be so quick. Two ladders were propped successfully against the fence, with carpet laid over the top barbed wire, and a ladder was slid down the other side. The atmosphere was frantic as we clambered over — headlights were driving towards us while it seemed an endless stream of women were crossing the barriers of destruction, bringing new life and hope.

As we jumped from the ladders on the other side, we crouched for a moment, waiting for other women, wondering "Will we get there?" In the next second we had joined hands — suddenly two policemen were there aggressively shoving the ladders and wrenching them away from the inside of the fence, leaving two women on top of the barbed wire. They jumped. We began singing and walking quickly, almost at a run, towards the silos. Our hearts were beating and our voices rang out clearly. The sky was light and it was softly raining on our faces.

I remember feeling ecstatic and overjoyed that we had successfully planted our statement for peace and life while standing on the top of what threatens the existence of our planet. Driven to Newbury Police Station we were charged with "breach of the peace". Still our energy continued to vibrate in our feelings and voices throughout the police cells.

Bee and Ceri

STOP CRUISE! **STOP CRUISE!**

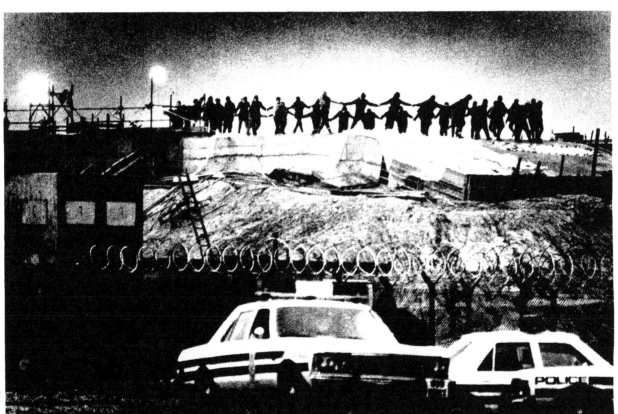

Raissa Page

Dancing on the silos — 1st January 1983

NONVIOLENT DIRECT ACTION
NONVIOLENT DIRECT ACTION
IS:

withholding tax
singing
talking to people
leaving messages (in library books
in the doctor's
in bus shelters
on the tube
on walls)
refacing not defacing
wearing badges
putting up stickers
flyposting
thinking
writing
getting information and
passing it on
blockades, sit-ins
occupations, strikes, boycotts
pickets
vigils
mass demonstrations
street speaking
street theatre
poems, songs, plays
removing signs and changing
their meaning
banners
newspapers
holding on to a vision
saying NO
believing
sharing feelings, ideas . . .
more and more . . .

Some people find some things easy,
other things difficult to do. I found it
useful to work out for myself what
actions I find difficult and try to come
to terms with *why*.

Not everyone can go over the fence at
Greenham.
Not everyone needs to.
There are so many other things to do.
Support roles are vital to the success
of any action,
in no way secondary.

SUPPORT ROLES

food & hot drinks for
the blockaders
talking to bystanders
peace keepers
watching out for cold,
tiredness
telling people what's
happening
giving out leaflets
buffering hostility
contacting the press
medical help
legal advice
keeping track of what's
happening
taking police numbers
following anyone who's
been arrested
contacting solicitors
listing people's names
giving moral support &
encouragement
helping to create a
dignified atmosphere.

BLOCKS TO NON-COOPERATION

Thoughtless support, going along with
things, afraid of what might happen,
what people might say, feeling
unconfident, not wanting to stand out,
feeling a moral obligation to obey and
not make a fuss. (People in authority
know better than I do, I might lose my
job, it won't make any difference because
they won't take any notice

NONVIOLENCE IS:

believing that people can change
channelling anger into action
dignity and power from inner conviction
a complete way of life
a reasoned response to an aggressive
situation
people co-operating within a group
communicating with opponents
a commitment to openness
trusting
celebrating life. . . .

Dr. Gwynneth Kirk
London, January 1983

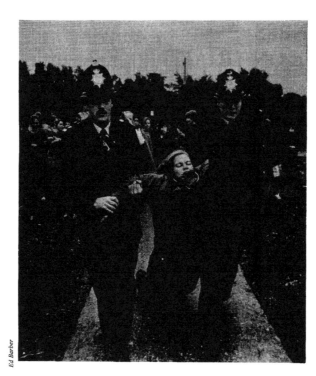

Ed Barber

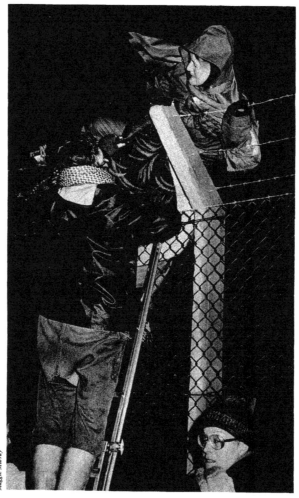

Maggie Murray

**This publication is itself a tool. Use the
pages as posters, or send one to your local
MP.**

NONVIOLENT DIRECT ACTION
NONVIOLENT DIRECT ACTION

'The macho-ness of the policemen and
their eventual heavy-handed approach at
the blocking of the gates cannot be
counteracted effectively either by outright
aggression or by complete passivity. Non-
violent action is *not* non-action. When
women are actually getting caught under
huge army trucks and being pulled or
kicked onto pavements only to get up
again and go back for more, it is *real* action
which requires *real* guts.'

Jane, NALGO rep, Newbury court

'A policeman trying to pull two arms apart
in a firmly linked human chain has to
directly confront his own feelings about
handling women, not as sexual objects but
as powerful beings . . . hacking through a
chain he can avoid all that. It's just the nice
easy masculine field of mechanics, no
feelings involved. That lack of understan-
ding as to what pain and suffering really
mean makes it possible to press a button
and annihilate a million people: that is
what we're trying to challenge.'

Dr. Lynne Jones, from Keeping the Peace

'There was a case in Bridgend, Wales where
30-odd people sat on top of a bunker that
was going to be built, just sitting there and
saying: We are not going to allow this to
happen. After concrete had been poured
all over these women the workmen refused
to carry on, they didn't want the women
to be hurt, and they went to the council
who called an emergency meeting and
reversed the decision about the bunker.
The bunker has since been demolished and
a factory built on that site which has given
jobs to the local area. Now that's just
twenty people putting their bodies where
their beliefs are. And if a quarter of a
million people who go to Hyde Park to the
rally would put their bodies against some
American base, they couldn't carry on with
it, they just couldn't do what they're
doing.'

Simone, Greenham Peace Camp

'The Sermon on the Mount and the
command to be peacemakers is something
which a Christian cannot escape, though
many try. Christians among us have a rule:
When we trespass on the base, we pray.
We make a daily habit of trespassing.'

Jean Hutchinson
resident at Molesworth

'Ursula, my mother, got involved with
Greenham Common. She came up for a
week over Christmas and she went over the
fence on New Year's Day. It's quite likely
she'll get a prison sentence. Every woman
who goes to prison must be replaced by
two or three others. I'm the only daughter
who's self-employed so I'll have to leave
my little daughter, she's three and a half.
It's obvious it's got to be done. Things are
stepping up. They put twenty-two in
prison, now it's forty-four, next time it
must be eight-eight.'

Diana, Newbury court, 15th Feb. 1983

'Persuading a hostile member of the public
to sign a petition can be more difficult
than sitting in the mud.'

Campaign, March 1983

'Unlike the Army Field Service Manual for
soldiers, where the overall objective is to
obey commands given from others up the
hierarchy, preparation for nonviolent
action emphasises that we act from our
own experience, convictions, emotions and
reason *in concert with others.*'

Peace News Broadsheet

Art and Solidarity Reader

NUCLEAR MADNESS — WHO SHOULD BE ON TRIAL

'I will not be bound over to keep *your* peace: I am already keeping my peace. I will not take punishment, or recant, or admit guilt. I am responsible for this — for seeing the war machine grinding on, building silos, arming the arsenals of the world with death — and using all the non-violent means I can to stop it. *I am asking you to keep the peace. We are not on trial, you are.*'

Katrina, Greenham Peace Camp

'I'm afraid; this sort of situation is designed to cause fear, to intimidate ordinary people; and fear can cause paralysis — as with the threat of nuclear war — but I was determined to overcome my fear because what we have to say is the most important thing anyone should be listening to. What we are saying is that we are at the 11th hour, we are at the brink of being destroyed, and it's not just my death or your death but the death of the whole planet . . . Each and every one of us has to question and challenge a system where people who have learned to live cooperatively like the Bush People of the Kalahari, the Red Indian people, the aborigine people of Australia are attacked by those who abuse or destroy everything they cannot understand. We cannot stand by while this continues. Nuclear weapons, particularly provocative first-strike weapons like cruise, are the logical conclusion of a life-denying culture that values aggressive domination and conquest above the power of empathy, sensitivity and compassion. We are trying to re-establish those values. They are vital for our survival.'

Rebecca , Greenham Peace Camp

'In 1969 the Genocide Act was passed . . . Cruise missiles coming to this country are a further stage of the crime of genocide. They are not a defensive weapon but a first strike weapon . . . it is my duty as a citizen of this country, as it is the duty of all citizens, to do everything within my power to prevent a crime which is about to be committed and that is why I walked onto the base . . . The first party to use a nuclear weapon is likely to destroy in the end the whole planet and all future generations. I am on trial for my life not just for a breach of the peace.'

Simone, Greenham Peace Camp

'I have no doubt that the tactical nuclear weapons deployed in Europe represent the worst danger for the peoples of the continent.'

Senator Nino Pasti, former Deputy Supreme Commander for NATO Nuclear Affairs.

'It is distressing that we are to be (tried under) laws framed in 1391 — a mockery upon this court (in) the nuclear age. We can be sent to prison, treated like criminals, because we do not want our families or any other individual obliterated. I will continue my protest until it is put to the electorate to democratically vote on the matter.'

Helen Johns

'The reason we have to take what seems to be radical action is that we have tried writing, lobbying and using the proper political structures. We are not only ignored but slandered as being in the pay of the Russians. We are told that we must be protected from the Russians by nuclear weapons but the CEGB (Central Electricity Generating Board) is still selling uranium to the Russians and the Americans are selling computer parts to them for weapons systems. It is people who are making money out of the arms race which lets it continue.'

Simone, Greenham Peace Camp

'I think that people want peace so much that one of these days, governments had better get out of their way and let them have it.'

Dwight D. Eisenhower, 1959.

'We are all of us intelligent people. How can we sit around hiding the truth, talking legal jargon. We could all be sitting together using our hearts and minds to deal with the terrible situation we face. Even if you feel that the possibility of a holocaust is remote, why does everyone refuse to discuss it. Today we have heard the bailiff say that he was only doing his job, the reasons for the peace camp being at Greenham Common are not his concern. The police say they are only doing their job because they are asked to by the bailiff. The court is here today because the police have brought us here. I am charged with disturbing the peace. My whole life is dedicated to peace. I may sing loudly but I do not swear or abuse anyone. I am totally non-violent. I do not eat meat, harm any person or animal on this planet. I try to find harmony with the earth, my cycles with the cycles of the moon and planets. I search for peace in a world which prepares for war.'

Sara., Greenham Peace Camp

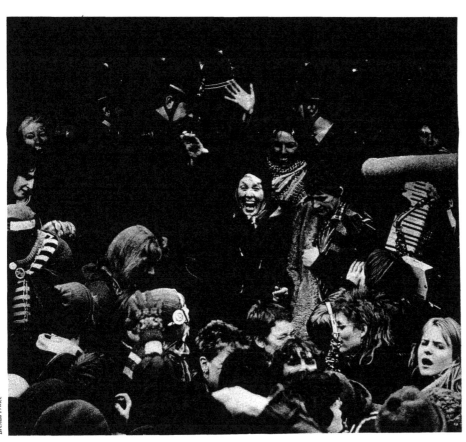

Brenda Prince

Outside Newbury Courthouse

'It's not just a question of costs and alternative military strategy. It's a moral question. There's really only one thing you need to ask yourself and that is: would you pull the trigger? would you press the button? And if the answer's "no" then you have to work with us and help in this struggle for peace.'

Sarah, Greenham Peace Camp

Richard Nixon, when President of the United States, commented, 'I can go into my office and pick up the telephone, and in twenty five minutes seventy million people will be dead.'

'I took part in the action because I feel it's a breach of the peace to have Cruise missiles on Greenham Common. It's endangering my life and others' and I believe everyone has a right to life. I can't participate in or allow murder to happen. So I have to do something about it. The prosecutor is avoiding the issue by accusing us of obstructing people in their daily lives when the issue *is* people's lives.

Tesse, Greenham Peace Camp

'In order to ensure respect for and protection of the civilian population and civilian objects, the Parties to the conflict shall at all times distinguish between the civilian population and the combatants and between civilian objects and military objectives and accordingly shall direct their operations only against military objectives.'

From The American Journal of International Law, *Vol. 72 (1978) Article 51 of the 1977 Protocol addition to the Geneva Convention*

Facsimiles from the Greenham Common Peace Camp

2. World-Building Solidarities

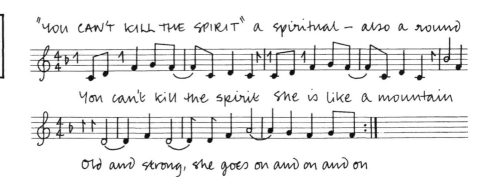

"YOU CAN'T KILL THE SPIRIT" a spiritual – also a round

You can't kill the spirit She is like a mountain

Old and strong, she goes on and on and on

STRIKE

24th May – International Women's Day of Action for Disarmament. Build local support for one-day women's strike through your trade unions and women's groups. Research local companies to approach women there – organise pickets.

Contacts

National: 'May 24th', 16 Arundel Road, Brighton, E.Sussex.
Fund-raising and donations: Women's Peace Action A/c, Midland Bank, North Street, Brighton. A/c No.: 51222449.
Northeast: Liz Reveley, 50 Third Ave, Heaton, Newcastle. Ph: 500343.
North Central: Leslie Boulton, 3 Wharncliffe Rd, Brookhill, Sheffield, Ph: 0742 25079.
Central (Leics, Notts). Andrea Heath, 15 Kimberley Rd, Leics. Ph: 0533 555691.
South Central (Women's Peace Camp/Oxford); Barbara or Aggie, 7 White Hill, Ecchinswell, Newbury, Berks. Ph: 0635 298512.
Central Wales: Thalia Campbell, Glangors Ynyslas, Borth, Dyfed. Ph: 097081360.
South Wales: Susan Lamb, Lynn Fortt, 7 York Tce, Porth, Rhondda, Mid Glam.
Southwest (Bristol, Bath): Gail Griffiths, Alison Segar, 8 St. Saviours Tce, Larkhall, Bath. Ph: 0225 319121 or 334895.
Southwest (Devon): Sara Meyer, 6 Fore St, Salcombe, Devon. Ph: 054884 2979 (wk) or 2851 (home).
Southeast (Brighton-Dover): Jan Pryer, 'The Mount', London Rd, Brighton, East Sussex. Ph: 0273 556744.
South Central: Sue Bolton, Ventnor, Isle of Wight. Ph: 0983 854457.

Information on Non-Violent Direct Action
Send s.a.e. to: NVDA Training Workshops, 7 White Hill, Ecchinswell, Newbury, Berks, or 1 Crowland Terrace, Islington, London N1.

WHERE IS GREENHAM COMMON?

The main entrance to the base is on the A339 out of Newbury on the Basingstoke road. Newbury is on both the A4 and M4 between London and Bristol. From London, there are trains hourly from Paddington Station (via Reading) and the single fare is £5.

The base has five entrances (recently a sixth has been opened) around its nine to ten-mile perimeter.

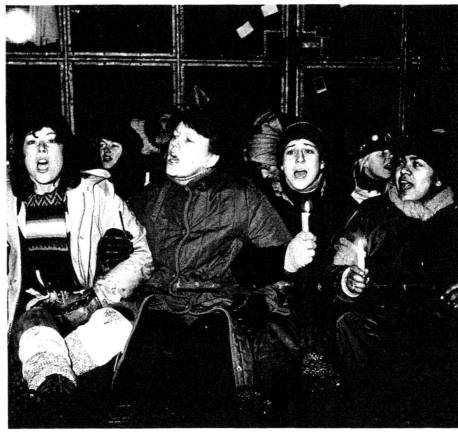

Brenda Prince

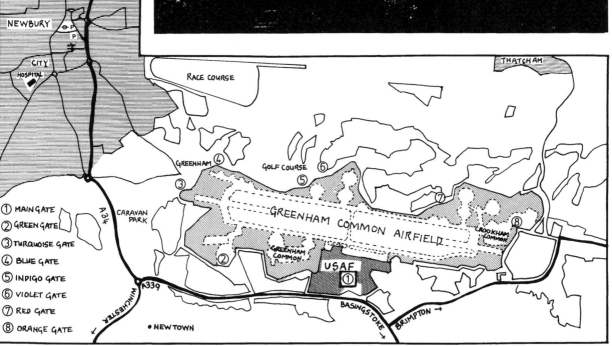

① MAIN GATE
② GREEN GATE
③ TURQUOISE GATE
④ BLUE GATE
⑤ INDIGO GATE
⑥ VIOLET GATE
⑦ RED GATE
⑧ ORANGE GATE

Britain has more nuclear bases and con-
sequently targets per head of population
and per square mile than any other country
in the world.

All proceeds to Greenham Common Peace Camp.

3

EXHIBITION COMMITTEE

Krishen Khanna
Shamshad
Manjit Bawa
Geeta Kapur
Ram Rahman
Madan Gopal Singh
Vivan Sundaram

We thank the following for their support:

Gallery Chemould, Bombay

Chitrakoot Art Gallery, Calcutta

Sakshi Gallery, Madras

Graphic Department, Faculty of Fine Arts, Baroda
for contributing portfolios of graphic prints

Satish Sharma & Ajay Desai
for organisational assistance

Design: Parthiv Shah & Vivan Sundaram
Assistance in layout: Nirmal Hazra

Artists Alert

This exhibition and auction are not for once charity shows, nor on the other hand are they meant to boost the art market — and the two kinds of shows are often the flip side of the same coin as those who recognise these mechanisms will know. There are no simple ways for an artist to survive, yet they must do more, they must intervene in the system that alienates them.

Interrupting the routine of survival and success there are causes that bring artists together. Fortunately there is still a sense of community and on occasion a sense of solidarity among Indian artists.

This is such an occasion. The murder of a fellow artist. It is the murder of a theatre person on location, while at work, and so it is a violation of the very profession of an artist even as it is a political murder.

Safdar was of course a theatre activist with a political purpose. He was a communist, and his group was performing a street play to support a wage increase for industrial workers where the issue was precisely the right to speak, the right of the worker to assert his or her minimum needs, to express his and her identity as a worker, through solidarity and action. The play was called Halla Bol.

The worker's right is a long way away perhaps but an artist's right of expression is taken for granted in a democratic society both because this is a publicised feature of liberal culture and because artists are rendered innocuous anyway in that culture. Can the artist say anything that can upset money or State power?

If it needed Safdar among us to die, in order to recall that an artist is not so innocuous then we must pay a certain price for this awareness. That price may be as private as self-reflection in which we allow our convictions to be put to the test. But Safdar's terrible sacrifice should also make us face up to the present, to become historically alert. And to make us recognise that there are times when you have to close ranks with your fellow artists and raise your voice.

It is not only a question of the freedom of expression, though in all societies this still claims many sacrifices before it is won. The question is to make your identity and your practice sufficiently complex so that it is not easily appropriated nor easily destroyed by antagonist forces. It may sometimes mean that an artist chooses to intensify his or her solitude challenging the pragmatic rules of conduct. This is a difficult choice too, and we should know how to honour it. But there are other ways to challenge the given circumstances, opposite ways. To break the isolation of a specialist role that our societies prefer, to engage in multifarious forms of creativity to demystify art practice. The subject-matter of art need not, must not, become uniform or populist, but it is important to create alternative forums in which further acts of public intervention are possible.

The letters and messages that have come to SAHMAT from a hundred or so artists who have agreed to participate in this exhibition and auction, are a testimony to the quality of concern of Indian artists. They want to link hands round the figure of Safdar though he was in some ways different. He was a theatre activist and a communist. These messages are themselves material to think about in regard to the Indian art situation.

Somnath Hore, that remote and ailing artist who has sustained his commitment to the Left over several decades, gives a moving little bronze called Comrade — a man holding in his arms a comrade who has fallen, and he writes, "Hashmi died a revolutionary death. One should take care to see that this does not become a cushion for somebody else's comforts. . . yet people cannot live by frustration; they have to look forward to a healthy and meaningful life."

Meera Mukherjee, an intractable presence in the Indian art scene, comes forth and gives an affirmative bronze image of people's solidarity (made on the occasion of young artists' demand for better art education facilities in Calcutta) called Andolan. Other artists make a motif of Safdar's death in terms of their own work, Arpita Singh, Altaf, Shamshad, Jatin Das, Suhas Roy, Vivan Sundaram. And a reticent artist like Prabhakar Barwe says simply that he is sahmat after the motto of the Safdar Hashmi Trust. And almost everyone says that they are grateful to be asked to show their solidarity through giving a work.

The works make an exhibition, the exhibition is put to auction, the money raised will go towards SAHMAT projects including, among other things, opportunities for artists to diversify their practice, to participate in collective activity and build up alternative structures of communication and action.

Safdar was in the process of drafting plans for what he called Janotsav, where artists from all fields would interact with each other and with local talent from bastis where there are no opportunities for creative expression. These plans are going to be developed by SAHMAT so that the first Janotsav is held early next year. In the meantime there are these possibilities to think along. To disseminate art works through local exhibitions, slide shows and discussions in the manner of adult literacy programmes. To actually choose a site, say in a workers' colony, set up a studio and work there for some months involving the residents. The sculptor, Soman, has already offered to do this, and he wants to donate his sculpture to the colony, preferably Sahibabad, in a space chosen and protected by the residents. There are other suggestions, of artists working with writers to illustrate childrens' books, of artists working with theatre people to design props, costumes, entire performances. Painters, sculptors, graphic artists are invited to give suggestions to SAHMAT about how they would like to participate in this Janotsav.

GEETA KAPUR

Devika Singh and Ram Rahman.
A Conversation

Revisiting the History
of Sahmat

Devika Singh: As a founding member can you explain how the artist collective Sahmat came to be. What was its initial vision and mandate?

Ram Rahman: On 1 January 1989, Safdar Hashmi – political activist, actor, playwright, poet – and his theatre group, Jana Natya Manch, were violently attacked while performing a street play in Sahibabad, an industrial area on the outskirts of Delhi. The play, titled *Halla Bol!* (Raise Your Voice!), was being performed as part of a campaign in support of a workers' strike. Hashmi died of his injuries the next day.

Hashmi was 34 years old when he died. Like many young people of his generation in India, he was deeply committed to secularism and egalitarianism – principles that drove the nation's struggle for independence from British colonial rule. After completing graduate work in literature, he began an academic career, but soon his interest in theatre merged with his growing political commitment and he became a full-time political activist. During the late 1970s and 1980s, Hashmi moved close to the Left, eventually becoming a member of the Communist Party of India (Marxist). He simultaneously embraced street theatre and what is known as political theatre, and led the growth of the Jana Natya Manch (popularly known by its abbreviated form Janam, meaning 'birth' in Hindi) into a forum of democratic and accessible theatre aimed at political change. Hashmi's brutal, politically motivated death aroused a spontaneous, nationwide wave of revulsion, grief and resistance, transforming him from outspoken political performing artist to a lasting symbol of the very values that his murderers had sought to crush.

The spontaneous anger generated by Hashmi's murder soon grew into a resolve among artists, writers, scholars, filmmakers, theatre artists and cultural activists to resist all forces that threaten the right to freedom of creative expression in India. In February 1989, within weeks of his death, a group of them came together to form Sahmat – the Safdar Hashmi Memorial Trust and Committee. From its inception, Sahmat has been a collective of, and a platform for, individuals with a broadly shared political perspective best described as politically Left. Through their works of art, exhibitions, public events and performances, and publications, members of Sahmat have joined forces against communalism – the influences of religious fundamentalism and sectarianism in sociopolitical life.

DS: This connects to a longer history of art and activism in India. How would you locate Sahmat in this history? Can it be compared to IPTA or to other collectives? What would you say distinguishes Sahmat from past examples in India or elsewhere?

RR: Art as activism in India was fostered mainly by the Communists in the 1940s. It was the vision of the general secretary of the then undivided Communist Party of India (CPI), P.C. Joshi, that writers, artists and performers should be involved in direct political action, which led to the founding of the Indian Progressive Writers' Association (PWA) in 1936 and the Indian People's Theatre Association (IPTA) in 1942. Both were directly affiliated to the CPI. In fact, the party had set up a commune in Bombay of performers, actors and writer members of IPTA and PWA, which functioned from 1943 to 1947 – until the official ties between these organisations and the party were severed after Joshi was ousted as general secretary.

The event that led to the formation of IPTA and provided the motivation for its incredible reach across India was the Bengal Famine of 1942. It was also the famine that prompted Joshi to recruit two visual artists, the photographer Sunil Janah and the illustrator Chittaprosad, to work for the party's newspaper *People's War*, and move them from Calcutta to the commune in Bombay; their official affiliation with the party ended in 1947 after Joshi's ousting. But those five years of intense cultural action had a lasting impact on cultural developments in India after independence. The idea of 'Unity in Diversity' – of the unity of a people's culture cutting across the multiple religious, caste

and class identities of the subcontinent – was propagated by the Communists in the 1940s. After the dissolution of IPTA in 1947, many of them moved to Delhi and found employment in various government cultural departments set up after independence, including All India Radio. It was through them that the cultural ideas of the Left movement became central to the national cultural ethos of the newly independent, Nehruvian India.

Sahmat's direct link to IPTA was through Bhisham Sahni, the writer, and Habib Tanvir, the theatre director. Both had also worked closely with Safdar Hashmi, and they served as the first and second chairpersons, in succession, of Sahmat. The experience of both helped guide Sahmat ideologically as well as in practical issues of communicating with non-traditional audiences. If the Bengal famine was a moment that galvanised IPTA, the demolition of the mosque in Ayodhya in 1992 played a similarly central role in Sahmat's trajectory and led it into a more activist phase.[145] It also served to broaden the base of the collective to include historians, archaeologists and social scientists. Sahmat's Ayodhya initiatives and the attacks on them led to its national prominence, in ways it had never imagined. By staying the course and keeping up the struggle and resistance through the arts, the collective has managed to survive and remain relevant.

I should add that when Sahmat was formed, it was decided at the very outset that it would be an artist-run collective and not an affiliate of the Communist Party of India (Marxist), although many in the founding group were Safdar's comrades in the party. This decision has allowed Sahmat the freedom to conceive and execute innovative projects, sometimes at lightning speed. Of course, Sahmat could never have survived without the support of the CPI(M), its cadre and organisational affiliates. Its first office was located in the enclosed verandah of a flat allotted to the writers' organisation of the party. Yet Sahmat's independence from party diktat has allowed for the participation of people with varying political beliefs, all essentially progressive. Sahmat likes to define itself as a 'platform'. Open-ended and inclusive, it has helped to create and maintain the space for cultural resistance.

DS: The 1992 demolition of the Babri Mosque (Babri Masjid) in Ayodhya was undisputedly, as you explained, a turning point in India's vision of a secular democracy. Yet the 1980s had already seen large-scale anti-Sikh riots and of course the assassination of Safdar Hashmi. Can you tell me about the rise of a general climate of intolerance and of sectarian violence in 1980s India?

RR: In the 1980s, India was faced with a huge insurgency in Punjab in the north. There was a section of the Sikh community that was calling for independence and for a Sikh homeland. We witnessed many years of terrible violence and assassinations by Sikh extremist groups. This was ultimately crushed by military force, but it led to the assassination of Prime Minister Indira Gandhi by her Sikh bodyguards in 1984. The aftermath of the assassination saw an organised massacre of Sikhs across north India in some of the worst sectarian violence that had been seen after independence and Partition. Many people who subsequently formed Sahmat were involved in relief efforts to help the victims of the Sikh violence, including Safdar Hashmi.

The 1980s also saw the Bharatiya Janata Party (BJP) and their mother organisation the Rashtriya Swayamsevak Sangh (RSS) mobilising politically against the Muslim community through their target – the Babri Mosque in Ayodhya, which they claimed was built on an earlier temple that had been the birthplace of the Hindu god Ram. Caravans of people rallying against the mosque crisscrossed India and left many instances of sectarian violence in their wake. When Safdar was killed in 1989, many of us were already mobilising against the rising sectarian politics we were witnessing. The Babri Mosque was ultimately destroyed in December 1992 by a huge mob, mobilised by the right wing Hindutva forces, which had been converging from across India.

Devika Singh and Ram Rahman. A Conversation

145 See *Hum Sab Ayodhya*, Sahmat 1993, Sahmat in association with the Aligarh Historians Association, Delhi, 2012. https://issuu.com/sahmat-india/docs/hum_sab_ayodhya_book_dec_2012_pdf_jpeg/1

Installation view from the exhibition 'Artists Respond: The Constitution of India at 70' at Jawahar Bhavan, Delhi, 30 January–August 2020. Photo: Ram Rahman, 2020.

Left to right: Vinit Gupta, top MF Husain, *Mural on the Freedom Movement,* below left: Aban Raza, Pushpamala N., right: Orijit Sen.

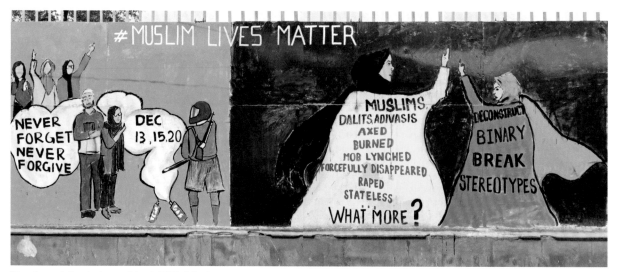

Street murals by students of Jamia Millia Islamia University, during their protest against the CAA law. December/January 2019/20. Photo: Ram Rahman, 2020.

DS: Moving to the programme Sahmat has led, it seems the collective has the capacity to bridge the art world and wider swaths of society. How would you describe the different strategies of display and modes of address that Sahmat has used over the years in its exhibitions, talks and publications?

RR: The art projects of Sahmat have been part of much larger programmes. These have included performances, publications and lectures, all of which have been connected to the themes of the individual exhibitions. Sahmat's great advantage has been the connection with progressive writers' groups across India, who write in many different languages. Student groups, activist groups and street theatre groups have also been very important as part of the network. It's this broad community that's given Sahmat an advantage in its outreach programmes, including the visual art projects. This is unique amongst activist groups in India.

Many of the exhibition projects were mounted as travelling shows and were displayed on the street or in public spaces. This was a great way of reaching people who wouldn't normally come and see an exhibition. A few of the exhibitions have been held in gallery spaces, but the majority have been in the form of travelling exhibitions, which are easy to assemble and easy to disseminate. This is a strategy that we evolved using the limited means of reproduction we initially had, like Xerox, handwritten texts and also hand-painted banners.

The books and pamphlets we produced have almost always been linked to our visual exhibitions. The idea was to give a solid theoretical and historical basis to the visual material. Many of the books were written by senior historians and social scientists in an easy to understand language for the lay reader. These were translated into different Indian languages to make them accessible to a wider readership, which may never have had access to the work of these academics before.[146]

All the art projects were thematic, and the proposals sent out to artists had texts by academics or artists as reference material. We consciously attempted to break the format of gallery-oriented painting – for instance, with the 'Postcards to Gandhi' project, where artists were asked to make works in postcard size. Other examples include 'Images and Words' – where artists and writers made small c. 25 cm square works that could be image or text or a combination – and 'Gift for India' – where we sent out a cardboard box for individuals to make a gift. Many painters were forced to confront a three-dimensional object for the first time. A number of artists' practices changed both in form and content as a consequence of these projects.

DS: As a photographer and designer yourself, how do you define the role these visual languages play in Sahmat's dissemination campaigns? I'm thinking here of Sahmat's own posters, pamphlets etc., as well as how Sahmat has encouraged others across society to use the efficacy of word and image, for instance with the 'Slogans for Communal Harmony' competition in 1992.

RR: Sahmat's design language has evolved into a recognisable visual style primarily through its use of strong graphic typography in English, Urdu and Hindi. The posters and broadsides, particularly those related to historical subjects, combined text, image and maps in densely layered compositions. These were primarily aimed at students. We combined historical timelines with texts on history, mythology, art history, architectural history and political history. We conceived our performance spaces with simple means: hand-painted cloth banners also became a Sahmat hallmark. These were designed by using calligraphy but in inventive typographic styles. The texts included poetry from the Sufi and Bhakti traditions, as well as from progressive writers.

In regard to the project 'Slogans for Communal Harmony' that you refer to, on 1 January 1992, Sahmat invited auto-rickshaw drivers in Delhi to participate in a competition – they were asked to create

146 India has a vast number of languages and dialects. Its Constitution does not give any of these the status of national language, though Hindi and English are the two languages that have been used by the Union government. The Constitution recognised 14 official regional languages since 1967. In 2007 this list was augmented to include 22 languages. 22 languages. There is a vast amount of literature on Ayodhya. For early commentary, see Sarvepalli Gopal (ed.) *Anatomy of a Confrontation: the Babri Masjid – Ramjanmabhumi Issue* (New Delhi: Viking, 1991); Sushil Srivastava, *The Disputed Mosque* (New Delhi: Vistaar Publications, 1991); Amartya Sen, 'Storm over Ayodhya', *New York Review of Books*, New York, 14 May 1992: 37–39; John McGuire and Peter Reeves (ed.), 'After Ayodhya: The BJP and the Indian Political System', *Journal of South Asian Studies*, Vol. 17, no. 1 (1994).

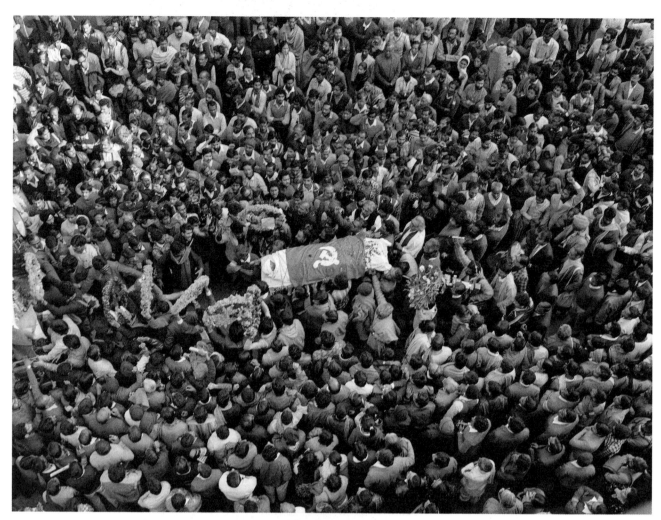

Ram Rahman, *Safdar Hashmi Funeral*, Delhi 1989

Sahmat's 'Images and Words' exhibition at Jamia Millia Islamia University,
Delhi, January 1999. In the background, Rekha Raj sings Sufi poetry from Punjab.
Photo: Ram Rahman

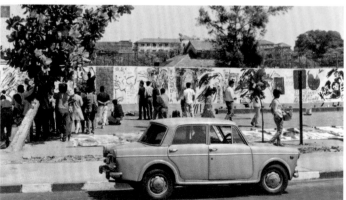

Artists paint a giant canvas on Marine Drive outside the performance venue
during *Anhad Garje*, Bombay, 20 February 1993. Photo: Ram Rahman

or select poems about brotherhood and communal harmony and paint the poems on the backs of their vehicles, to be judged on their content and design. This request resulted in one of the biggest public art projects mounted in India to date: hundreds of auto-rickshaw drivers sacrificed a day's fares and came together to participate in a procession starting at Delhi's Safdar Hashmi Marg and ending at India Gate. The diverse group of drivers – Sikhs, Hindus and Muslims among them – wrote pithy appeals for unity on their vehicles. The winning poems included: 'Deeds and not birth make a man great' by Ramesh Kumar; 'Slogan shouting and politicking cannot give any happiness. This comes from brotherhood' by Ramnivas; and 'Everyone feels hungry and needs bread to satisfy that hunger. Just as hunger has no religion, nor does bread know any such barriers' by Devnath Sahni. The jury included theatre director Ram Gopal Bajaj, artist Krishen Khanna and architect Romi Khosla; theatre director and actor M.K. Raina awarded cash prizes to the winners. The poems remained visible for years after the event – not only on the auto-rickshaws, but also painted on street-side fences and projected as slides in movie theatres. Sahmat repeated the project in Mumbai in March 1992, only this time using the city's taxis and taxi drivers (since auto-rickshaws aren't permitted in downtown Bombay). Actor Shabana Azmi and poet Javed Akhtar judged the contest there. This was a way of getting 'people's poetry' into public focus and it turned out to be hugely successful.

DS: Sahmat's initiatives have also elicited strong, critical and offensive reactions. I remember visiting a Sahmat exhibition dedicated to the artist M.F. Husain in the summer of 2009, just a few minutes after it was vandalised. Can you explain how Sahmat has defended Husain? What forms of backlash did other initiatives, not necessarily related to Husain, trigger?

RR: M.F. Husain (1915–2011) was India's best-known and most highly regarded modern artist. A flamboyant figure, he rose to super-stardom from extremely humble origins. The barefoot artist became a national icon. The only artist recognised by the poorest worker and the globetrotting industrialist alike, Husain actively cultivated an almost Sufi-like persona. Throughout his career, his subject had been the narrative of India's journey to modernity, through its popular culture, folk traditions and the rich mythology of its many religions. As a Muslim artist who had freely painted Hindu icons for decades (often bare-breasted, as in their classical depictions), Husain became the perfect and most prominent target of the Bharatiya Janata Party (BJP) and the Hindu Right wing (the Sangh Parivar). A few years after their successful demolition of the Babri Masjid in Ayodhya, they launched a culture war and took offence at Husain's renderings of the icons.

The attacks on Husain took many forms – beginning with the publication of an article against the artist in a right-wing magazine in 1996. His gallery in Ahmedabad, Gujarat, was targeted in October 1996 and some of his work was destroyed. There were attacks on exhibitions of his work in Delhi (1998) and on his home in Mumbai (1998), as well as protests all over the country against any of his work being exhibited or his films being screened. There was also a new strategy in play: magistrates across India accepted cases of religious blasphemy filed against the artist in an attempt to enmesh him in mandatory personal appearances at court hearings in cities all across the country.

Sahmat met the orchestrated attacks on Husain with a long and sustained defence. In 1996, in a well-attended march from the National Gallery of Modern Art to Rabindra Bhavan (Lalit Kala Akademi in New Delhi), participants – including prominent politicians – carried images of classical sculpture, emphasising the fact that all the goddesses in these traditions have always been bare-breasted and that nudity in Indian art had never been regarded as obscene. Sahmat took up Husain's cause in many public forums presented by artists and scholars and organised academic symposia to discuss the issues exposed by these attacks. Sahmat also led delegations to the President of India, the president of the Congress Party and the

Minister of Home Affairs. Through Sahmat, the artists' community expressed a vocal and visible solidarity in defence of the artist and his art. Sahmat's support of Husain was based on the understanding that the accusations and attacks were politically motivated and managed, having nothing to do with the so-called public sentiment cited as justification. From Sahmat's point of view, the issue went beyond the individual. Indian society was permitting groups to cynically use religious sentiment as a political weapon, allowing them to set the discourse of cultural and artistic practice.

Eventually, these attacks forced Husain into voluntary exile in Dubai. This shocked the art community. In the face of pressure from the BJP and right-wing groups, the government did not provide Husain protection to return to his homeland. The artist died in exile in June 2011.

In Sahmat's own case, the reaction to the exhibition 'Hum Sab Ayodhya' (literally: We all Ayodhya, 1993) became the most famous attack we experienced on free speech. Mounted in response to the demolition of the mosque in Ayodhya, 'Hum Sab Ayodhya' was a sort of pedagogical exercise. The idea was to take that one city in which this terrible episode of the destruction had happened, and to peel open the different layers of its history, contemporary, modern and ancient. Ayodhya had a rich ancient history, and it was a great religious site; but we also looked at its political and economic histories. Because so many Marxist historians participated in the project, it became a kind of exercise in Marxist historiography, and an exercise in popular/public culture using the format of the exhibition as our platform. We took quite complicated ideas and intricate, little-known histories, sourced from the fields of archaeology, early art history and architectural history, and put them in a form that could be seen and understood by people at large. The idea was to present the microcosm of the city of Ayodhya as a representation of India's whole culture and civilisation, and an emblem of postcolonial India's secular vision.

The stories about the Hindu god Rama exist in multiple forms all across India and South Asia, and even Southeast and Central Asia. One of the earliest iterations is a Buddhist version called the *Dasharatha Jataka*. In it, Rama and Sita, the king and the queen, and Lakshmana, are all siblings. It's a story of a jealous queen who exiles the children of another queen to the forest because she wants her son to rule. So there's the theme of exile, but there's no kidnapping of Sita, there's no Ravana, and there's no battle between Rama and Ravana, as in the conventional myth. Rama and Sita do come back from exile and the text states that they ruled as king and queen for 16,000 years. The BJP and right-wing groups picked up on that, saying that we were committing blasphemy by implying that Rama and Sita were brother and sister. They chose to ignore the fact that this is a version that exists in an ancient text, the Jataka tales, which the Buddhist community regards very highly as they're believed to have been told by the Buddha himself.

Sahmat was attacked for including this text in 'Hum Sab Ayodhya'. And the aggression was vicious, very coordinated. The exhibition was first attacked physically in Faizabad, where we were accused of religious blasphemy. The issue was then debated in the Indian parliament for three whole days, with nobody having seen the exhibition or read the texts in it. This, despite the fact that the exhibition was mounted not very far from the parliament in Delhi, at the Nehru Memorial Museum and Library, the former home of Prime Minister Jawaharlal Nehru and now a highly respected research institution that had actually coproduced the exhibition. We finally managed to get some parliamentarians to come and see the exhibition. We asked them, 'Why are you debating this without actually seeing the material that's there? You're being subjected to misinformation'. But it was too late, for the rumour machine of the Hindu Right, which is extremely effective, had planted the seed of doubt in everyone's mind that we'd committed a terrible blasphemy. They even conjured up a fabricated image of Rama and Sita, and we just didn't have the means to counter that scale of rumour-mongering.

The exhibition was seized from the Nehru Memorial Museum and Library by the Delhi police under very serious charges in the Indian legal code, including criminal conspiracy against the state, and deliberate malicious use of material to cause communal disharmony. We all thought we were going to get arrested. In the end, however, the arrests never happened. We then decided to challenge the seizure of the exhibition, and the subsequent effective ban on it, in court. Senior lawyers from the Supreme Court of India volunteered their time and effort to fight the case, and it became a major case on the freedom of expression in India. After eight years, Sahmat won the case in court with a very strong judgment against the initial seizure and berating of the government. The judgment has since become a key verdict in debates around freedom of expression in the Indian legal system.

DS: Thinking of Sahmat's history and legacy, over its 30-year exsitence, how have its ideas, working methods, ways of provoking debate and mobilising society evolved?

RR: In the early years of Sahmat, we were functioning in an environment where there were very few television channels and no internet. Newspapers were the prime means of information exchange. The kind of large public performance events that we'd organised in Delhi, Bombay, in Ayodhya and in many cities in India after the Babri Masjid demolition had a huge impact. The world of media has hugely transformed: we're now drowning in multiple television channels and in the internet – in other words, the media world is basically subsuming any kind of public event. Those kinds of events don't have the same effect now that they had back then.

 That being said, our annual performance event on 1 January, the anniversary of Safdar's death, has continued with as much vigour and relevance. It's an occasion for progressive citizens to come together at the beginning of the year to stand with each other in solidarity and reassert the commitment to a secular vision of society that's been slowly but surely corroded during the last 30 years and especially under attack from the current government. Our lecture series has provided a background to our activism with a focus on historical figures such as Gandhi and Nehru, who've been demeaned and attacked by the right-wing forces now in power in India. These events are widely attended by students and are also posted online and published. They continue to champion inventive and interactive formats. For example, painted backdrops against the war on the Palestinians, or the killings of writers and intellectuals in India in the recent past, became photo studio backdrops where people could be photographed in solidarity or resistance to issues, instead of just signing a letter online.

DS: In 2013 you co-curated an in-depth retrospective exhibition on Sahmat at the Smart Museum of Art of the University of Chicago. What was it like to present the work of Sahmat in the United States and what's the collective's relationship to the Indian diaspora in the US?

RR: When I travelled with 'Hum Sab Ayodhya' across universities in the US in 1993–94, I faced huge protests from Indian diaspora groups affiliated to the BJP/RSS. The Chicago exhibit drew no such response! The Chicago exhibit was the brainchild of curator Jessica Moss, who'd been at our 1 January event in Delhi a few years before. Being in a university museum and travelling to other university museums across the US, I think it showed students how layered responses could be to the intersection of art and politics and how we'd used local cultural traditions to mobilise culture in the political arena. It was a difficult exhibition to construct; it was hard to convey the range of Sahmat's interventions in a gallery setting. But I think the exhibition, combined with a substantial publication and the set of videos they produced, was a tremendous success. The book has a lasting value, as do the videos, which are online. I think the exhibition spoke more to the

American student and art community than to the diaspora, which is the way it should be.

DS: Sahmat has been fighting against the elision of the past with exhibitions such as this one, and by revisiting its own archives and exhibition history. How can archives be used to elicit new forms of mobilisation?

RR: The Sahmat archive is vast and has been meticulously maintained thanks to the rigour and discipline that the political experience of its left-wing members had conferred them. There are thousands of hours of video performance, with some of the greatest artists in India in performance. Some of these are slowly being brought back into public view for my generation, which has grown up since. We're all 30 years older and slowing down now. Our wish is that the archive will be a beacon of hope.

'Bomb the university
the hostels to rubble
raze our homes to the ground

what about me?
I am grass, I grow *back* on everything'.
– Pash (Punjabi poet, 1950–1988)

The tragic death of Safdar Hashmi in 1989 galvanised India to recognise the imminent threat to cultural freedom and freedom of thought. On 1 January 1989, goons of the then ruling dispensation attacked Hashmi along with his theatre group whilst performing a play. Janam, the theatre group, was performing *Halla Bol* (Speak Up!) in support of an ongoing labour strike, 15 kilometers from Delhi in Sahibabad, when the group was attacked with iron rods and guns. Hashmi, and a migrant worker, Ram Bahadur, lost their lives.

On 4 January, the surviving members of the group returned to the site where the attack had taken place and completed the play. Thousands gathered there – workers, artists, intellectuals and citizens – to pay respect to the man who was determined to take art back to the people.

Janam, short for Jana Natya Manch (People's Theatre Forum) literally means birth. Hashmi was a man committed to the cause of working with the people and for the people. A cultural activist, a sensitive playwright, a playful poet, and a malleable actor, he dedicated his efforts to make theatre that rose out of the concerns of the people. He *birthed* a forum that could be accessed by one and all, and continues to do so to date.

The collective grief and anger caused by Hashmi's murder built a resolve amongst artists, writers, filmmakers and intellectuals to resist all attempts to stifle creative expression and thought. This led to the formation of Sahmat – Safdar Hashmi Memorial Trust – in the early months of 1989, an artists' collective to cherish the memory of Hashmi and to further his commitment to the principles of democracy and secularism. Given the tragic manner of his death, Hashmi had become a powerful symbol of resistance and Sahmat, since its inception, has strengthened that commitment and stood up for creative freedom and cultural autonomy across India.

It would be no exaggeration to say that thousands of artists have been associated with this collective, and in turn shaped its course to raise conscientious questions wherever injustice was seen. Projects conceived by Sahmat can be defined as interventions to disrupt complacency towards all forms of injustice. The mode of realising these projects are innovative and inexpensive – cardboard boxes, postcards, cycle rickshaws, pushcarts, painted umbrellas – thus the projects are an open dialogue, a constructive effort and a statement of relevance to their time and context.

Following the trajectory: a marvellous vision, a grandiose delusion

On 6 December 1992, two grand edifices were brought down. A mob demolished the Babri Masjid (Mosque) in Ayodhya, and with that tore down the fabric of secular India. If Hashmi's death led to the formation of Sahmat, the horrifying destruction of Babri Masjid shaped the trajectory that Sahmat – and the nation – was to take henceforth. The demolition of the Babri Masjid was the culmination of a systematic campaign of the Hindu Right, which traces its roots to 1949. This time around, illegally and surreptitiously, in the middle of the night, 50 people broke into the mosque, and placed the idols of the Hindu deities of Ram, Sita and Laxman inside. Instead of removing the idols, the administration of Uttar Pradesh locked down the mosque, preventing Muslims from offering *namaz* in their house of worship. Thereon, a persistent myth was generated that the site of Babri Masjid was the birthplace of Lord Ram; it was amplified to such an extent that it eventually became an unwavering belief amongst much of the Hindu community. In 1984, the Vishwa Hindu Parishad (VHP – an extreme-right Hindu organisation) called for the Masjid to be removed all together and so began the *rath yatra* (a monumental Hindu chariot procession) an extraordinary political propaganda stunt designed to take over the Babri Masjid. In 1986, the locks of the Masjid were prematurely opened. Riots ensued; a curfew was declared. This led to a rise in communal tensions,[147] which slowly engulfed several parts of the country.[148]

In response to these developments, Sahmat launched the campaign *Artists Against Communalism* (AAC). As the statement issued on 1 January 1991, read:

> We, the artist's community of India, are deeply pained by the growth of communalism which has assumed unprecedented proportions in recent days. All artistic endeavour in India, both traditionally and in contemporary times, has been exemplary in upholding the values of secularism and cultural pluralism. We increasingly feel that we can no longer be silent spectators to the destruction of these values which have sustained our thoughts and endeavour. We wish to emphasize the paramount importance of peace, and appeal to the nation's conscience to rise above this tide of hatred and violence.[149]

Sahmat's campaign began with a 17-hour sit-in at Safdar Hashmi Marg, New Delhi.

AAC was a departure from the usual methods of protest, and positioned performance itself as a tool of resistance. In doing so, it created a new vocabulary of protest in India.

Performance art was wrenched from the relatively 'safe' space of museums and galleries and re-contextualised to become a form of protest. The campaign became an assertion of the plurality and composite nature of India's cultural traditions by bringing together on the same platform the enormous variety and richness of India's classical music and dance practices. Though AAC started in Delhi, it travelled to several cities across India and such expansive geographic actions went on to be one of Sahmat's most impressive hallmarks as new projects emerged.

As the year 1992 unfolded, Sahmat consistently responded to the dangers of growing communalism through sustained campaigns, seminars, film screenings and a 20-hour cultural sit-in. Sahmat printed thousands of copies of the National Street Theatre 1992 poster – *Aaj Koi Naraa Na Hoga, Sirf Desh Bachana hoga* (No More Slogans Today, Our Only Task Is To Save The Country) and covered the walls of Delhi along with distributing them as inserts in newspapers. Within days of the Babri Masjid demolition, in December 1992, defying police orders and imposed restrictions, Sahmat occupied the streets, and organised a sit-in on Safdar Hashmi Marg. Poetry was read, songs were sung, paintings were made; all protested against the demolition, all were unified in one voice of resistance.

It was to that defining moment that the further course of action is attributed. The nationwide grief and shock found expression and a unique sense of solace in the coming together of artists in programmes organised by Sahmat. These convergences prevented restless grief from becoming cynically existential, with mourners finding in that solidarity the courage to be present and vocal.

Within weeks of the demolition, Sahmat organised a festival, *Anhad Garje* (The Silence Reverberates), and brought together the best practitioners of the Sufi and Bhakti traditions from India and abroad. It was an affirmation by the entire cultural community of the broad and rich traditions of India, their openness, diversity and tolerance of all faiths. Set against a background of strident majoritarianism, it became a statement to defend a syncretic culture that belonged to all.

Sahmat took *Anhad Garje* to the various cities that were hit by communal violence after the Babri Masjid demolition, including cities of Bombay, Ahmedabad, Surat, Baroda, Valod and Lucknow. Posters were designed that combined imagery drawn by contemporary artists with poems of Sufi-Bhakti traditions. This became a series entitled *In Defence of Our Secular Traditions* and was distributed to the public at large, in order to spread the message of unity and communal harmony. *Anhad Garje* embodied a political commitment to defend the rich secular tradition of our past and present heritage.

147 Achin Vanaik, 'Reflections on Communalism and Nationalism in India', *New Left Review* (November-December 1992): 'The term "communalism" was first used by British colonialists to describe the situation of colonies like India and Malaysia, where religious minorities existed alongside a religious majority. The colonial use of the term gave it a negative connotation of bigotry, divisiveness and parochialism, thus helping to justify the colonial civilizing mission. It was also a way of understanding Indian history as colonialists saw and lived it. It apparently corresponded to the pattern of colonial expansion—defeat of the Mughal Empire, of Hindu princely kingdoms, of Ranjit Singh's Sikh empire. Indian nationalists adopted the term, accepted its negative significations, but saw it as a colonial, post-British phenomenon rather than a pre-colonial circumstance that the British inherited. Since, contrary to earlier hopes, communalism did not progressively decline after Partition and Independence, the task of reassessing the situation and searching for a deeper understanding of it has assumed new urgency.'
148 Valay Singh, *Ayodhya: City of Faith, City of Discord* (New Delhi: Aleph Book Company, 2018).
149 Sahmat's statement issued on 1 January 1991, http://sahmat.in/3011991.html accessed 27 August 2021.

The pursuit to reclaim communalised places and to reaffirm harmony took Sahmat to Ayodhya in August 1993. Choosing the symbolic date of 9 August, Sahmat inaugurated a cycle of cultural programmes all over the country.[150] Artists from across India gathered in Ayodhya and a nightlong performance of music and dance ensued. *Muktnaad (Sound Liberated)* started at night with Nehru's iconic Independence Day speech – *Tryst with Destiny*[151] – and continued with music, plays, poetry and dance. There were no speeches, no political statements, just the reverberation of solidarity and a deep sense of resistance.

Simultaneously, a kit of portable panels was exhibited entitled 'Hum Sab Ayodhya' (We are all Ayodhya), showcasing photographs, paintings, drawings and texts that illuminated the rich and complex past of the interwoven lives in a city like Ayodhya. It highlighted the various layers of history, lost in the cacophony of intolerance. It brought to the fore the forgotten history of the Buddhists, the Jains, the Muslims and the material evolution of lives. The exhibition was the outcome of a unique collaboration amongst India's most eminent historians, who worked closely with design experts to put up a visual and textual narrative of the great richness of the city of Ayodhya. Held simultaneously in 16 cities other than Ayodhya, within three days of its opening, the exhibition was attacked by a Hindu right-wing mob, which tore up selective panels that spoke of the plurality of *Ramayan* (an ancient epic which has recensions in at least three religions and several folk traditions). The attack was a denial of plurality and assault on rationality.

By now the fragility of the secular principle in India had become more pronounced existed in words, but lesser so in deeds. The demolition of Babri had truly exposed the sinister face of fascism. Communalism became gradually more localised and more unpredictable. It raised its ugly head time and again, most notably with the attacks on M. F. Husain. Husain, an important modernist artist, who personified the essence of plurality by engaging with almost all the prominent faiths in his art, was reduced to his singular identity of being a Muslim. Sahmat stood with him, steadfastly, calling out on his deliberate absence from major art exhibitions. The same solidarity and support extended to other artists such as Taslima Nasreen, who faced the ire of Muslim fundamentalists. In 1995, there was a protest meeting against the ban on Salman Rushdie's *The Moor's Last Sigh*, and excerpts from the book were read aloud in public.

A project emerged in 1994 that travelled to several cities and involved the dissenting voices of cartoonists. This was called *Punchline: Cartoonists against Communalism* – an exhibition of cartoons drawn from the period three months prior to and three months after the demolition of the Babri Masjid, which was later published as a book. The sporadic attacks on the artists and even civil society indicated a pattern whose ultimate moment was yet to come. There were increasing attacks on minorities – Muslims, Dalits and even Christians. To document this, and also to voice concern, in 1999 a 38-panel poster exhibition – *Harvest of Hatred* – was inaugurated by secular political leaders. The need to unite all secular forces, political, social and otherwise was greater than ever before. These poster panels travelled to several cities again, becoming a campaign in itself, raising the dangers of intolerance.

The Babri Masjid demolition of 1992 had set the stage for the Gujarat massacre of 2002. 50 odd Hindu pilgrims returning from Ayodhya were burnt alive in Godhra. Their bodies were paraded in an attempt to 'make the blood boil'. Madness ensued; vengeance was declared. The State itself activated the frenzied mob – attacking the defenseless, cutting open the innocent. Thousands of people were killed and many more displaced. The perverse logic of 'retaliation' justified the economic debilitation, social ghettoisation and cultural disintegration of the Muslim minorities.[152] It became a laboratory of the imminent Hindu Rastra. The rupture was so brutal and the wound so deep that recovery from the rot of communalism seemed improbable.

Who holds the State accountable when the state machinery itself is the perpetrator? How did we allow this, and how soon did we forget? Sahmat fought against forgetting. Sahmat fought for the living. Statements were issued, press conferences held, and artists were mobilised to donate paintings for relief of victims of the Gujarat holocaust. A fact-finding team was assembled and reports released. Together with another organisation Communalism Combat, Sahmat brought 40 survivors from Gujarat to Delhi, in order for their testimonies to be amplified in the corridors of the capital. The survivors met the President. The combined actions were articulated in a month-long programme entitled *Ways of Resisting* to mark 10 years of the demolition of the Babri Masjid and mourn the recent Gujarat Pogrom.

An exhibition was mounted that showcased existing works by contemporary artists who opposed religious fanaticism and fundamentalism, and introduced new modes and strategies in art-making practices. This exhibition marked two trends that went on to define the contemporary art scene in India – of installation and engagement with urban spaces. Sahmat was thus consolidated, not just as a mobiliser of civic agency, but as an incubator of artistic innovation. The works in the exhibition made a collective statement against the prevailing polity of violence and loss of democratic values. Artists, who had become witnesses to the trajectory of violence, situated themselves in this new paradigm as a disruption and a pause.

Let us
Defend
Our
Secular Tradition

साधो देखो रे जग बौराना रे साधो ।

देखो रे जग बौराना ॥

साची कहो तो मारन लागे,

भूठी कहो पतियाना

हिन्दू कहत हैं राम हमारा,

मुसलमान रहमाना

आपस में दोऊ लड़ै मरत हैं,

मरम न कोई जाना ॥

घर घर मन्तर देत फिरत हैं,

माया के अभिमाना

पीपर पाथर पूजन लागे,

तीरथ भये भुलाना ॥

देखो रे जग बौराना ...

माला फेरे टोपी पहिरे,

छाप तिलक अनुमाना

कहे कबीर सुनो भई साधो,

ये सब भरम भुलाना ॥

देखो रे जग बौराना ...

SAHMAT
8 Vithalbhai Patel House
Rafi Marg, New Delhi 110 001
Tel: 23711276, 23351424
E-mail: sahmat@vsnl.com

Aban Raza

The Constitution of India, despite the partition of 1947, affirmed the principles of secularism and socialism. Defined as a republic, India acknowledged the different ways of living and being. The pulls and pushes of historical threads defined the ebb and flow of the interaction of various cultures in varying degrees at different times, both internal and external. There is no singular event/feature/time/entity that has gone into the making of India. It has formed, developed and changed through the course of history. Sahmat thus realised the importance of revisiting history, of bringing out the forgotten narratives and moments that have gone into making modern India. The revolt of 1857, lesser-known narratives that shaped the National Movement, events like the Jallianwala Bagh massacre were commemorated and honoured in the form of posters, calendars, books and lectures.

The role of the artist in the making and shaping of a nation whilst witnessing the reality of contemporary violence up close was further deliberated in projects like 'Making of India' (2004) and 'Making History Our Own' (2007). These projects located the uniqueness of the individual within the larger collective, which it shapes as much as the collective shapes the individual. Questions on caste that have, for the most part, remained unresolved in India, the forced hierarchy of one language over others, the reductive justification of the dominance of the majority over the minorities, were all addressed by artists bringing their own history in relation to the larger construction of the idea of India. The gradual rise of Hindutva[153] forces and their appropriation of history has greatly compromised the idea of India as a secular, socialist, sovereign republic. The multi-layering of identities at the core of these projects celebrating individuality in the context of contributing to the whole posed a challenge to the homogeneous identity being built by the Sangh Parivar (RSS family).[154]

3. Collectivity

150 Quit India Movement – a significant moment in the National Independence movement led by Gandhi. It started 9 August 1942.
151 www.youtube.com/watch?v=lrEkYscgbqE accessed 26 August 2021
152 Sahmat, *Sahmat 20 years, 1989–2009: A Document of Activities and Statements* (New Dehli: Sahmat, 2009), 196.
153 Hindu Nationalism

154 Swati Parashar, *Women and Militant Wars: The politics of injury*, (New York: Routledge, New York 2020): 'The Sangh Parivar (literally known as the Sangh family) includes groups such as the Rashtriy Swayamsewak Sangh, the Bajrang Dal, Shiv Sena and the Vishwa Hindu Parishad. They articulate a militant Hindu nationalist politics, opposing the Muslim "other".'

The Ayodhya events of 1992 made the Gujarat pogrom of 2002 possible, and facilitated the resounding victory of Narendra Modi in 2014. The same Modi who was the chief minister of Gujarat, under whose watch Gujarat burnt, became the prime minister of sovereign, socialist, secular, democratic republic of India. In retrospect, a pattern of political design emerges and the Rashtriya Swayamsevak Sangh (RSS, an Indian right-wing, Hindu nationalist, paramilitary organisation, head of the Sangh Parivar)[155] is closer to realising its almost-100-year-old dream of a Hindu Rastra (Hindu Nation) with Modi as its current face.

Today's India is antithetical to the 'Making of India' since 1947. Since May 2014, the idea of India has been systematically eroded with the unabashed communal polarisation that has fatigued secular forces. The RSS has infiltrated all state institutions including the judiciary and the media. The legitimacy of the Sangh Parivar has grown and is dangerously omni-present. A part of the idea of India also died when Mohammed Akhlaq was murdered over the meat stored in his fridge in 2015 by cow vigilantes of the Hindu right.[156] This event was part of a series of mob lynchings, targeting the Muslims and Dalits. The Hindu right, embold-ened by the silence of the authorities, started targeting minorities by lynching them in a faceless crowd, in broad daylight, recording the crime with no shame.[157]

Cow vigilante violence is the use of physical force in the name of 'cow protection' claim-ing to defend the Hindu religion. This makes the Dalit communities vulnerable, since many of them are engaged with the task of making leather and disposing of cattle carcasses. The Muslims, who are seen as beefeaters, also become an easy target and thus the meat of the cow is an easy excuse to mobilise the mob to attack the minorities. This is a convenient way to effectively declare Hindu supremacy and establish social hierarchy by reinforcing caste in its most vulgar form.[158]

Through the first five-year term of Modi, the fragility of the secular principles had become dangerously apparent. In 2019 the fragility received another blow. The Bhartiya Janta Party (BJP) with its leader Narendra Modi, won the general election for the second time, with an increased majority, concretising the fascist order as the dominant polity.

And so began a new series of assaults on 5 August 2019 with the unconstitutional lockdown and the bifurcation of the state of Jammu and Kashmir.[159] All communica-tion was suppressed and countless people, including political leaders, were arrested. This was a direct suspension of the fundamental rights of the people of Jammu and Kashmir inscribed in the constitution – freedom of speech and expression, and personal liberties.

Curfew was imposed, internet suspended, all communications cut. How can this be democ-racy? The Centre had paralysed the entire infrastructure of food, of health, of transport and also, of being.[160] The ruling government had transformed Jammu and Kashmir into an open prison. Article 370, though hollowed out through the years by successive governments, guaranteed a special status of autonomy and identity to the people of Jammu and Kashmir. By abruptly removing it without any consul-tation, without following any legal procedure, the government showed its utter disregard for the constitution, and also its willingness to use brute force. The Sangh Parivar has never been comfortable with the idea that Jammu and Kashmir be constitutionally protected as a Muslim majority state. Seeking control over Kashmir, the land; the current government undermines the Kashmiris and their trust.

In the lead-up to Kashmir's 'silencing', the government had already started arresting members and activists of civil society from various parts of India, who raised pertinent questions against human-rights violations and spoke for the most vulnerable in far-flung areas inhabited by Adivasis (Indigenous people). The abuse of the draconian UAPA (Unlawful Activities Prevention Act), which does not permit bail, has been enforced upon human-rights activists, professors, lawyers and those who have been working for the rights of Indigenous tribes, Dalits and workers' movements. The cases are built on fabricated evidence and there has been no judicial relief; as some of the activists have been languishing in prisons for at least two years, with no trial in sight. It is a witch-hunt of all those who dare to speak up, making dissent a crime and not a democratic right. Chip by chip, democracy is being chiselled out into mere rubble.

On 5 August 2020 another brick of injus-tice was cemented in the grand edifice of assaults. The Supreme Court, which had failed to address the basic question of constitutional-ity regarding the 2019 clamp-down on Jammu and Kashmir, unanimously passed a judgment fraught with contradictions in the Babri-Ramjanmabomi case, catering completely to majoritarian sentiments. The first brick of the Ram Temple was laid on the very spot where Babri Masjid once stood, by no other than the Prime Minister of what is constitutionally a secular India. The dispute was over the title of an immoveable property – the mosque – and yet the Supreme Court ruled in favour of Hindu faith and belief over the rule of law by awarding the Babri Masjid site to the very party who demolished it. The Muslims accepted the verdict, for once again they were reminded of their 'place' in majoritarian India. This verdict dangerously aligns with public sentiment of the Hindu majority, setting a potentially explosive precedent for the future, when it will become legitimate to fix 'historical wrongs' defined as

such by a dominant group conveniently based on their 'belief'. What is more disturbing is that the Supreme Court, the last bastion of hope, directed the government to form a trust that will build the Ram Temple. By virtue of this, the Court has made the State the medium through which Hindu interests will be exercised.

In addition to these blows, the National Register of Citizenship (NRC), National Population Register (NPR) and the Citizenship Amendment Act (CAA) were simultaneously introduced. CAA is an act that, for the first time, allows religion to define citizenship. It offers citizenship to non-Muslim immigrants in Bangladesh, Pakistan and Afghanistan. This act extends to Hindus, Buddhists, Sikhs, Parsis, Christians and Jains; it blatantly excludes Muslims. The CAA appears harmless, until it is paired with the NRC. Here, the onus to prove citizenship is moved from the State to the individual. This leaves the most poor and under-privileged vulnerable, as is seen in the Northeast Indian state of Assam (the only state to have implemented the NRC, effectively stripping 1.9 million people of their citizenship and declaring them illegal).[161] The NRC is used to remove the citizenship of the most vulnerable, and then the CAA is implemented to recruit back the ones who belong to the majority religion, systematically leaving the Muslims out. Such an Act holds no place in a secular republic.

Sahmat released the following statement, which was endorsed by intellectuals, artists, writers, academicians, and citizens, on 1 January 2020:

The Union government has of late adopted a number of measures which seek to undermine the Constitution in letter and spirit, to divide the people on the basis of religion, to reduce the Muslim minority to second class status, and to suppress all dissent against these divisive policies.

The unilateral abrogation of Article 370 in August violated the clear understanding of the Constitution that any change in Jammu & Kashmir's status could only occur with the concurrence of the representatives of the people of that state. And now the government has enacted a Citizenship (Amendment) Act, which not only violates the Constitutional provision of equal rights, but would lead, when its sequel the National Register of Citizens is drawn up, to the languishing of large numbers of people belonging to the Muslim community in detention camps. In fact, millions of poor people belonging to all communities, who lack the requisite papers, would be subjected to immense hardships, uncertainty and terror.

While the country has erupted in opposition to the CAA and the NRC, with lakhs joining protest demonstrations, the response of the BJP government both at the Centre and the States, has been to weave a tissue of falsehoods, and to unleash unprecedented police brutality on the protestors, among whom again those belonging to the Muslim community have been singled out for particularly vicious treatment.

This assault on the right to dissent is unacceptable to us. This assault on the basic premises of our Constitution which express the values upon which modern India is founded is unacceptable to us. We demand the immediate and unconditional release of all political prisoners in Jammu and Kashmir, and the restoration of normalcy in that state through discussions. We demand that the government which holds office by swearing loyalty to the Constitution announce clearly that the NRC exercise is permanently abandoned. We demand that the CAA which discriminates between people on religious grounds is withdrawn. We demand that the basic right of the people to hold peaceful demonstrations is unconditionally respected.[162]

There was growing dissent against the unjust CAA, which led to peaceful yet assertive demonstrations. The State responded to these protests in a most brutal manner, sending the police illegally into university spaces of Jamia Millia Islamia, Delhi and Aligarh Muslim University, Aligarh, both minority institutions. The police used teargas and batons on unarmed and defenceless students in closed spaces like the library and hostels whilst destroying and damaging property. Many students were injured and had to be hospitalised; one of them even lost sight in his eye due to injury caused by the police.

155 Christophe Jaffrelot, *Hindu Nationalism: A Reader*, (Princeton: Princeton University Press, 2009).
156 CJP Team, 'The Lynching of Mohammed Akhlaw', *CJP* (5 February 2019): https://cjp.org.in/mohammed-akhlaq-lynching-case-timeline/ accessed 27 August 2021.
157 India Today Web Desk, 'Pehlu Khan lynching: All 6 accused walk free', *India Today* (14 August 2019): www.indiatoday.in/india/story/alwar-lynching-pehlu-khan-gau-rakshak-accused-acquitted-1580874-2019-08-14 accessed 27 August 2021.
158 Christophe Jaffrelot, 'Over to the vigilante', *The Indian Express* (13 May 2017): https://indianexpress.com/article/opinion/columns/over-to-the-vigilante-gau-rakshak-cultural-policing-beef-ban-4653305/ accessed 27 August 2021.
159 It is no longer a state but has been divided into two Union Territories.
160 The Centre is the Central Government (India is a federal structure with State Governments and the Central Government) so the Centre is the government of India. The Centre imposed the lockdown on Jammu and Kashmir, blocking it from the rest of the country, unconstitutionally overriding the State Government of Jammu and Kashmir on abrogating article 370 (which gives Jammu and Kashmir its special status).
161 'Assam NRC: What next for 1.9 million "stateless" Indians?' *BBC News* (31 August 2019): https://www.bbc.com/news/world-asia-india-49520593 accessed 27 August 2021.
162 The statement was read out loud at the annual Sahmat event, 1 January 2020 and circulated via email to artists in the network.

Resist the Assault on the Constitution!

Safdar Hashmi Memorial Trust (SAHMAT) presents an art exhibition

ARTISTS RESPOND

The Constitution of India at 70

Celebrate
Illuminate
Rejuvenate
Defend

On till 15th Feb

**Jawahar Bhawan, Raisina Road
Windsor Place, New Delhi
Ph: 9711155641**

Painter Manjit Bawa (on the left) plays the dholak (a percussion instrument) for the legendary Sindhi Sufi singer from Pakistan, Allan Faqir. Anhad Garje, Delhi, January 1, 1993.

Shubha Mudgal sings at Anhad Garje, Bombay, 1993.

This brutality sent shock waves across Delhi, and women from the nearby neighbourhood of Jamia Millia Islamia came out to protest. Shaheen Bagh a Muslim-dominated area of southeast Delhi, became the beacon of demonstration and hope. A group of 10 to 15 women stepped out and blocked three lanes of a six-lane road with a sit-in. With each passing day, more locals joined in and it became a continuous protest, growing exponentially in a matter of a few days. Students and citizens joined the women of Shaheen Bagh and came out on the streets to occupy them and proclaim their trust in the Constitution. The model was emulated in several states of India, all of which were headed by women.

The many Shaheen Baghs evoked imagery of the founders of the Indian Republic such as B.R. Ambedkar, Gandhi, Bhagat Singh, Jawaharlal Nehru, Maulana Azad (for whom secularism was central) and sang songs written by progressive writers like Faiz Ahmed Faiz, Muhammad Iqbal, pledging *Hum khagas nahin diikhayengey* (We won't show our papers). A bus stand of Shaheen Bagh on the blocked Kalindi Kunj road was converted into the Fatima Sheikh-Savitribai Phule Library, providing reading material on the Indian Constitution, revolution, racism, fascism, caste and other social and pertinent issues. Fatima Sheikh and Savitribai Phule, who defied upper-caste and patriarchy norms by establishing the first school for girls in Pune in the 1840s and fought to abolish discrimination and unfair treatment of people based on caste and gender, became the symbols of these women-led protests.

The solidarity generated by these movements, led by Muslim women, wasn't limited to the minority community but spread to the many who were proud of their Indian heritage; they came out on the streets to defend and protect the Constitution.

As predicted, the government, initially paralysed, eventually came down heavily in February 2020, to break the resolve of the people. This took the form of the Delhi riots, which saw the death of 53 people and destruction costing millions of rupees, primarily targeting the Muslims of North-East Delhi. Rioters wearing helmets, carrying sticks, stones, swords, guns and waving the saffron flag of the Hindutva Right Wing entered Muslim neighbourhoods while the police stood by. By the end of February, thousands of Muslims sought refuge in relief camps, and many left for their ancestral villages, fearful of their personal safety in the capital of India.

That year, amid this upheaval, the Constitution of India turned 70. The idea of India was formalised in this constitutional text, itself intended as a work-in-progress. A *document extraordinaire* that was unimaginatively attacked had to be defended by one and all. This formulated the framework of an exhibition organised by Sahmat entitled 'Celebrate,

Illuminate, Rejuvenate, Defend the Constitution of India at 70', as a contribution to the developments on the streets and an attempt to amplify the voice of resistance. It was an effort to take a collective stand against all the unconstitutional acts of the ruling dispensation. In that spirit, 54 artists came together to join with the guardians of the constitution on the streets. This included both senior and emerging artists from across the length and breadth of the country. A conscious effort was made to reach out to artists from Kashmir and Assam – states that were cut off unconstitutionally by the Central Government. With time, more voices attached themselves to the exhibition, taking the number of participating artists to 70, and the representation grew to include voices of Dalits, Adivasis, Muslims, LGBTQ, Kashmiris and artists from the northeastern part of India. The idea was for it to include as many voices, as much representation and as much resistance as possible. The works ranged from paintings, banners, sculptures, videos, text, photography and poetry.

Art, like resistance, needs to be created, needs to respond and remain relevant to socio-political events, and needs to make a statement against all nuances of injustices. The Indian Constitution provides us with a path to address such needs and to build a society where the identity of each individual is appreciated, respected and celebrated.

As written in the concept note of the call given by Sahmat to the artists:

> the exhibition sought to capture the spirit of audacity, the possibilities for the future and the dream of change through resistance that WE, THE PEOPLE OF INDIA have solemnly resolved to uphold. The many works invoked the name of the Constitution and become a celebration of the idea of India that we cherish – an idea that not just defines India today, but that will become a foundational pillar of a just society tomorrow.

Along with the exhibition, Sahmat organised several important talks, specifically addressing the several unconstitutional moves made by the ruling dispensation in the name of the Constitution. Rajeev Dhawan, representing the Muslim side in the Babri-Ramjanmabhoomi case, inaugurated the lecture series. A collection of articles critical of the judgment was published by Sahmat in the form of a book entitled *Justice Denied*.[163]

This engagement with the public and issues at large – documenting, publishing, organising, asserting, innovating, questioning, intervening – is more relevant today than ever before, generating more spaces where the culture of resistance against an increasingly intolerant polity will expand. Sahmat keeps the resistance

Aban Raza

3. Collectivity

163 Sahmat, *Ayodhya Verdict 2019: Justice Denied*, (New Dehli: Sahmat, 2019).

alive, and though the struggles have only increased, we must march on, with the banner held high towards the realisation of a true democratic order, on a path that this artists' collective started just over 30 years ago.

Reem Abbas

Smuggling Books into Sudan. A Brief History from 2012 to 2016

281

On 14 January 2014, the secretary-general of the National Council for Copyright and Neighbouring Rights and the Literal and Artistic Works, wrote a formal letter to the Sudanese customs department informing them that a two-part book titled *The Sudanese Vision* by Dr Amro Mohamed Abbas,[164] had been evaluated under article 43 of the 2013 copyright and neighbouring rights (protection) and literal and artistic works act, and approved for entry into the country on 29 November 2013 under the license number 2239.

At the time, copies of the book were stuck in customs having arrived from Egypt, where they had been printed by Azza Press, a fearless publishing house located on University Avenue in Khartoum. The publishing house was owned by Nur Al-Huda Mohamed,[165] a writer and publisher who had spent almost three years in the prisons of the government of Omer Al-Bashir after the latter's ascent to power through a military coup in 1989. Sudanese publishers had taken to printing in Egypt because Egyptian censors were very lenient regarding books by Sudanese authors, while government regulations made it legally and financially unsound to print books in Sudan.

In 2014, Al-Bashir – a corrupt and ruthless military general – had been in power for 25 years and his security agency and police forces controlled all aspects of life. What you wore and how you behaved in private and public were controlled by the public order (morality) police force, and activism and political work was controlled by the National Intelligence and Security Service (NISS), which had different branches such as tourism security, political security, NGO security and religious security, among other unknown forces. The religious security apparatus even harassed a yoga instructor, who was accused of spreading Buddhism, and monitored and intimidated Sudanese youth on social media if they openly identified as agnostic or atheist. The press was targeted by a body within the NISS called press security, as well as the police, making freedom of the press nonexistent. Security officers would arrive at newspaper offices every night to review the issues and take out the articles they deemed a threat to national security, and this was anything from articles on the president and his family to murder investigations. Journalists had to stick to other topics or risk being banned from writing in newspapers. Some continued to manipulate the system and speak their minds. The security apparatus and different government entities would take journalists to court on bogus charges to waste their time, impact their productivity and intimidate them into silence. At one point, Amel Habbani, a veteran award-winning journalist, had to attend trials on four out of five working days.

Access to books and magazines that were circulated inside the country was controlled by various entities. The political and press security sections were involved, as well as the different levels of the customs department, and sometimes the Foreign Ministry stepped in to control the activities of Sudanese publishers outside the country, including confiscating books published by Mohamed during a book fair in Cairo. Ironically, the National Council for Copyright and Neighbouring Rights and the Literal and Artistic Works, which was meant to protect literary work, was complicit in censoring literature and in conspiring with the security to ban books and persecute writers.

After receiving that promising letter from the Council, the publisher and author waited for news from customs, but every time they enquired, new excuses would emerge justifying the continued impoundment of the books. At one point, they were told that the security officer responsible for their case had travelled to Jordan to seek treatment for cancer. They had never met him, but found themselves becoming intimate with the details of his fight against the disease. They whole-heartedly prayed for his safe return to the country, only to be told that he had, unfortunately for everyone involved in this debacle, succumbed to death there. They were asked to wait for the transfer of the case to another officer.

The wait was prolonged, with no end in sight, and as the publisher and writer waited nine months to get the critical piece of paper needed for the release of the books, they began a scheme to smuggle them into the country. A number of people were recruited, including the author and his family, who scheduled trips to Egypt over the span of six months and brought back copies of the two-part book. The copies were hidden inside the bookshop, and only brought out when requested by a customer. There was a risk that a request would be made by a security officer, but it was one that both writer and publisher were willing to take.

'We fix people and the military breaks them down'

Mohamed was working at the publishing centre of the University of Khartoum when Al-Bashir came to power in 1989, but had taken leave to go to Syria to seek medical attention. He was impatiently waiting for a diagnosis of suspected cancer when he received a phone-call from his sister telling him that security men had come looking for him at home. She pleaded with him to stay in Syria. Mohamed's doctor informed him that a coup had taken place in Sudan in the early hours of the morning. Mohamed was shocked when the doctor told him: 'We fix people and the military breaks them down.'

He could have stayed in Syria, since he had his wife and young daughter with him, but he chose to come back and face his inevitable fate. He told his sister to inform the security services that he would arrive on Tuesday night in case they wanted to pick him up from the

airport. He was arrested just hours after he arrived at his office at the university. It was a crisp Saturday morning, barely a month after the coup, when he was taken to Cooper prison in Khartoum North.

Mohamed and Abbas had known each other since the 1970s, but were not particularly close at the time. In June 1989, Abbas was working at the Ministry of Health in Al-Fashir, the capital of present-day North Darfur state and was a member of the Sudanese communist party. He used his senior position to provide medical services and arrange secret family visits to political prisoners held in Shalla prison outside Al-Fashir city as the prison overflowed in the months after the coup. He would take the prisoners to the hospital for a routine check-up and have their families meet them there. At a time of great chaos, small acts of humanity are risky, but they form the basis of solidarity. For the families, seeing their loved ones lessened their suffering and anxiety.

It was in January 1990 that Abbas was sacked for 'the public good' and became a pensioner at the age of 40 due to his political affiliations. He was informed that he was black-listed from working in organisations, government entities and even the private sector. He returned to Khartoum with his family to drive a taxi and sustain a low-profile existence, but the security apparatus continued to seek him out. Money was short and everything of value was sold to feed his small family.

When Mohamed was released from prison in 1990, he returned to his job at the university before spending another stint in a 'ghost house' – or torture chamber – in 1991. A total of 53 other prisoners were incarcerated with Mohamed in the ghost house next to Citibank on the intersection of Al-Baladia and Mac Nimir avenue. Some were political prisoners and many were journalists, writers, painters and other creatives.

Upon its arrival to power in 1989 in what it called a 'bloodless coup', the Islamist government of General Omer Al-Bashir declared war on culture and began a bloody fight against books, theatre, art and music. In its first few days in power, the regime disbanded the parliament, banned all political parties, shut down the Sudanese Writers Union and confiscated its building opposite the Egyptian embassy in Khartoum. Newspapers, magazines, cinemas and theatres were closed. Luggage and mail were thoroughly searched by the security-operated Import and Export Bureau to look for books and articles that were deemed a threat to national security.[166] This massive crackdown on the cultural and artistic scene caused irreparable damage to its infrastructure, both material and human.Writers and publishers found themselves in prison and in exile. Those remaining struggled to put food on the table.

When he was released from the ghost house in 1991, Nur Al-Huda Mohamed found himself a pensioner, and with no other means to make ends meet, he began using his personal car as a taxi to support his family. After six years, hoping that the security apparatus had forgotten about him, Mohamed decided to get back in business and began operating in a small kiosk in Omdurman selling books and newspapers. The kiosk became a small shop on University Avenue inside a school, then expanded into an office, a bookstore and a storage area. Through his experience and network in the publishing world, he was able to establish contact with publishers in Egypt, Beirut, Iraq and other countries, and they showed solidarity by sending him books to sell. A Beirut-based publisher sent him a whole container of books and continued to support him when he founded Azza Publishing House.

By 2014, Mohamed was an established publisher. Although he didn't have much money to offer writers, he would print their books and sell them. To the government, he was a pariah whom they kept fighting, a nuisance who refused to go away. The security apparatus would regularly summon him for interrogations about his work and the books he published. Ruling party members would often call him, the publisher of the communist party, for printing books authored by communist party members, and their loyal journalists would go as far as to describe him as an infidel who published books critical of political Islam. To readers, Mohamed's store was a haven that helped them find knowledge and critical thinking at a difficult and dark time. It was a place where one could find books about religion and politics, many of which had been banned by the government. To his supporters, he was a brave man who deserved protection. This was given in the form of access to free personal spaces to store or hide his books, and through rights to books that he would print and benefit from their revenues.

Culture is Banned

Two years before the letter from the council, in 2012, Abdelaziz Baraka Sakin's books had been banned in Sudan. The government confiscated all copies at the Khartoum book fair, causing great financial losses to the writer, who had used his life-savings to finance the publication of his books, and traumatising him into fleeing the country in the following months. One of these books is a novel called *The Jungo – Stakes of the Earth*, which won a prestigious literary award in Khartoum.

Sakin quit Sudan and sought asylum, but he left behind a wide-scale solidarity campaign that made him perhaps one of the best-known writers in Sudan and inspired resistance in the form of cultural events, readings and online literary magazines. Sakin's friends

164 Based on inter-
views and documenta-
tion with Amr Mohamed
Abbas, an author and
public health prac-
titioner in 2013 and
2014.
165 The author inter-
viewed Nur Al-Huda
Mohamed on 3 December
2020 at Azza Press in
Khartoum-Sudan.

166 Reem Abbas and R.
El Melik *When Art is
Shut Down: Exploring
the Contemporary Im-
pact of the Crackdown
on Art Between 1989
and 2019*, forthco-
ming, 2021.

became distributors of his books and used their personal homes and vehicles to sell them. His books were also photocopied and sold by wandering booksellers out of bags and were displayed on old newspapers on the pavement near Comboni, a Christian school in downtown Khartoum.

In 2012, a group of writers began Mafroush, a monthly book fair and cultural event in Khartoum's Athena square. The event became a celebration of literature and art as booksellers sold their volumes, poets recited verses, painters showcased their artwork and youth groups held plays on makeshift stages. After decades of writers being targeted, damaging the infrastructure on which they depended to survive and also creating an environment where literature was so persecuted that people had mixed feelings about reading, literature was finally being celebrated. Many banned books were sold at Mafroush, such as Tayeb Salih's *Season of Migration to the North*, all of Sakin's books, and *The Longing of the Dervish* by Hammour Ziada. Two years later, Abbas's books would also make their way there.

People bought books from Mafroush because they knew the book-sellers were struggling. They bought them because they'd never seen so many books before, or so many people celebrating them. They bought books because attending Mafroush itself was an act of defiance and resistance. Security officers, with their unmistakable sunglasses and headsets and half-sleeve socialist suits, as they were called in Sudan, would be seen spying on groups in Mafroush. They would listen in to book readings, sipping tea and sighing as they observed the groups to make sure nothing 'political' was taking place.

In December 2012, security officers raided the offices of Al-Khatim Adlan Centre for Enlightenment and Human Development in Al-Amarat neighbourhood. They claimed that they represented the Humanitarian Aid Commission, where the centre was registered, and said that the registration has been cancelled. The centre was not an average NGO, but a cultural hub where young people and students came to watch documentaries, to use its large library and attend art galleries. In a dramatic scene, books from the grand library were taken outside and thrown into a truck. A security officer laughed as he jumped on top of the books in an attempt to crush the spirit of the employees at the centre. Neighbours watched as a library they loved and used was taken away and one man couldn't hold back his tears. The more he cried, the more the officer felt the need to perform on top of the books. The books were never retrieved, and there is a strong belief that they were burned after their confiscation.

In 2012 and 2013, mass protests shook the streets of Khartoum and other cities. In the course of only three days in September 2013,

more than 200 peaceful protestors were shot dead and many students, teachers, politicians and activists were detained. In the aftermath of the protests in 2013, the crackdown became more nuanced as civil society organisations were shut down or had their licenses revoked, and cultural institutions began to find it difficult to operate. Al-Khatim Adlan Centre for Enlightenment and Human Development might have been amongst the first cultural spaces to meet this fate, but it was not the only one. Between 2012 and 2015, the House of Arts, Al-Khatim Adlan Center, Ali El-Zein Cultural Centre, the Sudanese Studies Centre and Mahmoud Mohamed Taha Cultural Centre were shut down by the security apparatus. In January 2015, the Sudanese Writers Union was closed for a second time after it was re-opened in 2005.

Guard the Gate!

The Sudanese Writers Union tried its best to support its constituency and show solidarity even if the price was high. In October 2014, Abbas held a launch event for his banned book at the union's garden space. As the guests kept their eyes on the gate, waiting for the event to be interrupted by armed men, dates and cookies were served. Being there with copies of the books was an act of defiance. Biting into a cookie was an act of self-sustenance, since no one in their right mind would want to spend time in detention on an empty stomach.

It is not surprising that, in its attempt to protect and sustain the rule of Al-Bashir, the security apparatus found cultural centres and institutions and even individuals threatening. To rule people for so long and ensure that they comply with your policies and keep their mouths shut requires social engineering. The regime attempted to do this through altering the educational curriculum and using the media for propaganda purposes and to spread its fundmentalist values. Art has a poignant influence on our thoughts, and frees our minds to new possibilities, showing that nothing is absolute and that to perform and accept art is to open up to the possibility of a diversity of values and ideas. Art challenges any imposed hegemony of thought and this was dangerous to a regime that controlled all aspects of life.

In the absence of cinemas and theatre spaces, literature became a ray of light, and to those who believed in its power to help them save a generation from reproducing the same values as the oppressor, the fight was intense and came at the expense of their livelihoods, personal freedoms and even lives. The essence of this fight was everyday solidarity amonsgt the large constituency that believed that art is a tool for resistance. They opened up their houses for gatherings and readings when cultural centres were under fire, and used their personal resources to help distribute books,

radiating great confidence as they stood in front of customs officers with banned books in their suitcases on the way from Cairo and Dubai. They stood bravely against the dictatorship of Al-Bashir and challenged its flawed moral values in the fight for freedom. They are part of the infrastructure that kept knocking on stones until the revolution was instigated in December 2019 and finally got rid of Al-Bashir's government.

In October 2019, when a display of books by Mahmoud Mohamed Taha – a moderate Muslim scholar who had been executed in 1985 by a previous dictator for being an apostate – was attacked by a fundmentalist, the government stated that this act did not represent its views and the minister of information and culture announced that there would be no censorship of books. The revolution against Al-Bashir had been 30 years in the making, but as we have witnessed in other places, the need for revolutionary action does not stop with the fall of the dictator. A year and a half after Al-Bashir's demise and under Sudan's first civilian Prime Minister since 1989, writers are still struggling. The laws that govern their work are still in place and the institutions that should support and serve them continue to operate with the old methodology. Sadly, their demands are being deprioritised by the transitional government and they continue to remain on the periphery of the political scene.

Olivier Marboeuf

Dirty Faces. A Scene Without a Well-Known Face

Olivier Marboeuf

*Les visages sales
Une scène sans visage connu*

A Scene with no Familiar Faces

I'd like to try to speak here about some of my experiences of solidarity in the field of contemporary art and the forms of collectivity that this solidarity could presuppose, beyond appearances. In other words, not by looking at the image that the art field projects of itself – its institutions and various actors – but by piercing the surface of a mirror where it sees itself with the features of a benevolent and progressive face in which all should be able to recognise themselves. There could be several ways of dispelling this illusion. All are useful, in particular for understanding the precariousness that characterises the ecology of art practices today – if we agree here not to consider precariousness merely from the angle of economic problem, but also take into account the climate created by the structures of the art world and their most toxic stories.

To move forward to another place, which I imagine to be more supportive and habitable, we will have to question the persistence of the heroic figure of the artist and its consequences on the collective production of scenes of violence we do not wish to see. We will also have to consider the professional imagination(s) that transform and distribute this violence in art centres, museums and biennales, where everything is subsumed into questions of management, absurd missions, untenable contradictions and the taming of an administrative monster never sated by a ceaseless diet of reports of all kinds. All this creates the conditions and ambiances of art centres today. If we pay close attention, we could see here what is hidden by what they're showing. And with this same attentive eye, impervious to diversions, we could observe the rites of these institutions and professionals who noisily de-colonialise themselves, witness their methods of absorbing radical gestures and subaltern bodies for the benefit of a body of reference that is quite incapable of creating any other relations with what is not itself, except for extraction and transformation into market value. We know that the mere presence of this Body at the centre of the scene is sufficient to make it impracticable and toxic for all those who cannot recognise themselves in it, and who do not consent, whatever the ingenious form of the invitation, to become available matter, 'Black resources' (ressources nègres). No matter how many tons of benevolent discourse we spread over this minefield, and how thick a fertiliser of quotes from radical works by women-queer-black-Indigenous-people which are obviously *amazing*, we will still fail to transform this manner of inhabiting[167] into a scene of alliance. All of this will simply remain bad magic that will have to be eliminated in order to go somewhere else.[168]

Une scène sans visage connu

J'aimerais ici tenter de parler de quelques unes de mes expériences de solidarité dans le champ de l'art contemporain et des formes de collectivité que cette solidarité pourrait supposer, *au-delà des apparences*. C'est-à-dire en regardant ailleurs que dans l'image que se fait le champ de l'art – ses institutions et ses différents acteurs – de lui-même, en perçant la surface d'un miroir dans lequel il se regarde sous les traits d'un visage bienveillant et progressiste où chacun devrait se reconnaître. Il y aurait plusieurs manières de défaire cette illusion. Toutes sont utiles pour comprendre notamment la précarité qui est aujourd'hui l'écologie du travail de l'art – si l'on veut bien ici ne pas considérer la précarité sous le seul angle d'un problème économique, mais s'intéresser également aussi au climat que les structures de l'art et leurs récits les plus toxiques installent.

Pour s'avancer vers un autre lieu, que j'imagine plus solidaire et habitable, il serait nécessaire d'interroger par exemple la persistance de la figure héroïque de l'artiste et ses conséquences sur la production collective de scènes de violence qu'on ne veut pas voir. Il faudrait aussi s'attarder sur les imaginaires professionnels qui transforment et distribuent cette violence dans les centres d'art, les musées, les biennales où tout ne devient plus qu'histoire de gestion, de missions absurdes, de contradictions intenables et de domestication d'un monstre administratif jamais rassasié de rapports en tout genre. Tout cela fonde les conditions et l'ambiance des lieux d'art aujourd'hui. En faisant un effort d'attention, on pourrait ainsi voir *ce que cache ce qu'ils montrent*. Et avec ce même œil attentif, indifférent aux diversions, observer les rites de ces institutions et de ces professionnels qui se décolonisent bruyamment, leurs méthodes d'absorption des gestes radicaux et des corps subalternes au profit d'un *Corps de référence*, bien incapable de fonder d'autres relations avec ce qui n'est pas lui que celle de l'extraction et de la transformation en valeur marchande. Nous savons que la seule présence de ce Corps au centre de la scène suffit à la rendre impraticable et toxique pour tous ceux et celles qui ne s'y reconnaissent pas, et qui ne consentent pas, quelque soit la forme ingénieuse de l'invitation, à en devenir les matières à disposition, les ressources *nègres*. On aura beau déverser sur ce sol miné des tonnes de discours de bienveillance et un humus de citations d'œuvres radicales de *femmes-queer-noires-indigènes* évidemment *amazing*, on ne transformera pas pour autant cette manière d'habiter[220] en scène d'alliance. Tout cela

Olivier Marboeuf

I've put these questions to work in previous conversations and texts.[169] Even if they are still unresolved, I'd like to take another path here, which seems just as necessary to me, to similar ends: to depart towards other scenes. And to do this I'm going to make a detour in pursuit of a starting point. Choosing a particular starting point is a way of engaging a new perspective, affirming another gaze, even while removing oneself from that of the dominant narrator, with his agenda and order of things, his manufacture of History, with his heroes and statues. And thereby evading to a certain extent the violence of that narrator's innocence, his way of *not seeing*, as well as the skill of his captures. It means executing an escape from an uncomfortable *We (Nous)* in order to find another way, and other matters, from which to form this *Us*. I return to crime scenes in an effort of assemblage based on traces that remained in shadow, on stories that never knew how to find a place for enunciation. And this is why they continue to haunt me until they are finally able to liberate their meaning, elsewhere and later. What couldn't be said will now be able to be said or, even better, be able to participate in the composition of another place. We don't all arrive at the scene of solidarity by taking the same paths. It is essential to consider this precisely so that this scene can be different and owned by no one, in other words with no single root, and that its enunciation – it might be better to say, its apparition – comes not from a privilege, be it ever so benevolent, but from the friction created by the multiple voices of an assembly.

And so, in order to speak of the path that led me to Haiti in 2017 in the company of the film-maker Louis Henderson – a journey that allowed me to perceive the first signs of a scene of solidarity – I choose to begin my narrative two years earlier, at the start of a particularly tragic year in France. I want to anchor my story in a place that is important to me, the Espace Khiasma, a small associative art centre that I founded in 2004 and directed until 2018, located in a suburb close to Paris, in the department of the Seine-Saint-Denis. In an exercise where I hide myself behind the image[170] of Khiasma – a space that enjoys a certain renown on the French artistic scene having from an early date engaged in postcolonial critique, the representation of minority bodies and knowledge(s) – I'm exhuming here a few diffuse and underground tensions. For these tensions seem to me to illustrate certain limits to practices of solidarity in the field of French art, but also to signify certain avenues of thought for those who know how to persevere, and decide to truly see. If this text aims to travel to the heart of decades of agitated politics in troubled times and to undergo the experience of alliances with nameless bodies,[171] it is with the intention of advancing towards an imagined vision of solidarity that takes the form of a scene repopulated with the power of all *that* and all *those* whom no one wanted to see or to consider. A scene full of dirty faces.

restera de la mauvaise magie[221] dont il faudra bien se débarrasser pour aller ailleurs.

Ces questions, je les ai mise au travail dans des conversations et des textes précédents[222]. Si elles restent encore irrésolues, c'est un autre chemin, qui ne me semble pas moins nécessaire, que je souhaite emprunter ici à des fins similaires : partir vers d'autres scènes.

Et pour cela, je vais faire un détour, à la recherche d'un point de départ. Choisir un point de départ particulier est toujours une manière d'engager une nouvelle perspective, d'affirmer un autre regard tout en se dégageant de celui du narrateur dominant, de son agenda et de son ordre des choses. De sa fabrique de l'Histoire, de ses héros, de ses statues. Et ainsi s'évader d'une certaine mesure de la violence de son innocence, de sa manière *de ne pas voir*, comme de l'habileté de ses captures. C'est opérer une fuite depuis un *Nous* inconfortable pour chercher une autre manière et d'autres matières pour former ce *Nous*. Je reviens sur des scènes de crime, dans un effort d'assemblage à partir des traces restées dans l'ombre et de récits qui n'ont pas su trouver leur espace d'énonciation. Et c'est pour cela qu'ils continuent de me hanter jusqu'à qu'ils puissent libérer leur sens, ailleurs et plus tard. Ce qui ne pouvait pas se dire, va pouvoir se dire maintenant, ou mieux, va pouvoir agir dans la composition d'un autre lieu. Nous n'arrivons pas tous sur la scène solidaire par les mêmes chemins. Il est essentiel de le considérer pour que cette scène soit justement différente et sans propriétaire, c'est-à-dire sans racine unique et que son énonciation – il conviendrait même de dire son apparition - ne relève pas d'un privilège, fut-il bienveillant, mais bien de la friction des multiples voix d'une assemblée.

C'est ainsi que pour parler du chemin qui va me mener en Haïti en 2017, en compagnie du cinéaste Louis Henderson, où j'aurai l'occasion d'apercevoir les premiers signes d'une scène solidaire, j'ai choisi de débuter mon récit deux ans plus tôt, au tout début d'une année particulièrement tragique en France. J'ai souhaité l'ancrer dans un lieu important pour moi, l'Espace Khiasma, petit centre d'art associatif que j'ai fondé et dirigé de 2004 à 2018, en proche banlieue de Paris, dans le département de la Seine-Saint-Denis. Dans un exercice où je me faufile *derrière l'image*[223] de Khiasma – espace jouissant d'une certaine renommée sur la scène artistique française, en tant que lieu engagé très tôt dans la critique postcoloniale, la représentation des corps et des savoirs minoritaires – j'exhume ici quelques tensions diffuses et souterraines. Car ces tensions me semblent dessiner certaines limites des pratiques

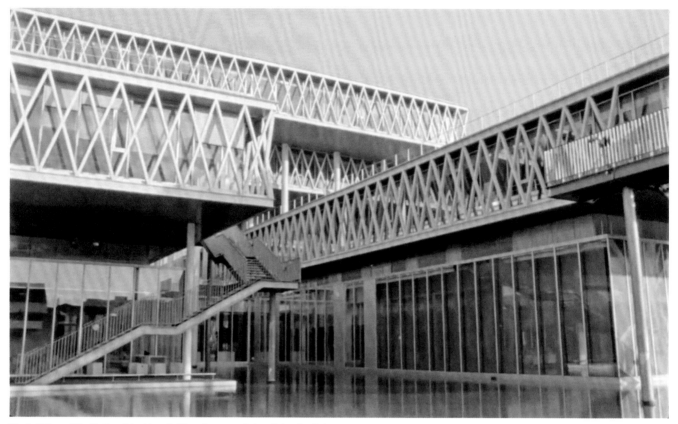

The building of the National Archives in Pierrefitte-sur-Seine, Saint-Denis by Massimiliano Fuksas, where the letters of Toussaint Louverture are imprisoned / Le bâtiment des Archives Nationales à Pierrefitte-sur-Seine, Saint-Denis de Massimiliano Fuksas où les lettres de Toussaint Louverture sont emprisonnées © Still from *Ouvertures* by The Living and The Dead Ensemble.

solidaires dans le champ de l'art français, mais aussi signifier certaines pistes pour qui sait insister, pour qui s'engage à voir. Si ce texte se décide à voyager au cœur de décennies politiques agitées, dans des temps troubles et à faire l'expérience d'alliances avec des corps sans nom[224], c'est bien pour s'avancer vers un imaginaire de solidarité qui prend la forme d'une scène repeuplée de la puissance de tout ce, celles et ceux qu'on ne voulait pas voir, ni considérer. Une scène de visages sales.

De l'empathie terroriste

Le 7 janvier 2015, un commando de deux hommes pénètre dans les locaux du journal satyrique Charlie Hebdo qui avait publié un peu plus tôt une série de caricatures du prophète Mahomet. Les deux intrus, lourdement armés, abattent d'abord un policier en faction – Franck Brinsolaro – pénètrent dans la salle de rédaction et ouvrent le feu, tuant les dessinateurs Cabu, Charb, Honoré, Tignous et Wolinski, la psychanalyste Elsa Cayat, l'économiste Bernard Maris, le correcteur Mustapha Ourrad, Michel Renaud et Frédéric Boisseau ainsi qu'une personne chargée de la maintenance du bâtiment. Puis les deux meurtriers, dont on apprendra plus tard qu'ils sont frères, quittent le bâtiment, abattent de nouveau un policier – Mohamed Merabet – et s'enfuient à bord d'une voiture. Saïd et Chérif Kouachi, c'est leurs noms, ne savent visiblement pas où aller. Après une course poursuite, ils se réfugient dans un entrepôt à Dammartin-en-Goële, une petite commune de Seine-et-Marne, en Région parisienne où ils seront abattus le 9 janvier par le Groupe d'Intervention de la Gendarmerie Nationale (GIGN). Ils revendiqueront leur crime au nom d'Al-Qaïda dans la péninsule Arabique (AQPA).

Un autre terroriste tue une jeune policière – Clarissa Jean-Philippe – et blesse un agent de voirie en pleine rue à Montrouge, au Sud de Paris, le 8 janvier 2015[225]. Il s'appelle Amedy Coulibaly. C'est lui qui le lendemain prend en otage les clients et les employés du magasin Hypercacher de la porte de Vincennes, faisant quatre morts. Avant d'être abattu par la police, Coulibaly affirmera au téléphone à une télévision s'être « synchronisé » avec les tueurs de Charlie Hebdo, et se réclamera de l'organisation État islamique – dite « Daech ».

L'émotion suscitée par ces attaques est sans précédent. C'est d'abord et même essentiellement autour de l'assassinat des journalistes que va se composer la mise en récit symbolique de ces drames. Au cœur de ce moment

On 7 January 2015, a two-man commando infiltrates the offices of the satirical newspaper *Charlie Hebdo*, which had recently published a series of caricatures of the prophet Muhammad. The two intruders, heavily armed, first kill an on-duty police officer – Franck Brinsolaro – then penetrate the newsroom and open fire, killing the cartoonists Cabu, Charb, Honoré, Tignous and Wolinski, the psychoanalyst Elsa Cayat, the economist Bernard Maris, the corrector Mustapha Ourrad, Michel Renaud, and Frédéric Boisseau, an employee responsible for building maintenance. The two murderers, whom we later learn are brothers, then leave the building, killing another police officer – Mohamed Merabet – and escape in a car. Saïd and Chérif Kouachi clearly don't know where to go. After a car chase, they take refuge in a warehouse in Dammartin-en-Goële, a small town in the Seine-et-Marne in the Paris region, where they will be killed on 9 January by the Groupe d'Intervention de la Gendarmerie Nationale (GIGN). They claim they committed the crime in the name of Al-Qaïda in the Arabic peninsula (AQPA).

Another terrorist kills a young policewoman – Clarissa Jean-Philippe – and wounds a road maintenance agent in Montrouge, a suburb south of Paris, on 8 January 2015.[172] The terrorist's name is Amedy Coulibaly. The next day he takes as hostage the clients and employees of the supermarket Hypercacher at the Porte de Vincennes, killing four people. Before being killed himself by the police, Coulibaly will affirm by phone to a television station that he had 'synchronised' his actions with the *Charlie Hebdo* killers, and claim he is part of the organisation Islamic State – called Daech.

The emotion generated by these attacks is unprecedented. It is at first, and perhaps essentially, the assassinations of the journalists around which the symbolic dramatisation of these events will be composed. At the height of this moment of shock, the graphic designer Joachim Roncin spontaneously creates a logo that will quickly become a viral hashtag: *Je suis Charlie* (I am Charlie). All over France, huge demonstrations, some of them spontaneous, others more political, take hold of this slogan to affirm their attachment to unconditional freedom of expression. But quickly a burning question emerges at the heart of the debate: are you Charlie?

'I am Charlie' asks in a literal way if *one sees oneself* in Charlie – in other words in the journalists assassinated in the attack. We know that *Charlie Hebdo*, a satirical paper with a 'stupid and nasty' sense of humour,[173] doesn't facilitate the task of such a projection, for its authors and cartoonists have always sought to play with the limits of decency, never sparing political figures nor avoiding contentious subjects. And yet here it isn't a question of being *with* Charlie, in other words to share the same stage of debate, but quite clearly to be

de sidération, le graphiste Joachim Roncin crée spontanément un logo qui va rapidement devenir un *hashtag* viral : Je suis Charlie. Partout en France, de gigantesques manifestations, certaines spontanées, d'autres plus politiques, s'emparent de ce mot d'ordre pour clamer leur attachement à la liberté d'expression sans condition. Mais très vite, une question va occuper le cœur du débat et brûler toutes les lèvres : êtes-vous Charlie ? « Je suis Charlie » demande de façon littérale si *on se voit* dans Charlie – c'est-à-dire dans la rédaction assassinée lors de l'attentat. On sait que Charlie Hebdo, journal satyrique à l'humour « bête et méchant »[226] ne facilite pas la tâche d'une telle projection car ses auteurs et dessinateurs ont toujours cherché à se jouer de la limite de la bienséance sans jamais n'épargner les politiques ou ni éviter les sujets qui fâchent. Cependant ici, il ne s'agit pas d'être *avec* Charlie, c'est-à-dire de partager une même scène de débat, mais bien d'*être* Charlie, au sens d'apercevoir un *autre soi* dans Charlie. Et c'est bien cela qui compose la limite de la formule empathique. Celle-ci dit quelque chose de la manière dont la société française a conçu jusqu'alors sa citoyenneté, par un principe d'absorption de tous et toutes dans le corps d'un citoyen sans genre, ni race, ni sexualité, sans relation particulière avec le territoire ou le Roman national. L'expression introduite dans un geste d'émotion par Roncin tombe, pour ainsi dire, bien.

Dix ans plus tôt, en novembre 2005, quand deux jeunes de Clichy-sous-bois, Zyed Benna et Bouna Traoré périssent électrocutés dans un poste électrique en tentant d'échapper à la police, personne n'imagine une manifestation monstre au cœur de Paris sous la bannière « Nous sommes Zyed et Bouna ». C'est toute autre chose qui se déroule alors. Et il me semble nécessaire pour comprendre le tumulte de l'année 2015 de le mettre en récit à partir de la perspective d'événements qui se déroulent dix ans plus tôt dans une périphérie de l'Empire[227]. Puisque la mort des deux jeunes Clichois[228] va déclencher une série de révoltes populaires qui depuis le département de la Seine-Saint-Denis va se répandre dans la plupart des banlieues de France à la manière d'une flaque d'essence où l'on jette un mégot. Le feu court à présent. La performance des ombres de la République remplit les écrans de télévisions et repeint de flammes les Unes de la presse. L'émeute crache, sans un mot d'ordre, un corps collectif vivant. Ce corps s'oppose à la nécropolitique d'Etat comme il refuse d'emprunter le chemin de ses aînés.

Car plus de vingt ans plus tôt, en 1983, ce sont déjà ces jeunes dont tous semblaient ignorer l'existence qui avait fait une entrée fracassante

Charlie, in the sense of recognising *another self* in Charlie. And it is this that composes the limits of the empathetic formula. This formula says something about the way in which French society has conceived of its citizenship up to this time, by a principle of absorption of all into the body of a gender-less, race-less, sex-less citizen, with no particular relation to the French territory or the official version of the nation's history. The expression introduced through Roncin's emotional act lands well.

Ten years earlier, in November 2005, when two young men from Clichy-sous-bois, Zyed Benna and Bouna Traoré, are electrocuted at a power plant while trying to escape from the police, no one imagines an enormous demonstration in the centre of Paris under the banner 'We are Zyed and Bouna'. Something completely different happens. And to under-stand the tumult of 2015, it seems necessary to relate it from the perspective of events that occurred 10 years earlier in a periphery of the Empire.[174] The death of the two young men from Clichy-sous-bois[175] will set off a series of revolts in working-class neighbourhoods that, starting from the department of Seine-Saint-Denis, will propagate themselves to the majority of suburbs all over France, like a lit cigarette thrown into a puddle of gas. The fire is raging now. The performance by the shadow people of the Republic fills TV screens and repaints the front pages of the press in flames. The insurrection spits forth with no watchword, a living collective body. This body opposes the necropolitics of the State in the same way it refuses to follow the path taken by its elders.

20 years before, in 1983, it was young people yet again, of whose existence everyone seemed ignorant, who made a shattering entry onto the French scene, their bodies their only political argument. They demanded that the practice of police, vigils, and security guards shooting at them like rabbits at the entrances to their HLM (low income housing) tower blocks cease. Starting in Marseille, the March for Equality and Against Racism[176] completed its Tour de France in the streets of Paris, and the most famous of the marchers even managed to plant their sneakered feet on the carpets of the Elysée Palace, where the president François Mitterrand – figure of the return of the Left to power, elected in 1981 – pretended to welcome them like old allies and delec-table guests. Soon afterwards, the Socialist Party created the association SOS Racisme, which quickly transformed these young people with dirty faces into a herd of baby seals that needed to be saved from mean racists with the power of a magic formula: 'Touche pas à mon pote' (Hands off my buddy).[177] In terms of an alliance, this was more of an absorption. The political ambitions of the movement were quickly siphoned off and the systemic critique of the racist would have to wait a few decades before being heard anywhere outside of militant Indigenous circles.[178] But this failed political *rendezvous* would weigh heavily on History, with ricocheting consequences. And it is from the

sur la scène française avec leur corps comme seul argument politique. Ils réclamaient déjà que l'on arrête de les tirer comme des lapins aux pieds des HLM. Depuis Marseille, la Marche pour l'égalité et contre le racisme[229] avait fini son tour de France dans les rues de Paris et les plus célèbres marcheurs étaient même venus poser leurs baskets sur les tapis de l'Elysée où le prési-dent François Mitterrand – figure du retour de la Gauche au pouvoir, élue en 1981- avait feint de les accueillir comme de vieux alliés et de délicieux invités. Dans la foulée, le Parti Socialiste allait créer l'association SOS Racisme qui transformerait bientôt cette jeunesse au visage sale en un vulgaire troupeau de bébés phoques qu'il faudrait sauver de méchants racistes par la puissance d'une formule magique : « Touche pas à mon pote »[230]. En fait d'alliance, il s'agissait plutôt d'une absorption. Les ambitions politiques du mouvement seraient vite siphonnées et la critique systémique du raciste attendrait bien encore quelques décennies avant de se faire entendre en dehors de cercles militants indigènes[231]. Mais ce rendez-vous politique raté allait peser lourd dans l'Histoire et ses ricochets. Et c'est à partir de l'épuisement de cette marche triomphale au grand jour que nous regardons la course nocturne de 2005, comme un rituel de deuil sans fin, une nécromancie qui se rend cette fois-ci insaisissable et illisible par les pouvoirs politiques. La Gauche n'y retrouve aucun des mots et motifs qui forment à ses yeux *la politique*. Encore moins un lieu de rendez-vous. C'est une apparition brutale et sans annonce, une pratique de la révolte comme expérience d'un monde politique à venir, un espace de vision et de transmission opaque.[232]

Une autre nuit

Alors quand, en 2015, des journalistes de télévision et de radio viennent tendre leurs micros devant les bouches des écoliers de Seine-Saint-Denis pour savoir si par le plus grand des hasards ceux-ci seraient « Charlie », on se demande ce qu'ils attendent : que des enfants parcourent dans l'autre sens la distance que des adultes n'avaient pas su franchir dix ans plus tôt alors que Zyed et Bouna disparaissaient de ce côté-ci du Périphérique[233] ? Ou peut-être que ces enfants d'immigrés comprennent subitement la valeur d'une vie alors que les violences policières ne cessaient de leur dire que la leur ne valait rien. Eux qui avaient grandi dans des paysages où la mort d'un jeune homme noir ou arabe n'était plus qu'un motif parmi d'autres, inscrit dans le béton. Dans une mémoire qui bégayait, un reste d'odeur d'essence, les cris étaient deve-

perspective of the extinction of this triumphal march in broad daylight that we observe the nocturnal race of 2005, like a ritual of endless mourning, a necromancy that this time around is elusive and illegible for political powers. The Left can find none of the words and motivations that in its view form *politics*. Even less so a place for encounter. It is a brutal and unannounced apparition, a practice of revolt as experimentation of a political world to come, a space of vision and opaque transmission.[179]

Another Night

So when in 2015 television and radio journalists aimed their microphones at the mouths of school children in the Seine-Saint-Denis to learn if by any chance the children were 'Charlie', we can wonder what they were expecting: that the children would cross in the opposite direction the distance that adults had not been able to transverse 10 years earlier when Zyed and Bouna disappeared on this side of the Périphérique?[180] Or maybe that these children of immigrants would suddenly understand the value of a life even as police violence ceaselessly told them that their own lives had no value. These children grew up in places where the death of a young Black or Arab man was merely one motif among others, carved in cement. With a memory that stuttered and a lingering odour of gas in the air, cries had become tinnitus. No, clearly, they did not see themselves in this world of Charlies. Obviously, the least we can say is that the

caricatures of Muhammad didn't make them laugh, because the cartoons appeared in a landscape that was already slick with humiliation, a place where you were obliged to feel ashamed of your Islam. But we would be wrong to see in these drawings the sole motive behind these events. We should rather ask how certain youths in the poorest department of France, maintained in zones of banishment and death, could ever see themselves in the white middle-class of this Parisian editorial team and in its caustic humour, presented to them as the ultimate form of a free humanity. Factually, on this *universal* scene, these children weighed less heavily than the shadows that dance in front of burning cars, at the edges of a far-off night. Another night, with its particular textures, sounds and odours.[181]

It is unfair to say that they wanted the death of these people from another world; simply put, this world did not truly exist for them. We have to recognise that there is no common air that these two worlds breathe together. What is lacking is a place where we could at least share this vital minimum.[182] What purpose do these suddenly proffered microphones serve if it isn't to organise the theatrical staging of the Republic and its rites of respectability addressed to the savages? The effect is expected, but we can't deprive ourselves of the tiny pleasure in these sad times of shining light on the edges of the civilised world. It is a small comfort, but a comfort nonetheless. And for the performance to be complete, Indigenous

nus acouphènes. Non, décidément, *ils ne s'y voyaient pas* dans ce monde des Charlie. Evidemment, le moins que l'on puisse dire c'est que les caricatures du prophète Mahomet ne les faisaient pas rire car elles apparaissaient dans un paysage déjà luisant d'humiliation où l'on se devait d'avoir l'islam honteux. Mais on aurait tort de voir dans ces dessins le motif unique de l'histoire. Et il faudrait plutôt se demander comment certains jeunes du département le plus pauvre de France, maintenus dans des zones de relégation et de mort, pourraient se reconnaître dans la classe moyenne blanche de cette rédaction parisienne et dans son humour caustique qu'on leur présentait comme la forme ultime de l'humanité libre ? Dans les faits, sur cette scène *universelle*, ces enfants ne pesaient pas plus lourd que des ombres qui s'agitaient devant des voitures en feu, aux confins d'une nuit lointaine. Une autre nuit, à la texture, au bruit et à l'odeur particulières[234].

Il est injuste de dire qu'ils avaient voulu la mort de ces hommes d'un autre monde, car ce monde n'existait simplement pas vraiment pour eux. Il faut se le dire, il n'y a pas d'air que ces deux mondes respirent ensemble. Il manque une scène pour au moins partager cela, un minimum vital[235]. Que font alors ces micros soudainement tendus si ce n'est d'organiser la mise en scène de la République et de ses rites de respectabilité adressés aux sauvageons ? L'effet est attendu, mais on ne se prive pas du petit plaisir, en ces jours tristes, d'éclairer les limites du monde civilisé. C'est un sombre réconfort, mais un réconfort quand même. Pour que le spectacle soit complet, les indigènes musulmans devront publiquement se désolidariser des islamistes avec lesquels on ne peut s'empêcher de les confondre, quand bien même dans le monde ils en sont majoritairement les victimes. Et ils devront se plier à ce rite humiliant non pour eux-mêmes mais pour faire partie de la République, qui leur concède en retour des zones de survie en ses périphéries. Et ceux qui ne le feront pas seront marqués au fer du signe de l'infamie. C'est ainsi que l'on installe l'unique scène solidaire où se joue la catharsis de la Nation. Gare à ceux qui ne savent comment s'y tenir.

Des serpents

Mais laissons un instant l'attaque de Charlie Hebdo et le spectre des frères Kouachi qui plane comme un masque sur le visage d'une certaine jeunesse *pas Charlie* en ce début de l'année 2015, pour nous intéresser à un autre protagoniste de cette tragédie : Amedy Coulibaly. La vie des frères Kouachi

Muslims should publicly disavow themselves from Islamists, with whom we cannot help but confuse them, even though across the world these same Muslims are for the main part victims. They should comply with this humiliating rite not for themselves, but to participate in the Republic, which in return deigns to concede them the right to live in survival zones on its peripheries. Those who refuse will be marked by a hot iron with the sign of infamy. This is how we install the sole scene of solidarity where the catharsis of the Nation is performed. Beware to those who do not know how to behave.

Snakes

But for the moment, let's leave the attack on Charlie Hebdo and the ghosts of the Kouachi brothers that float like a mask over the face of a certain strata of youth that is *not* Charlie at the beginning of the year 2015, and consider another protagonist in this tragedy: Amedy Coulibaly. The lives of the Kouachi brothers resemble a biography haunted by death, where the body soon loses any sense of dignity, value or emotional signification. It has exploded, been found without protection, without envelope. Chérif and Saïd's father died when they were still children. Their mother, who prostituted herself from time to time to support her family, committed suicide by ingesting medication in 1995 while she was expecting a sixth child. The boys were 12 and 15 at the time and embarked on a dark and rectilinear path. Coulibaly also experiences a primitive scene of violence when, during a robbery, Ali Rezgui, the person he considers to be his only friend, dies in front of him from a bullet to the gut fired by a police officer. But compared to the trajectory of the Kouachis, Coulibaly's life twists like a snake.[183] The police inquiry will later reveal that although he was considered for a time to be a 'lone wolf',[184] he maintained solid links with the Kouachi brothers – in 2006 he met Chérif in prison at Fleury-Mérogis, and especially came to know Diamel Beghal, a former member of the GIA,[185] who will become the mentor of the two young men. Coulibaly is therefore not alone. A whole network of people will supply him at the appropriate moment with a veritable logistical support for his fatal project, which is synchronised with the assassinations at *Charlie Hebdo*. But there is something quite particular about Coulibaly. A minor delinquent who slides progressively into organised crime before converting to Islam, his life as a 'loser' in the suburbs perhaps ended up serving as a remarkable camouflage. He is talked about as much for his apparent wish to escape from the spiral of bad luck that sticks to the skin of a young Black man in the suburbs as he is for his misdemeanours. A child from a large family with origins in Mali, he perfectly fits the delirious visions of the press, in which sub-Saharan immigration to the suburbs is criminalised by fabricating a new savage people living in the margins of the Republic.[186] There is nothing new here besides the spasms of

ressemble à une biographie hantée par la mort où le corps a perdu très tôt toute dignité, valeur ou signification affective. Il a explosé, s'est retrouvé sans protection, sans enveloppe. Le père de Chérif et Saïd meurt alors qu'ils sont encore enfants. Leur mère qui se prostituait occasionnellement pour subvenir aux besoins de la famille, se suicide en absorbant des médicaments en 1995 alors qu'elle attend un sixième enfant. Ils ont alors 12 et 15 ans et ils entrent sur une voie rectiligne et sans lumière. Coulibaly a lui aussi sa scène primitive de violence quand lors d'un cambriolage, celui qu'il considère comme son seul ami, Ali Rezgui, meurt sous ses yeux d'une balle dans le ventre, tirée par un policier. Mais à côté de la trajectoire des Kouachi, la vie d'Amedy serpente[236]. Un temps considéré comme un « loup solitaire »[237], l'enquête policière va révéler plus tard les liens solides qu'il entretient en fait avec les frères Kouachi – en 2006, il a rencontré Chérif en prison, à Fleury-Mérogis, et surtout Djamel Beghal, ancien du GIA[238], qui va devenir le mentor des deux jeunes hommes. Coulibaly n'est donc pas seul. Tout un réseau lui apportera, le moment venu, un véritable soutien logistique dans son projet funeste qui se synchronise avec les meurtres de Charlie Hebdo. Il y a pourtant quelque chose de particulier chez lui. Petit délinquant qui glisse progressivement dans le grand banditisme avant de se convertir à l'islam, on ne sait plus si sa vie de *loser* de banlieue n'est pas devenue un remarquable camouflage. Car Coulibaly fait parler de lui autant pour ses délits que par sa volonté apparente de se sortir de la spirale de poisse qui colle à la peau d'un jeune homme noir de banlieue. Enfant d'une famille nombreuse originaire du Mali, il épouse à merveille les paysages délirants de la presse de la Capitale où l'on criminalise l'immigration sub-saharienne de banlieue en fabriquant un nouveau peuple sauvage aux marges de la République[239]. Rien de nouveau que les spasmes d'une longue possession, symptômes d'une maladie nostalgique de l'Empire[240] – et de son économie des corps indigènes. Pourtant on dirait qu'Amédy veut nager vers une berge dans ce courant qui le titre vers le fond. En 2007, il introduit deux mini-caméras pour filmer en prison avec quatre autres codétenus les conditions insupportables de détention. A sa sortie, il contacte des journalistes pour diffuser les images qui seront montrées à la télévision. En 2009, alors qu'il travaille en contrat de professionnalisation à l'usine Coca-Cola de Grigny, dans l'Essonne (Région parisienne), il est accueillit avec une centaine de jeunes à l'Elysée par le président de la République de l'époque, Nicolas Sarkozy, lors d'une conférence pour l'emploi. Amedy passe encore entre les mailles et se glisse entre les catégories. On le dit sous influence, *mouton*, musulman de

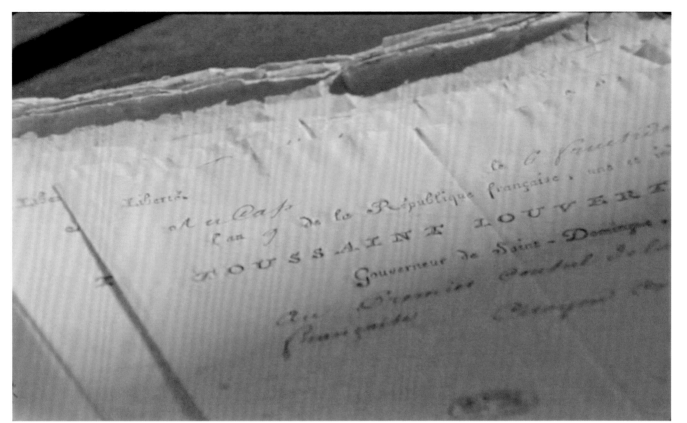

Letters from Toussaint Louverture / Lettres de Toussaint Louverture
© Still from *Ouvertures* by The Living and The Dead Ensemble.

pacotille, on le moque et pourtant il trace un chemin à nul autre pareil où il va recomposer un monde, une famille morbide.

En France, on a poussé des cris d'horreur dans la presse et les débats télévisés face à tous ceux dont on soupçonnait l'empathie pour des terroristes aux actes ignobles. De nouveau, marques de sauvagerie et d'incivilité s'appliquent à tous ceux qui tentent de fuir un récit républicain sans faille. Mais il y a peut-être une perspective qui manque lorsqu'on insiste à ne regarder sa société que depuis un œil unique et un corps qui vaut pour tous les autres. En amont même d'un quelconque débat sur les sources de la violence ou sur une inscription historique et géopolitique du terrorisme – réflexions qui en aucun cas ne banalisent le choc émotionnel de ces meurtres – il y a autre chose, de plus simple, de plus intime et finalement d'inavouable sur une scène qui ne peut l'imaginer, ne veut l'entendre. C'est justement de s'y voir. Pas dans Charlie, mais dans les corps et les vies de ces terroristes. Pas comme des abstractions mais à partir des matières connues, aimées et cabossées des paysages fantômes de la République. Et c'est paradoxalement à partir de ce savoir particulier, de cette perspective manquante et inavouable, que pourrait s'imaginer une scène élargie, solidaire. Même si nos trajectoires divergent, il y a bien quelque chose que je partage avec Amedy Coulibaly. C'est en lui, c'est en moi, nous ne l'avons pas choisi et nous en avons fait des choses différentes. J'ai moi aussi grandi en banlieue sud de Paris, je connais bien la Grande Borne et le bus 402 qui la traverse pour se refléter dans les Miroirs au pied des Pyramides à Evry puis filer en douce vers Corbeil-Essonnes et la fameuse cité des Tarterêts. Tout un programme de jeunesse et d'embrouilles. C'est ainsi que Coulibaly s'est installé dans le coin de ma tête. J'ai pensé aux amis, aux familles de son quartier, à tous ceux qui allaient subir le contre coup de son acte. Cela ne m'empêchait pas de penser aux victimes, mais cette fois-ci j'arrivais à penser à toutes les victimes à la fois, passées, présentes et futures.

Et puis, il y a eu autre chose, un sentiment diffus de colère. L'idée qu'Amedy Coulibaly puisse être quelque chose de plus que lui-même, qu'il soit la figure de l'imbécile de cette tragédie, le musulman un peu bancal et ignorant, le *galérien*[241] du terrorisme et que cela puisse avoir à voir avec le fait qu'il soit noir. Comme si, même au sein des évènements les plus dramatiques, persistait encore des hiérarchies et que le jeune homme noir occupait là aussi le fond d'une cale imaginaire qu'il n'aurait jamais quitté. A l'islamophobie ambiante, s'ajoutait le parfum d'une négrophobie qui ne disait pas son nom. Et Coulibaly devenait ainsi le nom d'un peuple sauvage qu'on n'avait pas su civiliser, un

a long possession, symptoms of a nostalgic malady for Empire[187] – and its economy of indigenous bodies. And yet one could say that Coulibaly wants to swim towards a river bank in this current that pulls him down toward the depths. In 2007 he brings two mini-cameras into prison to film (with four other co-inmates) the unacceptable conditions of imprisonment. Upon release, he contacts journalists to disseminate the images, which are shown on television. In 2009, while he is employed under a 'professionalisation' contract at the Coca-Cola factory in Grigny in the Essonne (Paris region), he is welcomed, along with a hundred other young people, to the Elysée Palace by then president Nicolas Sarkozy, to a conference on employment. Again Coulibaly slips through the system, slides between categories. He is said to be easily influenced, a *mouton* (sheep), a cheap Muslim; he is mocked and yet he traces a path that is inimical, a path that leads him to recompose both a world and a morbid family.

In the press and on televised debates in France there were cries of horror in reaction to people suspected of feeling empathy for terrorists who committed ignoble acts. Again, marks of savagery and incivility are applied to all those who try to flee a flawless Republican narrative. But perhaps a perspective is lacking when you insist on only regarding your society with a single eye and a single body that can be substituted for all others. Prior to any debate about the history of terrorist violence and its geopolitical origins – reflections that in no way

trivialise the emotional shock of these murders – there is something else, much simpler, more intimate and ultimately unmentionable in a scene that *cannot* imagine it, *will not* hear of it. It is precisely the fact of seeing oneself there. Not in Charlie, but in the bodies and the lives of these terrorists. Not as abstractions, but from composite matters that are known, beloved and battered, matters that are part of the phantom landscapes of the Republic. And it is paradoxically from the basis of this particular knowledge, this perspective that is lacking and unmentionable, that a larger scene, a scene of solidarity, could be imagined. Even if our trajectories diverge, there is still something that I share with Amedy Coulibaly. It is in him, it is in me, we did not choose it and we did different things with it. I too grew up in the southern suburbs of Paris, I know the Grande Borne and the 402 bus that crosses through it and ends up reflected in the waters of the man-made lakes Les Miroirs at the feet of Les Pyramides in Evry, before going on to Corbeil-Essonnes and the infamous Cité des Tarterêts. A whole programme of youth, confrontations and provocations. This is how Coulibaly installed himself in a corner of my head. I thought of the friends and the family in his neighbourhood, of all those who would suffer from the backlash of his act. This did not prevent me from thinking of the victims of his attacks, but this time I was able to think of *all* the victims at the same time: past, present and future.

And then there was something else, a

peuple qui ne savait rien des causes, de l'Histoire, de la politique, un peuple de grands enfants qui balbutiait une religion qui ne serait pas la sienne, un peuple hors de tout, une matière sans valeur.

Coulibalysmes

Quelques jours plus tard, mon téléphone sonne. C'est Alice Diop, la réalisatrice franco-sénégalaise. J'aime son travail, sa sensibilité, ses essais documentaires fragiles que j'ai déjà montrés à plusieurs reprises. Je l'ai aussi invité en résidence à Khiasma. Nous sommes devenus amis. Elle me parle spontanément d'Amedy Coulibaly. Un silence. Un malaise. Elle n'arrive pas à dire exactement pourquoi, mais comme moi, elle se désole qu'un jeune homme noir de banlieue ait décidé de faire une violence irruption dans ce tableau d'épouvante[242]. On ne sait pas quoi dire, pas quoi faire de ce sentiment de partager une même matière, un même paysage abîmé dont nous tentons de prendre soin, chacun à notre manière. On se sent soudainement un peu seules. Alors, on prend un rendez-vous avec d'autres à l'Espace Khiasma, juste pour voir. Nous nous réunissons d'abord toutes les semaines puis toutes les quinzaines sans vraiment savoir quoi faire d'autre que parler d'un fond de l'air raciste devenu irrespirable. Nous finissons par nommer l'espace de nos rencontres, Les Coulibalystes. Et ce n'est pas pour témoigner de l'empathie pour Amedy Coulibaly lui-même. C'est juste une manière de nous tenir debout, au cœur de ce peuple innommable de la banlieue que l'ombre d'un tueur a recouvert. La banlieue avait déjà eu assez de rendez-vous ratés, il nous fallait sortir de cette ombre et de toutes celles qu'on nous avait jetées dessus. Le président Nicolas Sarkozy n'avait-il pas dit en 2007 devant un parterre d'étudiants médusés à l'université Cheikh-Anta-Diop de Dakar : « *l'homme africain n'est pas assez entré dans l'Histoire* ». Franchement on y était bien entré dans la fameuse Histoire de la France, par les cales, les champs, les usines, les chantiers, les plages, les morts pour la patrie et les morts pour rien. Il y avait de nos muscles, de nos souffles et de nos sexes un peu partout dans la matière de cette Histoire. On cherchait peut-être simplement à s'échapper maintenant du tas de ressources dans lequel avaient plongé sans fin les mains habiles de cette Histoire-là. On cherchait à casser de nos poings les vitres de cet œil sous lequel on avait grandi. On ne cherchait pas à entrer dans l'Histoire, mais à fuir vers le vivant. Un vivant pour soi, et avec le monde. Parmi les Coulibalystes, il y a un peu toute sorte de gens. Des militantes racisées, des

diffuse feeling of anger. The idea that Amedy Coulibaly could be something more than himself, that he could be the figure of the imbecile in this tragedy, the wobbly and ignorant Muslim, the *galérien*[188] of terrorism, and that this could have something to do with the fact that he was Black. As if, even at the centre of the most dramatic events, hierarchies still persisted and the young Black man here too occupied the bottom of an imaginary ship's hold that he would never have left. Added to the ambient Islamophobia was the perfume of a *négrophobie* that refused to state its name. And Coulibaly thus became the name of a savage people that the Republic had not known how to civilise, a people that knew nothing about causes, history, politics, a people made up of adult children who stammered the words of a religion that would not be theirs, a people outside of everything, a value-less matter.

Coulibalysms

A few days later, my telephone rings. It's Alice Diop, the Franco-Senegalese filmmaker. I like her work, her sensitivity, her fragile documentary essays that I have screened several times. I've also invited her to take up a residency at Khiasma. We've become friends. Spontaneously she begins to speak about Amedy Coulibaly. Silence. Malaise. She can't manage to say why exactly, but like me, she is chagrined that a young Black man from the suburbs should decide to make a violent erup-

tion in this dreadful tableau.[189] We don't know what to say or what to do with the feeling of sharing a communal matter, a same damaged landscape, which we try to take care of, each in our own way. We suddenly feel a bit alone. And so we make a rendezvous with other like-minded people at the Espace Khiasma, just to see. At first we meet every week, then every two weeks, without really knowing what to do besides talking about the racist air that has become impossible to breathe. We end up naming the place where we meet The Coulibalystes. And this isn't to show empathy for Amedy Coulibaly himself. It's just a way of holding ourselves up, in the middle of these unnameable people from the *banlieues* who have been covered by the shadow of a killer. The suburbs had already experienced enough missed opportunities; we needed to get out of this shadow and all the others that had been projected onto us. In 2007 hadn't President Nicolas Sarkozy said in an address to a group of mesmerised students at Cheikh-Anta-Diop University in Dakar, 'The African man has not entered into History enough'? Frankly we really had entered the famous History of France, by way of ships' holds, fields, factories, work sites, beaches, deaths for the country and deaths for nothing at all. Our muscles, our breath, and our sexes were just about everywhere in the matter of this History. Maybe now we were simply trying to escape from a pile of resources in which the skilful hands of this History plunged and pillaged. We were trying to break with our

artistes et des cinéastes, des professionnels de l'audiovisuel et de l'édition, des enseignants de banlieue, des habitants de Seine-Saint-Denis qui fréquentent l'Espace Khiasma, des proches d'Alice et certaines de mes amies de l'époque. Chaque rendez-vous est à géométrie variable. Certains partent en râlant, d'autres arrivent en riant ou reviennent parce que quelque chose n'est pas clair, en redemande. Nous avançons à vue sans autre projet que de se parler, de s'écouter. Nous partageons un désir un peu flou de lutter contre la poussée de racisme et d'intolérance qui se dessine déjà après les premiers moments d'émotion — et qui s'accompagne du discours attendu de rééducation de la jeunesse de banlieue, celle-là même qui n'est pas assez entrée dans l'Histoire des Charlies. Mais ce qui est le plus remarquable dans cette assemblée disparate et improvisée, c'est plutôt la difficulté à construire un langage commun. Une large part des Coulibalystes passe la porte d'un centre d'art pour la première fois de manière spontanée[243]. Et c'est aussi l'une des premières fois que des rencontres dans ces murs rassemblent majoritairement des racisées.[244] Les difficultés que nous rencontrons alors préfigurent souvent certaines des scissions à venir au sein du mouvement antiraciste en France. Les adeptes des politiques de respectabilité *mainstream* comme les tenants de l'entreprenariat noir serrés sous la bannière « black is beautiful » ont forcément un peu les oreilles qui sifflent au son de la critique du capitalisme racial et de la musique des luttes intersectionnelles. Et l'inverse est vrai. Même si aucune position n'est figée dans la douce cacophonie de ces échanges. À cela s'ajoutent quelques inévitables malentendus entre les différentes générations qui viennent se poser là, l'espace d'un soir, autant que des difficultés à négocier un espace de parole et de soin entre des minorités et leurs alliées déclarées, au prix de la pacification de certains conflits. En somme, dans ce moment émotionnel intense, il nous manque l'horizon d'un lieu vers où nous déplacer — même si de lieu, il en sera souvent question comme du désir de réinvention du centre socio-culturel et de réactivation des héritages de l'éducation populaire[245].

Au bout de quelques mois, la dynamique s'épuise et ce qui va peut-être éteindre les dernières braises est le sentiment que nous ne nous trouvons pas au bon endroit pour aller ensemble de l'avant. Ce qui n'est pas faux si l'on considère que malgré toute sa plasticité, ses expériences et ses engagements dans les débats de société, l'Espace Khiasma reste identifié par certains comme un centre d'art contemporain, c'est-à-dire une institution élitiste. Quand bien même ce jugement est en partie injuste et qu'on pourrait lui

fists the windows of the eye under which we'd grown up. We weren't trying to enter History, but rather to escape toward the living. Living for the self and with the world.

Among the Coulibalystes, there are all sorts of people. Militant racialised individuals, artists and filmmakers, professionals from the audio-visual sector and publishing, teachers from the suburbs, residents of Seine-Saint-Denis who frequent the Espace Khiasma, friends of Alice and some of mine. Each meeting is different. Some people leave complaining, others arrive laughing or come back because something was unclear and they need more. We move forward with no other objective than to talk together, to listen to each other. We share a rather vague desire to fight the rise of racism and intolerance that is already emerging after the first moments of emotion – and which is accompanied by the expected discourse on re-educating the poor suburban young, the same young people who hadn't sufficiently entered into the History of (multiple) Charlies. But what is most remarkable about this disparate and improvised assembly is the difficulty we experienced when trying to build a common language. A large part of the Coulibalyste group is entering an art centre for the first time in a spontaneous way.[190] And it's also one of the first times that encounters within these walls gather together racialised people.[191] The difficulties we come up against here often prefigure some of the rifts that the French anti-racist movement will experience. Adepts of mainstream politics of respectability, as well as followers of Black entrepreneurship gathered under the banner 'Black is beautiful' find that their ears ache from the noise of critiques of racial capitalism and the music of intersectional struggles. And the inverse is also true, even if no position is fixed in stone in the soft cacophony of these exchanges. Into this mix are added a few inevitable misunderstandings between the different generations who decide to attend our evenings, as well as difficulties negotiating a space for speech and benevolence between minorities and their declared allies, at the price of the calming of certain conflicts. In sum, in this intense emotional moment, what we don't see on the horizon is a place toward which we can advance – even if we often talk about place as well as the desire for the reinvention of the socio-cultural centre and the reactivation of heritage(s) in *éducation populaire* in France.[192]

Within a few months, our dynamic fades and what perhaps finally extinguishes the last embers is the feeling that we're not in the right place to move forward together. Which is not untrue when you consider that despite Khiasma's plasticity, its experiences and engagements in societal debates, it is still identified by some as a contemporary art centre, in other words, an elitist institution. Even if this judgment is in part unfair and we could counter the argument by listing a number of the venue's activities, which include local and fragile populations, it is essential to glean from this experience the degree to which it is impossi-

opposer nombre des activités de ce lieu associant des populations locales et fragilisées, il est nécessaire de comprendre, à partir de cette expérience, combien il est impossible de créer une assemblée solidaire en la rassemblant en un point qui existe déjà, qui possède son propre vocabulaire et ses circuits de valorisation symbolique. Qu'on le veuille ou non, l'assemblée doit s'enfuir de cette capture pour inventer un langage commun qui formera en chemin un lieu, un lieu qui bouge et que nul ne connaît à l'avance.

Ainsi s'achève à Khiasma ce programme de l'ombre. Programme de l'ombre car il se déroule le soir, en dehors des horaires d'ouverture du centre d'art et en l'absence, la plupart du temps, des membres de son équipe. J'aime à penser qu'il y a un temps volé au lieu, comme l'esclave vole un peu de temps pour lui, pour elle, après une journée de travail. Un temps secret qui sort des règles du lieu pour former un espace obscur et potentiel, un jardin créole. Il y a évidemment un non-dit qui travaille ce lieu. Si je suis le directeur artistique et le fondateur de Khiasma, j'y suis aussi à l'époque le seul racisé, comme j'y suis le seul à avoir grandi en banlieue populaire et de ce fait à ressentir ce drame depuis une perspective particulière, elle-même un peu inavouable. Cet état de fait va cependant jouer un rôle dans la suite des évènements et inconsciemment, ce qui va me guider, c'est la recherche d'un lieu où pourrait se déverser ce trop-plein de non-dits, une veillée peut-être.

Des tables à renverser.

Novembre 2015. Quelques mois après l'extinction du cercle des Coulibalystes, une série d'attentats endeuille de nouveau Paris. Dans la soirée du 13 novembre 2015, un commando tire sur les spectateurs d'un concert dans la salle du Bataclan et sur les terrasses de cafés du 10ème et 11ème arrondissement de Paris. Un autre attentat simultané est déjoué devant le Stade de France où un kamikaze est neutralisé. 134 personnes perdent la vie ce soir-là et plus de 400 sont blessées. Ces nouvelles attaques produisent une émotion encore plus grande que celle de Charlie Hebdo et le sentiment d'arbitraire qu'elles charrient installe durablement en France la terreur qu'elles se sont données comme programme. La reprise du travail, quelques jours plus tard, à Khiasma se fait dans un climat très lourd. Difficile de trouver les mots pour échanger autour de ce drame. Le secteur artistique est doublement touché par l'attaque d'une salle de spectacle, mais aussi par les cafés visés par les terroristes et qui sont pour certains, comme Le Carillon, particulièrement fréquentés par

ble to create a group of solidarity by bringing it together at a site that already exists and possesses its own vocabulary and circuits of symbolic validation. Whether we like it or not, the assembly must flee this capture in order to invent a common language that, as it evolves, will form a place that moves and of which no one knows beforehand.

In this way our shadow programme comes to an end at Khiasma; 'shadow programme' because it transpires at night, outside of the art centre's normal hours and in the absence, most often, of members of the centre's team. I like to think it was time stolen from the place, the way a slave would steal a bit of time for him/herself after a day of work. A secret time that exists outside of the usual rules and regulations of the place, which helps to create an obscure space that has potential – a Creole garden. There is clearly something unspoken that animates this place. If I am the founder and artistic director of Khiasma, at the time I am also the only racialised person on the team, since I am also the only one to have grown up in a poor suburb and, consequentially, to have experienced this dramatic event with a very particular, personal, inhabited perspective, which is itself a bit unmentionable. This situation will play a role in ensuing events, and what is going to guide me unconsciously is the search for a place where we could set down this overload of unspoken things, the place for a wake perhaps.

November 2015. A few months after the extinction of the circle of Coulibalystes, a series of attacks plunges Paris into mourning again. On the night of 13 November 2015, a commando opens fire on the audience at a concert in the Bataclan theatre and on café terraces in the 10th and 11th arrondissements of Paris. Another simultaneous attack is thwarted in front of the Stade de France sports stadium, where a kamikaze is neutralised. A total of 134 people lose their lives and more than 400 are injured. These new attacks produce an even greater emotion than that triggered by the *Charlie Hebdo* attacks and the arbitrary nature that they carry with them helps to install a deep-seated atmosphere of terror in France.

The return to work a few days later at Khiasma takes place in a very heavy climate. It's difficult to find words to express ourselves concerning this dramatic event. The arts sector is hit doubly hard: an attack on a theatre audience, but also the fact that some of the cafés targeted by the terrorists, like Le Carillon, were frequented by people from the milieus of cinema and contemporary art. No more is needed for some people to noisily proclaim themselves as targets. Even if the President of the Republic, who is now François Hollande, explicitly declares that we are at war, this war he suddenly announces remains a perfectly abstract thing.

le monde du cinéma et de l'art contemporain – ce que je découvre à cette occasion. Il n'en faut pas plus pour que certains se constituent bruyamment en cibles. Même si le Président de la République, qui est maintenant François Hollande, déclare alors sans détour que nous sommes en guerre, cette guerre qu'il annonce soudainement reste un objet parfaitement abstrait. Quelques années plus tard, je me retrouve un peu par hasard à la rencontre préparatoire d'un séminaire sur la violence à l'université Paris 7 Diderot. Lors du tour de table, un jeune doctorant donne alors cette définition révélatrice : « la violence, c'est ce qui nous tombe dessus sans prévenir ». La violence serait donc un état d'exception. Et la définition pleine d'aplomb de ce jeune homme évacue de la scène toutes les existences qui la subissent de manière permanente. Cette incapacité à penser d'autres vies et relations à la violence est assez symptomatique, comme de ne pas considérer un instant les origines de cette violence qui manifestement ne « nous tombe pas dessus » depuis nulle part et sans raison. Il y a là une rupture *Nous*, une petite déchirure d'abord, une friction souterraine entre les plaques tectoniques, sous la surface du *Nous*. Puis la faille se creuse. Elle est maintenant apparente à la surface du *Nous* et personne ne sait quoi déposer dedans pour la combler ou simplement la rendre habitable. Aussi, je vois bien dans les yeux de la plupart des membres de mon équipe réunie autour de la table ce matin-là, que la déclaration du président ne fait aucun sens. Car, en quelque sorte, « cette guerre leur tombe dessus depuis nulle part ». *Nous* ne savons pas quoi en faire, ensemble. La violence des évènements eux-mêmes et l'empathie tragique qu'ils provoquent – ça pourrait tout à fait être *Nous* les morts – est redoublée par un autre sentiment, celui de la rupture d'une promesse non formulée, du récit sous-jacent de la nation française : *Nous* ne vivons pas en lieu sûr. La rupture du lieu sûr est vécue comme une forme de trahison. Le sentiment que l'horreur *Nous* tombe littéralement dessus depuis nulle part n'est pourtant que la conséquence du refus de voir la violence nécessaire à la production même de ce lieu sûr. A qui cela coûte de construire des lieux *sympas* dans d'anciens quartiers populaires ? Comment rendre sensible la violence de la gentrification, celle qui s'exerce à la marge d'une scène pacifiée et en en évacuant les plus dangereux sujets qui sont aussi ici les plus démunies ? Comment rendre compte de la guerre faite aux pauvres qui a lentement redessiné l'Est Parisien et s'attaque aujourd'hui à la banlieue de la capitale ? Ce qui est alors tragiquement impossible à partager, ce sont bien des expériences différenciées de la violence qui permettraient de resituer un drame dans un véritable continuum. C'est en ces

A few years later, I find myself a bit by chance at a preparatory encounter for a seminar on violence at the University of Paris 7 Diderot. As we present ourselves around the conference table, a young doctoral candidate offers this revealing definition: 'Violence is what hits us from out of nowhere'. Violence would thus be an exceptional state. And the confident definition of this young man evacuates from the scene all existences that undergo violence in a permanent manner. This incapacity to think of other lives and other relations to violence is rather telling, as is not considering for an instant the origins of this violence, which manifestly doesn't 'hit us from out of nowhere' and for no reason. There is a rupture of *We* (*Nous*) here – at first a small tear, a subterranean friction between tectonic plates, beneath the surface of *Us*. Then the fault line grows deeper. Now it's apparent at the surface of *Us* and no one knows what to fill it with or even simply how to make it inhabitable. And so that November morning I clearly see in the eyes of most of my team that the president's declaration makes no sense. Because in a way this war hits them from out of nowhere. *We* don't know what to do, together. The violence of the events themselves and the tragic empathy they provoke – *We* could very easily be the slain – are increased by another feeling, the breaking of a non-articulated promise from the underlying myth of the French nation: *We* do not live in a safe place. The rupture of the safe place is experienced as a form of betrayal. Yet

the feeling that horror is literally falling on *Us* from out of nowhere is only the consequence of the refusal to see the violence necessary for the production of this safe place. For whom does it cost anything to build 'cool' places in former working-class neighbourhoods? How can the violence of gentrification be made visible, a violence that is exerted at the margins of a peaceful scene and by evacuating the most dangerous subjects who are also the most destitute? How to understand the war against the poor, which has slowly redrawn the map of eastern Paris and is now attacking the suburbs of the capital?

What is tragically impossible to share is the differentiated experiences of violence, which would allow us to re-situate a dramatic event in a veritable continuum. It is in these terms that we need to understand the discourse of President Hollande. He knows that the war, both in the distal and proximal sense, is the conditions of *here*, as the unexpected eruption of the *Gilets Jaunes* (Yellow Vests) on the scene of city centres a few years later will remind us. And the way in which this revolt will be extinguished by State violence will signify in a remarkable manner a *becoming-Black* (*devenir-nègre*)[193] of the French working classes. There is definitely a war at the threshold of the visible world, at the peripheries of the Empire. The multiple mutilated or dead bodies of young racialised men in the poor neighborhoods of France and its 'overseas' departments have always been the morbid markers of this war.

The dream of the Maroons / Le rêve des Marrons
© Still from *Ouvertures* by The Living and The Dead Ensemble.

Others are joining them now: all those who, like the Maroons before them, dream *with* the forests and (primary) matters of the world, who tremble, breathe and suffer with their environs.

Sitting at our office table with my young team, I don't know what to say this day, for perhaps you have to have a little bit of Coulibaly in your veins or a consciousness of the lives of other Coulibaly's to feel beneath the tragic power of this dramatic event, beyond shock, something known, familiar, *that doesn't come from out of nowhere.* In lieu of terrorising empathy, we'll need to substitute the desire for solidarity with those who are not *Us*, do not come toward *Us*, escape from the margins of the safe zone and take away with them something that *We* do not want to know. But at this moment, and perhaps I'm wrong, I say nothing; I have no words to stuff into the gaping fault lines at the heart of *Us*.

A few days later, I find myself sitting at another table, at a small conference of the contemporary art network TRAM, which convenes together the directors of about 30 contemporary art centres in Ile-de-France. Each participant recounts news of people injured at one of the cafés that was attacked or who were near them when the event took place. I have nothing to say; I know no one who frequents those cafés. I only know the housing projects in Grande Borne where Amedy Coulibaly grew up. This is useless knowledge and cannot be shared here. It exists beyond the evidence of the *Us* sitting at the table. I don't insist. We agree to write a collective letter of support from our network to the families of victims. A few days later, I reread the rough draft of the letter that has been waiting in my emails. A priori, it's just a formality. But the letter is less anodyne than expected. It's hard for me to swallow what it recounts in the name of an *Us* in which I cannot reside. The terrorists *would have attacked the beauty* that we represent but *obscurantism will not prevail over the spirit of Enlightenment that guides us.* A spirit of Enlightenment that I had just spent over a decade deconstructing in the art centre I directed, in order to reveal its racist, sexist, and extractivist nature. As to incarnating beauty, I hadn't imagined when Khiasma became a member of TRAM a few years earlier, that we were entering the kingdom of beautiful things and beautiful people. Again, the awkwardness of this rough draft, proposed by an employee in the network who believed s/he was doing something good, resembled a sketch of a scene of purity and elegance caught by surprise by this influx of dirty-faced violence that had appeared from out of nowhere, in other words from the ship's hold of modernity, from a cellar of an HLM tower block, from a stinking dormitory in Syria, or a vulgar cave in the tribal zones of Pakistan. The incapacity of a certain art world to consider the violence of its conditions of existence was exposed here in all its tragic splendour and most pathetic innocence. After I sent in my slightly vehement feedback, the letter was simplified and all was forgiven.[194]

termes qu'il faut comprendre le discours du président Hollande. Il sait que la guerre dans le lointain et dans le proche sont des conditions de cet *ici,* comme ne manquera pas de nous le rappeler quelques années plus tard l'irruption inattendue des Gilets Jaunes sur la scène des centre villes. Et la manière dont cette révolte sera éteinte par une violence d'Etat signifiant de manière remarquable *un devenir-nègre*[246] des classes populaires françaises. Il y a bien une guerre au seuil du monde visible, dans les périphéries de l'Empire. Les multiples corps mutilés et tués de jeunes hommes racisés dans les quartiers populaires de la métropole française et de ses « outre-mers » en ont toujours été les balises morbides. D'autres les rejoignent à présent. Tous ceux et celles qui comme les Marrons avant eux rêvent *avec* les forêts et les matières du monde, tremblent, respirent et souffrent avec les paysages. Devant cette table, avec ma jeune équipe, je ne sais quoi dire ce jour-là car il faut avoir peut-être un peu de Coulibaly en soi ou une conscience de la vie d'autres Amedy, pour sentir sous la puissance tragique de cet événement, au-delà de la sidération, quelque chose de connu, de familier, *qui ne vient pas de nulle part.* A l'empathie terrorisante, il va falloir alors substituer le désir de solidarité avec ce qui n'est pas *Nous*, ne vient pas vers *Nous*, s'enfuit depuis les marges de la zone sûre et emporte quelque chose que *Nous* ne voulons pas savoir. Mais à ce moment, et j'ai peut-être tort, je ne dis rien, je n'ai pas de mots à jeter dans ces failles au cœur du *Nous*.

Quelques jours plus tard, je me trouve autour d'une autre table, celle d'une petite réunion du réseau TRAM qui rassemble les directeurs d'une trentaine de lieux d'art contemporain d'Île-de-France. De nouveau, chacun échange des nouvelles sur des personnes blessées dans un café ou si proches des évènements. Je n'ai rien à raconter, je ne connais personne qui fréquente ces cafés. Je ne connais que la cité de la Grande Borne où a grandit Amedy Coulibaly. C'est un savoir qui ne sert à rien et ne peut être partagé sur cette scène-là. Il est en dehors de l'évidence du *Nous* qui compose alors le tour de table. Je n'insiste pas. Nous nous accordons quand même pour écrire une lettre de soutien aux familles des victimes de la part du réseau. Quelques jours plus tard, je relis le brouillon de la lettre qui est resté dans ma boîte mail pendant un moment. A priori, ce n'est qu'une formalité. Mais la lettre est moins anodine que prévu. J'ai du mal à avaler ce qu'elle raconte au nom d'un *Nous* que je ne peux décidemment pas habiter. Les terroristes « se seraient attaqués à la beauté » que nous représenterions mais « l'obscurantisme ne viendrait pas à bout de l'esprit des Lumières qui nous guident ». Esprit des Lumières que je

From one cave to another, the journey begins again / D'une grotte à l'autre, le voyage recommence. © Still from *Ouvertures* by The Living and The Dead Ensemble.

venais de passer plus d'une décennie à déconstruire dans le centre d'art que je dirigeais alors pour en dévoiler la nature raciste, sexiste et extractiviste. Quand à incarner la beauté, je n'avais pas imaginé que l'adhésion de Khiasma à Tram, quelques années plus tôt, composerait une entrée dans le royaume des belles choses et des belles personnes. De nouveau, la maladresse de cette ébauche de courrier, proposé par un employé du réseau qui pensait bien faire, ressemblait au dessin d'une scène de pureté et d'élégance prise par surprise par cette violence au visage sale, sortie de nulle part, c'est-à-dire de la cale de la Modernité, d'une cave de HLM, d'un dortoir puant en Syrie, ou d'une vulgaire grotte dans les zones tribales du Pakistan. L'incapacité d'un certain monde de l'art à considérer la violence de ses conditions d'existence était ici étalée dans sa plus tragique splendeur et sa plus navrante innocence. Après mes retours un peu véhéments, le courrier serait simplifié et tout serait alors pardonné[247].

Durant cette même période, je me retrouve un peu par hasard — mais pas tout à fait quand même — autour d'une dernière table où je représente moi-même cette fois-ci le réseau d'art contemporain TRAM. Les directeurs et directrices des plus grands musées et établissements culturels parisiens se serrent en un large anneau présidé par la Ministre de la Culture de l'époque. Puisqu'il faut le dire avec les mots qu'autorise l'Etat, la fameuse diversité est plutôt absente de ce cercle magnifique où le mâle blanc au poil gris domine de façon remarquable. Et ce qui s'imagine sous les dorures des salons de la République comme adjuvant culturel à la violence policière déjà programmée est donc sans surprise. Afin de contrer l'effroi des attentats, quoi de mieux que d'affréter des autobus pour transporter les troupeaux de djihadistes en devenir qui peuplent sans nul doute la banlieue vers la beauté de nos plus beaux musées. Nos trésors finiraient de leur récurer les yeux et l'esprit pour qu'ils voient la splendeur de la République et les merveilles de nos collections redresseraient les vertèbres de leur esprit citoyen. L'art adoucit les mœurs et chasse les esprits sauvages. Et au fond, tout ce trésor national leur appartient autant qu'à *Nous*. L'ironie est à son comble quand le directeur de Musée du Quai Branly glisse alors à l'oreille de la Ministre une offre de service, lui qui dirige l'un des plus remarquables sanctuaires d'objets spoliés du patrimoine de l'Empire français[248].

Décidemment, cette fameuse année 2015 me donne envie de renverser quelques tables. Mais il ne faudrait pourtant pas gâcher les ressources de ces festins toxiques. Car une fois digérés, ces mets inconfortables offriront plus tard quelques beaux étrons truffés de diamants. Il faudra y plonger les

During this same period, I find myself – a bit by chance but not completely so – at yet another table where I myself represent TRAM. The directors of the largest museums and cultural establishments in Paris are seated elbow to elbow in a ring presided over by the Minister of Culture. Since it must be said in the language authorised by the State, the famous diversity is considerably absent from this magnificent circle, where the gray-haired white male dominates to a remarkable extent. And so what is imagined here beneath the gold mouldings of the salons of the Republic as cultural additive to the police violence that has already been programmed is not surprising. In order to counteract the terror of the attacks, what could be better than chartering buses to transport herds of budding jihadists, who doubtlessly inhabit the suburbs, toward the beauty of our most magnificent museums. Our treasures will surely manage to scrub their eyes and minds so they will be able to see the splendour of the Republic, and the marvels of our collections will straighten the vertebrae of their civic spirits. Art softens the manners and hunts down savage spirits. And basically, this national treasure is as much theirs as it is *Ours*. Irony is at its acme when the director of the Quai Branly Museum whispers an offer of service in the ear of the Minister, this man who heads one of the most remarkable sanctuaries of despoiled objects from the patrimony of the French Empire.[195]

Decidedly, this infamous year 2015 has given me the urge to overturn a few tables. But one shouldn't spoil the resources of these toxic feasts, because once digested, these uncomfortable delicacies will later offer a few turds riddled with diamonds. We'll have to plunge our hands into an exercise of divination to perceive a future informed by these scenes. They show us the dividing line between empathy and solidarity, the latter being that particular movement toward that which refuses to be a surface for amicable projection. The tables, whether we overturn them or leave them, tell us that we have to go elsewhere, towards a place that isn't yet there, a place to come, owner-less, where different perspectives, different ways of feeling and speaking, could find a felicitous arrangement.

Here are a few decomposing matters that inhabit my intestines as I travel with the filmmaker Louis Henderson to Haiti for the first time in the summer of 2017; we begin a collaboration with artists from Port-au-Prince, which will result in the birth of the film *Ouvertures* and the formation of the artistic group The Living and the Dead Ensemble.[196] This adventure has now moved greatly beyond the creation of this first film, but it seems interesting to me to examine how it already presaged a vision of solidarity.

mains dans un exercice de divination pour apercevoir un futur informé de ces scènes. Elles nous montrent la ligne de partage entre l'empathie et la solidarité, la seconde étant ce mouvement particulier vers ce qui se refuse à être une surface de projection amicale. Les tables, qu'on les renverse ou qu'on les quitte, nous disent qu'il faut partir ailleurs, vers un lieu qui n'est pas encore là, un lieu à venir, sans propriétaire, où pourront s'agencer des perspectives, des manières de ressentir et de dire différentes. Voici quelques matières en décomposition qui habitent mes intestins alors que je me rends avec le cinéaste Louis Henderson pour la première fois en Haïti, à l'été 2017, afin de débuter une collaboration avec des artistes à Port-au-Prince qui donnera naissance au film *Ouvertures* et au groupe artistique The Living and the Dead Ensemble[249]. Cette aventure dépasse aujourd'hui largement la réalisation de ce premier film, mais il me semble cependant intéressant de regarder en quoi il annonce déjà un imaginaire de solidarité.

Vers Ayiti[250]

Parler de solidarité en Haïti c'est immanquablement faire surgir le spectre du tremblement de terre de janvier 2010[251] qui a remis l'île au cœur de l'attention mondiale, faisant peut-être oublier toutes les formes d'occupation et d'ingérence de puissances étrangères qu'a subit depuis son indépendance la première République Noire de l'Histoire. Quand bien même les forces haïtiennes sont venues à bout des armées de Napoléon au prix d'une longue lutte (1791-1804), la France n'a pas pour autant quitté les jeux d'influence culturelle et politique de son ancienne colonie, Saint-Domingue. Pas plus que les Etats-Unis qui après avoir occupé l'île de 1915 à 1934, continuent d'en dicter les fondamentaux économiques. La solidarité en Haïti, fleure bon le parfum âcre du FMI, le tissu impeccable des uniformes des Nations Unies et les eaux de toilettes de nuées d'ONG qui « apportent leur aide à une population démunie ». Dans ce bal de délicats gestes solidaires, l'autonomie n'a pas sa place. Il n'y a pas d'autre scène que celle où l'on engraisse une impayable dette. Puisque l'indépendance ne s'obtiendra pas sans frais. Il n'aura pas suffit d'une victoire militaire pour chasser la plus puissante armée du monde, il faudra aussi dédommager l'Etat français de son manque à gagner alors qu'il perd au terme de cette guerre sa plus riche colonie de l'époque, première productrice mondiale de sucre[252]. La dette du colonisé est sans fin alors que la dette coloniale, elle, ne sera jamais payée, ni aux pays africains dont on

Talking about solidarity in Haiti necessarily means invoking the ghost of the earthquake of January 2010,[198] which placed the island at the centre of the world's attention, perhaps making us forget about all the forms of occupation and interference by foreign powers to which it had been subjected since it became the first Black Republic in History. Even when Haitian forces overcame Napoleon's army after a long struggle (1791–1804), France did not cease its manoeuvring for cultural and political influence over Saint-Domingue, its former colony. No more than the US, which after occupying the island from 1915 to 1934, continued to dictate its economic fundamentals. Solidarity in Haiti smells of the acrid perfume of the IMF, the impeccable fabric of the uniforms of the United Nations' forces, and the *eaux de toilettes* of hordes of NGOs who 'bring their aid to a destitute population'. In this dance of delicate gestures of solidarity, autonomy is out of place. There is no other scene than the place where an unpayable debt is fattened up. Because independence cannot be obtained without incurring expenses. A military victory will not have been enough to chase away the most powerful army in the world, and the French State will also have to be compensated for the deficit it incurs at the end of this war by losing its richest colony at the time, the most important producer of sugar in the world.[199] The debt of the colonised is endless, whereas the colonial debt will never

be paid, not to African nations from whom populations were abducted to transport them to the Americas, nor to peoples and lands that were deeply scarred in the process of building the toxic habitat of the Plantationocene.[200]

The Haitian population exists in the Caribbean region somewhere between the glory of past struggles and ostracism of a poor population in a country ravaged by the accrual of catastrophes and debts of all sorts. Add to this already disastrous tableau a political pantomime that grows more and more grotesque and today only serves the interests of a small circle of privileged actors, self-barricaded on the higher altitudes of the island. And yet despite all this, in the middle of this chaos and trivialised violence, Haiti has a remarkable cultural and artistic dynamic. But here too, local infrastructures and autonomy are lacking and it is France and a handful of foundations financed from abroad that remain the principal operators at the scene of local representation.

When we arrive in Haiti in July 2017, we come by way of a detour, not following the usual Francophone institutional circuit, where the Institut Français serves as both luminous beacon and influential guide. The Haitian author and slammer Rossi Jacques Casimir,[201] whom Louis Henderson met in 2016, gathers a group of young authors, poets and actors for a first workshop.[202] Even if we still have no idea concerning the definitive form of the film that we will invent as we go, we do already imagine that *Ouvertures* will be a meditation on the

a arraché les populations pour les transporter jusqu'aux Amériques, ni aux peuples et aux terres qu'on a meurtris pour construire l'habiter toxique du Plantationocène[253].

La population haïtienne vit ainsi dans la région caraïbe entre gloire des luttes passées et ostracisation d'un peuple pauvre au pays ravagé par l'empilement des catastrophes et des dettes de toute sorte. S'ajoute à ce tableau déjà néfaste un pantomime politique de plus en plus grotesque qui ne sert aujourd'hui que les intérêts d'un cercle de privilégiés, barricadé dans les hauteurs de l'île. Pourtant, au cœur de ce chaos et de la violence banalisée, Haïti possède une dynamique culturelle et artistique remarquable. Mais là aussi les infrastructures locales manquent et l'autonomie n'est pas au rendez-vous quand c'est encore la France et quelques fondations financées par l'étranger qui sont les principaux opérateurs de la scène de représentation locale.

Quand nous arrivons en Haïti en juillet 2017, c'est par une voie détournée qui n'emprunte pas le circuit institutionnel francophone habituel où l'Institut Français trône en phare et prescripteur. C'est l'auteur et slameur haïtien Rossi Jacques Casimir[254], que Louis Henderson a rencontré en 2016, qui rassemble pour un premier atelier un groupe de jeunes auteurs, poètes et comédiens. Même si nous n'avons pas encore en tête la forme définitive du film qui va s'inventer en chemin, nous imaginons déjà *Ouvertures* comme une méditation autour de la place du héros révolutionnaire Toussaint Louverture dans l'imaginaire de la jeunesse haïtienne d'aujourd'hui. Nous choisissons de partir de la pièce de théâtre, *M. Toussaint,* écrite en 1961 par le poète et penseur martiniquais Edouard Glissant[255]. Glissant parvient à partager la complexité et les paradoxes de Louverture avec son texte qui met en scène l'affrontement du héros aux dernières heures de sa vie dans sa cellule glacée du fort de Joux[256] avec une assemblée bigarrée de personnages de l'histoire haïtienne. Nous ne savons pas encore, au terme de ce premier atelier, que nous allons nous engager à mettre en scène une version de la pièce qui sera présentée en décembre 2017 au cimetière de Port-au-Prince dans le cadre de la Ghetto Biennale[257], non sans l'avoir traduite à la demande du groupe en créole haïtien – alors que la pièce originale était écrite en français. Par ce geste, il s'agit autant de restituer leur langue à certaines figures de l'Histoire comme le célèbre Marron révolté Mackandal que de tenter de partager ce récit plus largement avec la population locale[258]. C'est ainsi que le processus d'écriture vivante du film va s'engager. Il documente d'abord l'histoire d'une

place held by the revolutionary hero Toussaint Louverture in the imagination of Haitian youth today. We decide to begin with the theatre play *M. Toussaint*, written in 1961 by the Martiniquan poet and thinker Édouard Glissant.[203] Glissant succeeds in sharing Louverture's complexities and paradoxes in his text, which stages the confrontation of the hero in the last hours of his life in his freezing cell in Fort Joux[204] with a colourful assembly of figures from Haitian history.

We don't yet know at the end of this first workshop that we are going to stage a version of the play that will be presented in December 2017 at the Port-au-Prince cemetery as part of the Ghetto Biennale,[205] after having translated the text into Haitian Creole at the request of the group, while the original play was written in French. This act of translation restores their language to certain figures of history, such as the famous Maroon Mackandal, as well as sharing the play more widely with the local population.[206] This is how the *living writing* process of the film begins. It first documents the story of a theatre company trying to stage Glissant's play in Port-au-Prince. But progressively the hopes and doubts of the young actors emerge, as the opportunity to travel beyond the island becomes possible. They begin to speak of culture and language, how history is written, identity … until the moment when they meet a strange character who turns out to be none other than the ghost of Louverture. Here he is, back again, anonymously, after having accomplished his promise of crossing the oceans in the opposite direction.[207] With the arrival of this mysterious guide, another journey begins. The company leaves the city and ends up rediscovering the music of caves and the echoes of the revolutionary past.[208] But the figure who returns as a ghost is not talkative. He has discarded the attributes and heavy costume of leader. He has climbed down from his pedestal, escaped from the bronze. He heralds a new age, an age of errancy as principle of collective history. After this liquidation – liquefaction – of the hero,[209] the film closely follows the re-composition of an assembly. It is therefore not only the narrator who dissipates progressively – *who is speaking?* – but also any authority to name the scene of representation – *where is it being said and what is being said*? Added to the trouble of multiple voices is the loss of the thread of the story and this loss is perhaps the central subject. The characters' errancy literally carries the film on towards other scenes.

It is by leaving Port-au-Prince for destinations unknown by all – both in the film and in the real life of the group – that the members of the Ensemble embark on a journey to another mode of composition of the world – an assembly between humans, but also with other forms of existence: vegetal, mineral, ghostly. In the second part of the film, two actors in the group suddenly come down with a strange illness; they are haunted by their characters. Zakh and Bijou travel to the heart of a fevered delirium.

compagnie qui tente de monter la pièce de Glissant à Port-au-Prince. Mais progressivement ce sont les espoirs et les doutes des jeunes auteurs qui se font entendre alors que se présente l'opportunité de voyager hors de l'île. Ils parlent alors de culture et de langue, d'écriture de l'histoire, d'identité… Jusqu'à ce qu'ils rencontrent, un étrange personnage qui ne serait autre que le spectre de Louverture lui-même. Le voilà de retour, anonymement, après avoir accompli sa promesse de traverser les mers dans l'autre sens[259]. A la suite de ce guide mystérieux commence alors un autre voyage. La compagnie quitte la ville et finira par retrouver la musique des grottes et les échos du passé révolutionnaire[260]. Celui qui revient en spectre n'est cependant pas des plus bavards. Il s'est défait des attributs et du lourd costume de leader. Il est descendu du son piedestal, s'est évadé du bronze. Il annonce un autre temps, celui de l'errance comme principe d'une histoire collective. A la suite de cette liquidation – liquéfaction – du héros[261], le film épouse la recomposition d'une assemblée. Ce n'est donc pas le seul narrateur qui se dilue alors progressivement – *qui parle ?* – mais aussi toute l'autorité de nommer la scène de représentation – *où ça parle et de quoi ça parle* ? Au trouble de la plurivocalité s'ajoute donc la perte du fil du récit et cette perte en est peut-être même le sujet central. L'errance des personnages entraîne alors littéralement le film vers d'autres scènes.

C'est en quittant Port-au-Prince pour des lieux inconnus de tous – à la fois dans le récit du film comme dans la vie réelle du groupe – que les membres de l'Ensemble vont s'engager vers un autre mode de composition du monde – une assemblée entre les humains mais aussi avec d'autres formes d'existence, végétales, minérales, fantomatiques. Dans la seconde partie du film, deux acteurs de la compagnie se retrouvent subitement atteints d'une étrange maladie ; ils sont hantés par leur personnage. Zakh et Bijou voyagent alors au cœur d'un délire fiévreux. Ils errent à la lisière d'une mangrove dans la peau des deux marrons, Mackandal et Makaïa, ceux-là même qu'ils incarnent dans la pièce d'Édouard Glissant. Leur mal étrange interroge le corps collectif de la compagnie. Doivent-ils soigner les deux jeunes hommes ou décider de tous avaler le même remède ? C'est la seconde solution qui est finalement choisie. S'ils retrouvent alors leurs deux compagnons, c'est dans un autre espace, une grotte, un autre temps, une autre scène où les transportent les puissances magiques conjointes d'un fruit et du rythme d'un orchestre Rara[262]. Notre compagnie bavarde en perd la voix et c'est bien la grotte où elle a été mystérieusement transportée qui devient le narrateur de la scène finale de recomposition d'un monde où plus rien n'est séparé. Le temps du rêve comme

They wander at the edges of a mangrove in the skins of two Maroons, Mackandal and Makaïa, the very figures they play in Glissant's play. Their strange malady questions the collective body of the company. Should they care for the two young men or decide to swallow the remedy, all of them together? They finally opt for the second solution. If they find their two companions, it is in another space, a cave, another time, another scene where the conjoined magical powers of a fruit and the rhythm of a Rara orchestra transport them.[210] Our talkative company loses its voice and it is the cave to which they have been mysteriously transported that becomes the narrator of the final scene, the re-composition of a world where nothing will be separate anymore. Both dream time and the pantheon of history reappear in the present. The space of the visible welcomes the invisible Maroon forces liberated by allied vegetation.[211] The music in the cave calls forth a new uprising and nourishes it with all the past struggles it has sheltered. Strata of time accumulate without covering each other. The film becomes a spiral. Revolutionary history can begin again, but without repeating itself because it is informed by new knowledge, enriched with new presences. It has rediscovered a living and *multi-voiced* memory.

In this way, *Ouvertures* inaugurates a series of shifts that will participate in a method of construction of scenes in movement, where the subject will no longer be a particular territory or history – notably that of Haiti – but rather the possibility of bringing together an ensemble of perspectives – *from* the Caribbean, in other words from the point of view of eyes that until now have been ignored and bodies that transport unspeakable knowledge. And it isn't a coincidence if the first of these shifts occurs between the great noise of the capital toward the Haitian countryside, a real *péyi andéyò* (country outside). The insatiable Republic of Port-au-Prince, as we like to call it, has always looked at itself in the mirrors of the west, absorbing the resources and concentrating the powers of the country, beginning with the power of recounting its history. Contempt for the lives and struggles of the countryside partially echoes a historic colour line between Black rural people and elite urban mulattoes – which is rather fluctuating – one of the consequences of which is the long period of disrepute at the heart of Haitian historiography concerning the contribution of the Maroons to the revolutionary combat. This disrepute of the Maroon serves to profit a pantheon of urban heroes.[212] Even today, the rural sector is condemned to feed the city and survive with the meagre resources that remain. Therefore this movement in the film from the city towards the countryside signifies a shift from a scene of representation towards a minority scene, under-represented, towards a space of struggle and invention of other forms of life.

Keeping its distance with codes of the theatre of the oppressed (*théâtre forum*), which uses the stage as the place – as well

le panthéon de l'histoire réapparaissent dans le présent. L'espace du visible accueille les forces marronnes invisibles que libère la végétation alliée[263]. La musique de la grotte appelle un nouveau soulèvement et le nourrit de toutes les luttes qu'elle a abritées. Les temps s'accumulent sans se recouvrir. Le film devient spirale. L'histoire révolutionnaire peut ainsi recommencer mais sans se répéter car elle est informée de nouveaux savoirs, enrichie de nouvelles présences. Elle a retrouvé une mémoire vivante et *plurivocale.*

Ainsi, *Ouvertures* inaugure une série de déplacements qui vont participer d'une méthode de construction de scènes en mouvement où le sujet ne sera plus un territoire ou une histoire en particulier – celle d'Haïti notamment – mais bien la possibilité de mettre au travail un ensemble de perspectives – *depuis* la Caraïbe, c'est-à-dire depuis des yeux jusqu'à présent ignorés et des corps qui transportent des savoirs inavouables. Et ce n'est pas un hasard si le premier de ces déplacements s'opère depuis le vacarme de la capitale vers la campagne haïtienne, véritable *péyi andéyò* – pays en dehors. Car la gourmande République de Port-au-Prince, comme on aime à appeler, s'est toujours regardée dans les miroirs de l'Occident, absorbant les ressources et concentrant les pouvoirs du pays, à commencer par celui de mettre en récit son histoire. Le mépris à l'endroit des vies et des luttes des campagnes fait en partie écho à une ligne de couleur historique entre paysans noirs et élites mulâtres des villes – qui reste dans les faits assez fluctuantes – dont l'une des conséquences est la longue période de déconsidération au sein de l'historiographie haïtienne de l'apport des Marrons au combat révolutionnaire. Et ceci, au profit d'un panthéon de héros urbains[264]. Aujourd'hui encore, le monde paysan est condamné à nourrir la ville et à survivre avec le peu de ressources qu'on lui concède. Aussi ce mouvement de la ville vers la campagne signifie le déplacement d'une scène de représentation vers un lieu minoritaire, sous-représenté, vers un espace de lutte et d'invention d'autres formes de vie.

Prenant ses distances avec les codes du théâtre citoyen qui fait de la scène le lieu – comme espace et comme temps – de concentration et de dénouement du conflit politique, *Ouvertures* lui préfère une scène qui erre, une assemblée qui se transforme en se déplaçant, avec ses hésitations, ses impasses, ses crises, ses difficultés et ses fulgurances. Cette assemblée ne demande pas seulement *qui* parle mais d'*où ça parle* et dépasse ainsi la question de la représentation minoritaire pour engager celle des scènes de représentation. Le film porte aussi attention à une archive particulière, composée de récits, d'images qui n'auront pu être dit, qui n'auront pu appa-

as space and time – of concentration and denouement of political conflict, *Ouvertures* prefers an errant stage, an assembly that transforms as it moves, with its hesitations, impasses, crises, difficulties and brilliance. This assembly not only asks *who* speaks, but also *from where* things are said, thus moving beyond the question of minority representation to engage with the question of scenes of representation. The film also focuses attention on a very particular archive, made up of stories, of images that couldn't be communicated by words, that couldn't appear elsewhere and that the protagonists carry within themselves as they search for a place.[213] And so if *Ouvertures* presents a journey – from the ice of the French Jura to a secluded site in Haiti, from one cave to another – it is also guided by a principle of metamorphosis of the archive, and this change of state also affects characters. Again, finding another space where all can live – what we suppose would be a space of solidarity – will signify a necessary becoming-different (*devenir différent*) of all the protagonists – and not a process of *memification*.

Ouvertures begins with a graphic archive: the letters that Toussaint Louverture wrote to Napoleon from his prison,[214] which today are still prisoners of the French National Archives in Saint-Denis (French suburb), where the elegance of Massimiliano Fuksas' architecture replays in a stylised way – probably unconsciously – the aesthetics of a sophisticated and futuristic detention centre. The film

departs from this state of stasis and captivity. Following the steps traced by Louverture in his cell in the Fort de Joux, it now exposes the stratographic archive of the Jura Mountains, the natural and mineral archives that compose the landscape of the revolutionary leader's detention and death in exile. But the ice around him is slowly liquefying. It soon gushes in torrents and underground rivers that carry us to the ocean. The unrepresentable experience of the Middle Passage of the Atlantic here takes the form of an abstract drifting in the depths of the blue and plunging underneath the maps of the oceans. The third archive of the film is oceanic and, as the Saint Lucian poet Derek Walcott so beautifully wrote in *The Sea is History*, the sea is its monument and its grave.[215] The archive lies at the bottom of the seas, limestone of the bones of those who were thrown overboard, or who preferred suicide as a way to escape the slave life the ships were carrying them towards. Hybrid matter where bone becomes ally of coral, where shells and living matters create a skeleton for the New World. It is on this monstrous structure that the Caribbean body will be constructed, while its muscles register the violence of work and exhaustion, its eye gazing on a life of terror. Its flesh will become the tableau where the violent and morbid lessons of the *Code Noir* (Black Code)[216] will be engraved. Those who will be deprived of being, deprived of their goods and then of the capacity to cultivate land for their own benefit,[217] will accumulate a world within themselves. The last

raître ailleurs et que transportent en eux les protagonistes à la recherche d'un lieu[265]. Aussi si *Ouvertures* met en scène un voyage – de la glace du Jura français à un lieu reculé en Haïti, d'une grotte à une autre – il est également guidé par un principe de métamorphose de l'archive et ce changement d'état affecte jusqu'aux personnes/personnages. De nouveau, trouver un autre lieu vivable pour tous – ce que nous supposons être un espace solidaire – signifiera un nécessaire *devenir différent* de tous protagonistes – et non un processus « mêmification ».

Ouvertures débute par une archive graphique : les lettres que Toussaint Louverture a écrites à Napoléon depuis sa prison[266] et qui sont aujourd'hui encore elles-mêmes prisonnières des Archives Nationales françaises à Saint-Denis (banlieue parisienne) où l'élégance du bâtiment de Massimiliano Fuksas rejoue de façon stylisée – probablement inconsciemment – l'esthétique d'un lieu de détention futuriste et sophistiqué. De cet état de stase et de captivité, le film s'en va une première fois. Sur les pas du fantôme de Louverture dans sa cellule du Fort de Joux, il expose cette fois l'archive stratigraphique des montagnes du Jura, archives naturelles et minérales qui composent le paysage de détention du leader révolutionnaire, mort en exil. Mais la glace se liquéfie lentement. Elle jaillit bientôt en torrents et en rivières souterraines qui nous emmènent jusqu'à l'océan. L'expérience irreprésentable du Passage du Milieu atlantique prend ici la forme d'une dérive abstraite dans les profondeurs du bleu et le dessous des cartes. La troisième archive du film est océanique et comme l'a si bien écrit le poète de Sainte-Lucie Derek Walcott dans *The Sea is History*, la mer est son monument et son tombeau.[267] L'archive gît au fond des mers, calcaire des os de celles et ceux que l'on a jeté par-dessus bord ou qui ont choisi le suicide pour s'évader de la vie d'esclave vers laquelle les emportait les bateaux négriers. Matière hybride où l'os s'allie au corail, où le coquillage et les matières vivantes fabriquent un squelette pour le Nouveau Monde. C'est sur cette structure monstrueuse que va se construire le corps antillais, alors que ses muscles vont enregistrer la violence du travail et l'épuisement, son œil une vie de terreur. Sa chair va devenir le tableau où s'écrivent les leçons violentes et morbides du Code Noir[268]. Celles et ceux que l'on va priver d'être, de biens puis de capacité à cultiver la terre pour leur propre bénéfice[269], vont accumuler à l'intérieur d'eux-mêmes. La dernière archive d'*Ouvertures* est ainsi une archive du corps, mais un corps qui n'est pas un soi isolé du monde, un corps-paysage qui témoigne de l'expérience d'une Humanité rejetée hors de Humanité – comme d'autres peuples indigènes – et qui a développé

archive in *Ouvertures* is an archive of the body, a body that is not a self isolated from the world, but rather a body-landscape that bears witness to the experience of a Humanity rejected outside of Humanity – like other Indigenous peoples – and that has developed as a result particular complicities from its long sojourn in the world of the colony's natural resources. Thus when this archive returns, it is not alone, but announces itself with the cacophonous sonorities of all the forms of life and death that populate it, all the suffering endured in silence. *Ouvertures* saturates the scene of confessions. The film's trajectory bears witness to a necessary movement towards new scenes; in other words, paradoxically towards what cannot be shown, what escapes representation, but which does *act on* its characters. In this way, a *péyi andéyò* (country outside) in the film opens up, where the assembly continues to debate, to learn, to define itself, as it will continue to do as it travels to a French suburb and participates in a wake at the centre of a world on fire.[218] As a centripetal film that endlessly flees from itself towards a periphery that it cannot contain, *Ouvertures* announces an imagined form of solidarity as the possibility of other places to come.

Recomposition of Us, Elsewhere

The Martiniquan researcher Malcom Ferdinand speaks of the enslavement of Blacks in the Americas as a politics of the (ship's) hold, 'a way of being in relation to the other by which an intense proximity is installed – the other is as close as possible, in the intimacy of the home, on the boat or on the plantation.' And it is in this sense that he sees in the colonial inhabiting 'an enterprise of memification, reduction of the Same [...] a living-without-the-other'.[219] He thus places the politics of destruction and toxic proximity in the same perspective of elimination as other forms of possible life. This is why the idea of a distance, a separation, is first a form of simple flight, but also an escape from a politics of absorption. This flight opens the possibility of another place, another inhabiting, another way of worlding. Looking back, I see in *Ouvertures* the fragile beginning of a human adventure – which has continued on – that turns the refusal to present oneself on the scene of alliances – and of representation – into an act of solidarity, bearer of the desire for an imaginary place that is *not yet there*. I see a refusal to return to proximity unless it is situated at the heart of the colonial eye and inhabiting. Perhaps it was the lack of consent to this movement, this errancy, that plagued the circle of Coulibalystes a few years earlier. Engaging in an adventure that explodes out of frameworks, out of known places and forms of art, seeks this relation of solidarity to which no empathy obliges us and that no form precedes – and for this reason escapes the production of value. On the path toward this place, unspeakable attachments could make themselves heard and unnameable lives could exist in an

de ce fait des connivences particulières par son long séjour dans le monde des ressources naturelles de la colonie. Aussi quand cette archive fait son retour, elle ne revient pas seule et s'énonce dans les sonorités cacophoniques de toutes les formes de vie et de mort qui la peuple, de toutes les souffrances passées sous silence. *Ouvertures* sature ainsi la scène des aveux. La trajectoire du film témoigne du mouvement nécessaire vers de nouvelles scènes, c'est-à-dire paradoxalement vers ce qu'il ne peut montrer, ce qui fuit sa représentation, mais qui *agit* ses personnages. Aussi, s'ouvre alors un *péyi andéyò* du film où l'assemblée continue de débattre, de s'informer, de se définir comme elle va le faire en voyageant plus tard vers une banlieue française pour s'engager dans une veillée au cœur d'un monde en feu[270]. En tant que film centripète qui s'enfuit sans cesse vers une périphérie qu'il ne contient pas, *Ouvertures* annonce un imaginaire de la solidarité en tant que possibilité d'autres lieux à venir.

Recomposition du Nous, ailleurs.

Le chercheur martiniquais Malcom Ferdinand parle de l'esclavage des Noirs dans les Amériques comme d'une politique de la cale, « (...) *une manière d'être en relation à l'autre par laquelle une intense proximité est mise en place – l'autre est au plus proche, dans l'intimité du foyer, sur le navire ou sur la plantation.* Et c'est à ce titre qu'il aperçoit dans l'habiter colonial « *une entreprise de mêmification, de réduction au Même, (...) un habiter-sans-l'autre* »[271]. Il place ainsi les politiques de destructions et de proximité toxique dans une même perspective d'élimination d'autres formes de vie possible. C'est pourquoi l'idée d'une distance, d'un écart, est d'abord une forme de fuite radicale des vies subalternes face à la fatalité de leur destruction pure et simple, mais aussi une échappée depuis une politique de l'absorption. Cette fuite ouvre la possibilité d'un autre lieu, d'un autre habiter, d'une autre manière de faire monde. Aussi j'aperçois avec le recul, dans *Ouvertures*, le début fragile d'une aventure humaine – qui s'est poursuivie depuis – qui fait du refus de se présenter sur la scène des alliances – et de la représentation – un acte de solidarité, porteurs du désir d'un lieu imaginaire qui n'est pas *déjà là*. Refus de revenir dans la proximité si ce n'est au cœur de l'œil et de l'habiter colonial. C'est peut-être consentir à ce mouvement, à cette errance qu'il avait manqué au cercle des Coulybalystes quelques années plus tôt. Et s'engager dans une aventure qui sorte des cadres, des lieux et des formes connues de l'art, pour rechercher

experience where everyone, like the characters in *Ouvertures,* loses their tongue, adopts and participates in the sonorities of a re-peopled world.

167 I borrow this expression from the Martiniquan researcher Malcom Ferdinand, whose book, *Une écologie décoloniale* (Paris: Le Seuil, 2019) I see as a companion piece to this text. By taking the French Caribbean plantation as a departure point for his account of the climate crisis, Ferdinand shines light on the shadows of the Anthropocene in order to show the extent to which we are living today with the critical consequences of the Plantationocene.

168 Isabelle Stengers and Philippe Pignarre consider the necessity of no longer merely taking satisfaction in denouncing the ills of capitalism and its remarkable capacities for 'possession', but also of making concrete actions to protect ourselves from them, thereby defusing the idea that it acts 'magically' and without a body. Philippe Pignarre and Isabelle Stengers, *Capitalist Sorcery: Breaking the Spell*, trans. Andrew Goffey (London: Palgrave Macmillan, 2007).

169 See also: Olivier Marboeuf, *Decolonial variations* (https://olivier-marboeuf.com/2019/05/09/variations-decoloniales/).

170 The figure of the storyteller I'm interested in and who appears in a number of my texts has something tempestuous in his nature. He is a prowler, a rascal who lurks and sticks his tongue in places where he shouldn't.

171 In the text *Un corps sans nom* in *L'Esprit Français, contre-cultures 1969-1989* (Paris: La Maison Rouge and La Découverte editions, 2017), I try to evoke the particularities of the cultural productions of the children of immigrant workers from the Maghreb at the beginning of the 1980s, when this population of immigrants made an abrupt appearance on the scene of French representations.

172 It is thought that he was actually targeting a Jewish school in the neighbourhood.

173 The magazine *Hara-Kiri*, founded in 1960 by François Cavanna and Professor Choron, the ancestor of *Charlie Hebdo*, presents itself as 'nasty and stupid'. This spirit remains the trademark of satirical publications that follow the genealogy of this turbulent and tempestuous ancestor.

174 I examine this notion of the peripheries of the Empire in the text 'Les Empire intérieurs' (in the magazine *Tumultes*, no. 54, Editions Kimé, Paris, June 2020) in which the recent history of Clichy-sous-bois in the suburbs of Paris echoes the trial of the Martiniquan Insurgents of 1870. In both cases, the motif of the French citizen is articulated on the basis of the production of its negative: the savage – who will also be the executed figure in the Republican ritual. As we shall see later in this text, performing an act of solidarity requires revealing all presences that participate in a scene: those who have no voice and those who are spoken of by others, those who remain in the shadows and those whom the colonial body renders invisible.

175 Muhittin Altun,

Olivier Marboeuf

cette relation solidaire qu'aucune empathie n'oblige et qu'aucune forme ne précède – et de ce fait qui échappe à la production d'une valeur. Sur le chemin vers ce lieu, pourront se faire entendre des attachements inavouables et exister des vies innommables dans une expérience où chacun, comme les personnages d'*Ouvertures,* perd sa langue, adopte et participe aux sonorités d'un monde repeuplé.

220 J'emprunte cette expression au chercheur martiniquais Malcom Ferdinand dont je fais du livre *Une écologie décoloniale* (Le Seuil, Paris, 2019), la nécessité d'une écriture compagne de ce texte. En prenant la plantation de la Caraïbe française comme point de départ du récit de la crise climatique, Ferdinand éclaire les ombres de l'Anthropocène pour montrer combien c'est bien dans les suites critiques du Plantationocène que nous vivons aujourd'hui.

221 Isabelle Stengers et Philippe Pignarre abordent dans leur livre *Une sorcellerie capitaliste : Pratiques de désenvoûtement* (Editions La Découverte, Paris, 2005), la nécessité non plus de se contenter de dénoncer les méfaits du capitalisme et ses capacités de possession remarquables, mais de former des prises concrètes pour s'en protéger et ainsi défaire l'idée qu'il agit « magiquement » et sans corps.

222 Voir notamment : Olivier Marboeuf, *Variations décoloniales* (https://olivier-marboeuf.com/2019/05/09/variations-decoloniales/)

223 La figure du conteur qui m'intéresse et file nombre de mes textes a quelque chose d'intempestive. C'est un rôdeur, un lascar qui traîne et met sa langue là où il ne faut pas.

224 Dans le texte *Un corps sans nom* (in *L'Esprit Français, contre-cultures 1969 - 1989*, éditions La Maison Rouge et La Découverte, Paris, 2017), je tente d'évoquer les particularités des productions culturelles des enfants des travailleurs immigrés du Maghreb au tournant des années 80 quand ceux-ci font une apparition brutale sur la scène des représentations françaises

225 On pense qu'il visait en fait une école juive du quartier.

226 Le magazine Hara-Kiri fondé en 1960 par François Cavanna et le professeur Choron, ancêtre de Charlie Hebdo, se présente lui-même comme « bête et méchant ». Cet esprit restera la marque des publications satyriques qui suivront la généalogie de cet ancêtre turbulent et intempestif.

227 J'examine cette notion de périphéries de l'Empire dans le texte *Les Empires intérieurs* (in Revue Tumultes n°54, Editions Kimé, Paris, juin 2020) où l'histoire contemporaine de Clichy-sous-bois, en banlieue de Paris, fait écho au procès des Insurgés de la Martinique en 1870. Dans les deux cas, le motif du citoyen français s'articule à partir de la production de son négatif : le sauvage – qui sera aussi le mis à mort du rituel républicain. Comme nous le verrons plus loin dans le texte, faire acte de solidarité nécessite de donner à ressentir toutes les présences d'une scène, celles qui n'ont pas de voix et celles qui sont parlées par d'autres, celles qui se tiennent dans l'ombre et celles que le corps colonial invisibilise.

228 Muhittin Altun, également grièvement blessée avec ses deux amis est le seul des trois protagonistes qui survivra à ce drame.

229 La Marche pour l'égalité et contre le racisme est une marche antiraciste. Il s'agit de la première manifestation nationale du genre en France. Elle fait suite à des affrontements entre la police et des jeunes du quartier des Minguettes durant l'été 1983 dans une banlieue populaire de Lyon. A cette occasion, la grave blessure de Toumi Djaïdja, président de l'association SOS Avenir Minguettes, va devenir le symbole de la violence raciste contre

3. Collectivity

also severely wounded with his two friends, was the only one of the three protagonists to survive this event.

176 The March For Equality and Against Racism was the first national demonstration of its kind in France. It occurred in reaction to confrontations between the police and youths in the Minguettes neighbourhood in a poor suburb of Lyon during the summer of 1983. On this occasion, the severe injuries of Toumi Djiaidja, president of the association SOS Avenir Minguettes, became the symbol of racist violence against North African youths, culminating in 1983. Using the model of actions advocated by Martin Luther King, a long march begins in Marseille in relative anonymity on 15 October. And yet on 3 December, 1983, a veritable human river of marchers invades the streets of Paris.

177 The slogan by itself merits an entire study. For the moment, we'll stick to the fact that it negated any inclination of this

'buddy' to defend him/herself and any space of autonomy to build and protect him/herself. This buddy, whose name we wouldn't dare say, is neutralised and saved by someone else, who is going to speak in his/her place and through him/her speak to a racist who becomes *Racism*. The entire debate saves face for the historic foundations of the State and becomes an anaesthetised scene of empathy. Between 'Touche pas à mon pote' and 'Je suis Charlie', we move from paternalist distance to absorption into a republican Me without ever imagining relational modes that occur *skin to skin*.

178 It was only in May 2020, following the assassination of George Floyd in Minneapolis and the viral expansion of the Black Lives Matter movement, that the notion of systemic racism erupted into the mainstream media in France, although the term had long served as a battle horse for the Mouvement de l'Immigration et des Banlieues (MIB), and

then later for the Parti des Indigènes de la République (PIR), considered as a radical bugbear of anti-racism.

179 The same reproach is made of the Haitian Revolution (1791-1804), which gave birth to the first Black republic in history. It doesn't follow a written programme, but is an experimental revolution where a diversity of human and non-human forces gather together, an experimentation of the decomposition of a social order in view of reconstructing another.

180 The city of Paris is circled by a multi-laned peripheral boulevard that for a long time signified the material and symbolic limit between the capital and its suburbs.

181 During a speech made in Orléans on 19 June 1991, the French politician Jacques Chirac - who became President of the Republic in 1995 - used the phrase 'the noise and odour' to speak of problems of nuisance and disturbance linked to certain immigrant populations. The

expression became famous. It marks the progressive shift of the discourse of the French Right toward that of the Extreme Right, beginning in the mid-1980s. The music group Zebda from Toulouse used the phrase as the title of its hit militant song.

182 'I can't breathe', worldwide leitmotiv of the struggle against police violence, became the slogan of human life in the time of a pandemic. Breathing together, sharing a precarious breath, could be the translation of a possible scene of solidarity.

183 The expression recalls the very particular form of the HLM housing projects of the Grande Borne in Grigny where Amedy Coulybaly grew up. Conceived of by the architect Émile Aillaud, the concrete buildings take the form of snakes.

184 Terrorists acting alone, outside any identified network, whose acts are thus difficult to predict.

185 The Groupe Islamique Armé (1991-99) was an Islamist terrorist organisation of Salafiste

djihadist ideology created during the Algerian civil war. Its objective was to overthrow the Algerian government and to replace it with an Islamic State.

186 In 2005, in an interview with the Israeli journalist Haaretz, the French philosopher Alain Finkielkraut had directly linked the revolts provoked by the deaths of Zyed Benna and Bouna Traoré to the problem of Islam in France. He was continuing a long obsessional work that posits that the suburbs are nothing more than a territory of fear, caught between religious radicalisation, polygamy and collective rapes in the cellars of HLM tower blocks.

187 In my text 'La possession de Vanneste' (in *Mouvement*, no. 63, 2012, 94-96), I relate the delusional episode of the French deputy Christian Vanneste. In June 2004, he presented a sub-amendment to the law of 23 February 2005, according to which 'The Nation expresses its recognition of the women and men who participated in the work accom-

la jeunesse maghrébine qui culmine en cette année 1983. Sur le modèle des moyens d'action prôné par Martin Luther King, une longue marche débute alors à Marseille, dans un relatif anonymat, le 15 octobre. Pourtant, le 3 décembre 1983, c'est une véritable marée humaine qui va envahir les rues de Paris.

230 Le slogan à lui seul mériterait une étude. Nous retiendrons pour l'heure qu'il anéantit toute velléité de ce «pote» à se défendre lui-même et tout espace d'autonomie où se construire et se protéger. Ce pote, dont on n'oserait dire le nom, est en quelque sorte neutralisé et sauvé par un autre qui va parler pour lui et surtout à travers lui à *un* raciste qui devient *le* Racisme. Tout le débat épargne donc les fondements historiques de l'Etat et devient une scénette d'empathie. Entre « Touche pas à mon pote » et « Je suis Charlie », on passe de la distance paternaliste à l'absorption dans un Moi républicain sans jamais imaginé des modes de relation *de peau à peau*.

231 Ce n'est qu'en Mai 2020, à la faveur de l'assassinat de George Floyd à Minneapolis et de l'expansion virale du mouvement Black Lives Matter, que la notion de racisme systémique fera irruption dans les média *mainstream* en France alors que le terme avait longtemps été l'un des chevaux de bataille du Mouvement de l'Immigration et des Banlieues (MIB) puis du Parti des Indigènes de la République (PIR), considéré comme un épouvantail radical de l'antiracisme.

232 On fait d'ailleurs le même reproche à la révolution haïtienne (1791-1804) qui va

donner naissance à la première république noire de l'histoire. Elle ne suit pas un programme écrit, c'est une révolution expérimentale ou s'assemblent une diversité de forces humaines et non-humaines, une expérience de décomposition d'un ordre social en vue d'en reconstruire un autre.

233 La ville de Paris est encerclée d'un boulevard périphérique qui a longtemps signifié la limite matériel et symbolique entre la Capitale et ses banlieues.

234 Lors d'un discours à Orléans le 19 juin 1991, l'homme politique français Jacques Chriac - qui deviendra Président de la République en 1995 - utilise l'expression « Le bruit et l'odeur » pour parler des problèmes de nuisance liés à certaines populations immigrées. L'expression fera date. Elle marque le progressif déplacement du discours de la droite française vers celui de l'extrême-droite à partir du milieu des années 80. Le groupe de musique toulousain Zebda fera de ces mots le titre d'une célèbre chanson militante.

235 « I can't breath / je ne peux pas respirer », leitmotiv mondial de la lutte contre les violences policières est devenu celui de la vie humaine en tant que pandémie. Respirer ensemble, partager un souffle précaire, pourrait alors être la traduction d'une possible scène solidaire.

236 L'expression rappelle ici la forme très particulière de la cité HLM de la Grande Borne à Grigny où a grandit Amedy Coulybaly. Imaginés par l'architecte Émile Aillaud, les bâtiments de béton y prennent la forme de serpents.

237 Terroristes agissant seul, en dehors de tout réseau identifié, et dont les actes sont ainsi difficilement prévisibles.

238 Le Groupe Islamique Armé (1991-1999) est une organisation terroriste islamiste d'idéologie salafiste djihadiste créé lors de la guerre civile algérienne. Son but était de renverser le gouvernement algérien pour le remplacer par un État islamique.

239 En 2005, dans un entretien pour le journal israélien Haaretz, le philosophe français Alain Finkielkraut avait directement lié les révoltes populaires provoquées par la mort de Zyed Benna et Bouna Traoré au problème de l'islam en France. Il poursuivait ainsi une longue œuvre obsessionnelle où la banlieue n'est rien d'autre qu'un territoire d'épouvante, entre radicalisation religieuse, polygamie et viols collectifs dans les caves des HLM.

240 Dans le texte *La possession de Vanneste* (in *Mouvement*, n°63, 2012, 94-96.), je relate l'épisode délirant du député français Christian Vanneste. En juin 2004, il présente un sous-amendement à la loi du 23 février 2005, selon lequel « *La Nation exprime sa reconnaissance aux femmes et aux hommes qui ont participé à l'œuvre accomplie par la France dans les anciens départements français d'Algérie, au Maroc, en Tunisie et en Indochine ainsi que dans les territoires placés antérieurement sous la souveraineté française. Les programmes scolaires reconnaissent en particulier le rôle positif de la présence française outre-mer, notamment en Afrique du Nord et accordent à l'histoire et aux*

plished by France in the former French departments of Algeria, Morocco, Tunisia, and Indochina, as well as in the territories formerly placed under French sovereignty. School programmes recognise in particular the positive role of the French presence overseas, notably in North Africa and accord to the history and sacrifices of combatants from the French Army hailing from these territories the eminent place to which they have every right.' He recalls, with this act, a certain nostalgia for the age of the colonies; the shadow of the lost Empire that possesses him slowly seeps into France until it becomes a veritable political ghost of this period.

188 The term 'galérien' is used in the suburbs to speak of someone who struggles, cannot find work, a girlfriend, or any way to lead a dignified life.

189 This episode speaks worlds about the fractures at the heart of French subaltern worlds and about the difficulty of building veritable

political imaginations and convergences within African diasporas, in France in particular.

190 Racialised populations from poor working-class neighbourhoods usually discover the activities of art centres by way of pedagogical actions organised by school programmes. In professional jargon, these visitors are referred to as 'captive audiences'.

191 However, in 2006 Khiasma welcomed youths from working-class neighborhoods for an evening of debate after the death of Zyeb Benna and Bouna Traoré.

192 The history of the so-called *éducation populaire* is long in France. Given its many tendencies, formulating a single definition of it is a difficult task. Here we retain Laurent Besse's proposition, which affirms that *éducation populaire* would be an 'educative action that pretends to principally touch working-class areas and which intends to act on the individual outside of school in order to transform society'. Laurent Besse, 'Edu-

cation populaire' in Christian Delport, Jean-Yves Mollier, Jean-François Sirinelli (ed.), *Dictionnaire d'histoire culturelle de la France contemporaine* (Paris: Presses universitaires de France, coll. 'Quadrige. Dicos Poche', 2010), 270.

193 The Cameroon thinker Achille Mbembé coined the expression *le devenir-nègre du monde* (the becoming-Black of the world) in his celebrated book, *Critique of Black Reason*, trans. Laurent Dubois (Durham: Duke University Press, 2017). With this term he tries to define a politics of disregard emanating from the dominant classes toward a large part of humanity that has become exploitable, interchangeable, disposable. But the expression is debated in the milieu of Black studies, where the fungibility of the Black slave is considered to be a singular episode that participates in a global anti-blackness and which cannot be extended to all exploited populations. By shifting the term *nègre* toward a

substantive as I do here, I see as Malcom Ferdinand does, Black matters as an ensemble of human and non-human matters violently exploited by extractivist capitalism, while also considering the specific history of Black Africans enslaved in the Americas as a specific human story.

194 On the cover of *Charlie Hebdo* no. 1778, the first to appear after the attack, the cartoonist Luz represents a supposed prophet Muhammad carrying a 'Je suis Charlie' sign with a tear on his face, underneath the title 'All is forgiven'.

195 The production of a report on modalities for restitution of objects despoiled by France on the African continent is requisitioned from the Senegalese academic and economist Felwine Sarr and the French art historian Bénédicte Savoy. The results of their shared work, 'Rapport sur la restitution du patrimoine culturel africain. Vers une nouvell ééthique relationnelle' (Report on the restitution of

the African cultural patrimony. Towards a new relational ethic) is submitted to the President of the French Republic, Emmanuel Macron, in November 2018. https://bj.ambafrance.org/Telecharger-l-integralite-du-Rapport-Sarr-Savoy-sur-la-restitution-du.

196 For more information, see https://thelivingandthedeadensemble.com/.

197 Ayiti is the Indigenous name of the island that Christopher Columbus named Hispaniola and which later became a French colony under the name Saint-Domingue. Upon its independence, the first Black Republic declared itself under the name Haiti, a gesture that paid tribute to its pre-colonial naming. To 'shift' the imaginations of the Anthropocene, and literally extract slave struggles from the hold of the modern ship and recognise the value of Indigenous cosmogonies, where the human and the non-human are intertwined, Malcom Ferdinand proposes: 'In the name and place of Gaïa, the name of Lovelock's

sacrifices des combattants de l'armée française issus de ces territoires la place éminente à laquelle ils ont droit. » Il rappelle par cet acte une mélancolie certaine du temps des colonies et l'ombre de l'Empire perdu qui le possède va lentement s'emparer de la France jusqu'à composer un véritable spectre politique de cette époque.

241 On utilise le terme de « galérien » en banlieue pour parler de celui qui n'y arrive pas, qui « galère », ne trouve pas de travail, de copine, de moyen de vivre une vie digne.

242 Cet épisode en dit long sur les fractures au cœur des mondes subalternes français et sur la difficulté de construire de véritables imaginaires et convergences politiques au sein des diasporas africaines de France notamment.

243 Les populations racisées issues des quartiers populaires découvrent le plus souvent les activités des centres d'art dans le cadre d'actions pédagogiques organisées avec des établissements scolaires. Dans le jargon professionnel, on rassemble ces visiteurs sous l'appellation «public captif »

244 Même si, dès 2006, Khiasma accueillait les jeunes des quartiers populaires pour une soirée de débat, un an après la mort de Zyeb Benna et Bouna Traoré.

245 L'histoire de l'éducation populaire est longue en France. Au regard de ses nombreux courants, une définition unique reste un exercice difficile. Nous retiendrons ici la proposition de Laurent Besse qui affirme que l'éducation populaire serait une « action éducative qui prétend toucher principale-

ment les milieux populaires et qui entend agir sur l'individu hors de l'école pour transformer la société » (Laurent Besse, « Éducation populaire », dans Christian Delporte, Jean-Yves Mollier, Jean-François Sirinelli (dir.), Dictionnaire d'histoire culturelle de la France contemporaine, Paris, Presses universitaires de France, coll. « Quadrige. Dicos Poche », 2010, 270)

246 C'est au penseur camerounais Achille Mbembé que l'on doit l'expression le devenir-nègre du monde dans son célèbre livre Critique de la Raison nègre (La découverte, Paris, 2013, 9) Il tente par ce terme de définir une politique de mépris par les classes dominantes d'une large part de l'humanité devenue exploitable à souhait, interchangeable, jetable. L'expression fait cependant débat au sein de Black studies où la fongibilité du noir esclave est considérée comme un épisode singulier qui participe à un négrophobie global (global anti-blackness) et qui ne saurait être étendue à toutes les populations exploitées. En déplaçant le terme nègre vers un substantif comme je m'applique à le faire, j'envisage comme Malcom Ferdinand, à la fois les matières nègres comme un ensemble de matières humaines et non-humaines exploitées violemment par le capitalisme extractiviste, tout en considérant l'histoire spécifique des Noirs africains esclavagisés dans les Amérique comme un récit humain spécifique.

247 En couverture du Charlie Hebdo n° 1778, le premier à paraître après l'attentat, le dessinateur Luz représente un supposé prophète Mahomet

portant un panneau Je suis Charlie en versant une larme, en dessous du titre « Tout est pardonné ».

248 Un rapport sur les modalités de restitution d'objets spoliés par la France sur le continent africain est commandé à l'universitaire et économiste sénégalais Felwine Sarr et à l'historienne de l'art française Bénédicte Savoy. Le résultat de leurs travaux conjoints, « Rapport sur la restitution du patrimoine culturel africain. Vers une nouvelle éthique relationnelle » est remis au président de la République française Emmanuel Macron, en nombre 2018. www.culture.gouv.fr/Espace-documentation/Rapports/La-restitution-du-patrimoine-culturel-africain-vers-une-nouvelle-ethique-relationnelle

249 Plus d'informations ici : https://thelivingandthedeadensemble.com/

250 Ayiti est le nom indigène de l'île que Christophe Colomb nommera Hispaniola qui deviendra plus tard une colonie française sous le nom de Saint-Domingue. A l'indépendance, la première république noire se déclarera sous le nom d'Haïti par un geste qui revient à la nomination précoloniale. Pour « décaler » les imaginaires de l'Anthropocène, sortir littéralement les luttes des esclaves de la cale du vaisseau moderne et reconnaître la valeur des cosmogonies indigènes où l'humain et le non-humain s'intriquent, Malcom Ferdinand propose l'hypothèse Ayiti : « En nom et place de Gaïa, nom de l'hypothèse environnementaliste de Lovelock, je propose de reconnaître

Olivier Marboeuf

3. Collectivity

environmentalist hypothesis, I propose to recognize the intrusion of the World-Mother in the modern world: Ayiti.' (*Une écologie décoloniale*, 407).

198 The earthquake, which occurred on 12 January 2010 in Haiti, caused more than 230,000 deaths and 220,000 injured. Everyone agrees that following this dramatic event the Haitian people rediscovered for a time a veritable sense of solidarity that extended beyond the lines of social classes. International support was unprecedented, led by a diaspora spread across the world.

199 It was only in 1825 that France recognised Haiti's independence, in exchange for the payment of an indemnity of 150 million francs in gold, to 'compensate the former colonists', payment that was renegotiated in 1838 to 90 million – the equivalent of 17 billion euros in 2012. Although this 'debt' was entirely reimbursed in 1883, the payment of interest on necessary loans continued into

the middle of the twentieth century.

200 The notion of Plantationocene is introduced to counter the effect of the discourse on the Anthropocene as a period where the most important transformations on Earth and its climate are linked to the effect of human activities. The Plantationocene tries to focus responsibility more specifically not on all humans, but rather on certain colonial ways of inhabiting the Earth, among which the plantation and its methods – deforestation, monoculture, slavery, patriarchy, toxic pollution – constitute a strong symbol. The idea of the plantation is extended here to all forms of radical extraction from the commons of the world considered as a heap of 'resources' to be appropriated.

201 Rossi Jacques Casimir is notably an active member of Nou pran lari a, an association in Haiti that supports local artists and organizes itinerant exhibitions in the country.

202 The project of this film – which at

its inception was to have been called 'Let us die rather than fail to keep this vow' – finds its origins in the English filmmaker Louis Henderson's reading of the book *Les Jacobins noirs*, written by the Trinidad and Tobago thinker CLR James, and discovery of the theatrical play *M. Toussaint* by the Martiniquan author Édouard Glissant. Henderson imagines a return of the revolutionary leader Toussaint Louverture in today's Haiti. This figure will continue dissolving itself into a work that became collective thanks to the implication of Caribbean authors. In this way, *Ouvertures* invents its own particular form and relation to a choral and cacophonous archive.

203 In our work we used the stage version, which appeared in 1986 (Paris: Editions du Seuil).

204 After a meteoric ascension, the former slave Toussaint Breda, later known as Louverture, was deported to France on 7 June 1802, by order of Paris. Napoleon refused

to see his precious colony emancipated from the mother country under the leadership of the man he had himself named the Captain-General of Saint-Domingue.

205 http://www.ghetto-biennale.org/

206 In Haiti, although French is the language of politics and the press, and dominates in the field of culture, 90% of the local population only speaks Creole.

207 'I will take up the work again. I will cross the oceans in the other direction.' Toussaint Louverture in *M. Toussaint* by Edouard Glissant, scenic version (Paris: Editions du Seuil, 1986), 50.

208 History does not begin again, however, and a new loop begins in the spiral of time.

209 I explore this organic transformation of the figure of the hero in the text *Returns and overtures: Toussaint on the way to the future* (Versopolis, 2020). https:// www.versopolis.com/ times/reportage/ 953/returns-and-overtures-part-1

210 Rara is a form of

music that originated in Haiti and is played in street parades, generally during Easter week. The genre is centred around an ensemble of cylindrical bamboo trumpets called *vaksens* (which can also be made from metal tubes), but also includes drums, maracas, *güiros* (a percussion instrument), and metal bells. The *vaksens* are also used to make repetitive and rhythmic sounds by way of a baton. If the genre is for the most part Afro-centric, it is also characterised by a few Taino-Amerindian instruments, such as the *güiros* and maracas. Songs are always sung in Haitian *kreyòl* and celebrate African ascendancy in the Afro-Haitian population. Voodoo is often practised.

211 In the text 'Towards a de-speaking cinema (a Caribbean hypothesis)', I develop in the following terms the particular question of contingency/complicity between spaces that are called natural and those that have been cast out of humanity by the separations of modernity: 'The

l'intrusion de la Terre-mère du monde moderne : Ayiti. » (Une écologie décoloniale, 407)

251 Le tremblement de terre, survenu le 12 janvier 2010 en Haïti a fait plus de 230 000 morts et 220 000 blessés. Tous témoignent alors que dans ce drame, le peuple haïtien s'est redécouvert pendant un temps de véritables solidarités au-delà des classes sociales. Le soutien international a été sans précédent, porté par une diaspora éparpillée de par le monde.

252 La France ne reconnaîtra qu'en 1825 l'indépendance d'Haïti, moyennant le paiement d'une indemnité de 150 millions de francs ou pour « dédommager les anciens colons » qui sera renégociée en 1838 à 90 millions – l'équivalent de 17 milliards d'euros en 2012. Si cette « dette » est entièrement remboursée en 1883, le paiement des intérêts des prêts nécessaires courra lui jusqu'au milieu du XXe siècle.

253 La notion de Plantationocène est introduite afin de contrer l'effet du discours sur l'Anthropocène comme ère où les transformations les plus importantes de la Terre et de son climat seraient liées à l'effet des activités humaines. Le Plantationocène tente de pointer plus spécifiquement la responsabilité non pas de tous les humains mais de certaines manières coloniales d'habiter la Terre dont la plantation et ses méthodes – déforestation, monoculture, esclavagisme, patriarcat, pollution toxique – constitue un symbole fort. La notion de plantation est ici élargie à toutes les formes d'extraction radicale du commun du monde considéré comme un amas de

« ressources » appropriables.

254 Rossi Jacques Casimir est notamment un membre actif de Nou pran lari a, association très impliquée en Haïti dans le soutien des artistes locaux et qui organise des expositions itinérantes dans le pays.

255 Nous utilisons dans notre travail la version scénique parue en 1986 (Éditions du Seuil, Paris)

256 Après une ascension fulgurante, l'ancien esclave Toussaint Breda devenu Louverture est déporté vers la France le 7 juin 1802 sur ordre de Paris. Napoléon refuse de voir sa précieuse colonie s'émanciper de la métropole sous la houlette de celui qu'il a nommé lui-même capitaine-général de Saint-Domingue.

257 http://www.ghettobiennale.org/

258 En Haïti, si le Français est la langue de la politique, de la presse et domine le champs de la culture, 90% de la population locale ne parle que le créole.

259 « J'entreprends le travail à nouveau. Je traverserai les mers dans l'autre sens. » M. Toussaint Louverture in *M. Toussaint* d'Édouard Glissant Version scénique (Éditions du Seuil, 1986), 50.

260 L'histoire ne recommence pas cependant, c'est une nouvelle boucle dans la spirale du temps.

261 J'aborde cette transformation organique de la figure du héros dans le texte *Returns and overtures : Toussaint on the way to the future* (Versopolis, 2020) www.versopolis.com/times/ reportage/953/returns-and-overtures-part-1

262 Le rara est une forme

musicale originaire de Haïti, jouée lors de défilés de rue, généralement au cours de la semaine de Pâques. Le genre se centre sur un ensemble de trompettes en bambou cylindriques appelées vaksens (qui peuvent aussi être faites de tuyaux en métal), mais dispose également de tambours, de maracas, de güiros (un instrument à percussion), et de cloches en métal. Les vaksens effectuent des sons répétitifs et rythmiques à l'aide d'un bâton. Le genre, même si majoritairement afro-centré, se caractérise également par quelques instruments taino-amérindiennes comme les güiros et les maracas. Les chansons sont toujours chantées en kreyòl haïtien et célèbrent l'ascendance africaine de la population afro-haïtienne. Le vaudou y est souvent pratiqué.

263 Dans le texte « Towards a de-speaking cinema (a Caribbean hypothesis) », je développe en ces termes la question particulière de la contingence / connivence entre les espaces dits naturels et celles et ceux qui ont été jetés hors de l'humanité par les séparations de la Modernité : « (…)The subaltern body, a body without rest, because it never is in its own place, nor is ever in the process of accumulating the fruits of its labor-transports its own decor; a crush of materials, images and languages, landscapes invaginated through errancy and flight. In this way the subaltern flees a form of primitive availability, that of the object/body/image property, both fungible and interchangeable, alternately convoked, exposed and hidden. S/he then moves on to another availabili-

subaltern body, a body without rest, because it is never in its own place, nor ever in the process of accumulating the fruits of its labour, transports its own décor: a crush of materials, images and languages, landscapes invaginated through errancy and flight. In this way, the subaltern flees a form of primitive availability, that of the object/body/image property, both fungible and interchangeable, alternately convoked, exposed and hidden. S/he then moves on to another availability, that of radical contingency with the worlds that surround her/him – in other words, perhaps toward a form of non-discernment, of camouflage and alliance with and in non-human forms rather than a projection of self toward a scene of emancipation imagined by others. […] it seems difficult to me to speak of minority political cinema – or of a cinema of Black lives – without confronting the difficulty of representing certain bodies and forms of life that have long been dispossessed, not only of the possibility to produce their own mode of appearance, beyond a life in the world of death, the collections of objects and resources, but also of their own paths and agendas for a return-detour toward a living commons (*un vivant commun*). It's clear s/he/they can no longer return to a self-proclaimed Humanity, having existed as wild and unworthy materials at the heart of the Nature of the Moderns, in which capitalism stripped (and continues to extract) their riches. I would say that they return toward and by a populated and sonorous scene – where perhaps they will not be recognised and where they do not ask to be recognised.'

212 Held in contempt and never mentioned throughout the nineteenth century, when the only figures to shine are the heroes and fathers of the nation, the Maroon revolts and with them the contribution of the common people to the revolution will soon find a place, and even a centrality, in Haitian history, through the pens of official narrators of a new Black nationalism, a political account of populist inspiration, for which the Maroon would be the essentialised symbol. When François Duvallier acceded to power in 1957, he saw in the *noiriste* fable an efficient way of chasing out the elite mulatto who had been in power until then.

213 This place is not only a physical space, but requires a collective performance in order to appear: the wake. On this subject see: Olivier Marboeuf, 'Those who hold a wake for negro images', in *Reader of the 12th Biennal of Bamako* (Berlin: Archive Books, 2019).'

214 Toussaint Louverture, who led a large part of the revolutionary combat of the former French colony Saint-Domingue (1791-1804), was exiled to the Fort de Joux in France in 1802 by Napoleon, who feared the growing influence of this freed slave, now a formidable war strategist. Although Napoleon had made Louverture the governor of the precious sugarcane-producing island, he condemned him to the cold of a prison in the Jura, where Louverture died in 1803.

215 See https://poets.org/poem/sea-history.

216 The Code Noir (Black Code) was a French royal edict, whose first version dates from 1685. It came into effect that same year in Martinique and Guadeloupe, then in 1687 in Saint-Domingue, with sometimes quite important variations in the text, and finally, in Guyana in 1704. The edict of 1685 filled a juridical void, since slavery had been unknown in France for several centuries, even though it had been an established practice in the French islands of the Caribbean since at least 1625. One of the most remarkable aspects of the Code Noir is that it legitimised and even defined the punishments to be inflicted on slaves – and notably to escapees who interrupted by their attempts to flee the economic process of the plantation. Violence was thus graduated and organised by a legal framework that, on paper, was part of royal law and not an element of domestic practices. But in fact, what was left to the discretion of masters was wide enough to ensure that the whip set the rhythm of plantation life. We can see in the Code an attempt by the State to maximise the mercantile economy of the islands – and in particular the economy of sugar and coffee, where France hoped to lead the European market.

217 At the time of the definitive abolition of slavery in the French Antilles in 1848, an ensemble of laws would limit the possibility of slaves to cultivate land and often oblige them to sign work contracts on agricultural exploitations run by white former plantation owners before allowing the former slaves to circulate freely.

218 This is the weft of the new theatrical performance of the Ensemble, *The Wake*, created between 2020 and 2021.

219 Malcom Ferdinand, *Une écologie décoloniale*, 59. (Our translation).

Olivier Marboeuf

3. Collectivity

ty, that of radical contingency with the worlds that surround her/him—in other words, perhaps toward a form of non-discernment, of camouflage and alliance with and in non-human forms rather than a projection of self toward a scene of emancipation imagined by others. (…) it seems difficult to me to speak of minority political cinema—or of a cinema of Black lives—without confronting the difficulty of representing certain bodies and forms of life which have long been dispossessed, not only of the possibility to produce their own mode of appearance, beyond a life in the world of death, the collections of objects and resources, but also of their own paths and agendas for a return-detour toward a living commons (un vivant commun). It's clear s/he/they can no longer return to a self-proclaimed Humanity, having existed as wild and unworthy materials at the heart of the Nature of the Moderns, in which capitalism stripped (and continues to extract) their riches. I would say that they return toward and by a populated and sonorous scene—where perhaps they will not be recognized and where they do not ask to be recognized. »

264 Méprisées et passées sous silence tout au long d'un XIXème siècle où brillent les seuls héros et pères de la nation, les révoltes des marrons et avec elles la contribution populaire à la révolution vont retrouver bientôt une place et même une centralité dans l'Histoire haïtienne sous la plume de narrateurs officiels d'un nouveau nationalisme noir, récit politique d'inspiration populiste dont le marron serait le symbole essentialisé. François Duvallier, quand il accède au pouvoir en 1957, voit dans la fable *noiriste* une manière efficace de chasser l'élite mulâtre au pouvoir jusqu'alors.

265 Ce lieu n'est pas seulement un espace physique, il nécessite une performance collective pour apparaître, c'est le lieu de la veillée. Voir à ce sujet : Marboeuf, Olivier, *Those who hold a wake for negro images*, in Reader of the 12th Biennal of Bamako, Archive Books, Berlin, 2019.

266 Toussaint Louverture qui a mené une large part du combat révolutionnaire de l'ancienne colonie française Saint-Domingue (1791 à 1804) est exilé au Fort de Joux en France en 1802 par Napoléon qui craint l'influence grandissante de cet ancien esclave affranchi devenu un redoutable stratège de guerre. Alors qu'il en avait fait lui-même le gouverneur de cette précieuse île sucrière, il le condamne à la froideur d'une prison du Jura où Louverture meurt en 1803.

267 https://poets.org/poem/sea-history

268 Le Code Noir est un édit royal français dont la première version date de 1685. Il entre en application cette même année à la Martinique et à la Guadeloupe, puis en 1687 à Saint-Domingue avec des variantes parfois importantes dans le texte. Et, enfin, en Guyane, en 1704. L'édit de 1685 vient combler un vide juridique, puisque l'esclavage est inconnu en France depuis plusieurs siècles, alors qu'il est établi, en fait, dans les îles françaises des Antilles depuis 1625 au moins. L'un de ses aspects les plus remarquable est qu'il légitime et même défini les châtiments à porter aux esclaves - et notamment aux fugueurs qui interrompent par leur fuite le processus économique de la plantation. La violence est ainsi graduée et organisée par un cadre légal qui, sur le papier, relève de la loi royale et non des pratiques domestiques. Mais dans les faits, ce qui est laissé à la discrétion des maîtres est assez large pour que le fouet rythme la vie de la plantation. Il convient cependant de voir dans le Code Noir une tentative par l'Etat de maximiser l'économie mercantile des îles - et notamment celle du sucre et du café dont la France vise le leadership en Europe.

269 Au moment de l'abolition définitive de l'esclavage dans les Antilles françaises en 1848, un ensemble de loi fera en sorte de limiter la possibilité des esclaves de cultiver la terre et les obligera souvent pour pouvoir circuler librement à signer des contrats de travail sur des exploitations agricoles dirigées par les anciens planteurs blancs.

270 C'est la trame de la performance et du prochain film à venir de l'Ensemble, *The Wake*.

271 Malcom Ferdinand, *Une écologie décoloniale*, 59.

Situatedness. Radical Accomplices, Indigenous Epistemologies and
New Technologies of Solidarity

315

4

Contributions from the
Norwegian Solidarity
Committee for Latin
America (LAG)

Dulce Celina Ureña Hernández
Statement (2020)

317

Pirata Bordadora, *Incendiarlo todo*
(Burn Everything)

This patch was made in September 2020 during a direct
action in Ecetepec, one of the epicentres of femicide
in Mexico, in which women burnt down the Institute
for Human Rights as a protest against the authorities'
ignorance of the escalation of the killing of women. The
patch, along cwith many others, was sold to raise funds
for the women's action.

I burn everything, I tear it all apart, if some guy one day turns off the light in your eyes

Ever since I first heard this part of the song, something has been simmering in me. From then on, and while I am embroidering, I have been thinking of many women: my sister, my friends, and also those who are no longer with us. Each news of another one passing makes me sadder, angrier, and I am filled with fear. But I remember the Zapatistas telling us women that they are not afraid, or that when they are, they control it. I try to control it so that it doesn't paralyse me, and so that the light in me doesn't extinguish, so that I can burn something.

The verse goes:

> I burn everything, I destroy everything
> If some guy one day turns off the light in your eyes
> If they take one, we all respond

The situation with femicide in Mexico is increasingly grave, and each murdered woman is an open wound.

Yo todo lo incendio, yo todo lo rompo si un día algún fulano te apaga los ojos

Me incendia por dentro esta parte de la canción desde la primera vez que la escuché. Desde entonces y mientras bordaba tenía en mente a muchas mujeres: a mi hermana y a mis amigas, pero también a las que ya no están. Cada noticia me entristece, enrabia y me llena de miedo. Pero me acuerdo que las Zapatistas nos hablan a las mujeres que no tienen miedo o que si lo tienen lo controlan. Yo intento nomás controlarlo, que no me paralice y que la lucecita no se me apague para que alcance a quemar alguito.

La estrofa completa es:

> Yo todo lo incendio, yo todo lo rompo
> Si un día algún fulano te apaga los ojos
> Ya nada me falta, ya todo me sobra. Si tocan a una, respondemos todas.

La situación de feminicidios en México parece agravarse cada vez más, y cada mujer muerta es una gran herida abierta.

Sound: *Canción sin miedo* by Vivir Quintana

Que tiemble el Estado, los cielos, las calles
Que tiemblen los jueces y los judiciales
Hoy a las mujeres nos quitan la calma
Nos sembraron miedo, nos crecieron alas

A cada minuto, de cada semana Nos roban amigas,
nos matan hermanas
Destrozan sus cuerpos, los desaparecen
No olvide sus nombres, por favor, señor presidente

Por todas las compas marchando en Reforma
Por todas las morras peleando en Sonora Por las
comandantas luchando por Chiapas
Por todas las madres buscando en Tijuana

Cantamos sin miedo, pedimos justicia
Gritamos por cada desaparecida Que resuene fuerte
"¡nos queremos vivas!"
Que caiga con fuerza el feminicida
Yo todo lo incendio, yo todo lo rompo Si un día algún
fulano te apaga los ojos Ya nada me calla, ya todo me
sobra Si tocan a una, respondemos todas
Soy Claudia, soy Esther y soy Teresa Soy Ingrid, soy
Fabiola y soy Valeria Soy la niña que subiste por la
fuerza Soy la madre que ahora llora por sus muertas

Y soy esta que te hará pagar las cuentas
¡Justicia! ¡Justicia! ¡Justicia!

Por todas las compas marchando en Reforma
Por todas las morras peleando en Sonora Por las
comandantas luchando por Chiapas
Por todas las madres buscando en Tijuana

Cantamos sin miedo, pedimos justicia
Gritamos por cada desaparecida Que resuene fuerte:
¡Nos queremos vivas!
¡Que caiga con fuerza el feminicida!
¡Que caiga con fuerza el feminicida!
Y retiemblen sus centros la tierra Al sororo rugir del
amor Y retiemblen sus centros la tierra Al sororo rugir
del amor

Contributions from the Norwegian Solidarity Committee for Latin America
Vivir Quintana

4. Situatedness

Let the state, the skies and streets tremble. Let the judges, and courts tremble. We have had enough.

Peace is being taken away from us women They gave us fear, we grew wings Each minute of every week They take away our girlfriends, they kill our sisters They destroy their bodies, they make them disappear Please don't forget their names, Mr President!

For our comrades marching in Reforma For all the girls fighting in Sonora For the female commanders fighting for Chiapas For all the mothers searching in Tijuana

We sing without fear, we ask for justice We scream for each missing woman Let it resonate loudly 'We want us alive!' Let the femicide end up in jail I will burn down everything, I will shatter everything If one day some guy turns off the light in your eyes.- Nothing silences me anymore, everything is left over If they touch one of us, we all answer. I'm Claudia, I'm Esther, and I'm Teresa I'm Ingrid, I'm Fabiola, and I'm Valeria I'm the girl you kidnapped I'm the mother who now cries for her assassinated daughters

And I am the one who will make you pay the bill. (Justice! Justice! Justice!)

For our comrades marching in Reforma For all the girls fighting in Sonora For the female commanders fighting for Chiapas For all the mothers searching in Tijuana

We sing without fear, we ask for justice We scream for each missing woman Let it resonate loudly 'We want us alive!' Let the femicide end up in jail.
And the Earth's centre shall tremble with the sisterly roar of love
And the Earth's centre shall tremble with the sisterly roar of love

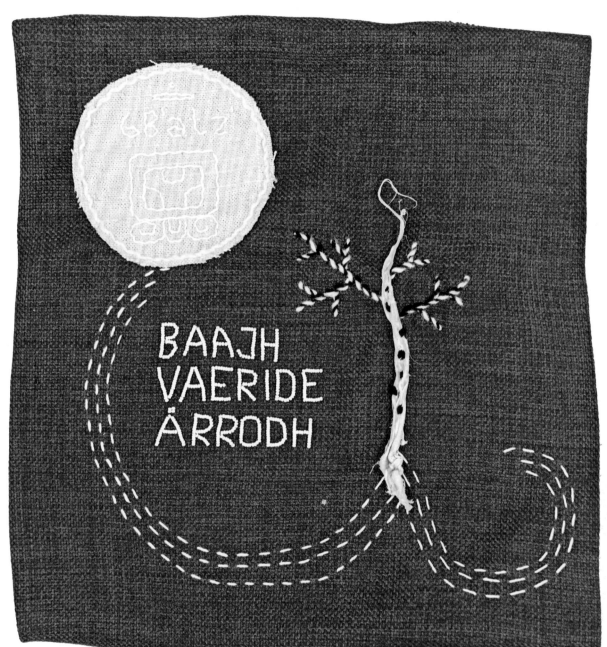

Solidarity Brigade in Chiapas, Mexico 2012

Eva Maria Fjellheim's textile work with glass beads, woollen thread and reindeer sinews embroidered on cotton cloth for the *Solidarity Patchwork*. Photo: Ingrid Fadnes, 2021.

On 17 September 2017 (6'Batz' in the Mayan calendar Cholq'ij) Latin-Amerikagruppene i Norge's (LAG – the Norwegian Solidarity Committee for Latin America) brigade participants from Colombia and Guatemala took part in a protest action to support the reindeer herders in Gåebrien Sijte and Saanti Sijte, Sápmi in their battle against the Stokkfjellet Wind-farm development. This experience led me to write the chapter 'Solidarity Without Borders' in LAG's book commemorating its 40th anniversary *I dag er fortsatt alltid [Today is Still Forever]* (Solidaritet forlag, 2018). - 'Baajh vaeride årrodh! La fjella leve! ¡Qué vivan las montañas!' [Let the mountains live!]

We shout in Southern Saami, Norwegian and Spanish. Saami, environmental activists and other allies are gathered on a small farmyard in the municipality of Selbu in Sør-Trøndelag (Mid-Norway/Southern Sápmi). We are here to defend the mountains against the wind-farm development that Trønder Energi has received concessions to complete, on the mountain Stokkfjellet which is located in the most important calving area for the reindeer herds. With us are four brigade participants from Colombia and Guatemala with their fists in the air. These lands may be unknown to them, but the struggle is familiar. Abya Yala and Sápmi are far apart geographically, but they are painfully aware of how important the fight for land, waters and territory is for Indigenous peoples' language, culture and survival– also here in the north.

In Sápmi as in Latin America, Indigenous people are experiencing increasing pressure on their land, on top of the structural discrimination they experience within legal, political and social frameworks. Globally, the demand for minerals, power and other natural resources is increasing, threatening the livelihood of Indigenous peoples. Faced by powerful national and international economic interests, Indigenous peoples' sovereignty is challenged. Those of us who vocalise these issues and stand at the barricades for their rights experience criminalisation, humiliation, and are referred to as radical troublemakers who are blocking the development of the country. Because of this, it is worth drawing some parallels and learning from each other's experiences, not least in order to stand stronger together when facing similar challenges.

LAG is acknowledging that the fight for democracy, justice and peace needs strengthening here in Norway. During this process, the brigades, both from Norway and Latin America play a central role. Meetings across territories and struggles are not just contributing towards mutual organisational learning, but also amplifying the fact that solidarity is mutual, without borders – and as such, even more powerful. This counts not only in Sápmi, but across all nations that fight capitalism and its oppressive forces.

Sound Episode 3: 'Baajh vaeride årrodh! La fjella leve' in the Radio Series 'I Elsa Laulas Fotspor gjennom Sápmi – 100 år med samisk rettighetskamp'.

DET VAR STATEN

DET VAR IKKE FLAMMENE

JUSTICIA POR LAS 41 !

Det var ikke flammene, det var staten
It wasn't the flames, it was the state by Brigada Digna
Rabia, Latin-Amerikagruppene i Norge's (LAG – the
Norwegian Solidarity Committee for Latin America) soli-
darity brigade to Guatemala in 2019: Ane Bermudez, Inga
Haugdal Solberg, Lars Christian Moen, Olav Torgersen,
Viljar Eidsvik, Jørgen Narvestad Anda, Kristina Vatland,
Wid Al-Shamkawy, Ragnhild Holtan, Ragni Flagstad for
Solidarity Patchwork. Photo: Ingrid Fadnes, 2021.

On the night of 8 March 2017, in a state-run orphanage known as El Hogar Seguro Virgen de la Asunción in San José Pinula, Guatemala, 56 young girls were locked in a room as punishment after a confrontation with the orphanage's staff. Earlier, the girls had complained about sexual violence at the orphanage, as well as being drugged and exploited. When the violence and suppression continued even after this, they arranged a demonstration on 7 March 2017, during which they attempted to escape from the orphanage. They were found and brought back by the police, and locked in the room on the order of then President of Guatemala, Jimmy Morales. The girls set fire to mattresses hoping this would force their captors to let them out of the room. But the doors remained closed. Staff and police also prevented fire fighters and other residents of the orphanage from helping the girls. When the doors were finally opened, 19 girls had lost their lives and even more were seriously injured. Many of those who were brought to hospital died from the injuries. Only 15 of the 56 girls survived.

The event reflects the country's lack of effective state protection of children, at the same time as highlighting many of the deep structural problems that exist in Guatemalan society, and which put children at risk. Not only were the girls not protected by the state institutions that exist in the country, but it was these very institutions that subjected them to abuse. The institutions killed the girls.

The soundtrack is a performance by the Guatemalan artist and poet Regina José Galindo. You hear the sound of 41 women, including some of the mothers who lost their daughters in the fire. The women are locked in a small room for nine consecutive minutes, and shout to memorialise the girls.

Production: Sildy Gómez Lima,
Sound recording: Enrique Juárez
Casa de la Memoria 'Kaji Tulam',
Guatemala City, 2017
http://www.reginajosegalindo.com/en/home-en/

Warning: the recording is powerful and can be hard to listen to.

Sound: Regina Galindo, *Las escucharon gritar y no abrieron la puerta*, 2017

Contributions from the
Norwegian Solidarity
Committee for Latin
America (LAG)

Ingrid Fadnes and
Emory Douglas
Zapantera Negra.
An Artistic Encounter Between
the Zapatistas and the Black
Panthers (2012)

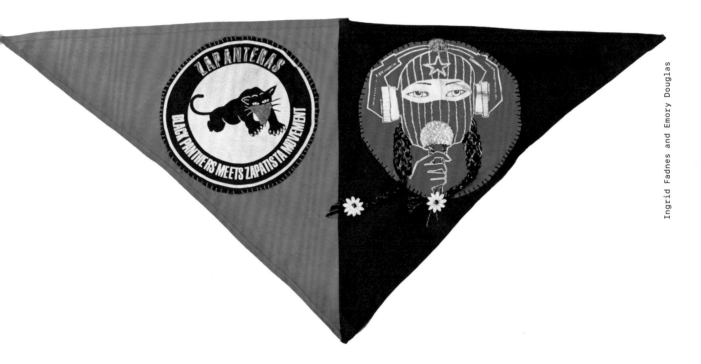

Ingrid Fadnes' patch for *Solidarity Patchwork.*
Photo: Ingrid Fadnes.

What do you get when you cross the Indigenous movement of the Zapatistas from Chiapas, Mexico, with the Black Panthers from the US? The *Zapantera negra* gathered the visual results of four encounters between the two that took place from 2012 to 2014. Central to the encounters were artistic expressions and actions that laid the foundation for conversations about autonomy, self-determination, colonialism and racism. The encounters were guided by the works and the presence of the former Minister of Culture of the Black Panther Party for Self-Defense, graphic artist Emory Douglas. During his time with the Black Panther Party (1966–1982), he created iconography to represent Black-American oppression.

The Black Panther Party was one of the most important movements countering the historical discrimination against Black people in the US and around the world. Inspired by the discourse and the words of Malcolm X and Franz Fanon, they confronted the racist government in the US. Douglas was a revolutionary artist and part of the national leadership of the party. He made countless artworks for the social struggle, and illustrated the day-to-day life of Black people in American neighbourhoods. His illustrations, cartoons and drawings were published in the official newspaper of the Panthers. His friend and artistic companion, Rigo 23 from Portugal, describes his art as 'a combination of the times of institutional slavery with contemporary police reality … like the sounds of the slums, Emory's

drawings are always loaded. Full of life, serene and fierce.' His posters and drawings are extremely diverse, changing in style over the years. He drew the black panther that later became one of the strongest symbols of the party's struggle, and which remains the best known. The black panther was painted both at EDELO and on the murals that were made as a collective effort in the autonomous school in the MAREZ on 17 November.

The Black Panthers programme and platform was launched in October 1966: *What We Want and What We Believe*. Among the things that were demanded was freedom: freedom to determine the destiny of their own Black community, including work, decent housing, and an education 'that reveals the true nature of this decadent society [...] an education that teaches us true history and our role in today's society'. In 1994, the Zapatista Army of National Liberation (EZLN) came out of the jungle armed, fighting for the demands of freedom, democracy, justice, work, shelter, food, land and education.

In 2012, I met Douglas in Chiapas and joined one of his trips to the autonomous Zapatista regions, to the Caracol 4 – Morelia. We went first and foremost to paint, but also to share our thoughts. On a crooked wooden bench inside the Zapatista school, I had the opportunity to interview Douglas. The interview was later published on the website of the independent journalist collective Subversiones, with whom I collaborated over several years.

En 2012 conocí a Emory Douglas, el Ministro de Cultura de The Black Panther Party, en el estado de Chiapas, en la frontera entre México y Guatelama. Me uní a uno de sus viajes a las regiones autónomas zapatistas, al Caracol 4 - Morelia. Fuimos ante todo a pintar, pero también a compartir nuestros pensamientos, y yo tuve la oportunidad de entrevistar a Douglas. La entrevista fue publicada posteriormente en la página web del colectivo de periodistas independientes Subversiones, con quien colaboré durante varios años. La entrevista fue realizada en el mes de Noviembre del 2012: https://subversiones.org/archivos/5779

Zapantera Negra: Panteras rebeldes en la selva zapatista

«En nombre de la tierra, el pan, la vivienda, la educación, el vestir, la justicia y la paz, háganse a los cerdos lo que ellos nos hacen a nosotros». Mensaje del partido de las Panteras Negras el 18 de Julio. 1970. The Black Panther Party fue de los movimientos más importantes para la lucha en contra de la discriminación histórica de personas de color «black people» en EE. UU y en el mundo. Inspirados por el discurso y las palabras de Malcolm X y Franz Fannon, enfrentaron al gobierno racista de EE. UU.

El hombre que creó los icónicos carteles y la imagen identitaria del partido de los Panteras Negras entre 1967 y 1981, fue el Ministro de Cultura, Emory Douglas.

Quien se encuentra aquí frente a mí, sonriendo como siempre, en una banca chueca en el auditorio del Municipio Autonomo Rebelde Zapatista (MAREZ), 17 de noviembre, en el Caracol IV Torbellino de Nuestras Palabras. Emory ha viajado para ser parte del encuentro llamado: Zapantera negra. Zapatistas rebeldes meets The Black Panthers.

Comenzaré con una pregunta simple: ¿Qué estás haciendo aqui Emory?

Me invitaron a una residencia artística por dos semanas durante Noviembre a llevarse a cabo en el Centro Cultural EDELO (En Donde Era La ONU) en San Cristobal de las Casas, Chiapas, México. Como parte de la visita estaba planeado ir a las comunidades zapatistas para hacer un trabajo gráfico. Es mi primera vez aquí. Fue el compañero Caleb (Duarte Piñon) del EDELO quien me invitó después de conocernos en San Francisco. La propuesta era venir como artista en resistencia en el espacio cultural, pintar en las comunidades zapati-

Independent media – and not the mess of alternative media we see today – constituted a fundamental part of communication in our very recent history. The development of communication and media platforms is still a crucial tool for many social movements. Had it not been for the meetings with the Zapatistas and countless *medios comunitarios*, I would probably never have learned to make radio pieces or write for a living.

I'll start with a simple question: what are you doing here, Emory?

The Cultural Centre EDELO (En Donde Era La ONU – where the United Nations Used to Be) in San Cristóbal de las Casas, Chiapas, invited me to take up an artistic residence for two weeks during November. This is my first time here. It was comrade Caled from Edelo who invited me after we met in San Francisco. The proposal was to come here as an artist in residence in a cultural space, paint in the Zapatista communities, and to make a mix of my art, some old posters, and the art of young people in Chiapas. This was how my old posters where re-made by comrades from here, not painted, but as embroideries. We made an exhibition from this called 'I Am We', where the theme was reflected in the embroideries that several Zapatista women collectives created by taking and remixing seven of my art images and using Zapatista expressions and interpretations. This work has impressed me, it's genius, and for me

to see that my work can inspire new ones, fills me with love.

What's your connection with the Zapatista movement?

My connection with the Zapatistas has to do with solidarity. The solidarity with their struggle for basic human rights. This is the tangible relationship between them and the Black Panthers, although the two fights are from different times. The Zapatistas started to organise when the Black Panther party began to dissolve. In 1981 the party came to an end, but it's in the spirit of what it represents symbolically that the relationship between the struggle of the Black Panthers and the Zapatista of today exists.

What's the strongest connection between the struggle of the Black Panther Party and the Zapatista's struggle?

The two struggles focus on self-determination. The act of fighting to determine and decide on your own destiny and the destiny of the community. The struggles are about the development of our own social order, programmes and institutions, and of course, what unites us too, is the struggle and resistance against the repressive state. The situation in Chiapas has been, and is, worrying. Here we're in a militarised zone, not only occupied by the Mexican

stas y que se hiciera una mezcla entre mi arte, algunos carteles viejos, y la arte de jóvenes zapatistas en Chiapas. Así fue que mis carteles fueron «re-creados» por compañeros y compañeras de aquí, pero ya no pintados, sino bordados. De todo este trabajo se realizó una exhibición titulada "I am We" [Yo soy nosotros] en donde la reinterpretación de 7 de mis trabajos gráficos hecha por mujeres zapatistas, dio nombre a dicha muestra. Es un proceso que me ha dejado sumamente impresionado, es ingenioso, y para mí ver como mi trabajo puede inspirar a nuevas propuestas me llena de amor.

En el tiempo del partido de los Panteras Negras, Emory Douglas fue un artista revolucionario y parte del liderazgo nacional del partido. Hizo incontables obras de arte a favor de la lucha social, y fue él quien ilustró la lucha cotidiana de las personas de color en los barrios en EE. UU. Sus ilustraciones, viñetas y caricaturas fueron publicadas en el periódico oficial de los *Panthers*. Él no se consideraba a sí mismo artista o protagonista de alguna lucha en su tiempo ni hasta la fecha. Su amigo y compañero artístico Rigo. 23 de Portugal, describe el arte y el trabajo de Emory como "una combinación de los tiempos de la esclavitud institucional con la realidad policiaca contemporánea" y que "como los sonidos de los barrios pobres, los dibujos de Emory siempre están cargados. Llenos de vida, serenos y feroces".[1] Sus carteles y dibujos son muy diversos y el estilo se ha cambiado a través de los años. Él creó la pantera negra que más tarde sería uno de los símbolos más fuertes de la lucha del partido y que hasta la fecha sigue siendo de los más conocidos e importantes para presentar la lucha de los Black Panthers. Este famoso símbolo de la pantera fue pintada tanto en el EDELO como entre todos los murales que se hicieron como un esfuerzo colectivo en la escuela autónoma en el MAREZ *17 de noviembre*.

Muralistas en Morelia

Entre las 17 personas que acompañan a Emory al *17 de noviembre* se encuentran artistas comprometidos a la lucha de abajo a la izquierda en México y el mundo. Hay compañeras y compañeros de EdelO y artistas jóvenes de los altos y de la selva chiapaneca. Poco a poco se van acercando alumnos de la escuela y sus promotores de educación. Aquí todos somos artistas y estamos vivimos algo que fue importante para Emory durante tiempo en el periódico de los Panthers: cada uno enseña a otro. Algo que es parte fundamental de la organización de las Bases de Apoyo Zapatistas (BAZ). Alrededor de la banca chueca

army, but also by armed groups and para-military groups. In the jails of Chiapas fellow Zapatistas are imprisoned, and repression and counterinsurgency policy is very present. The Black Panthers also suffered a lot of repression in its time and still has its political prisoners today.

What message can you give in this respect?

Repression is something universal. There will always be aggression against people who are in opposition to an unjust system. Political prisoners are a problem around the world. We still have people in jails who were in the party. They're prisoners from the 1960s and 70s, more than 40 years ago! Of course, there's a connection between us due to the shared experiences of repression and political prisoners.

Has there been a direct relationship between the Black Panthers and the Zapatistas before?

Not a direct relationship, but we've always been informed by the people who are connected to both the US and Chiapas – people who've spread the Zapatista word and the situation in which they find themselves.

What are you doing today?

We continue the fight against the repression of the state. We, those of us who remain and to date, can move around and breathe, continue in the same fight. We continue with our meetings to honour our legacy and pass it on to the youth, who are interested in our history. Personally, I travel a lot to give talks on the history and historical struggle of the party, through the artwork I did during the time of the party.

Do you think that your intervention in the art of the Zapatista struggle can make more people aware of a struggle that for many has been forgotten in recent years?

Oh yes! Definitely. I want to continue research-ing the struggle and the history of the Zapatista people and incorporate it into my artistic work. I hope to be able to return soon, and I'm sure I'll bring the Zapatista word to my talks and exhi-bitions and tell people about my visit and the deep mark it has left on me. What I see here in Chiapas is something in development, some-thing that's growing step by step in its own time, but they're very determined steps. What I see is a process that's happening here and now.

How do you see the current situation in the US? What do the young people you meet in your talks tell you?

en medio del auditorio hay gente mezclando pintura, otros proyectando letras en la pared, algunos están hasta arriba de las escaleras pintando los postes de diferentes colores y hay otros que están abajo haciendo sugeren-cias para quizás no pintar de todos los colores, sino hacer algo más armónico. Todas las opiniones y propuestas son válidas y Emory regala una sonrisa a cada uno. Los jóvenes de la escuela participan con dibujos, interpretaciones de su propia historia y lucha de las comunidades rebeldes zapatistas. Se escucha música a través de las bocinas, la cual fue seleccionada por Emory: la voz de su compañero Tigi Ness, quien fue ministro de Cultura del partido Polynesian Panther Party [El partido Polinesio de las Panteras]. Tigi Ness es músico y Emory se levanta a dar una vuelta y bailar unos pasos de "I was born in the city, raised in the streets, had religion in my system, was poisoned in my sleep … the factory was my future, the ghetto was my grave. Look at me now." del album Froom street to the sky.

¿Cuál es tu conexión con el movimiento zapatista?

En realidad mi conexión con el movimiento Zapatista tiene que ver con la solidaridad. Solidaridad con su lucha por los derechos humanos básicos. Esta es la relación tangible que tenemos entre ellos y los Black Panthers [Panteras Negras], aunque son dos luchas de tiempos distintos. Los zapatistas comen-zaron a organizarse cuando el partido de las panteras se disolvía. En 1981 se acaba la historia del partido, pero es en el espíritu de lo que representa simbólicamente que se crea la relación entre la lucha de los Black Panthers [Panteras Negras] de entonces con la lucha zapatista de ahora.

¿Cuál es el enlace más fuerte entre la lucha de los Black Panthers [Panteras Negras] y la lucha zapatista?

Las dos luchan se enfocan en la autodeterminación. El acto de luchar para poder determinar y decidir sobre tu propio destino y el destino de la comuni-dad. Las luchan son por el desarrollo de nuestro propio orden social, progra-mas e instituciones, y, por supuesto, lo que también nos une, es la lucha y la resistencia en contra del Estado represor. La situación en Chiapas ha sido y continúa siendo preocupante. Aquí estamos en una zona militarizada, no sólo por el ejército mexicano, sino también por grupos armados y grupos para-

We currently have strong resistance in the US due to the economic crisis. Not just a crisis, but a total collapse of the economic system. So there are many people who are interested in developing alternative programmes, such as those that emerged during the time of the Panthers. These were social programmes that were proposed by the party and implemented where we could. Now there are people who want the return of these programmes, but of course, the times we live in now are more complicated than those times.

The Zapantera Negra struggle

Among the plans for the *Zapantera Negra* encounter is the production of a magazine with the same name. It has not yet been published, but the idea of the group of artists around the EDELO is to launch the magazine in five countries, to be downloaded and reproduced from an internet page. The magazine will be developed with Douglas' guidance and will serve as a contemporary tribute to his work.

Among the 17 people who accompanied Douglas were artists committed to the struggle from the left in Mexico, and in the world. There were comrades from EDELO and young artists from the highlands and the jungle in Chiapas. Here we were all artists, and we were experiencing an idea that was important to Douglas during his time on the Panthers' newspaper: each one, teach one. This is also the foundation, the social and organisational base of the

Zapatistas (BAZ). Surrounding the crooked wooden bench in the centre of the auditorium, people mixed paint, projected words on a wall, or painted poles in different colours from the top of a ladder. Others were on the ground making new proposals: to perhaps not paint all of the poles in the same colour, but rather to make something more harmonic. All opinions and proposals were valid and Emory gave a smile to everyone. The young people from the school contributed with drawings, interpretations of their own struggle and the rebel Zapatista communities. From the loudspeakers we heard music chosen by Douglas: the voice of Tigi Ness, who was the Minister of Culture of the Polynesian Panther Party. Tigi Ness is a musician and Emory gets up to walk around and dance a little to 'I was born in the city, raised in the streets, had religion in my system, was poisoned in my sleep ... the factory was my future, the ghetto was my grave. Look at me now', from the album *From Street to Sky*.

The night is coming to Morelia. Inside the auditorium a couple of spotlights help the patient muralists. Emory is among them. Coffee and beans are shared in the mist outside the community kitchen of the school. Going up to the auditorium again, we can hear the students from the school sing:

> Listen all governments
> Those who are destroying the world
> enough of so much injustice
> enough of the fucking government that

militares. En las cárceles de Chiapas hay compañeros zapatistas presos y la represión y la política contrainsurgente esta muy presente. EL partido de los Black Panthers [Panteras Negras] también sufrió mucha represión en su tiempo y hasta la fecha tiene sus presos políticos.

¿Qué mensaje podrías dar al respecto?

Sí, sí, sí, la represión es algo universal. Siempre habrá agresión en contra de la gente que está en oposición a un sistema injusto. Los presos políticos son un problema en todo el mundo. Nosotros todavía tenemos en las cárceles gente que estaba en el partido. Son presos de los años 60's y 70's, ¡más de cuarenta años atrás! Claro que hay una conexión entre nosotros por el hecho de compartir experiencias de represión y presos políticos.

¿Ha existido alguna relación directa entre los Black Panthers [Panteras Negras] y los zapatistas antes?

Una relación directa no, pero siempre hemos estado informados por la gente que ha estado conectada entre EE. UU. y Chiapas. Personas que han difundido la palabra zapatista y la situación en que se encuentran.

¿Qué haces hoy en día?

Seguimos en la lucha en contra de la represión del Estado. Nosotros, los que quedamos y que hasta la fecha podemos movernos y respirar, seguimos en la misma lucha. Continuamos con nuestras reuniones para honrar a nuestro legado y pasarlo a las nuevas generaciones, a los quienes están interesados en nuestra historia. Yo en lo personal, viajo mucho para dar charlas sobre la historia y la lucha histórica del partido a través de la práctica artística que hice en ese tiempo para el partido.

¿Crees que tu intervención con el arte de la lucha zapatista puede hacer que más gente este informada de una lucha que para muchos ha quedado en el "olvido" los últimos años?

steals from us
the cities are already bored
of unfulfilled promises
men, children, women and the elderly
the time has come to wake up
united we can achieve
to color the world
we want the world to change
only united we can change
we will fight against evil
offering our life fighting
and that's why we tell everyone
until death is necessary

My father was a soldier.
He had in his hands with which to
plow freedom and getting old when he
couldn't fight anymore he said he would
fight anyway.
Now we are all soldiers
we have in our hands with more to plow
freedom
and getting old and not being able
to fight anymore
We will have to rise up and fight
anyway.[272]

The new Zapatista generations are receiving
the legacy of the word and the struggle of
their parents, people who fought in the war,
of their Zapatista great-grandparents, of their
ancestors who were crushed during history by a
colonial and racist power. We recall an old slave
song claimed by The Black Panthers connecting
the history of oppression with the struggle of
contemporary Black people:

We are soldiers of an army
We must fight, it does not matter to die.
We must raise the bloody flag
we must raise it to death.
My mother was a soldier.
She had in her hands with
which to plow freedom
and growing old and when
she couldn't fight anymore
she said she would fight anyway.

272 Translation of the
song from the book
Black Panther. The
Revolutionary Art
of Emory Douglas /
Pantera Negra, El
arte revolucionario
de Emory Douglas.
Rizzoli, 2007.

¡Claro! Definitivamente. Yo quiero seguir investigando sobre la lucha y la
historia de los pueblos zapatistas e incorporarlo en mi trabajo artístico. Espero
poder regresar pronto, y estoy seguro en que llevaré la palabra zapatista a
mis charlas.y exposiciones, y contaré a la gente sobre mi visita acá y la huella
profunda que me ha dejado. Lo que veo aquí en Chiapas es algo en desarrollo,
algo que esta creciendo paso a pasito en sus propios tiempos, pero son pasos
muy determinados. Lo que veo es un proceso que esta sucediendo aquí y
ahora.

Dentro de los planes del encuentro Zapantera Negra esta la producción de
una revista con el mismo nombre. Todavía no ha sido publicada, pero la idea del
colectivo de artistas alrededor del EDELO es lanzar la revista en cinco países,
que se pueda descargar y reproducir desde una página en internet. La revista
se desarrollará con la orientación de Emory y servirá como un homenaje en
vida a su trabajo.

Regresando a la banca chueca con Emory, una última pregunta. Él está ya un
poco inquieto, con ganas de tomar un pincel y unirse a las fuerzas muralistas.

¿Cómo ves la situación actual de EE. UU.? ¿Qué te
dicen los jóvenes que encuentras en tus charlas?

Actualmente tenemos una fuerte resistencia en EE. UU. por la crisis
económica. No sólo una crisis sino un colapso total del sistema económico.
Entonces hay mucha gente que les interesa desarrollar programas alterna-
tivos, como los programas que surgieron durante el tiempo del partido de los
Black Panthers [Panteras Negras]. Estos eran programas sociales que fueron
propuestas del partido y también implementados donde podíamos. Ahora hay
gente que quiere el regreso de estos programas, sin embargo, los tiempos en
que vivimos ahora son más complicados que aquellos tiempos.

La lucha Zapantera Negra

El programa y la plataforma de los Black Panthers [Panteras Negras] fue
lanzado en octubre de 1966: *Lo que queremos y lo que creémos*. Entre las
cosas que se exigían estaba libertad: libertad para poder determinar el destino
de su propia comunidad negra, incluyendo trabajo, viviendas dignas, y una
educación "que revele la verdadera naturaleza de esta sociedad decadente
(...), una educación que nos enseñe nuestra verdadera historia y nuestro papel

en la sociedad actual". En 1994 el Ejército Zapatista de Liberación Nacional (EZLN) salió de la selva armado y preparado para hacer de su palabra y su lucha las demandas de libertad, democracia, justicia, trabajo, techo, alimento tierra y educación. Reivindicando la lucha de sus antepasados y saliendo de una larga noche de 500 años.

La noche esta llegando a Morelia. Dentro del auditorio hay un par de focos iluminando para los muralistas pacientes. Emory está entre ellos naturalmente. El cafecito y los frijolitos se comparten en la neblina afuera de la cocina comunitaria de la escuelita. Subiendo otra vez al auditorio se escuchan los alumnos de la escuelita cantando:

> Escuchen a todos los gobiernos. Los que andan destruyendo el mundo: ya basta de tanta injusticia y que nos roban los pinches gobiernos, los pueblos ya estamos aburidos de tantas promesas sin cumplir hombres, niños, mujeres y ancianos:
> ya llegó el tiempo de despertar unidos nosotros lograremos a que el mundo tenga buen color si queremos que el mundo se cambie, sólo unidos podemos cambiar
> lucharemos en contra del mal
> ofreciendo nustra vida peleando y es por eso que decimos a todos hasta morir es necesario (...)

Las nuevas generaciones zapatistas recibiendo el legado de la palabra y la lucha de sus padres milicianos en la guerra, de sus bisabuelos zapatistas y de sus antepasados oprimidos durante la historia por un poder colonialista y racista. Recordamos una vieja canción de los esclavos reivindicada por Las Panteras Negras conectando la historia de la opresión con la lucha de la gente negra contemporánea:

> Somos soldados de un ejército debemos luchar, no importa morir. Debemos alzar la bandera ensangrentada debemos alzarla hasta morir. Mi madre era soldado. Tenía en sus manos con qué arar la libertad y al envejecer y no podía luchar más dijo que lucharía igual. Mi padre era soldado. Tenía en sus manos con qué arar la libertad y al envejecer y no podía luchar más dijo que lucharía igual. Ahora todos somos soldados tenemos en nuestras manos con más qué arar la libertad y al envejecer y no poder luchar más tendremos que alzarnos y luchar igual.[273]

Ingrid Fadnes and Emory Douglas

273 Canción traducida en el libro *Pantera Negra, El arte revolucionario de Emory Douglas*. Alias, 2012.

Irene Soria Guzmán

Probably Everybody. Notes Towards Technology for Situated Solidarity

333

Irene Soria Guzmán

Probablemente todxs: apuntes hacia una tecnología para la solidaridad situada

My body tells me that, over the past few months, I've spent more hours in front of my computer and more time on my mobile phone than ever before. In the lockdown enforced through the coronavirus pandemic in 2020, I discover how my social life has been reduced to discussions and clashes on social media and reactions to my publications; I stay connected via video calls that seem to go on forever, while new anxieties take shape. I read about death, tragedy, inequality, injustice. I feel over-whelmed. After that I read more pleasant news, about people sharing recipes, photos of their cakes, exercise routines, their children's work, the life of their plants. I later share my feel-ings – my fears and doubts in a country in the Global South[274] with widespread job insecu-rity – seeking solidarity. I think about how it all becomes vast data offering an ever-increasing amount of information on us as a species and our behaviour 'in captivity'.

I wonder whether there are sci-fi narratives that describe not only robots that take control of our will, or travelling in flying cars, but also life in confinement. If not, then the present offers more than enough input for new fictional accounts of a technological dystopia, where social inequality becomes ever broader and different forms of injustice replicate, spread and intensify.

If the future is already here, or at least a taster of what might be in store, can we glimpse solidarity amid this apparent dystopia?

Through cyberpunk, science fiction put forward acts of technological resistance with a Do-It-Yourself ethos and the figure of the hacker, calling on the need to know how everything works, in order to then 'break it' and create it again. In this sense, the piece *Probably Chelsea* – the work of biohacker artist Heather Dewey-Hagborg, in collaboration with activist, whis-tle-blower, former US Army intelligence analyst and trans woman Chelsea Manning – invites us to reflect on new forms of solidarity in the face of social inequality issues that spread via technology, whilst also advocating hacking into deep-seated notions of capitalist society.

One of the work's multiple 'hacks' is to cast doubt on what we know about and how we interpret data, which, understood and utilised to benefit the power that dominates and controls technology and its intended user, holds importance regarding the way in which it is gathered en masse, related and crossed over with other data. In the piece, the artist uses Manning's genetic data to create 30 different possible portraits of her. In this way, it shows how supposed biologically inscribed notions of identity are subject to interpretation and even obsolete. Hacking DNA in terms of the 'source code' of an iconic figure of our age, a key part of one of the biggest leaks of classified infor-mation of power, tells us: 'We are all Chelsea Manning'.

Mi cuerpo me dice que en los últimos meses, he pasado más horas frente a mi computadora y al pendiente de mi celular, como nunca antes en toda mi vida. En el confinamiento por la pandemia del coronavirus en el 2020, descubro que mi vida social se ha limitado a las discusiones y conflictos en redes sociales y a la cantidad de veces que alguien reacciona a mis publicaciones; vivo conec-tada a videollamadas que parecen interminables, a la par de que nuevas ansie-dades toman forma. Leo sobre muertes, tragedias, desigualdades, injusticias. Me abrumo. Después leo noticias amables, la gente comparte recetas, fotos de sus pasteles, sus rutinas de ejercicio, las labores de sus hijxs, la vida de sus plantas. Luego, comparto sentires; los miedos e incertidumbres en un país del sur global[289], con condiciones laborales precarias, se solidarizan. Pienso en cómo todo esto, se vuelve una inmensa cantidad de datos que ofrece cada vez más información de nosotros como especie y de nuestro comportamiento "en cautiverio".

Me pregunto si algún relato de ciencia ficción incluyó dentro de sus imag-inarios posibles, además de los robots que se apoderan de nuestra voluntad o donde viajamos en autos voladores, esta vida en el encierro. De no ser así, este tiempo presente ofrece una buena cantidad de insumos para nuevos y más precisos relatos ficcionales de distopía tecnológica, donde la desigualdad social se hace cada vez más amplia y las injusticias se replican, extienden y magnifican.

Si el futuro ya está aquí, o al menos una pequeña prueba de lo que podría llegar a ser, ¿vislumbramos solidaridad en esta aparente distopía?

Hackear desde el arte

289 Si bien, el tér-mino "sur global" me sirve para comunicar una idea "general" de condiciones similares en países de América Latina (Abya Yala), la India, o el sur de África, evidente-mente, cada uno tiene particularidades y es difícil de englobar en uno solo, sin embargo, me atrevo a usarlo para términos de expresión de una idea de "unión".

En el cyberpunk, la ciencia ficción propuso acciones de resistencia tecnológica con el *"do it yourself"* y con la figura *"hacker"* que apelan a la necesidad de conocer cómo funciona todo para luego "romperlo" y crearlo de nuevo.

Es precisamente la pieza "Probably Chelsea" -producto del trabajo de la artista bio-*hacker*, Heather Dewey-Hagborg, en colaboración con la activista, denunciante, ex analista de inteligencia del ejército de Estados Unidos y mujer trans, Chelsea Manning- la que nos invita a reflexionar nuevas solidaridades frente a una problemática de desigualdad social que se extiende a través de la tecnología, a la par que nos propone *"hackear"* nociones profundamente arraigadas en el contexto de la sociedad capitalista.

Furthermore, the work examines hate speech such as racism and transphobia, predicated on immovable notions of race or gender inherited from the exercise of power in nineteenth-century science. The markedly biased human 'classifications' it formulated unfortunately remain with us centuries on. *Probably Chelsea* expounds the inaccuracies and bias involved in DNA phenotyping, criticises notions of science and technology – both the epitome of the unquestionable – and prompts the recognition that there are no certainties, that both science and technology, beyond being inaccurate, have ended up being deeply reductive.[275]

In this 'dystopian reality', the hacker, with origins dating back to the 1960s, regains relevance as a figure of technological dissidence. The hacker that emerged with the then nascent computer set forth a ludic, ingenious, creative, tenacious and transgressive vision for problem-solving. Different studies and genealogies of hackers[276] all recognise them as aficionados embracing challenges, with a liking for exploring the limits of possibility and, more recently, as figures opposing technological subjugation. Their ideology straddles the right to information and anonymity, the freedom of access to a programmer's source code,[277] affinity with the free software movement and freedom of knowledge.

One of the most valid proposals offered by hacker culture is the importance of knowing how things work and using it to open cracks in the system, just as Dewey-Hagborg has

274 Although the term 'Global South' is useful to get the idea across of 'general' conditions shared in countries in Latin America (Abya Yala), India and Southern Africa, clearly each has its own characteristics and is not easily grouped into one whole. That being said, I venture to use it as a term to express an idea of 'union'.

275 In the words of the artist: 'It's not so much that the technology is inaccurate, it's that it is reductive'. Heather Dewey-Hagborg, 'Sci-fi, Crime Drama with a Strong Black Lead', https://thenewinquiry.com/sci-fi-crime-drama-with-a-strong-black-lead

276 Gabriela Coleman, Pekka Himanem, Eric Raymond, Steven Levy. In Mexico: Miguel Ángel Lozano Chairez, Guiomar Rovira, Gunnar Wolf, and Jorge Lizama, among others.

277 The source code is a series of lines of text that work as instructions that a computer must follow to execute a programme and, therefore, carry out certain actions. As a result, the source code in software fully describes its operation and is written in programming language. The philosopher Pekka Himanen defines it as the 'DNA of software, its form in language used by those who programme it. Without the source code, a person can use the programme but cannot develop it in new directions, or study it'.

Uno de los múltiples *"hacks"* de esta obra, es poner en entre dicho lo que sabemos de los "datos" y su interpretación, los cuáles, han sido entendidos y usados en beneficio del poder que domina y controla la técnica y para quienes éstos, son importantes en la medida en la que son recolectados en masa, se relacionan y cruzan con otros. En esta pieza, la artista usa datos genéticos de una sola persona, para probar cómo es que estas supuestas nociones de identidad inscritas biológicamente, están sujetas a interpretación, al tiempo que se prueban obsoletas. El *"hackeo"* al ADN en tanto "código fuente" de una figura icónica de nuestra era, quien fuera pieza clave para una de las más grandes filtraciones de información clasificada del poder, nos dice: "todxs somos Chelsea Manning".

Así mismo, esta pieza interpela los discursos de odio como el racismo y la transfobia, que se fundamentan en nociones inamovibles de raza o género, herencia de un ejercicio de poder de la ciencia del siglo XIX que hacía "clasificaciones" humanas con amplios sesgos, y que por desgracia, parecen seguir entre nosotras siglos después. "Probably Chelsea", expone la inexactitud y sesgos involucrados en el fenotipado del ADN, critica las nociones de ciencia y tecnología, -epítomes de lo incuestionable- e invita a reconocer que no existen las certezas, que tanto la ciencia como la tecnología, mas que ser inexactas, han resultado ser profundamente *reduccionistas*[290]

En esta posible "realidad distópica", la cultura *"hacker"*, que encuentra su origen en la década de los *60s*, vuelve a tomar relevancia en tanto figura de disidencia tecnológica. La persona "hacker" que emerge con el entonces naciente cómputo, propone una visión lúdica, ingeniosa, creativa, tenaz y transgresora para resolver problemas. Diversos estudios y genealogías de lo *hacker*[291], coinciden con la idea de reconocerles como entusiastas que se enfrentan a retos, que gustan de la exploración de los límites de lo posible, y que a últimas fechas, han sido personajes disidentes que se oponen al sometimiento tecnológico. Su ideología cruza con el derecho a la información y al anonimato, la libertad de acceso al código fuente[292] de programación, la afinidad con el movimiento de *software* libre, y libertad de conocimiento.

Una de las propuestas más valiosas que nos ofrece la cultura *hacker,* es la importancia de saber cómo funcionan las cosas y encontrar en ello, las posibilidades para fisurar el sistema. Así como lo hace Dewey-Hagborg, al indagar y conocer el funcionamiento del ADN; como lo hizo Chelsea Manning al interior del duro núcleo de la milicia estadounidense; así como las personas trans y no binarias cuestionan la imposición violenta del género, las mujeres negras

290 En las propias palabras de la artista "no es tanto que la tecnología sea *inexacta*, es que es *reductiva*" dentro de su texto: "Sci-fi, crime, drama with a strong black lead". Disponible en: https://thenewinquiry.com/sci-fi-crime-drama-with-a-strong-black-lead.

291 Consultar a: Gabriela Coleman, Pekka Himanem, Eric Raymond, Steven Levy. En México: Miguel Ángel Lozano Chairez, Guiomar Rovira, Gunnar Wolf, Jorge Lizama, entre otros.

292 El código fuente es un conjunto de líneas de texto que son las instrucciones que debe seguir la computadora para ejecutar un programa, y por lo tanto, realizar ciertas acciones. Por tanto, en el código fuente de un *software* está descrito por completo su funcionamiento y está escrito en algún lenguaje de programación. El filósofo Pekka Himanen lo define como "el ADN de un *software*, su forma en el lenguaje utilizado por quienes lo programan; sin el código fuente, una persona puede utilizar un programa, pero no puede desarrollarlo en nuevas direcciones", ni estudiarlo.

Irene Soria Guzmán

4. Situatedness

Tener una guerra en la lengua. (A war on the tongue),
Angela Juana Rivera, 2020. CC BY 4.0.

done in investigating and gaining knowledge of how DNA behaves; or Chelsea Manning did inside the unyielding nucleus of US warfare; or trans and non-binary people do in questioning the violent imposition of gender; or Black and Indigenous women do in questioning the idea of race; or bodies with disabilities do in questioning ideas of capacitism; or art and poetry do in challenging our reality, enabling us to imagine other possible worlds.

With hacker culture as a point of departure, will it be possible to imagine other technologies not aligned to power and which reflect politics of solidarity for oppressed groups? Is 'hacking everything' really possible in the search for new strategies to build more ethical and inclusive systems?

The spark that brought the flame

Cyberpunk also foresaw the idea of 'cyberspace' and with it the possibility of control in a more accurate and distinguishable way by those in power. The mounting need for hyper-connectivity in our life in captivity has enabled us to (re)recognise the internet as a space that, to be inhabited, requires the payment of 'technology rent',[278] covered by the data obtained from our habits. To this effect, an account is required by some companies offering internet services — as I write this, I wonder whether I still know anyone who doesn't have a Google or Facebook account.

278 In the words of Latin American philosopher, Bolivar Echeverría: 'If we call rental of land the money the landowner receives for use of their land, then we can also call technological rent the money the technology owner receives for use of "their" technology.' In 'Technological Rent and Historical Capitalism', *Mundo siglo XXI*, number 2 (2005) 17.

Irene Soria Guzmán

4. Situatedness

e indígenas han cuestionado la idea de raza, o los cuerpos con discapacidad cuestionan las ideas capacitistas; y así como el arte y la poesía lo hacen con nuestra realidad permitiéndonos imaginar otros mundos posibles.

A partir de la cultura hacker, ¿será posible imaginar otras tecnologías que no estén alineadas al poder y que reflejen la política de solidaridad de los grupos oprimidos?, ¿es posible *"hackeralo* todo" en la búsqueda de nuevas estrategias para construir sistemas más éticos e inclusivos?

La chispa que enciende la flama

El *cyberpunk*, también vislumbró la idea del "ciberespacio", y con ello la posibilidad de control de manera más precisa y diferenciada por parte de quienes están en el poder. La creciente necesidad de hiper-conectividad de nuestra vida en "cautiverio" nos ha permitido (re) conocer a Internet como este espacio que para ser habitado, requiere del pago de una "renta tecnológica"[293], la cual se cubre con los datos obtenidos a partir de nuestros hábitos. Para ello, es necesario invariablemente tener una cuenta en alguna de las empresas que ofrecen servicios de Internet. Justamente, mientras escribo esto, me pregunto si aún conozco a alguien que no tenga una cuenta de Google o Facebook.

Aunado a esto, tenemos aún mas certezas de la cantidad de información que los gobiernos y empresas pueden tener de la población, gracias a personas que antepusieron el bien común frente a sus propios intereses y con ello, encendieron la llama de la esperanza en esta posible distopía. Chelsea Manning, quien filtrara miles de documentos clasificados de la milicia norteamericana, a costa de su vida en libertad y paz mental; o Edward Snowden, ex contratista de la NSA, quien tuvo que huir de su país, son las chispas disidentes que posibilitan el *"exploit"* del sistema. Por sus filtraciones, hoy sabemos que tanto los poderes privados como los Estados, se vinculan para realizar una vigilancia sistemática de ciertas poblaciones, situaciones que algunos *hackers* del MIT de los *60s* vislumbraron y temieron.

Como es de esperarse, en un "ciberespacio" que replica los poderes y desigualdades del mundo físico, algunos grupos sociales se verán más afectados que otros. La búsqueda de nuevas estrategias para construir sistemas más éticos e inclusivos, así como imaginar y soñar "otras" tecnologías posibles, resulta absolutamente vital si pensamos en Internet como un territorio en disputa[294].

293 En palabras del filósofo latinoamericano Bolivar Echeverría:"si llamamos renta de la tierra al dinero que el terrateniente recibe por el uso de su tierra, podemos llamar también renta tecnológica al dinero que el propietario tecnológico recibe por el uso de "su" tecnología".
294 Internet como "territorio en disputa" es una propuesta de autores desde el Sur que lo conectan con la defensa de la tierra y del territorio de la explotación capitalista de las grandes empresas. *Esta premisa es explorada en la investigación del Dr. Domingo Manuel Lechón Gómez y en las prácticas de organizaciones civiles como Sursiendo, en San Cristóbal de las Casas, Chiapas, México.*

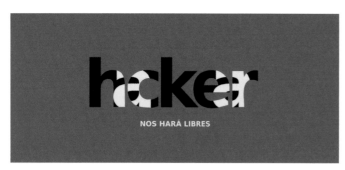

Hackear nos hará libres. (To hack will set us free),
Irene Soria Guzmán, 2017. CC BY 4.0.

In addition, there is increasingly more evidence of the potential amount of information that governments and companies have on the population, and that evidence is down to those who put the common good before their own interests and, therefore, lit a flame of hope in this possible dystopia. Manning, who leaked thousands of classified US military documents at the expense of her freedom and peace of mind, and Edward Snowden, a former NSA contractor who had to flee from his country, are the dissident sparks that enable the system to be exploited. Their leaks mean that today we know that private powers and states are linked in order to carry out systematic surveillance on certain populations, circumstances envisgaged and feared by some hackers at MIT in the 1960s.

As expected, in a cyberspace that replicates the physical world's powers and inequalities, some social groups are more affected than others, and the search for new strategies to build more ethical and inclusive systems, to imagine and dream of 'other' possible technologies, is vital if we are to think of the internet as disputed territory.[279] Framed in this context, perhaps it is worth asking: who makes the technology — and how exactly does it work — that enters our lives and bodies and knows our emotions? How does it affect new possibilities of solidarity?

295 *Software as a service* es un modelo de distribución de programas de cómputo al que se accede mediante suscripción y donde los datos se alojan de forma centralizada en servidores de una compañía a los que se accede vía Internet. La empresa se ocupa del servicio de mantenimiento, de la operación diaria y del soporte del *software*, que puede ser consultado en cualquier computadora. En la práctica, un "SaaS" es un programa que ofrece diversos servicios, muchos de ellos aparentemente gratis; por ejemplo, Google ofrece el servicio de almacenamiento de documentos, o el de mapas de diversas ciudades; Facebook ofrece el servicio de una red social digital donde se puede intercambiar mensajes, comentar publicaciones o enviar mensajes privados. Whatsapp, es un servicio de mensajería instantánea, etcétera. La condición para acceder a estos servicios, suele ser tener una cuenta y la aceptación de términos y condiciones, que incluye el permiso de uso, correlación y almacenamiento de los datos de la persona usuaria.

En este contexto, quizá vale la pena preguntarnos ¿quién hace y cómo funciona exactamente esa tecnología que entra a nuestras vidas, a nuestros cuerpos y que conoce nuestras emociones? ¿cómo afecta a las nuevas posibilidades de solidaridad?

Lo que hay que *hackear*

Las cinco grandes empresas que tienen el monopolio del poder tecnológico, y que son conocidas como GAFAM (Google, Apple, Facebook, Amazon y Microsoft) controlan gran parte del "ciberespacio" y tienen en común que su tecnología propia, gran parte del corazón de su funcionamiento y formas de control, se lleva a cabo a través de *software,* particularmente del llamado *Software as a Service* (SaaS)[295], que sirve de mediación entre los procesos que "corren detrás" de las tecnologías de la información, y la forma en que interactuamos con nuestros -hoy imprescindibles- equipos de cómputo.

Dicho de otro modo, si bien la comunicación con nuestros equipos tecnológicos es eficaz, fácil, cómoda e inmediata, ésta también nos oculta los procesos que ocurren detrás, lo cual vuelve estos mecanismos desconocidos y lejanos al entendimiento de las y los usuarios finales. Este proceso en tanto ejecución de *software*, tiene como característica, que su código fuente de programación está oculto, es decir, que los pasos a seguir en su complejo funcionamiento, son un "secreto industrial" que responde a la lógica capitalista de "propiedad intelectual", lo cual impide verlo, estudiarlo y modificarlo; así mismo, imposibilita saber qué es lo que hace exactamente la parte "lógica" de nuestros aparatos; se oculta una técnica, un "saber-hacer", y por lo tanto una forma de conocimiento. Lo que está escrito en el código fuente de programación se vuelve en la "ley"[296] del *software,* los aparatos que lo ejecutan, y por supuesto del ciberespacio que habitamos.

La decisión de estas empresas de cerrar el código fuente, y con ello impedir que las personas usuarias conozcan la forma en la que está hecha la tecnología que usa sus datos, su intimidad y su vida como insumo, es una forma de ejercer control y poder. De tal suerte que, decidir cerrar y ocultar el código, es una decisión política, y las empresas deben asumirla.

El ocultamiento de este código fuente de programación, ha llevado a algunas personas a hablar de "cajas negras" que impiden ver su funcionamiento. Por ejemplo, la propia Heather Dewey-Hagborg dice que: "tendemos a ver los sistemas técnicos como cajas negras neutrales, pero si los abres y miras

279 The internet as 'disputed territory' is a proposal by authors from the South who connect it with the defence of land and the capitalist exploitation of large companies. This premise is explored in the research conducted by *Dr Domingo Manuel Lechón Gómez and in the practices of civil organisations such as Sursiendo, in San Cristóbal de las Casas, Chiapas, Mexico.*280 Software as a Service is a distribution model for computer programmes and accessed by subscription, whereby data is stored in a centralised system in the servers of a company and accessed via internet. The company takes charge of maintenance, daily operation and software support, which can be checked on any computer. In practice, SaaS is a programme offering different services, many of which are ostensibly free; for instance, Google offers a document-storage system and maps of different cities; Facebook the service of a digital social network where you can exchange

messages, comment on publications or send private messages; WhatsApp is an instant messaging service, and so on and so forth. The condition for accessing these services usually involves setting up an account and accepting the terms and conditions, which include permission to use, correlate and store users' data.
281 'Code is law', as Lawrence Lessig asserts in his book *Code: And Other Laws of Cyberspace, Version 2.0,* (New York: Basic Books, 2009).

The five biggest companies with a monopoly on technological power, known as GAFAM (Google, Apple, Facebook, Amazon and Microsoft), control a large part of cyberspace and all share the fact that their own technology, largely at the heart of their operations and forms of control, is software-based, particularly the so-called Software as a Service (SaaS),[280] which serves to mediate between processes that 'run behind' information technology and the way in which we interact with our – now indispensable – computers.

To put it another way, although communication with our technological equipment is efficient, easy, comfortable and immediate, it hides the process behind it, making these mechanisms unknown and cut off from the understanding of the final users. This process in terms of software execution is characterised by the programming source being hidden; namely, the steps to follow in its complex operation are an 'industrial secret' responding to the capitalist logic of 'intellectual property', which in turn obstructs it from being seen, studied and modified, and also makes it impossible to know what exactly the 'logic' part of our devices does. Technology, 'know-how' and, therefore, a form of knowledge, is hidden. What is written in a programme's source code becomes the 'law'[281] of software, the devices that execute it and, needless to say, the cyberspace we inhabit.

los componentes, verás que reflejan las suposiciones y motivaciones de sus diseñadores"[297], en este sentido, el código refleja posiciones políticas de quien lo genera.

Por otro lado, una de las tantas reflexiones que nos han ofrecido las teorías feministas, que a su vez, han *"hackeado"* mucho de lo que creemos del funcionamiento del mundo, es que las tecnologías -y la ciencia- no son "neutras" y que responden a los intereses de las empresas que las proveen, particularmente, intereses apegados a la economía capitalista, individualista y de consumo. Así mismo, las decisiones detrás de ella, están encabezadas por individuos específicos con una visión particular de la tecnología, con experiencias y formas de ver el mundo. Nombrarlos ayuda a reconocer que esta "falsa neutralidad" en realidad es la visión de hombres blancos, heterosexuales, cisgénero[298], del norte global.

Quizá una manera de relacionar la caja oculta que hoy es el *software,* con las personas que han tomado la decisión de "cerrarlo", nos permita llamarles de manera más acertada: "cajas blancas" en lugar de cajas negras, y con ello, dar una idea más precisa de que se trata de decisiones políticas de los hombres blancos que deciden expresamente cerrar el código fuente.

Hakeando de otro modo

Chelsea Manning es una de las chispas que encienden el fuego de la disidencia, no sólo por las miles de filtraciones de documentos diplomáticos de uno de los países mas poderosos del mundo, sino por la lucha personal que ha representado su transición de género en un mundo transfóbico y hostil. Muchas de las resistencias frente a los esquemas que replican ideas hegemónicas de dominación, tienen su origen en los sentires y pensares de cuerpos disidentes, de grupos en la marginalidad, de poblaciones del sur global y/o de personas en condiciones de subalternidad, ya que son los mayormente afectados por las imposiciones que no les representan. Conocer, escuchar y empatizar con estas experiencias, podrían darnos algunas claves para imaginar tecnologías más inclusivas, éticas y solidarias.

Uno de los instrumentos de análisis en tanto lucha contemporánea que ha servido para (re) conocer experiencias en un mundo desigual, ha sido el feminismo. Las diversas teorías feministas nos han expuesto el origen del sistema patriarcal que nos oprime en tanto mujeres, y como mencioné anteriormente, nos han ofrecido herramientas de análisis para *"hackearlo".* Sin embargo,

296 Como diría Lawrence Lessig: "El código es ley", en su libro: Code 2.0.
297 *"Sci-fi, crime, drama with a strong black lead",* disponible en: https://thenewinquiry.com/sci-fi-crime-drama-with-a-strong-black-lead
298 Personas cuya identidad de género coincide con su fenotipo sexual

The decision made by these companies to close the source code and, therefore, hamper users' knowledge of how this technology utilises their data, privacy and life as input is a way to exercise control and power, so that deciding to close and hide the code is a political decision and one that companies must assume. Concealing a programme's source code has led some to talk of 'black boxes', which cloud a view of its operation. For instance, Dewey-Hagborg asserts: 'We tend to look at technical systems as neutral black boxes, but if you open them up and look at the component parts, you find that they reflect the assumptions and motivations of their designers.'[282] Thus, the code reflects the political position of whoever creates it.

By comparison, one of the many reflections set out by feminist theories, which in turn have 'hacked' much of what we believe in the workings of the world, is that technology – and science – is not 'neutral' and lies in the interests of the companies providing it, specifically interests tied to economic capitalism, individualism and consumerism. Furthermore, the decisions behind it are headed by specific individuals with a particular vision of technology, and with experience and ways of seeing the world. Naming them helps to recognise that this 'false neutrality' is really the view of white, heterosexual, cisgender males[283] from the Global North.

Perhaps a way to relate the hidden box – nowadays software – to the people who have made the decision to close it is to call it a 'white box', instead of black, and, consequently, offer a more precise idea of the exact nature of the political decisions of white men who decide to close the source code.

Hacking another way

Manning is one of the sparks that lights the fire of dissidence, not only on account of the thousands of diplomatic document leaks in one of the most powerful countries on the planet, but also the personal struggle represented by her gender transition in a world marked by transphobia and hostility. Much resistance to blueprints that replicate hegemonic ideas of domination stems from the feelings and thoughts of dissident bodies, groups on the margins, populations from the Global South and/or people in situations of subjugation, because they are those most affected by the impositions that fail to represent them. Being aware of, listening to and empathising with these experiences can offer us some keys to imagining more inclusive, ethical and solidary technology.

One of the instruments of analysis in the contemporary struggle that has contributed to recognising experiences in an unequal world has been feminism. The different feminist theories have exposed the origin of the patriarchal system that oppresses women and, as I touched upon above, have offered us different tools of analysis to 'hack' it. Yet some

algunos feminismos como el liberal, han conformado un propio sistema hegemónico, donde ciertas realidades son difícilmente reconocibles y donde han sido omitidas ciertas experiencias de racialización, migración o de grupos etarios.

Es por ello que mujeres negras, mujeres de color y mujeres indígenas se unieron para visibilizar a esas "otras" mujeres a expensas de sus propios contextos individuales. Sus historias, contextos y experiencias han sido difíciles de reconocer y de entender para las mujeres blancas. Hablar de la alianza entre las mujeres negras, de color, y en general de "todas las que no son blancas"[299], es reconocer que no hay una sola opresión, sino que vivimos en una "matriz de opresiones"; además de cuestionar fuertemente al feminismo blanco y liberal que no incluye las realidades de muchas mujeres del margen. Esto nos permite pensar en las múltiples violencias que sufren las personas transgénero y no binaras, ya que, la diferencia entre sexos no reside en si se tiene o no pene, sino en si se forma parte o no de la economía fálica masculina[300].

Es por ello que mujeres negras, trans, indigenas y de color, deben ser centrales en la lucha feminista para un movimiento verdaderamente liberador y solidario. Luego entonces, una nueva visión de la tecnología tendría que venir cargada de esta perspectiva, engranar desde la solidaridad de las bases, reconocer estas múltiples opresiones, mirar y analizar de manera crítica, de "abajo hacia arriba".

Hacia una solidaridad situada

Nuestra posible realidad distópica nos obliga a pensar nuevas vertientes de la palabra que da eje a esta exposición: la solidaridad. Una "nueva" solidaridad, tendría un conocimiento mas "diferenciado" que permita empatizar con realidades que no necesariamente viviremos en carne propia. La interseccionalidad, el feminismo decolonial, el feminismo negro, el feminismo de la frontera o los transfeminismos, nos ayudan a visibilizar múltiples alianzas, a pesar de las distancias y las diferencias, de la misma manera en que las personas del todo el mundo lo hicieron con Chelsea, incluso sin siquiera conocerla.

Chela Sandoval explica esto un poco mejor con la "afinidad-a-través-de-la-diferencia" con la que teje una posible "metodología de los oprimidos", la cual nos permite ver especificidades "como una oportunidad para el cuidado afectuoso para aprender cómo ver fielmente desde el punto de vista del otro"[301]. Dicho de otro modo, de existir una nueva solidaridad, ésta no sería

299 Tal como lo dice Maria Lugones, pensadora feminista decolonial.

feminisms, such as liberal feminism, have become part of a hegemonic system where certain realities are hard to recognise and where certain experiences of racialisation, migration and age groups have been omitted. This is the reason why Black women, women of colour and Indigenous women united to grant visibility to these 'other' women at the expense of their own individual contexts; their histories and experiences have not been easy for white women to recognise or understand. To speak of the alliance between Black women, women of colour and, in general, 'all those that are non-white'[284] is to acknowledge that there is not one sole oppression, and that we live in a 'matrix of oppressions', roundly questioning the white and liberal feminism that does not include the realities of many marginalised women. This enables us to think about the multiple forms of violence endured by transgender and non-binary people, for the difference between the sexes does not lie in having a penis or not, but whether one is part of a phallic masculine economy.[285]

This is why Black women, trans women, Indigenous women and women of colour must be at the centre of the feminist struggle for a truly liberating and solidary movement, after which a new view of technology would have to arrive fully charged with this perspective, engaging from the solidarity of the foundations, recognising these multiple oppressions and critically looking from the 'bottom up'.

282 'Sci-fi Crime Drama with a Strong Black Lead', https://thenewinquiry.com/sci-fi-crime-drama-with-a-strong-black-lead.

283 People whose gender identity matches their sexual phenotype. 284 In the words of Maria Lugones, a decolonial feminist thinker in her text: 'Towards a decolonial feminism', in *Hypatia* vol 25, No. 4 (Fall, 2010) 111. https://hum.unne.edu.ar/generoysex/seminario1/s1_18.pdf accessed 26 April, 2021.

285 Just as bell hooks sets out in her text: 'Black Women, Shaping Feminist Theory' in: *Other inappropriate, feminism from the borders*, ed. Traficantes de sueños (Madrid: Traficantes de sueños, 2004), 40.

300 Tal como lo dice bell hooks, en su texto: "Mujeres negras, dar forma a la teoría feminista".

301 Chela Sandoval citando a Haraway para tejer la "metodología de los oprimidos" en su texto "Nuevas ciencias. Feminismo Cyborg, y metodología de los oprimidos.

302 Esto es parte de una conversación que tuve con la Dra Gabriela Gonzalez Ortuño mientras escribía este texto. Hablábamos de nuestras experiencias como mujeres nacidas en colonias populares periféricas de la Ciudad de México y cómo eso ha marcado nuestras vidas académicas.

303 Aura Cumes en su texto: "La presencia subalterna en la investigación social: reflexiones a partir de una experiencia de trabajo", en: *Conocimientos y prácticas políticas: reflexiones desde nuestras prácticas de conocimiento situado*. Chiapas, Ciudad de México, Ciudad de Guatemala y Lima. CIESAS, UNICACH, PDTG-UNMSM, 2011.

"unitaria" ni totalitaria sino que buscaría la afinidad a través de la diferencia, una solidaridad de diferencias. En ese sentido, propongo la búsqueda de una solidaridad situada en tanto experiencias de los grupos oprimidos, y subrayar el hecho de la importancia de su enunciación.

La solidaridad situada retomaría los actos de resistencia para reconocer el conocimiento que se adquiere desde la experiencia, en la práctica y en los saberes, pues las vidas trans, no binarias, con discapacidad, negras, latinas, e indígenas, suponen un nodo de conocimientos y experiencias que pocas personas dentro de los grupos en el poder hegemónico podrían experimentar, su propia existencia es el *"hack"* del sistema. Es gracias a esas experiencias que podríamos tejer otras formas de entender al mundo, quizá mas solidarias e incluyentes. De ahí que la tecnología en tanto discurso de la técnica y el "saber-hacer" sea en clave interseccional, decolonial y *hacker*.

En esta línea, habría también que cuestionar la palabra "solidaridad" enunciada nuevamente desde una posición de privilegio. Desde mi contexto en el sur global, como mujer latina, nacida en un barrio popular de la periferia de la Ciudad de México, este concepto se entiende mejor como "la lucha", pues expresa con mayor claridad la unión en tanto metas afines de diversos miembros de la sociedad por el bien común. Entender y vivir "la lucha", sería el vehículo para retomar la experiencia de las bases, lo cotidiano, de prácticas que poco o nada son relacionadas con el poder. Estos cuerpos oprimidos y conscientes, que conocen la importancia del la enunciación porque, hay violencias pero también hay solidaridad que nos atraviesa[302] ... y eso, la gente de la "caja blanca", no alcanza a ver.

Probablemente todxs

Aura Cumes propone aprovechar la "desventaja" de la marginalidad para imaginar formas que desafíen los poderes en sus múltiples dimensiones[303]. Las experiencias "al margen" permiten una perspectiva para criticar la hegemonía racista, clasista, capacitista y sexista, y con ello, crear una contra hegemonía que sea poco esperada por los grupos con poder. En este sentido, la importancia de la enunciación de cuerpos subalternos, oprimidos o en desventaja, radica en la comprensión de que las construcciones sociales que nos oprimen, son impuestas y modificables. Entender cómo funcionan estas jerarquías sociales y estructuras de poder, es entender cómo funciona el mundo y el primer paso para "hackear" el sistema.

Our dystopian reality forces us to think of new strands of the word around which this reader revolves: solidarity. A new solidarity would have more differentiated knowledge, opening the way to empathise with realities through which we will not necessarily live in the flesh. Intersectionality, decolonial feminism, black feminism, cross-border feminism and transfeminisms help us to envisage multiple alliances, despite distance and difference, in a similar fashion to the way people from all over the world did so with Manning, without even knowing her.

Chela Sandoval explains this a little better with the term 'affinity through difference', which she uses to weave a possible 'methodology of the oppressed', allowing us to see the specifics 'as a chance for emotional care to learn how to see faithfully from the point of view of the other'.[286] In other words, the existence of a new form of solidarity would be neither 'unitary' nor totalitarian, but would instead seek affinity through difference, a solidarity of differences. In this respect, I propose the search for a situated solidarity that is concerned with experiences of oppressed groups and stresses the importance of its articulation.

Situated solidarity would come back to acts of resistance so as to recognise knowledge gained from experience, in practice and in know-how, because the lives of trans and non-binary people, people with disabilities, and Black, Latin and Indigenous people signify a confluence of knowledge and experiences that few inside hegemonic power groups could perceive. Their very existence is to 'hack' the system. It is because of these experiences that we can interweave other ways of understanding the world that are perhaps more solidary and inclusive. Thus, technology concerning the discourse of technology and 'know-how' will be in an intersectional, decolonial hacker code.

In this vein, the word 'solidarity', articulated from a privileged position, would also have to come under scrutiny. From my own context in the Global South, as a Latin woman born in a working-class neighbourhood on the outskirts of Mexico City, this concept is better understood as 'the struggle', since it expresses with greater clarity a union in terms of the targets of different members of society for the common good. Understanding and living 'the struggle' would be the vehicle for returning to experience the foundations, the everyday, practices bearing little or no relation to power. These oppressed and mindful bodies know the importance of this articulation because, yes, there is violence but there is also solidarity running through us,[287] and that is what people from the 'white box' fail to see.

Es por ello que la propuesta sea convertirnos en un "nuevo código" (*new source*) de fuente abierta, como el ADN de Chelsea y sus múltiples posibilidades; ser comunidad para romper la "caja blanca" cerrada, el control del *software* y los datos, y vislumbrar una salida de esta "distopía tecnológica", donde los avances no sean una repetición de los ejercicios de poder y jerarquías impuestas. Debemos mirar hacia un horizonte de mayor apertura y participación colectiva, que incluya múltiples voces, tal y como sugiere Dewey-Hagborg en su obra. Probablemente todxs ayudemos a tejer una solidaridad situada, basada en el conocimiento que surge a partir de la experiencia y la transgresión de las normas capitalistas, patriarcales y de género.

Pensemos por último que leer este texto desde una latitud del norte global no significa solo darse cuenta de que hay "otrxs" en condición de opresión o subalternidad, y que no es una realidad lejana. Sin bien hemos dicho ya que las opresiones no son homogéneas y que existe una matriz de diferencias, recordemos que la opresión es entendida como la ausencia de elecciones, ¿qué pasaría si las tecnologías de la posible distopía, nos quitaran completamente la posibilidad de elegir, como lo están haciendo ya, poco a poco y casi sin darnos cuenta? frente a ese ese escenario, la lucha presente y futura, es y será de todas, todes y todos.

Probably everybody

Aura Cumes suggests utilising the 'disadvantage' of marginalisation to imagine forms that defy powers in their myriad dimensions.[288] Experiences 'on the outside' open up a perspective to criticise racist, classist, capacitist and sexist hegemony and, therefore, to create a counter hegemony that would almost capture groups of power unawares. Therefore, the importance of articulating bodies that are subjugated, oppressed or disadvantaged rests on an understanding that the social constructs that oppress us are imposed and can be altered. Understanding how these social hierarchies and power structures work means to understand how the world works and is the first step to 'hacking' the system.

Thus, the proposal is for us to become a 'new code', a new open source, similar to Manning's DNA and her multiple possibilities; to be a community so that we can break open the closed 'white box' and the control of software and data in order to glimpse a way out of this technological dystopia, where advances are not repeated exercises of power and imposed hierarchies. We must look towards a new horizon with a broader opening and collective participation that includes multiple voices, just as Dewey-Hagborg suggests in her work. Probably everybody can help to weave a knowledge-based situated solidarity that stems from experience and the transgression of capitalist, patriarchal and gender-based norms.

Finally, let us consider that reading this text from coordinates in the Global North is not simply to realise that there are 'others' in situations of oppression and subordination, that it is not a distant reality. While we have already pointed out that oppressions are not homogenous and exist in a matrix of differences, we also reiterate that oppression is understood as an absence of choice. What would happen if the technology in this possible dystopia completely removed our capacity to choose? This is in fact happening, gradually, right under our noses. In the face of this scenario, the present and future struggle belongs and will belong to each and every one of us.

286 Chela Sandoval quoting Donna Haraway to thread together a 'methodology of the oppressed' in her text 'New Sciences. Cyborg Feminism and Methodology of the Oppressed', in ibid., 94.
287 This is part of a conversation I had with Dr Gabriela Gonzalez Ortuño while I was writing this text. We spoke about our experiences as women born in working-class areas on the outskirts of Mexico City and how it has shaped our academic lives.
288 Aura Cumes in her text: 'The Subordinate Presence of Social Research: Reflections from an Experience of Work', in *Knowledge and Political Practices: Reflections from Our Practices of Situated Knowledge* (Chiapas, Mexico City, Guatemala City and Lima: CIESAS, UNICACH, PDTG–UNMSM, 2011).

Irene Soria Guzmán

4. Situatedness

Heather Dewey-Hagborg and Chelsea Manning, illustrated by Shoili Kanungo

Suppressed Images (2017)

Heather Dewey-Hagborg and Chelsea Manning, illustrated by Shoili Kanungo

In 2015, Chelsea Manning and artist Heather Dewey-Hagborg collaborated on an artwork titled *Radical Love*. In this work, Dewey-Hagborg created portraits of Manning based on DNA extracted from her hair clippings and cheek swabs.

Suppressed Images is a graphic short story illustrating how this collaboration took place and imagining what future might unfold.

This story was published the morning before Chelsea's commutation was announced, and the future they envisioned finally came true with her release on 17 May, 2017.

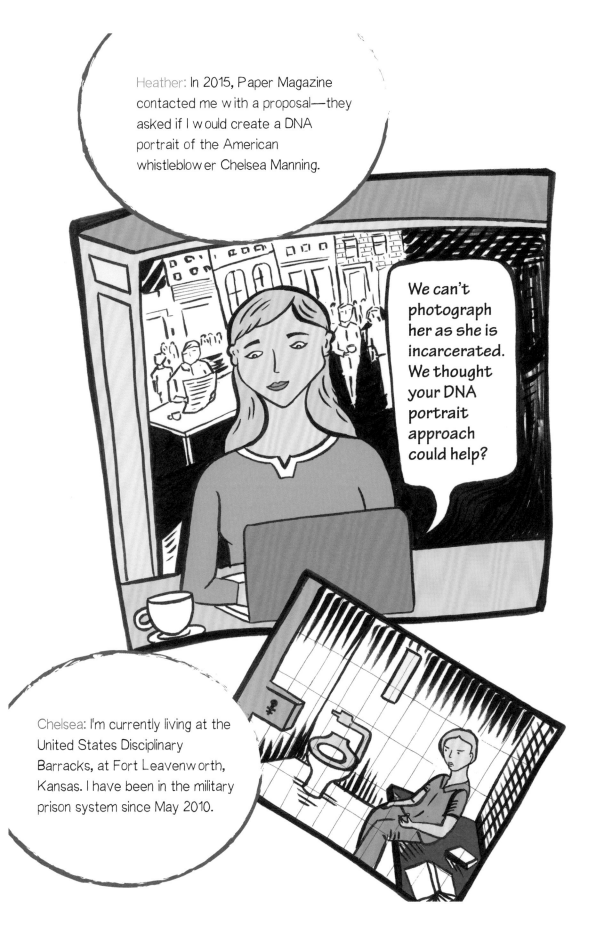

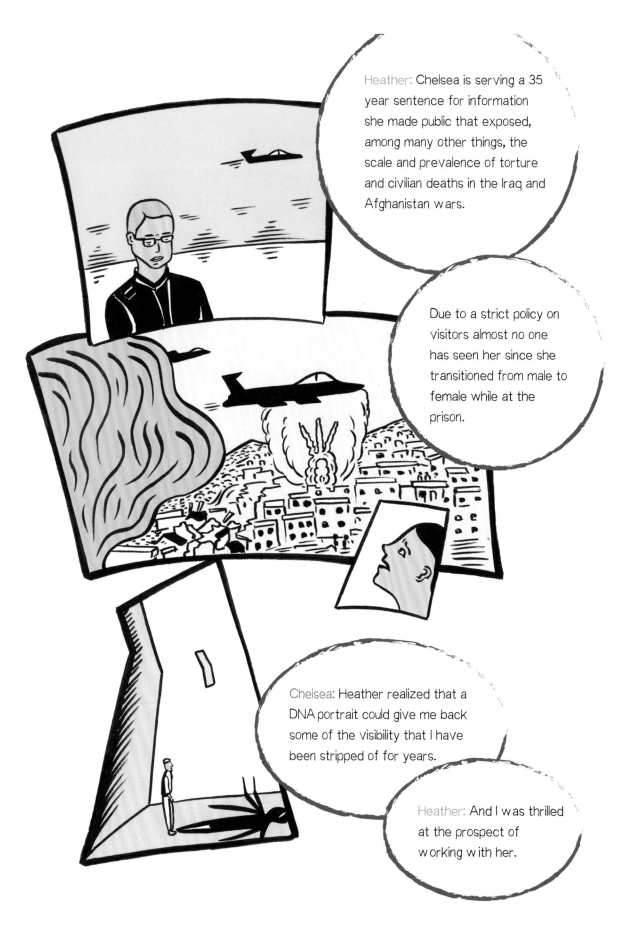

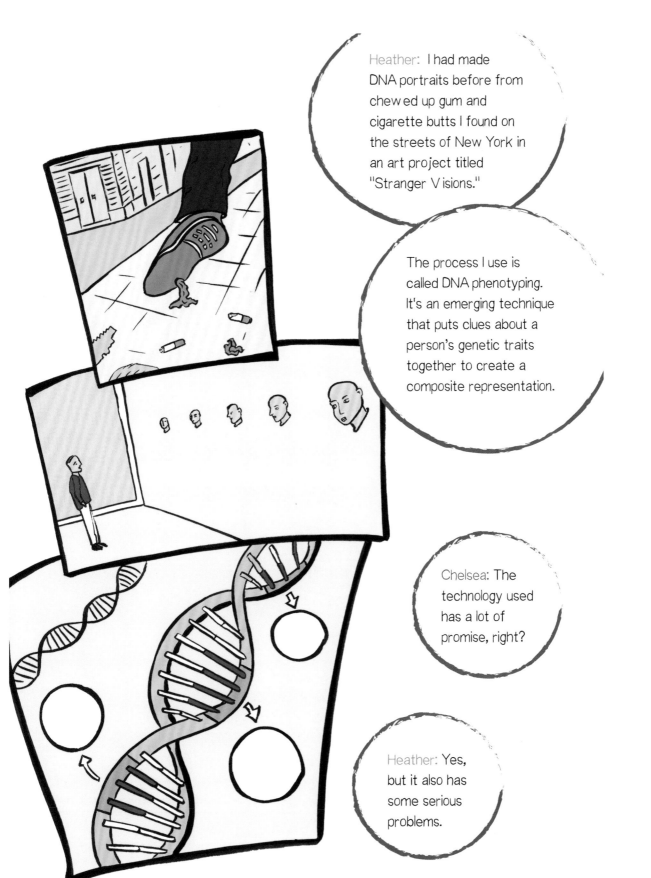

Heather: I had made DNA portraits before from chewed up gum and cigarette butts I found on the streets of New York in an art project titled "Stranger Visions."

The process I use is called DNA phenotyping. It's an emerging technique that puts clues about a person's genetic traits together to create a composite representation.

Chelsea: The technology used has a lot of promise, right?

Heather: Yes, but it also has some serious problems.

4. Situatedness Heather Dewey-Hagborg and Chelsea Manning, illustrated by Shoili Kanungo

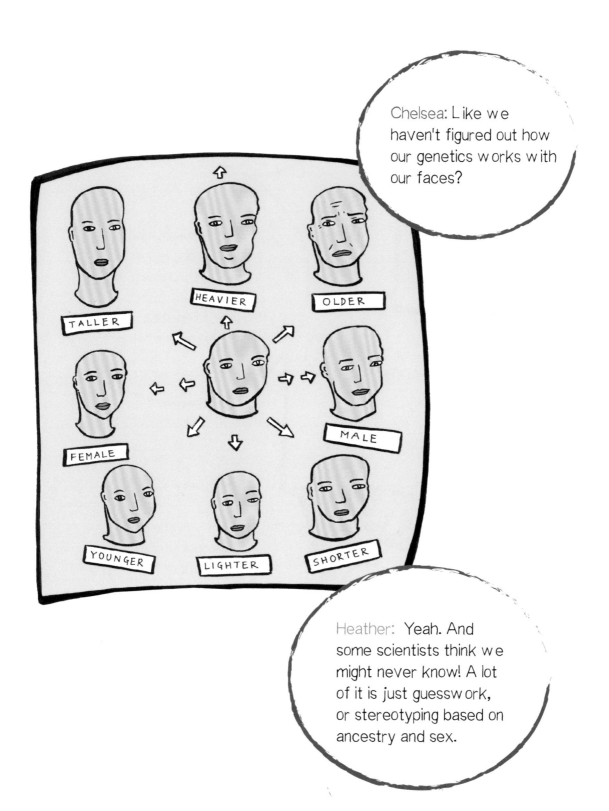

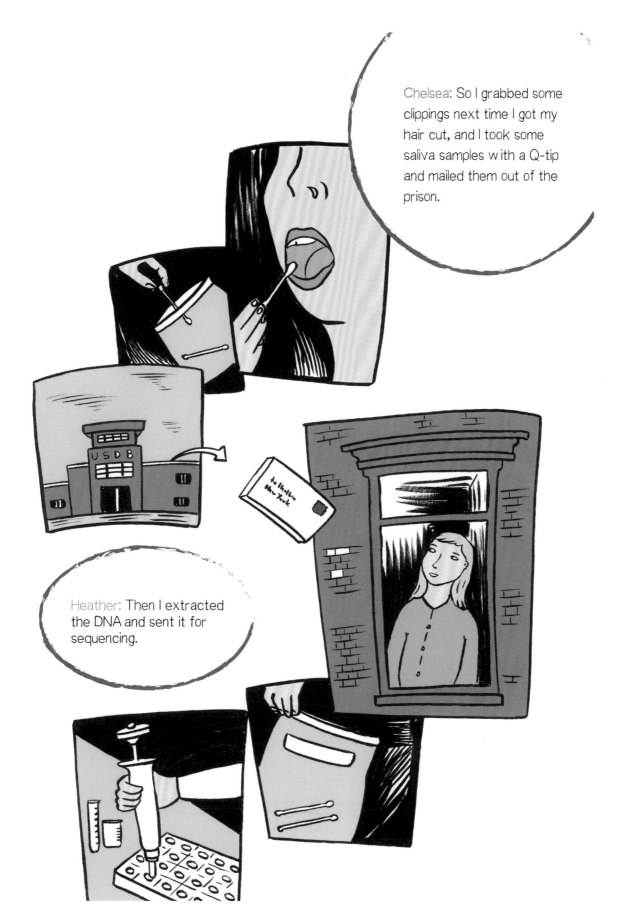

IMAGE PROFILE:

ANCESTRY: WESTERN EUROPE

RS12913832 GG: BLUE EYES

RS4648379 CC: TYPICAL NOSE

RS6548238 TC: BMI -0.26

Heather: And I generated a handful of different possible faces based on the data and then chose the one that I thought was the most compelling.

Chelsea: Right, and I had a little bit of say in the selection. I didn't want to look too masculine.

Heather: There were two options that I thought of. I could leave the sex parameter out entirely. There really wasn't any reason to deem it worthy of analyzing. Or we could go with self-identified gender over genetic sex.

Chelsea: Either could be a powerful choice.

Heather: So I created two portraits, one gender "neutral" and one "female."

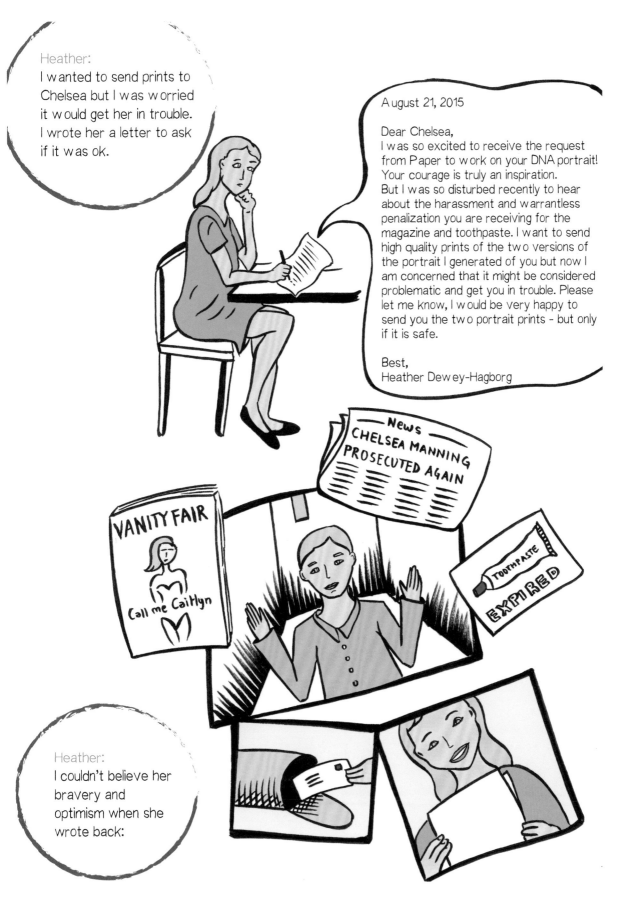

Heather:
I wanted to send prints to Chelsea but I was worried it would get her in trouble. I wrote her a letter to ask if it was ok.

August 21, 2015

Dear Chelsea,
I was so excited to receive the request from Paper to work on your DNA portrait! Your courage is truly an inspiration. But I was so disturbed recently to hear about the harassment and warrantless penalization you are receiving for the magazine and toothpaste. I want to send high quality prints of the two versions of the portrait I generated of you but now I am concerned that it might be considered problematic and get you in trouble. Please let me know, I would be very happy to send you the two portrait prints - but only if it is safe.

Best,
Heather Dewey-Hagborg

News
CHELSEA MANNING PROSECUTED AGAIN

VANITY FAIR
Call me Caitlyn

TOOTHPASTE
EXPIRED

Heather:
I couldn't believe her bravery and optimism when she wrote back:

4. Situatedness Heather Dewey-Hagborg and Chelsea Manning, illustrated by Shoili Kanungo

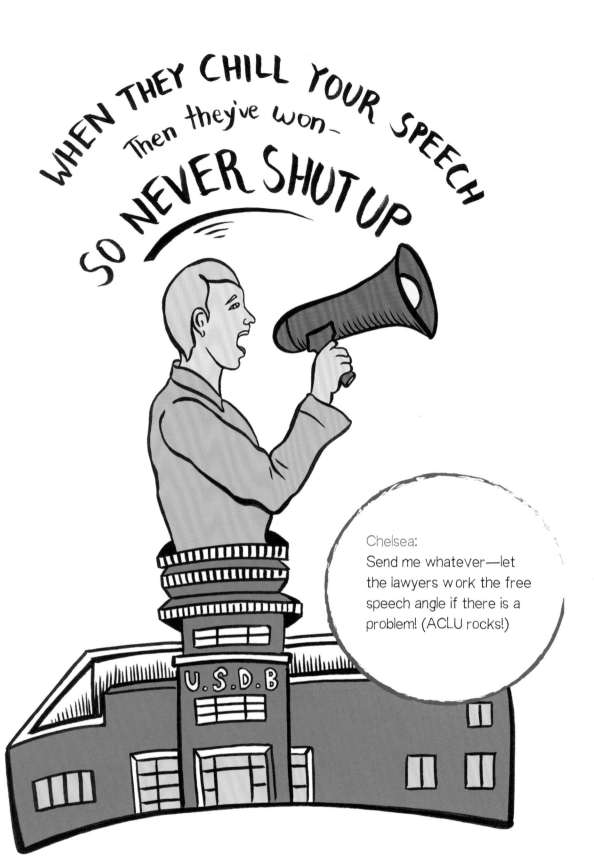

Heather: The 3D printed versions premiered at the World Economic Forum in 2016.

Chelsea: They gave a kind of visibility back to me.

Heather: At one of the most elite and inaccessible events of the year, at that. And now, the portraits continue to travel the world.

Chelsea: But, I still haven't seen them in person.

4. Situatedness Heather Dewey-Hagborg and Chelsea Manning, illustrated by Shoili Kanungo

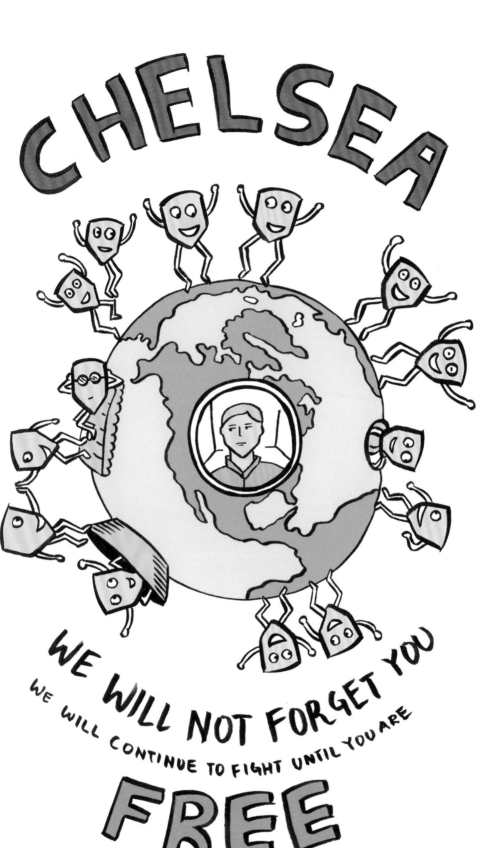

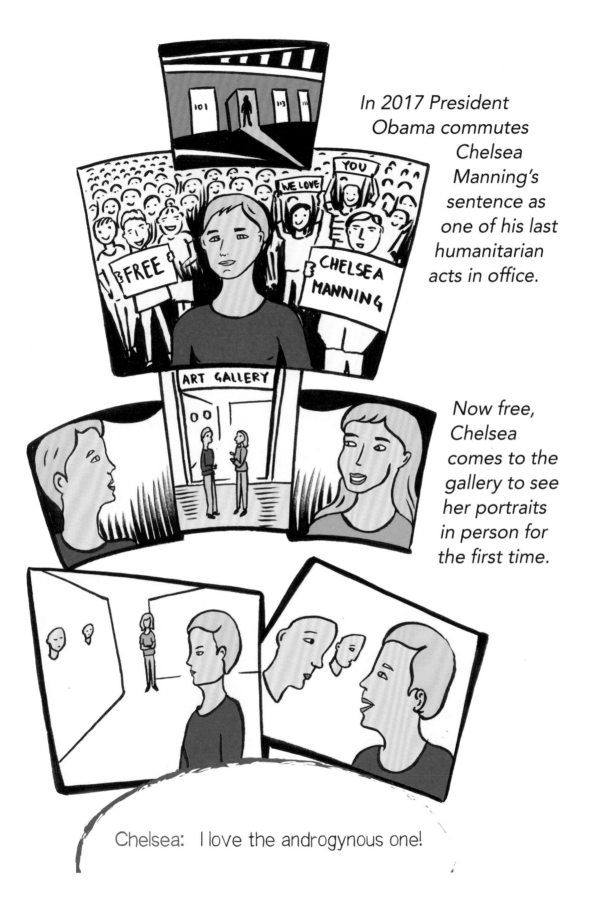

In 2017 President Obama commutes Chelsea Manning's sentence as one of his last humanitarian acts in office.

Now free, Chelsea comes to the gallery to see her portraits in person for the first time.

Chelsea: I love the androgynous one!

4. Situatedness Heather Dewey-Hagborg and Chelsea Manning, illustrated by Shoili Kanungo

ART AND SOLIDARITY READER

Reem Abbas
is a journalist, blogger, writer and researcher with a degree in Journalism and Sociology and a postgraduate degree in Gender and Migration Studies. Her writings and socio-political commentary have been published in *The Guardian, The Christian Science Monitor, The Nation, The Washington Post, Inter-Press Service, Women's eNews, Doha Center for Media Freedom, Index on Censorship Magazine* among other online and print publications. She is currently working on a book on the cultural and artistic scene in Sudan and its resistance to the government of Al-Bashir from 1989–2019 in collaboration with the cultural platform Andariya.

Toufoul Abou-Hodeib
is a Lebanese-Palestinian-Norwegian scholar and Associate Professor of History at the University of Oslo. Born and raised in Beirut, she received her graduate education at the University of Amsterdam and the University of Chicago. She is interested in material culture and the social and cultural history of the Levant, and is author of *A Taste for Home: The Modern Middle Class in Ottoman Beirut* (Stanford University Press, 2017).

Noor Abuarafeh
is a Palestinian artist who explores imagination and history, focusing on how history is documented, read and perceived, as well as how these elements may be used to predict the future. Much of her practice centres on text-based works, which she describes as alternative forms of books. Abuarafeh's work has been featured internationally in solo and group exhibitions and presentations, including 'The Moon Is a Sun Returning as a Ghost', Al Ma'mal Foundation for Contemporary Art, Jerusalem (2019); *Again, Palestine. Palestinian Women Filmmakers,* ZINEBI 16, Bilbao, Spain (2019); *Pour Elle,* Manoir Museum, Martigny, Switzerland (2018); *The Last Museum: Museum of all Museums* (performance), Mosaic Room, London (2018); *Gaudiopolis* – The City of Joy, OFF-Biennale Budapest (2017); Sharjah Biennial 13, Sharjah and Ramallah (2017).

Yásnaya Elena Aguilar Gil
(Ayutla Mixe, Oaxaca) is a Mexican linguist, writer, translator, language rights activist and researcher. Her working languages are Ayuujk (Mixe), Spanish and English. She has carried out projects that meet the needs of speakers whose language is at risk of disappearing.

Ali Hussein Al-Adawy
is an Egyptian curator, researcher, editor, writer and critic of moving images, urban artistic practices, and cultural history from Alexandria. He has curated a number of film programes and seminars such as *Serge Daney: A homage and retrospective* (2017) and *Harun Farocki: Dialectics of images... Images that cover/uncover other images* (2018). Together with Paul Cata, he curated the exhibition 'The Art of Getting Lost in Cities: Barcelona & Alexandria' (2017). He was co- founder of *Tripod,* an online magazine for film and moving images criticism (2015–17) and was part of the editorial team of *TarAlbahr,* an online platform for urban and art practices in Alexandria (2015–18).

Salvador Allende (1908–1973)
was a Chilean politician and co-founded Chile's Socialist Party. Allende ran for the presidency multiple times before becoming Chile's first democratically elected Socialist president in 1970. His government was covertly opposed by US president Richard Nixon, but widely supported among Chile's working class as well as left-wing governments and intellectuals world-wide. A military coup led by General Augusto Pinochet resulted in Allende's death on 11 September 1973, and Chile's 13-year-long period of military dictatorship.

Beth Brant (1941–2015)
was a poet and writer. She was born in Detroit to an Irish-Scottish mother and a Mohawk father. In her poems, she often addressed themes of feminism, Native rights, and family. Brant was the author of *Mohawk Trail* (1985), which included poetry, stories, and essays; the short story collection *Food and Spirits* (1991); and the nonfiction prose volume *Writing as Witness: Essay and Talk* (1994). Her work

has been translated into German, French, Chinese, and Italian. Brant edited the anthology *A Gathering of Spirit: A Collection by North American Indian Women* (1988) and the interview collection *I'll Sing 'til the Day I Die: Conversations with Tyendinaga Elders* (1995).

Wendy Carrig
is a British photographer whose early student work documenting the women of Greenham Common Peace Camp was hidden in negative files for over 25 years, but are now gaining traction. Carrig's commercial fashion and portrait photography gained awards from the Photographic Portrait Prize, Portrait of Britain and Portrait of Humanity, and Carrig is the first woman photographer to have twice been awarded the Association of Photographers' GOLD award. Her personal work has been exhibited in the National Portrait Gallery, The Royal Photographic Society and the Houses of Parliament.

Heather Dewey-Hagborg
is a US-based artist and biohacker who is interested in art as research and technological critique. Her controversial biopolitical art practice includes the project *Stranger Visions,* in which she created portrait sculptures from analyses of genetic material (hair, cigarette butts, chewed-up gum) collected in public places. Dewey-Hagborg has shown work internationally at events and venues including the World Economic Forum, the Daejeon Biennale, the Guangzhou Triennial, and the Shenzhen Urbanism and Architecture Biennale, Transmediale, the Walker Center for Contemporary Art, the Philadelphia Museum of Art, and PS1 MOMA. Her work is held in public collections of the Centre Pompidou, the Victoria and Albert Museum, the Wellcome Collection, the Exploratorium, and the New York Historical Society. Dewey-Hagborg has a PhD in Electronic Arts from Rensselaer Polytechnic Institute. She is a Visiting Assistant Professor of Interactive Media at NYU Abu Dhabi, a Sundance Art of Practice Fellow, an Artist-in-Residence at the Exploratorium, and is an affiliate of Data & Society.

Emory Douglas

is a US-based illustrator of graphic images depicting the struggles of African Americans, Douglas became an influential force within the Black Panther Party from 1967 to 1980. In 1967 he became the Panthers' 'Revolutionary Artist and Minister of Culture'. He played a central role in the newspaper *The Black Panther,* often designing the front cover. In the past 15 years his work has been exhibited in major art institutions, including Museum of Contemporary Art, Los Angeles; the New Museum in New York and Tate Modern, London.

Ntone Edjabe

is a Cameroon-born and South Africa-based journalist and DJ. He is founder of *Chimurenga* – a Pan African platform of writing, art and politics – and curates, together with Neo Muyanga, the Pan African Space Station (PASS). PASS is a periodic, pop-up live radio studio; a research platform and living archive, as well as an ongoing internet-based radio station. He is also co-founder and member of the DJ collective Fong Kong Bantu Soundsystem.

Ingrid Fadnes

is a Norwegian journalist, who writes for the Norwegian daily newspaper *Klassekampen* and has previously worked as a teacher and researcher at the Institute for Journalism and Media at the OsloMet University. She holds an MA in Latin American studies and has worked in Mexico, Central America and Brazil for about 10 years. From 2012–16 she was the coordinator of the solidarity brigades of The Norwegian Solidarity Committee for Latin America (LAG Norge).

Eva Maria Fjellheim

is a Southern Sámi PhD fellow at the Centre for Sámi Studies at The Arctic University of Norway, UiT, where she is researching 'green colonialism' and the dilemmas that occur in the intersection of climate-change mitigation politics and Indigenous peoples' rights in the context of renewable energy developments. She is an active member of the Norwegian Solidarity Committee for Latin America (LAG Norge), a radio producer and a writer.

Katya García-Antón

is director/chief curator of the Office for Contemporary Art Norway. She graduated as a biologist, and transitioned into the arts with a Master's degree in nineteenth and twentieth century art from The Courtauld Institute of Art, London. She has worked at The Courtauld Institute of Art, Museo Nacional Reina Sofía Madrid, ICA London, IKON Birmingham, and the Centre d'Art Contemporain Genève. She curated the Nordic Pavilion, Venice Biennial in 2015 and the Spanish Pavilion in the Venice Biennial 2011. She has curated over 100 exhibitions of art, design and architecture, and was most recently chief curator for 'Actions of Art and Solidarity' (2021). In OCA, García-Antón has generated significant Indigenising practices and programs, the most complex of which regards OCA's role as commissioner of the transformation of the Nordic Pavilion into the Sámi Pavilion at the 59th International Venice Biennale, 2022. García-Antón is part of the curatorial group for the Sámi Pavilion. In August 2022 she becomes director of the Northern Norway Art Museum (NNKM).

Soledad García Saavedra

is a Chilean art historian and curator. García Saavedra's current research focuses on the intersections between Pop art and popular culture, past and present revolutions, and critical museology. She was curator of Public Programs at the Museo de la Solidaridad Salvador Allende where she co-edited the book *Mirada de Barrio*: *arte y participación colectiva para imaginar territorios y comunidades* (MSSA, 2021).

IKON

magazine has been, since its founding by Susan Sherman and Gale Jackson in 1967 in New York, dedicated to centring art and poetry 'as an impetus to action, not divorced from, but irrevocably part of our involvement in this world'. It set out to break what at the time were taboos within the art and poetry worlds – that artists and writers weren't supposed to write about their own work or the people they knew, and that art was seen as autonomous from the world in which it was created. In the mid-1980s,

IKON was published as a second series that focused particularly on women's labour and included special issues made in collaboration with groups such as 'Art Against Apartheid', 'Asian Women United', and 'Coast to Coast: National Women Artists of Color'.

Gavin Jantjes

is a UK-based South African curator, artist and writer. He was an active critic of the apartheid regime, and one of his most renowned works, *South African Colouring Book* (1975/89), integrates photographic images into a work of art intended as a tool of knowledge about South Africa's apartheid policies. Based in Norway for a number of years, Jantjes was artistic director of the Henie Onstad Kunstsenter and later international curator at the National Museum of Art, Architecture and Design in Oslo. He has also served as a trustee of the Tate, Whitechapel and Serpentine Galleries. His work has recently been featured in solo exhibitions at Tyburn Gallery, Oslo Kunstforening and as part of *Dak'Art* Biennale of Contemporary Art in Dakar.

Geeta Kapur

is among India's most internationally noted art critics and curators; her work has been published and presented in anthologies and museums around the world. Her books include *Contemporary Indian Artists* (1978), *When Was Modernism: Essays on Contemporary Cultural Practice in India* (2000) and *Critic's Compass: Navigating Practice* (2016). She has been member of the International Jury for the biennials in Venice (2005), Dakar (2006), and Sharjah (2007), and was the founding editor of *Journal of Arts & Ideas,* as well as serving on the Advisory Council of *Third Text* for two decades; she is currently on the Advisory Board of *ArtMargin.* Kapur has lectured in universities and museums worldwide and held Visiting Fellowships at the Indian Institute of Advanced Study, Shimia; Clare Hall, University of Cambridge; Nehru Memorial Museum and Library, Delhi; University of Cambridge; Nehru Memorial Museum and Library, Delhi; University of Delhi and Jawaharlal Nehru University Delhi.

Shoili Kanungo
is an artist and writer based in New Delhi. Her comics, illustrations and writing have been published in *The Indian Quarterly, The New Inquiry, Livemint* amongst others. She has a BA in philosophy from St Stephens College in New Delhi and an MA in design from the University of New South Wales, Sydney. She is interested in philosophy, science, society, mythology, travel narratives, and mental health.

Lara Khaldi
is an independent curator and critic based between Jerusalem and Amsterdam. Khaldi lectures in media studies at Al-Quds Bard College in Jerusalem and previously taught art history and theory at Palestine's Birzeit University. A former assistant programme director at the Sharjah Art Foundation and director of the Khalil Sakakini Cultural Centre in Ramallah, Khaldi went on to complete the Curatorial Programme at De Appel, Amsterdam in 2014. Her recent projects include *Shifting Ground,* an off-site project for the Sharjah Biennial (2017) in Ramallah, a solo exhibition by Noor Abuarafeh at the Al Ma'mal Art Foundation in Jerusalem, 'Unweaving Narratives' (2018) at the Palestinian Museum, Birzeit, and 'Overtones' (2019) at the Goethe Institute, Ramallah. Khaldi has also contributed to a number of publications such as *Time has fallen asleep in the afternoon sunshine* (Mousse Publishing, 2019) and *Of(f) Our Times: Curatorial Anachronics* (Sternberg Press, 2019), as well as edited a number of publications, most recently *In aching agony and longing I wait for you at the Spring of Thieves: Jumana Emil Abboud* (Black Dog Press, 2018). She is currently a member of the artistic team of documenta fifteen.

Ixchel León
Is a Guatemala-born Kaqchikel and Kiche activist based in Norway, who served as chair of Latinamerika-gruppene i Norge (LAG) – The Norwegian Solidarity Committee for Latin America. She also served as leader of SAIH at Ås, Norway, and worked with SAIH to develop tools for the decolonisation of academia.

Audre Lorde
was a Black feminist, lesbian, poet, mother, warrior (1934–1992) born in New York to immigrant parents. Her activism and her published work, speaking to the importance of struggle for liberation among oppressed peoples and of organising in coalition across differences of race, gender, sexual orientation, class, age and ability have left an indelible mark on global discourse. An internationally recognised activist and artist, Lorde was the recipient of many honours and awards, including the Walt Whitman Citation of Merit, which conferred the mantle of New York State poet for 1991–93.

Chelsea Manning
is an activist, technologist and former intelligence analyst who in 2010 publicly disclosed hundreds of thousands of classified US military and diplomatic documents to WikiLeaks, exposing a range of governmental abuses related to the Afghanistan and Iraq Wars. She has received a range of international awards that celebrate her courage and the global impact of her activism, including the US Peace Prize in 2013 and the EFF Pioneer Award in 2017. Manning is now a highly visible leader in both the movements for transgender justice and government accountability. She lectures, writes, and tweets on everything from cryptocurrency to human rights to machine learning.

Olivier Marboeuf
is a writer, storyteller and curator. He founded the independent art centre Espace Khiasma (www.khiasma.net), which he ran from 2004 to 2018 in Les Lilas, on the outskirts of Paris. At Khiasma, he developed a programme addressing minority representations through exhibitions, screenings, debates, performances and collaborative projects. Interested in the different modalities of transmission of knowledge, Marboeuf imagines permanent or ephemeral structures based on conversations and speculative narratives. He is currently a film producer at Spectre productions.

Barbara Masekela
is a South African poet, educator and anti-apartheid activist who has held central positions within the African National Congress (ANC), among them Head of the ANC's Department of Arts and Culture. Appointed by President Nelson Mandela after he was released from his 27-year prison term, she became South Africa's ambassador to France and UNESCO (1995–99).

Naeem Mohaiemen
combines films, drawings, sculptures, and essays to research socialist utopia, incomplete decolonisation, malleable borders, unreliable memory, and the decaying family unit. His projects often start from Bangladesh's two postcolonial markers (1947, 1971) and then radiate outward to unlikely, and unstable, transnational alliances: Lebanese migration networks, Japanese hijackers, and a Dutch academic. He is a Mellon Teaching Fellow at Columbia University, New York, and Senior Research Fellow at Lunder Institute of American Art, Maine.

Mário Pedrosa (1900–1981)
was a Brazilian political activist, journalist, art and literature critic and one of Latin America's most cited intellectuals. He was also a pioneering curator and museum director who was instrumental in the establishment of the São Paulo Biennial. Upon invitation from President Salvador Allende, he organised the International Committee for Artistic Solidarity with Chile. Having spent time in the Soviet Union to take courses at the International Leninist School in Moscow and studying at the University of Berlin, he was exiled from Brazil upon his return in 1929 for his relationship with the Trotskyist movement. In the 1970s he was exiled a second time, in Chile, where his network of international artists and curators helped build the collection for the Museum of Solidarity.

Ram Rahman
is a photographer, curator, designer, activist and co-founder of Sahmat, a leading force in the resistance of inter-religious strife and defender of free speech in India. He is known for his street

photography in Delhi and other parts of India, as well as portraits of artists and intellectuals. His work is widely exhibited globally in both solo and group exhibitions at Duke University, Raleigh, and Kiran Nadar Museum of Art, New Delhi, among others. He received the Forbes India Art Award in 2014 for curating the exhibition 'The Sahmat Collective: Art and Activism in India since 1989' at the Smart Museum of Art in Chicago.

Laura Raicovich
is a New York-based writer and curator whose most recent publication is *Culture Strike: Art and Museums in an Age of Protest* (Verso 2021). She recently served as Interim Director of the Leslie Lohman Museum of Art; was a Rockefeller Foundation Fellow at the Bellagio Center; and was awarded the inaugural Emily H. Tremaine Journalism Fellowship for Curators at *Hyperallergic*. While Director of the Queens Museum from 2015 to 2018, Raicovich co-curated *Mel Chin: All Over the Place* (2018), a multi-borough survey of the artist's work. She lectures internationally and in 2019–20 co-curated a seminar series titled *Freedom of Speech: A Curriculum for Studies into Darkness* at the New School's Vera List Center for Art and Politics, from which she is co-editing an anthology of writings on the subject. She is also the author of *At the Lightning Field* (CHP, 2017) and co-editor of *Assuming Boycott: Resistance, Agency, and Cultural Production* (OR, 2017).

farid rakun
is a member of ruangrupa, a non-profit contemporary art organisation founded in 2000 by a group of artists in Jakarta. ruangrupa focuses on advancing art ideas in urban contexts and in the broad scope of culture. They do this through exhibitions, festivals, workshops, researches and book, magazine, and online journal publications. ruangrupa is the artistic director of documenta fifteen, Kassel, 2022.

Aban Raza
Aban Raza is a New Delhi-based printmaker and painter whose practice originates from the crossover between her political concerns and philosophical preoccupations. Her first solo exhibition was held in 2020 at Galerie Mirchandani + Steinruecke, Bombay, India. She has co-directed *M Cream,* a feature film, which saw a theatrical release in 2016. In 2020, she curated an exhibition for Sahmat entitled 'Celebrate, Illuminate, Rejuvenate, Defend the Constitution of India at 70'.

Devika Singh
is Curator, International Art at Tate Modern. Her writing has appeared widely in exhibition catalogues, magazines and journals. She was previously Smuts Research Fellow at the Centre of South Asian Studies at the University of Cambridge and a fellow at the Centre allemand d'histoire de l'art, Paris. She curated exhibitions including 'Planetary Planning' (Dhaka Art Summit, 2018) and 'Homelands: Art from Bangladesh, India and Pakistan' (Kettle's Yard, 2019–20) and co-curated 'Gedney in India' (Jehangir Nicholson Art Foundation, CSMVS, Mumbai, 2017; Duke University, 2018).

Irene Soria Guzmán
is a Mexican Feminist Studies PhD candidate, researcher, designer, activist for the free software and free culture movements and author and compiler of the book *Ética hacker, seguridad y vigilancia*. She explores the concept of hack-feminism in her own practices and questions what a decolonial technology would look like. She is also a Creative Commons Mexico chapter representative.

Kwanele Sosibo
is a journalist and writer based in Johannesburg, South Africa. He is the arts editor at the *Mail & Guardian*. In 2011, he became the inaugural Eugene Saldanha Fellow in social justice and inequality reporting and has since published numerous long-form features in publications such as *The Con, Chimurenga, Baobab* and *Rolling Stone*.

Eszter Szakács
is a PhD candidate in the project IMAGINART—Imagining Institutions Otherwise: Art, Politics, and State Transformation at the Amsterdam School for Cultural Analysis at the University of Amsterdam. Previously she worked at tranzit.hu Budapest, where she has been co-editor of the online international art magazine *Mezosfera*, co-editor of the book *IMAGINATION/IDEA: The Beginning of Hungarian Conceptual Art – The László Beke Collection, 1971* (tranzit.hu, JRP|Ringier, 2014), and curator of the collaborative research project 'Curatorial Dictionary'. She is a curatorial team member of the civil initiative OFF-Biennale Budapest.

Dulce Celina Ureña Hernández
is based in Guadalajara City, Mexico where she works with embroidery to campaign against gender-based violence and femicides, which are overrepresented in her homeland, Mexico. Since starting embroidery as an everyday activity in 2018, it has also become a livelihood that has secured Ureña Hernández' economic independence.

Alice Walker
is an internationally celebrated writer, poet and activist whose books include seven novels, four collections of short stories, four children's books, and volumes of essays and poetry. She won the Pulitzer Prize in Fiction and the National Book Award in 1983 for her book *The Color Purple*. That same year, Walker coined the term *womanist* to mean 'black feminist or feminist of colour'.

Art and Solidarity Reader. Radical Actions, Politics and Friendships stems from the conversations and research that were generated in the three-years of preparation leading to the opening of the exhibition 'Actions of Art and Solidarity' in January 2021. OCA is deeply honoured to have counted on committed dialogue partners in its making.

'Actions of Art and Solidarity' was curated by Katya García-Antón (Director/Chief Curator) at Office for Contemporary Art Norway (OCA), with the research and coordination support of Liv Brissach (OCA Project Officer), Itzel Esquivel (OCA Project Coordinator) and Drew Snyder (OCA Programme Manager) in Oslo, and Aban Raza (in Delhi). The exhibition was organised in collaboration with Kunstnernes Hus, and the public programme was co-curated by OCA and Kunstnernes Hus.

OCA is eternally grateful to all the authors who have committed their thought, energy and research in producing the new texts for this *Reader*: Reem Abbas; Toufoul Abou-Hodeib; Noor Abuarafeh; Yásnaya Elena Aguilar Gil; Ali Hussein Al-Adawy; Wendy Carrig; Katya García-Antón; Soledad García Saavedra; Gavin Jantjes; Lara Khaldi; Olivier Marboeuf; Naeem Mohaiemen; Ram Rahman; Laura Raicovich; farid rakun, ruangruppa; Aban Raza; Devika Singh; Irene Soria Guzmán; Eszter Szakács.

In addition we extend our sincere appreciation for the permission to reprint essays by the following authors: Salvador Allende, Beth Brant, Heather Dewey-Hagborg, Emory Douglas, Ntone Edjabe, Ingrid Fadnes, Eva Maria Fjellheim, Geeta Kapur, Shoili Kanungo, Ixchel León, Audre Lorde, Chelsea Manning, Barbara Masekela, Mário Pedrosa, Kwanele Sosibo, Dulce Celina Ureña Hernández and Alice Walker. We are specially thankful to the Museo de la Solidaridad Salvador Allende; Sahmat; Gale Jackson and Susan Sherman from IKON magazine; Ingrid and Astrid Fadnes; Latinamerika-gruppene i Norge (LAG) and Fridman Gallery for permission to reprint texts originally published in their publications.

We are also deeply grateful for the collaboration with Naeem Mohaiemen and Eszter Scakács, whose anthology (ed.) *Solidarity Must be Defended* (Budapest: tranzit.hu / Eindhoven: Van Abbemuseum / Istanbul: SALT / New Delhi: Tricontinental / Gwangju: Asia Culture Center) has a place in this Reader in the form of an extended image archive; and for the collaboration with the Gwangju Biennale's curators Natasha Ginwala and Defne Ayas, which resulted in the inclusion of the text by Reem Abbas.

Our wholehearted thanks are extended to Sahmat (and especially Ram Rahman, Ashok Kumari, Rajen Prasad, Naresh Kumar and Lalit Narayan for their hospitality whilst researching in Delhi and for their generous collaborative spirit), as well as the MSSA's Director Claudia Zaldivar and her colleagues Caroll Yaski, María José Lemaitre, Isabel Cáceres and Camilla Rodríguez for their attentive dialogues with us and for their hospitality while researching in Santiago, Chile.

A very special thanks to Geeta Kapur and Vivan Sundaram for sharing their excellent expertise and for their most generous guidance at different points in the making of the Reader, as well as to Octavio Zaya, Maritea Dæhlin, Ingrid and Astrid Fadnes, Kristine Khouri, Rasha Salti and Vera Tamati for inspiring conversations, connecting us with peers and offering useful advice.

Finally we extend our sincere gratitude to the many wonderful people for their precious support to this Reader: all staff members at OCA, designer Hans Gremmen, copy editor Melissa Larner, publisher Astrid Vorstermans at Valiz and Wilco Art Books for production.

Suppressed Images, written by Heather Dewey-Hagborg & Chelsea Manning, illustrated by Shoili Kanungo. Courtesy of the artists and Fridman Gallery, NY.

Salvador Allende, *Palabras del presidente de la republica, compañero Salvador Allende, en la inauguración del 'Museo de la Solidaridad' en quinta normal. Santiago, miercoles 17 de mayo de 1972.* Original transcription. Courtesy of Museo de la Solidaridad Salvador Allende.

Mário Pedrosa, *Opening speech at the First Exhibit of the Museum of Solidarity – May 17, 1972.* Original transcription. Courtesy of Museo de la Solidaridad Salvador Allende.

Salvador Allende, 'A Los Artistas del Mundo'. Allende's letter at the inauguration of the Museo de la Solidaridad. Santiago, Chile, 17 May 1972. Fondo Museo de la Solidaridad. Courtesy of Museo de la Solidaridad Salvador Allende.

Jwana te la Krus Posol, *Para sembrar la tierra.* Originally appeared in Ámbar Past, Xalik Guzmán Bakbolom and Petra Hernándes (editors/fathermothers), *Conjuros y ebriedades: cantos de mujeres mayas,* (San Cristóbal de Las Casas: Taller leñateros, 1998). Printed with permission from Taller leñateros, 2021.

Wendy Carrig, *Visual Essay,* select images from her *Greenham Common* photography series, 1985. Courtesy of the artist.

Geeta Kapur, 'Artists Alert' was originally published in the catalogue *Artists Alert: An Exhibition of Painting, Sculpture, Graphics and Photography* (New Dehli: Sahmat, 1989). Reprinted with permission from the author.

IKON – Creativity and Change Second Series # 5/6. A Special Double Issue: Art Against Apartheid – Works for Freedom, 1986 front page and editorial statement by co-editors Gale Jackson and Susan Sherman. Copyright © IKON Inc. Reprinted with permission from Gale Jackson and Susan Sherman.

Audre Lorde
'Apartheid U.S.A.' – from *A Burst Of Light and Other Essays* by Audre Lorde
Copyright © 1988 by Audre Lorde
'Sisters in Arms' – from *The Collected Poems of Audre Lorde*
Copyright © 1997 by Audre Lorde
Reprinted with permission from Regula Noetzli – Affiliate of the Charlotte Sheedy Literary Agency.

Alice Walker
'The People Do Not Despair. An Introduction to Art Against Apartheid', first published in *IKON – Creativity and Change* Second Series # 5/6. *A Special Double Issue: Art Against Apartheid – Works for Freedom,* 1986. Reprinted by permission of *IKON* and The Joy Harris Literary Agency, Inc.

Beth Brant
'Mohawk Trail' and 'For All My Grandmothers' originally appeared in *Mohawk Trail* (Forebrand Books, 1985). Reprinted with permission from Inanna Publications and Education Inc.

Barbara Masekela interview, edited from an interview conducted and taped by James Cason and Michael Fleshman in Lusaka, 12/6/84 and revised and brought up to date by Barbara Masekela, December 1985. Facsimile *IKON* 33–38: Photos by Frank Dexter Brown of children at a SWAPO refugee camp, Nyango, Zambia. ANC and SWAPO refugee settlements are similar in the type of support provided to refugees from both South Africa and Namibia.

Canción sin miedo by Vivir Quintana is reprinted with permission from the author. Vivir Quintana ig: [@] vivirquintana
fb: Vivir Quintana

Dulce Celina Ureña Hernández, 'Pirata Bordadora. "Incendiarlo todo"' (México, 2020). This text was first published in Astrid Fadnes and Ingrid Fadnes (ed.), *Et lappeteppe av solidaritetshistorier,* as a part of Latin-Amerikagruppene i Norge / The Norwegian Solidarity Committee for Latin America (LAG)'s collective art project *Solidaritetssteppet / The Solidarity Patchwork* (2021),

which was commissioned for and first presented at OCA's exhibition 'Actions of Art and Solidarity' (Kunstnernes Hus, 2021).
Ingrid Fadnes and Emory Douglas, 'Zapantera Negra. An Artistic Encounter between the Zapatistas and the Black Panthers (2012)' was first published in *SubVersiones* in November 2012: https://subversiones.org/archivos/5779 accessed 23 February 2022.

The full version of Eva Maria Fjellheim's, 'Excerpts from Solidarity without Borders' was published in Norwegian as 'solidaritet i praksis og uten grenser' *I dag er fortsatt alltid – 40 år med Latin-Amerikagruppene i Norge* (Oslo: Latin-Amerikagruppen i Norge), 2018.

Ixchel Léon, 'Statement' (2017) was first published on the website for the project 'Et eget rom som rommer flere rom' – an exhibition curated by the Norwegian Solidarity Network for Latin America, https://feministiskerom.no/rom/hogar-seguro/ accessed 23 February 2022.

An edited version of Kwanele Sosibo's interview with Ntone Edjabe appeared in *Mail & Guardian* (Johannesburg) of 27 May 2020 https://mg.co.za/friday/2020-05-27-reproducing-festac-77-a-secret-among-a-family-of-millions/ accessed 23 February 2022.

Excerpts from the book *FESTAC '77: The 2nd World Black and African Festival of Arts and Culture,* a publication by Chimurenga, published by Chimurenga and Afterall Books, in association with Asia Art Archive, the Center for Curatorial Studies, Bard College and RAW Material Company, 2019. Courtesy of Chimurenga.

The Greenham Factor, 1984 was a booklet containing photos, stories and testimonies, published by Greenham Print Prop.

Map from booklet prepared by unnamed Greenham women in 1984, from the archive donated to MayDay Rooms by Gwyn Kirk. Reprinted by permission of the donor and MayDay Rooms.

Invitations to The Fire Dragon Feast for the Future, at Greenham Common Peace Camp, Midsummer 1983. From the files of Mie Bak Jakobsen, Women for Peace. http://www.fredsakademiet.dk/abase/sange/greenham/sigrid.htm accessed 20 August 2021.

Editor:
Katya García-Antón

Assistant editor:
Liv Brissach

Contributors:
Reem Abbas
Toufoul Abou-Hodeib
Noor Abuarafeh
Yásnaya Elena Aguilar Gil
Ali Hussein Al-Adawy
Salvador Allende
Beth Brant
Wendy Carrig
Heather Dewey-Hagborg
Emory Douglas
Ntone Edjabe
Ingrid Fadnes
Eva Maria Fjellheim
Katya García-Antón
Soledad García Saavedra
Gavin Jantjes
Geeta Kapur
Shoili Kanungo
Lara Khaldi
Ixchel León
Audre Lorde
Chelsea Manning
Olivier Marboeuf
Barbara Masekela
Naeem Mohaiemen
Mário Pedrosa
Ram Rahman
Laura Raicovich
farid rakun, ruangruppa
Aban Raza
Devika Singh
Irene Soria Guzmán
Kwanele Sosibo
Eszter Szakács
Dulce Celina Ureña Hernández
Alice Walker

Copy-editor and proof-reader:
Melissa Larner

Graphic design:
Hans Gremmen

Translation:
Liz Young, French–English, for
 Olivier Marboeuf
Neil Fawle, Spanish–English for
 Yásnaya Elena Aguilar Gil and
 Irene Soria Guzmán
Liv Brissach, Norwegian–English
 for Ixchel León and Eva Maria
 Fjellheim

Language consultation
(Spanish / French):
Elsa Itzel Archundia Esquivel
Martina Petrelli

Production support:
Drew Snyder
Elsa Itzel Archundia Esquivel
Eirin Torgersen
Martina Petrelli

Typefaces:
Jungka
SF Mono

Paper:
Munken Lynx

Lithography and printing:
Wilco Art Books

Publisher: Valiz, Amsterdam,
www.valiz.nl

ISBN 978-94-93246-02-7

Printed and bound in NL/EU

The book is realized with
generous funding from the
Fritt Ord Foundation

FRITT ORD